Artists and Warfare in the Renaissance

ARTISTS
AND
WARFARE
IN THE
RENAISSANCE

J R Hale

Yale University Press
New Haven & London 1990

'The difference between a German and an Italian apple tree is enormously large.'

Georg Baselitz, 1987, from a lecture given at the Royal Academy, London

Endpapers
Front: Albrecht Altdorfer, *The Utrecht Campaign* (detail), see plate 24.
Back: Georg Lemberger, *The War in Picardy* (detail), see plate 231.

Copyright © 1990 by Yale University

Designed by Mary Carruthers

Set in Linotron Bembo by Best-set Typesetter Ltd, Hong Kong
Printed in Hong Kong by Kwong Fat Offset Printing Co. Ltd

Library of Congress Cataloging-in-Publication Data
Hale, J. R. (John Rigby), 1923–
 Artists and warfare in Renaissance Europe / J.R. Hale.
 p. cm.
 Includes bibliographical references.
 ISBN 0-300-04840-8
 1. Art, Renaissance. 2. Art and war. I. Title.
N6370.H25 1990 90-12295
760'.09'024 – dc20 CIP

CONTENTS

PHOTOGRAPHIC CREDITS

The author and publisher are grateful to the following people and institutions for providing illustrations for this book:

Amsterdam, Rijksmuseum 1, 20
Basle, Historisches Museum 12
Basle, Oeffentliche Kunstsammlung, Kunstmuseum 55, 252 (Colophoto Hans Hinz; Kupferstichkabinett 2, 5, 6, 32, 34, 46–8, 59, 75, 82, 91, 97, 96, 108, 215, 222, 303, 310
Bern, Historisches Museum 31, 112, 157
Berlin, SMPK, Dahlem 102, 114, 144; Kupferstichkabinett 9, 26, 37, 49, 50, 54, 58, 71, 178, 225, 321
Brussels, Bibliothèque Royale Alber 1er 13, 328
Coburg, Kunstsammlungen der Veste Coburg 69
Copenhagen, Hans Petersen for Statens Museum for Kunst 100
Dresden, Gemäldegalerie 307
Dublin, National Gallery 199, 200
Erlangen, Universitätsbibliothek 92
Florence, Alinari 136, 141, 186, 191, 198, 247, 262, 273, 276–7, 282, 284, 291, 300, 305–6; Index 194, 202, 259, 276, 294; Scala, 169, 196–7, 204, 212, 234; Soprintendenza delle Gallerie 121, 254, 329
Frankfurt, Städelsches Kunstinstitut 61
Graz, Alte Galerie 137, 213
Innsbruck, Tiroler Landesmuseum Ferdinandeum 181

Karlsruhe, Staatliche Kunsthalle 221, 304
Glasgow, Glasgow Museums and Art Galleries 177
London, The British Library 65, 193; The Trustees of The British Museum, Department of Prints and Drawings 11, 33, 41, 126, 131, 133, 203, 299; Hampton Court 280; The Imperial War Museum 345; National Gallery 201, 314; Sotheby's, The Philip Pouncey Collection 171; The Board of Trustees of the Royal Armouries 235; The Warburg Institute 97, 98, 122; Victoria and Albert Museum 265
Lucca, Archivio di Stato di Lucca 124
Lucerne, Zentralbibliothek 150, 214
Lugano, Thyssen-Bornemisza Collection 315
Madrid, Prado 274
Middleton, Mr W John Smith 340
Modena, Biblioteca Estense 168, 267, 279; Soprintendenza 45
Munich, Alte Pinakothek 241, 242, 244, 245, 284; Bayerische Nationalmuseum 295; Bayerische Staatsbibliothek 42
New Haven, Yale University Library, James Jackson Jarves Collection 128
Norfolk, Holkham House 211
Nuremberg, Germanisches Nationalmuseum 60, 72, 266, 243; Stadtbibliothek Nürnberg 158
New York, Copyright The Frick Collection 85, 319; E V Thaw & Co., Inc. 146

The Metropolitan Museum of Art 88, 281 (The New York Historical Society, Gift of Thomas Jefferson Bryan); Pierpont Morgan Library 125
Oxford, The Ashmolean 163, 174 The Bodleian Library 127, 342, 344
Paris, Service photographique de la réunion des musées nationaux 142, 176, 188, 210, 251, 275, 285, 290, 334; Bibliothèque Nationale 19, 64, 271; Caisse Nationale des Archives des Monuments Historiques 338–9
Philadelphia, Museum of Art 145; The John G Johnson Collection 332
Rotterdam, Museum Boymans-van Beuningen 269
Stockholm, National Museum 240; Anders Qwarnstrom © 258
Stuttgart, Staatsgalerie 311
Turku, Turku Provincial Museum 95
Venice, O Bohm 129, 134, 278
Vienna, Graphische Sammlung Albertina 15, 23–4, 80, 86, 90, 231, 233–4; Kunsthistorisches Museum 40, 333; Osterreichisches Staatsarchiv 10, 21, 229; Osterreichische Nationalbibliothek 62, 153–4
Washington DC, National Gallery of Art 18, Lessing J Rosenwald Collection 337
Weimar, Kunstsammlungen 309
Wurzburg, Martin von Wagner – Museum der Universität 219
Zurich, Zentralbibliothek 189

ACKNOWLEDGEMENTS

Much of the groundwork for this book was prepared during a blissfully concentrated year at the Princeton Institute for Advanced Study. Its continuation owes most to the Warburg Institute, not just for its books but for the tolerant and interested mood it generates. The third institution to which my debt is great is University College London, an employer whose seriousness of purpose, and generous attitude to the support of research, makes one despair the more as the shadows close over the glades of learning represented by British universities. Grants from my College, and from the University of London, have enabled me to travel to see many of the works discussed or mentioned in this book. But the major support of such visits was a grant from the British Academy which has had a major influence on the form the book has taken.

For the chance to try out the validity of some of its themes, I am grateful to a number of universities: Manchester, Warwick, Edinburgh, Kent, Toronto, Brown, Johns Hopkins, and the University of California at Los Angeles, as well as a conference at Bellaggio organized by *The Journal of Interdisciplinary History*. I hope I have incorporated the protests and suggestions made on these occasions, as well as when I have hazarded themes more locally.

Among the individuals whose eyes have not glazed over at my response to the question 'What are you working on?', my chief debts are to Christian Andersson, Linda Carroll, Ernst Gombrich, Martin Kemp, David Kunzle, Irving Lavin, Michael Levey, Kristen Lippencott, Keith Moxey, John Rowlands, Nicolai Rubinstein, Philip Rylands, Anne and Juergen Schulz and Evelyn Welch. None saw my subject as particularly eccentric, and I am grateful.

Presided over by Nazneen Razwi, the history department office of my College has done me proud; I would like to pay particular tribute to Julia Cornes, cryptographer–extraordinary.

I thank warmly the readers to whom the Press sent my typescript. They encouraged a major revision of what grew up as an unchastened labour of love, and it is due to them if it has emerged less, as Dürer put it in reproaching his contemporaries' lack of self-discipline, 'like a wild and unpruned tree'. And finally, I thank Beth Humphries for the care she has lavished on making the book user-friendly while copy-editing the text and its apparatus, and Mary Carruthers, for sharing with me a relish for the illustrations she deftly fitted into place.

INTRODUCTION

D URING THE PERIOD (from the mid-fifteenth to the mid-sixteenth century) covered by this book, the Art of War underwent important changes. Infantry, rather than cavalry, became the decisive arm. Firearms changed the nature, if not the outcome, of battles. Fortifications of new design changed not only the appearance of town walls and fortresses but the balance in campaigns between battles and sieges. Armies grew in size and cost. There was an unprecedented amount of debate about their composition, leadership and function, both in war and in peace. And it was a period when warfare was constantly either actual or threatening.

It was also a time when the visual arts had acquired an unprecedented command over description and expressiveness, when alongside the continuing vitality of Netherlandish art and its increasing response to the ever self-renewing range of that of Italy, the arts in Germany and Switzerland reached, in their own very different spirit, a level of powerful and original accomplishment not to be rivalled until the nineteenth century. Moreover, a novel market for prints and a widening interest in uncommissioned drawings gave artists a new opportunity to choose their own subjects and express their own attitudes outside the normal constraints of patronage – constraints which themselves were slackening as patrons increasingly recognized that they were not simply giving orders to receptive artisans. Socially and aesthetically the two themes, war and art, called for a matchmaker.

Yet while historians of the Renaissance have investigated artists' response to religious and erotic experience and explored the relationship between art and attitudes to the natural world and to the human face and personality, the connection between art and war, surely a major aspect of human existence, has been glanced at only fitfully. Yet to review it is to release a mass of images, often of high, sometimes supreme quality, only some of which have been appreciated for their own sake and still fewer seen within the overall context of art's response to war and its agents as determinants of life, death, and social and political fortunes.

The purpose of this book is not, however, to 'illustrate' changes in the nature of warfare, or to gloss literary comment or polemic with pictures: these are areas explored elsewhere. Artists of the calibre of Verrocchio and Burgkmair designed armour, Leonardo's inventions included new forms of weaponry. Michelangelo designed fortifications and Dürer wrote a treatise on them. But these topics, too, have their own historians. All will be drawn on from time to time, but my concern is to suggest how the pictorial imagination of the Renaissance responded, spontaneously or to order, to the outstanding visual and emotional aspects of warfare – the troops themselves, and the battles, skirmishes and sieges that made up a conquering or defensive campaign. And because the subject, treated in breadth for this period, is new, it seemed responsible to adopt the critical survey as an approach.

It is natural to start with the unprecedented (and for centuries unmatched) development of military genre and its equally novel keystone, the figure of the common

soldier. The imagery is so copious, so richly suggestive, that the theme is deployed in terms of the two zones which chiefly contributed to it, Switzerland–Germany and Italy, over the first three chapters.

The discrepancies that emerge between the two zones are striking. So much so that the next two chapters, 4 and 5, attempt to account for them, using the soldier theme as a fresh mode of re-entry into the wide-ranging comparison between northern and southern states of mind that engaged contemporaries and has never ceased to intrigue (and embarrass) historians. Why so many visual responses to soldiers and their manner of life in the north and so few south of the Alps? What social, emotional, aesthetic and market factors conditioned the admissibility of soldiers as objects of interest in their own right into the subject matter of art? Willy-nilly, the book became a tentative contribution to comparative cultural history.

So the interpretative core of the book lies here. And the reader, whether or not in agreement with its analysis, will at least find a point of view from which to consider the less sharply contrasted images which follow: representations of battles and sieges, the visual terminology that both released and restricted the expression of attitudes towards war and peace, and, in Chapter 9, reminders of the habitual confrontation in churches and chapels between the devout – praying maybe in time of war – and the soldiers of Passion and martyrological scenes in religious art; soldiers who increasingly came to resemble those reviewed in the opening chapters. And from the brief epilogue the reader will see why the book concentrates on the Germanic and Italian zones, both gripped by war at the peak of their respective artistic Renaissances.

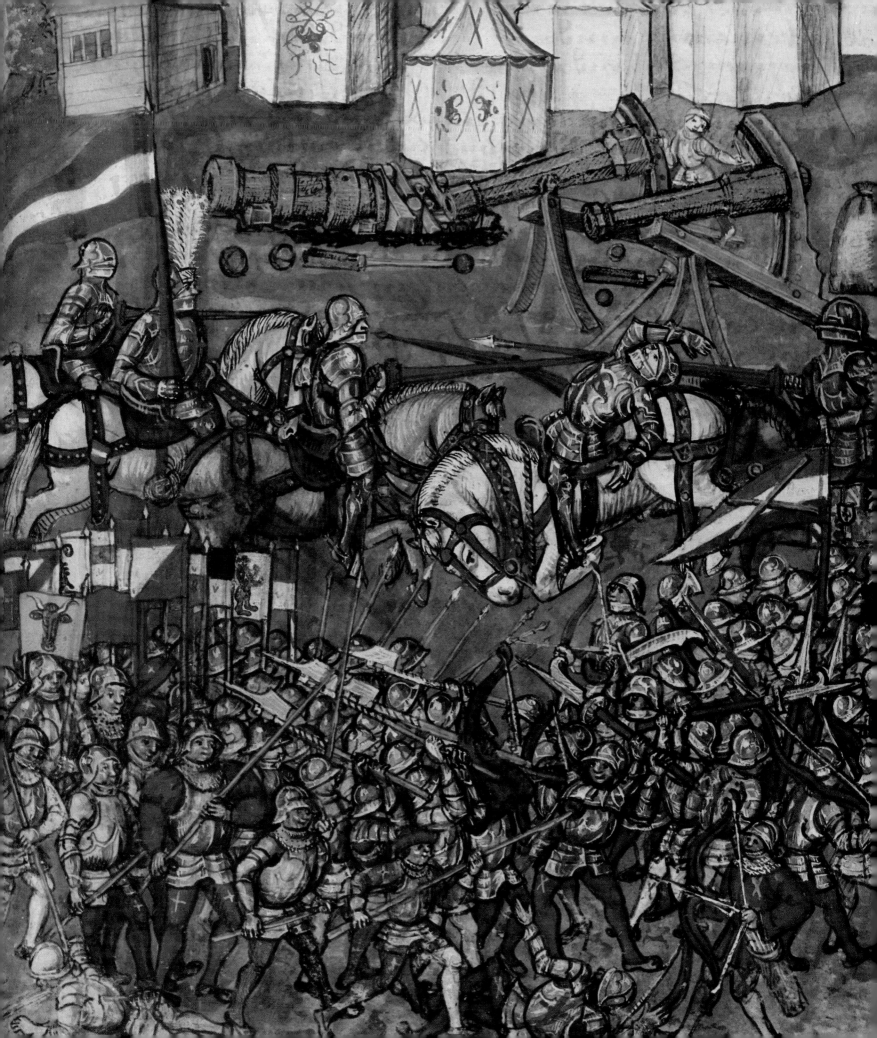

CHAPTER 1
Germanic Military Genre

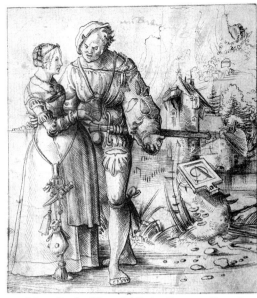

1. Urs Graf, *The Soldier's Return*. Drawing, *c*.1520. Amsterdam, Rijksprentenkabinet.

Though it is the battle painting that first comes to mind in connection with art and war, the most richly innovative aspect of artists' interest was what can loosely be called military genre. This was almost exclusively a northern, more specifically a German and Swiss speciality. To treat it as such, and to follow with suggestions as to its origins and its astonishing vitality, will do much to explain why this book is concerned with the differing attitudes taken by artists north and south of the Alps to experiences common to both areas.

The wealth of works of art, chiefly in graphic media, that reflect contemporary interest in the way of life of soldiers, confront us with a problem of definition. The depiction of informal, non-combat scenes of military life did become a genre: unprecedented in quantity and not to be rivalled on such a scale anywhere in Europe until the nineteenth century. Some artists owe their names to it (the so-called Master of the Landsknechts), others made a corner in it. But in the other sense of 'genre', the steady, un-value-laden and not too deliberately 'artistic' rendering in pictorial terms of a selective aspect of social life, the application must be more hesitant. Did any artist, even in the largely theory-free north, want simply to record 'pictures of everyday life'? Held still as in a workshop pose, or reconstructed from memory as a subject for its own sake scarcely mediated through other considerations, the soldier's real presence could be fairly directly illustrated. But even in the single images we shall look at, there is commonly a pull either towards an enhancement of pictorial interest or an allusiveness to some non-objective significance: pride, danger, patriotism, sexuality. To move the single image into a conversing group was to intensify the play of imagination. To move it further into the mixed circumstances of a military career so at odds with that of homebodies, was to invite another layer of comment between the recording of everyday life and what the artist was moved to say about it.

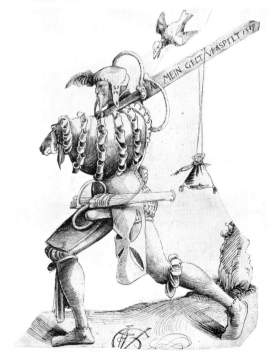

2. Urs Graf, *Landsknecht Returning from the Wars*. Drawing, 1519. Basle, Kunstmuseum, Kupferstichkabinett.

Men joined up for the chance of bettering a merely cost-of-living military wage by bonuses for gallantry or specially risky duties, by post-victory looting or the less formal perks that could be scrounged by armed men on the move among civilians. The literary evidence for this is clear. It is also notably lacking in accounts of soldiers who returned with the ready cash to better their families' circumstances. A dangerous trade had its freedoms and distractions: women, drink, dice, finery. The return of a soldier, full of apologies for his empty purse, to a disappointed wife, pregnant and with the symbols of the cares of housekeeping hanging from her girdle in Urs Graf's drawing of *c*.1520 (Fig. 1), was doubtless a common scene in Swiss villages. Stonily she listens to his explanations. He may have been one of those who did not supplement the wage which was, in any case, not always paid in full, or on time – hence frequent mutinies and desertions. But before seeing this careful, signed drawing as a slice of life, even if an exemplary one, we can turn to another Urs Graf drawing. A soldier, this time a German one, strides doggedly home, broke (Fig. 2). A bird, not his *alter ego* a bird of prey but a duck, dives mockingly at him. His

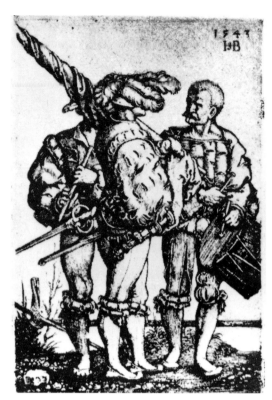

3. Hans Sebald Beham, *Where Shall We Go Now?* Engraving, 1543.

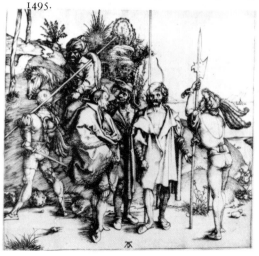

4. Albrecht Dürer, *Recruiting Scene*. Engraving, 1495.

predicament is spelled out along his sword: 'all my money wasted', and by the slit purse that dangles from it. Where did it go? Probably not (for this drawing deliberately invites conjecture) on his distinctive Landsknecht costume, for this is a mustachioed veteran of many campaigns – all the worse that he has not learned to husband his money. The suggestion of the jutting codpiece, encircled by the side-arm hilt whose shape echoes the still less realistic hilt of his double-handed sword, is that it vanished into the plackets of camp prostitutes. In the light of this drawing, the askance look of the poor young man in the previous one, his helpless gesture of explanation, his tyro's expenditure on the Reisläufer's uniform, and the fact that his purse-strings are hooked into his sword hilt, turn a genre into a moralizing subject. Soldiering and good housekeeping do not go together.

Clues to the non-objective significance of what seem to be genre subjects are not always so clear. In *c.*1543 Hans Sebald Beham engraved a scene which would appear to be a matter merely of visually interesting routine:[1] an officer on his rounds visits the men readying the reserves of powder and ball in case they are needed during the siege that is going on in the background. In a dated engraving of 1543 he shows these soldiers, a fifer, a drummer and a standard bearer, in serious confabulation (Fig. 3).[2] The drummer listens intently, his sticks lingering over his drumhead, the fifer lowers his instrument as he, too, listens to the central figure whose furled flag obscures the fifer's face just as his own, in profile, is almost hidden by the plumes in his head-dress. There is a calculated informality here. Yet there is an inscription: 'the war is over; where shall we go now?' So this is less an episode, slightly dressed up, than an indictment; soldiers are the natural disturbers of peace. And Beham's earlier sympathy with the peasants of 1525, directly referred to in another engraving, of 1544,[3] suggests the breadth of the indictment. Should we now look for a hidden significance in his siege scene? Not necessarily. When in a work roughly contemporary with Beham's,[4] Hans Bink shows a pikeman and his woman (holding the almost inevitable dog) with their child, who, precociously dressed in Landsknecht mode, holds – another cliché – a purloined cock, this is surely not an allegory of the handing down of militarism generation by generation, but simply a gratification of an audience's interest in the domestic habits of the soldiery.

Their career began with recruitment. No artist drew the enlistment of a tyro (though Jost Amman in 1555 was to show the arch of halberds through which he was inducted into the moral and disciplinary world of a Landsknecht company), but Dürer, in an engraving attributed to 1495,[5] did portray a pair of civilian recruiters discussing terms with one of those wandering bands of freelances who roamed from one conflict to another: in this case two pikemen, a halberdier and a Balkan light cavalryman (Fig. 4). Though the print is full of artistic challenges gleefully met (the halberdier is something of a demonstration piece), this would have been a familiar scene in the environs of Nuremberg and Dürer does not appear to harp on its significance.

From recruitment onwards, a constant preoccupation was pay: '*point d'argent, point de Suisse*' as Racine put it. Urs Graf's 1515 huddle of soldiers debating with their captain whether or not to fight despite their arrears of pay (Fig. 6) – this was the year of Marignano, and Pope Leo X was slow in raising money for the crucial Swiss component in his anti-French army – rings true, even without checking its verisimilitude against an analogous woodcut scene, this time of officers and men in separate discussion groups, made by Burgkmair for Maximilian's: idealized autobiography *Weisskunig*.[6] Another preoccupation was diversion, the whiling away of time, which was a major problem in forces without regular drill, kit inspection or training manoeuvres. The presence of women in armies buttressed the view of armies as alternative societies with their own non-civilian mores; sexual relationships, as we shall see, constituted a major theme for artists and, not unnaturally, a slanted one. But Niklaus Manuel's sketchbooks (Fig. 5), which give the impression of his taking graphic snapshots as he strolled through the camp life he shared, show easy,

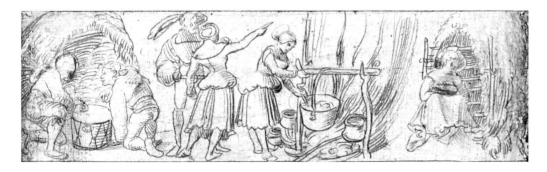

5. Niklaus Manuel, *Scenes from Camp Life* (detail). Drawing, *c*.1520–2. Basle, Kunstmuseum, Kupferstichkabinett.

affectionate embraces and casual scenes – a couple conversing, a woman cooking, another eating by herself in the mouth of a temporary hut.[7] These jottings premise a largely lost genre base that generally became subsumed within the convention that finished works, whether drawings or prints, should comment as well as record. Daniel Hopfer's etched *Soldier and a Woman* is one of the rare works that retain in a 'work of art' the off-hand affectionate camaraderie of Manuel's sketches (Fig. 7). Is it an apple she holds? If so, it is not the apple of discord or temptation, but something filched to munch on the march. Similarly value-free are the woodcuts designed in 1529 by Anton Woensam[8] to satisfy an interest in the off-duty as well as the combat roles of troops engaged in the defence of Vienna against the Turks. In one of them a captain plays cards at a trestle table with his men as a woman pours wine. In another, Landsknechts use a drum as a dice table. These are take-it-or-leave-it, unnagging genre scenes.

The soldier's career could end with a debilitating wound or with death. With a few exceptions battle was off-limits to genre because of the formal problems presented. Altdorfer, or an artist very close to his style, met this challenge by drawing an aftermath of battle scene (Fig. 8): a dead soldier in a wood, a wounded one supporting himself against a tree.[9] 'Art' soars above them in the whizzing jets of ink and white pigment. It is not a finished work. In the top right-hand corner, upside-down, is the outline of another soldier, a nonchalant, jaunty figure. But the work shows how deeply the vicissitudes of the soldier's life could affect the imagination of

6. Urs Graf, *Landsknechts in Council*. Drawing, 1515. Basle, Kunstmuseum, Kupferstichkabinett.

7. Daniel Hopfer, *Soldier and a Woman*. Etching, *c*.1530.

8. Albrecht Altdorfer (attrib.), *A Wounded Landsknecht*. Coloured drawing, *c*.1510–12.

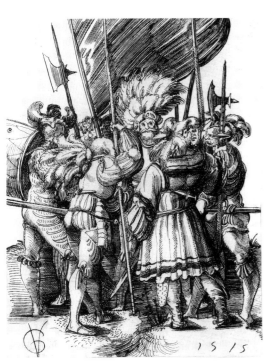

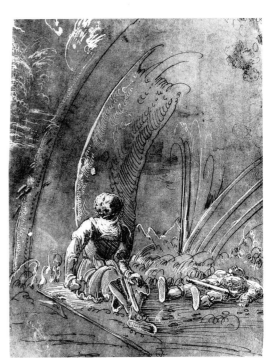

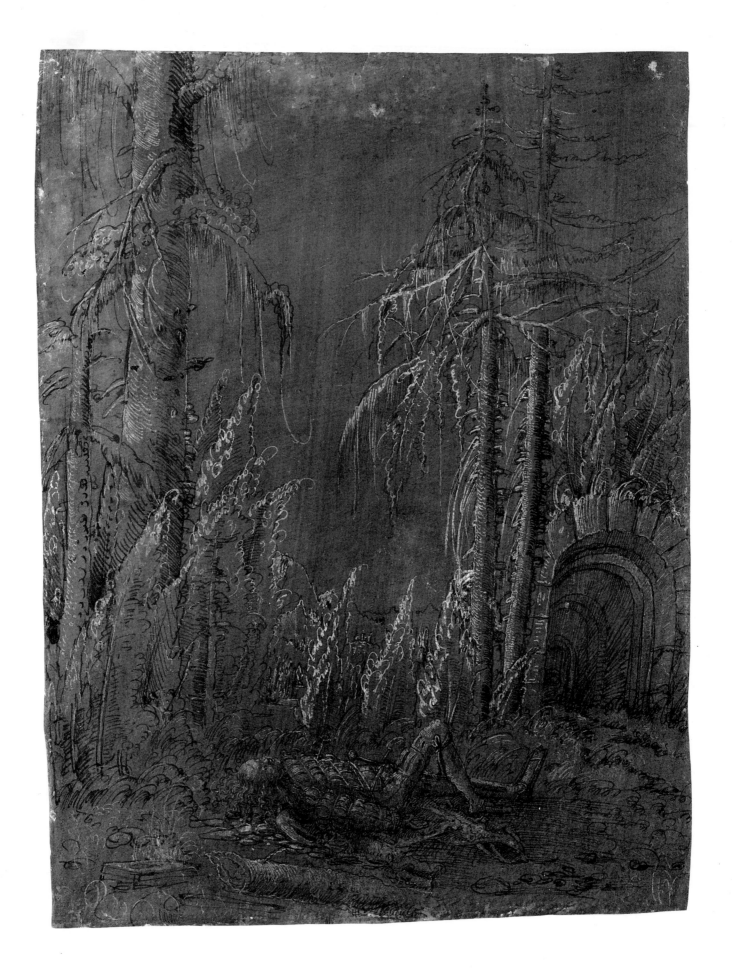

artists. And how much further a genre subject could be treated in a non-genre way appears in Altdorfer's *The Dead Landsknecht*.[10] In this drawing (Fig. 9), which is finished for presentation or sale, the fallen soldier lies again, in a wood, among fallen branches and bare trees. In this intensely romantic work, interest in the corpse, felled in the Wild Man's own habitat,[11] is dispersed upwards into the sky and towards the enigmatic arched passageway on the right, which suggests a long, vaulted approach to the sort of tomb to which neither fallen branches nor fallen common soldiers have access.

To poeticize in this way is at least a warning. Fascination with a socially vital subject does not necessarily lead to a genre treatment by artists responding directly to it. The richest veins of genre lie in the illustrations to texts, where the artist works to orders within whose limits he can record his own interest in realistic details.

The insecurely identified master[12] who produced illustrations in or just before 1516 for the first historical work produced under the direction (and, to some extent at least, from the dictation) of Maximilian I, the account of his father's and his own career up to 1508, was a notably talented artist who also made drawings featuring soldiers which were unrelated to any text. It is under the subject guidance of the *Historia Friderici et Maximiliani*, however, that his easy acceptance of the detail and atmosphere of real life comes out most strongly. Whether in a landscape setting, as in the *Execution Scene*,[13] or indoors, as in the drawing of the young Maximilian's getting first-hand experience of tapping a bronze furnace in a gunfounder's workshop (Fig. 10),[14] there is, for all the softening effect of the artist's line, a real focusing of attention on what the occasion might have been like. As we shall see, another artist-illustrator, Hans Weiditz, still referred to as the Petrarch Master from his woodcuts for the 1539 German translation of the *De remediis utriusque fortunae*, allowed himself a far greater liberty of interpretation of a work which was, after all, remote from his own times. All the same, while the themes he chose to update in a military context are heavily value-laden, the text exerts a discipline which keeps most of his designs hesitating just short of the descriptive borderline beyond which genre moves across to comment or reality-traducing self-expression.

Another medium familiar to a number of artists from their apprentice days, which reflected a genre interest in soldiers and was endorsed by patrician taste, was goldsmith's work, notably those elaborately befigured covered cups and table fountains for which the fashion peaked around 1500. Echoing the mimed between-course interludes and the sculptured pastry confections of ceremonial princely banquets, there were ships with decks a-jostle with soldiers among the crew, and castles guarded by miniature Landsknechts. Dürer designed a fountain on which a lively befeathered halberdier and a stradiot (turbaned, armed with bow and light lance) stand on a hillock and support the tree on which the topmost bowl rests.[15] In another fountain design (Fig. 11 – like the former, not known to have been executed), from a pedestal populated by two Landsknechts with feathers and slashed sleeves, a huntsman, a cowherd and a shepherd with the animals appropriate to them, rises a feigned landscape through which stroll a group of peasants and a party of seven Landsknechts, a drummer and a fifer, a standard bearer, two pikemen and two halberdiers. Dating from *c.*1500, it is the most relaxed of Dürer's military genre scenes, although intended for great expense and grand occasions. Its mood recurs less frequently in the two-dimensional media which were artists' chief, and more self-conscious concern. But it characterizes the relaxed conversation piece drawing of *c.*1520–1 by Urs Graf,[16] in which three soldiers are quietly served wine by a woman of the camp. It pervades the roughly contemporary tapestry in Basle (Fig. 12), which shows soldiers very much at home, and unresented, among the familiar activities in the landscape surrounding a town: a wagon, pedestrians, a huntsman, a peasant woman fishing, an urchin holding his nose and jumping off a bridge into the river.

It is when the soldier is least isolated from others, least a formal, framed, subject,

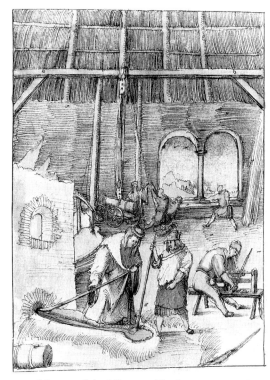

10. Master of the History, *The Young Maximilian in a Gun Foundry*. Coloured drawing, before 1515? Vienna, Staatsarchiv.

9. Albrecht Altdorfer, *The Dead Landsknecht*. Coloured drawing, 1511–13. Berlin SMPK, Kupferstichkabinett.

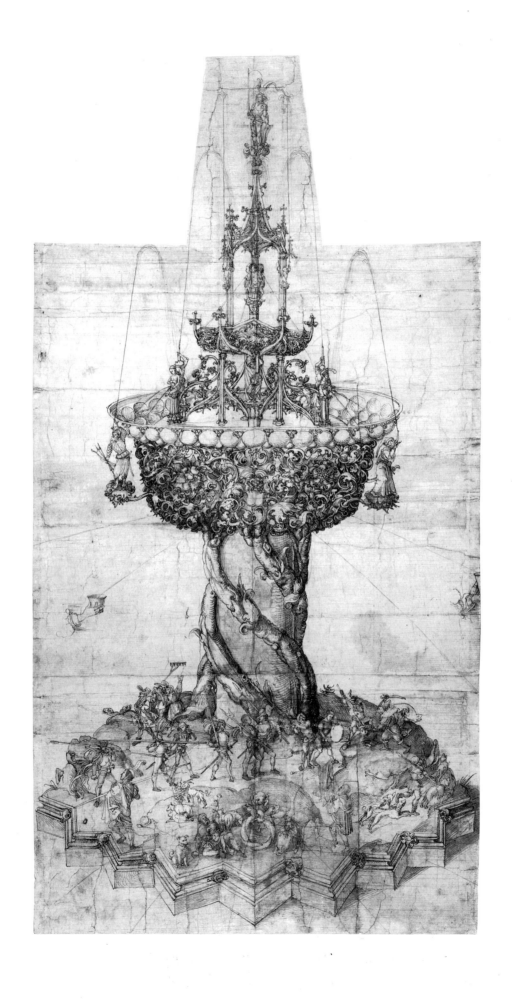

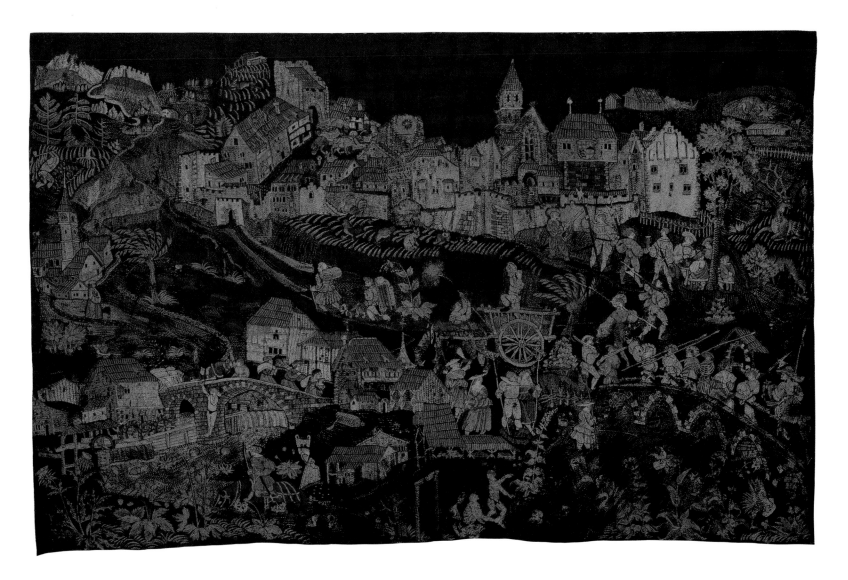

that artists touch him in with a nonchalance that marks the take-it-or-leave-it approach to the recording of social facts that is the essence of genre.

An example is the theme of the march, the military equivalent of the civic and religious procession, the streams of pilgrims or the ambassadorial trains which had been familiar sights in city streets or country lanes for centuries. While armies normally shambled along, not in step, fife and drum sounding to keep the spirits up rather than to set the pace, artists were tempted to formalize the scene, to respond to the rare moments – passing a reviewing stand, or otherwise demonstrating an untoward smartness of demeanour (the ranks trim, the pikes uniformly shouldered, the legs moving in time). But it is the most civilian section of the line of march, the *Tross*, or baggage train, that was rendered most naturalistically.

Under its special officers, the *Trossmeister*, responsible for the organization of horses and wagons to carry personal impedimenta and supplies of foodstuffs and equipment, and the *Hurenweibel*, whose job it was to control the numbers and, as far as was practicable, to keep an eye on the deportment of female camp-followers, the baggage train not only had its social analogues, like the harvest home, but a pictorial tradition. The latish fourteenth-century miniature in the Zurich *Weltchronik*,[17] which illustrates the journey of Jacob and his family to Egypt with a wagonload of women accompanied by sheep, goats and a pig (and, interestingly in the light of later *Tross* scenes, a cock on top of the wagon's tilt), and a Brussels illumination

12. *Soldiers in a Village Landscape.* Tapestry, 1st third of sixteenth century. Basle, Historisches Museum.

11. Albrecht Dürer, *Design for a Table Fountain.* Coloured drawing, *c.*1500. London, British Museum.

7

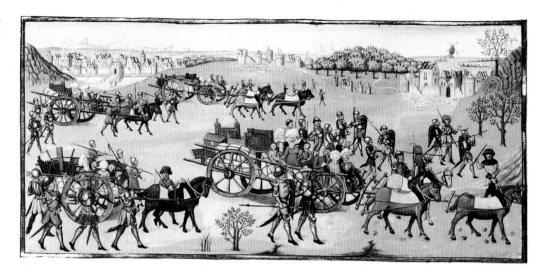

13. *The Hercynian Invasion of Gaul: the Baggage Train.* Miniature, 1448. Brussels, Royal Library, Ms.9242, f.184. Jacques de Guise, *Chroniques de Hainault.*

of 1448 (Fig. 13) showing a baggage and artillery train under escort,[18] prepare us for later treatments of the theme.

But if genre was helped by precedent, its freedom from it was also hard won. A glance at the Housebook Master's wagon train drawing shows this clearly enough (Fig. 14). The wagons here are deployed in three tiers, as in the Brussels miniature, though they face in the opposite direction (not unnaturally for an engraver if he had, in fact, seen the miniature). The wicker-bodied supply wagons appear between two files of those wagons whose stout, shuttered sides, pierced by gun-ports, made them into temporary fortifications when drawn up around the perimeter of a camp. A feathered fifer cheers the train along. It is escorted by groups of soldiers, summarily observed, but convincingly soldiers none the less, strolling rather than marching along. The horsed vanguard converse, turn to look back, shout back at a driver. A woman tries to check her companion's overindulgence in his flask. A hound sniffs the ground. A carpenter – the essential repairman in war trains – bends along under the weight of his axe. And, out of another tradition, an ass's-eared fool rides on the back of the leading supply wagon. We shall look later on at folly's role in focusing attention on the reality of human appearance and behaviour.

Some forty years on (if the *Hausbuch* drawing is from the later 1470s) the theme assumed its exemplary Renaissance form. In connection with his role as co-

14. Housebook Master, *Army on the March.* Drawing after 1475. Private collection.

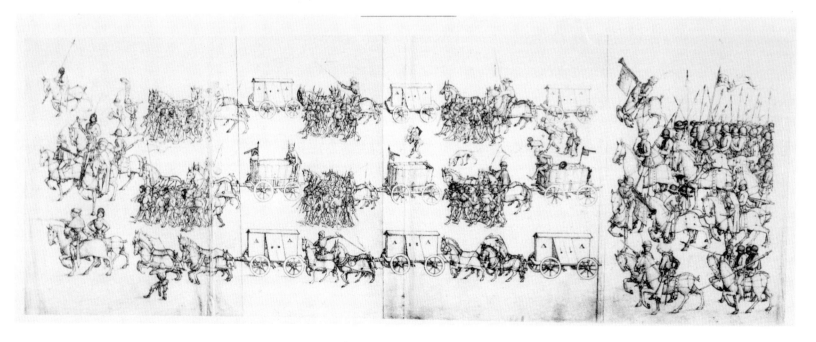

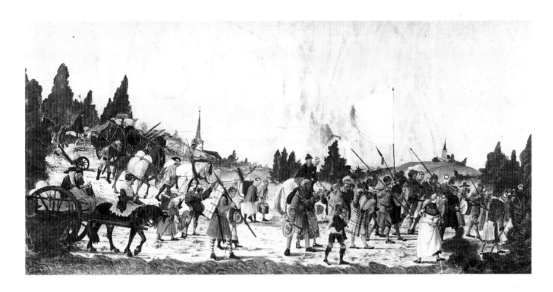

ordinator of the squad of artists contributing to Maximilian's commission for a vast frieze depicting a *Triumphal Procession*, his court painter, Jörg Kölderer, sketched in watercolour the layout for a more detailed treatment of the baggage train section (Fig. 15).[19] Apart from the banner identifying the Emperor's senior *Trossmeister*, Hieronymus von Herren, and the labelled verses identifying his function, the train itself has a depressed uncoordinatedness that rings true to the tail end of a march.

Though by temperament a visionary, very much the man to follow his own imagination, Altdorfer, when he came in 1517 or 1518 to extrapolate from this sketch his highly finished 6-sheet woodcut version, responded with detailed alacrity to its informal, unmoralizing mood (Fig. 16).[20] He brings the procession nearer the picture edge, closes up its stragglingness and sharpens the presence of the landscape. But these devices do not detract from the work's sense of verisimilitude either in the train's pace and grouping or in the rendering of individual figures and the bundles and baskets, tools and cradles they bear along. With its men, women, children and animals – the dogs, the burdened goat, a pet pig – Altdorfer's *Tross* frieze alone justifies the use of the term 'the society of soldiers'. Some passages in other sheets may be 'artistic'; the *Trossmeister* whose banner and panel are retained (though left uninscribed), the little lion-dog, the young woman standing in the wagon with the cask. But though apart from a few guards the soldiers have gone ahead, to be joined by the *Tross* when setting camp, their off-stage presence is strongly suggested, and not only by the poles slung with new shoes to replace those worn beyond repair in the stages of their march. The whole series has an atmosphere of shuffling relevance to its militant rendezvous.

Hans Sebald Beham's 4-block baggage train of *c.*1530 also shows the camp-follower support element in armies, here in the contingent from his own city, Nuremberg, whose arms, along with those of Bavaria, are on the wagons (Fig. 18).[21] As with Altdorfer, the scene gains credence from details observed in civilian, peasant and urban labourer life; the jugs carried in a sling over the back, the women kerchiefed to keep the dust out of their mouths and nostrils. There is more deliberate sentiment here; a woman offers a drink to the wounded man riding a gaunt horse. On the bundle on her head stands a cock, by now a symbol of semi-licensed pilfering. The chief difference, however, quality apart, is that while Altdorfer's baggage train simply tramped and trundled along, Beham makes his scene into a narrative episode. As the verses explain, the troops ahead have fallen in with the enemy. The commander has despatched one of his staff guards to order the *Hurenweibel* to send up the soldier-servants with their masters' equipment and stop the rest of the train, pending further news of the action.

9

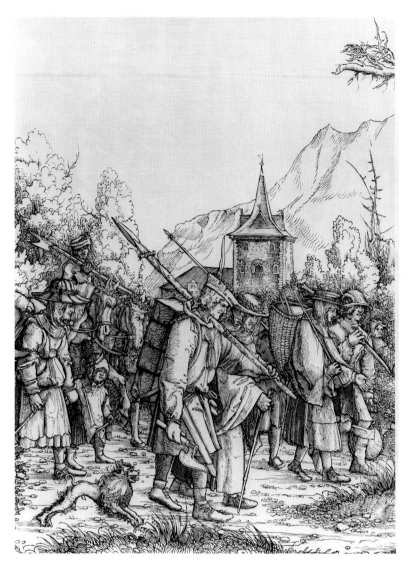

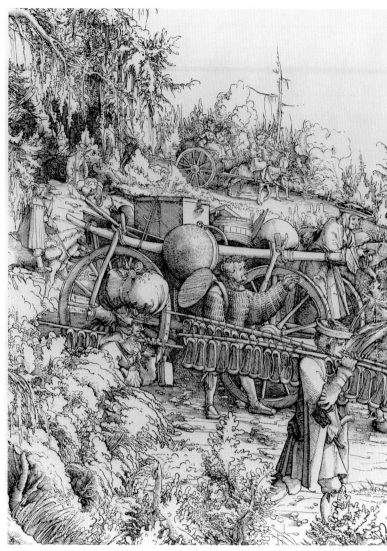

16. Albrecht Altdorfer, *Baggage Train and Camp-followers*. Woodcut (5th and 6th block), 1517–18.

17. Erhard Schoen, *Baggage Train and Camp-followers*. Woodcut (3rd block), 1532.

The same desire to give genre a story – and Altdorfer could take it for granted that his would be seen in the context of the soldier procession entrusted to other artists – marks Erhard Schoen's *Tross* of 1532, also in four blocks.[22] There is much homely detail here. Women ride on cruppers or walk beside their men. A pig squeals as it is carried upside down on a man's back by a stick thrust between its tied legs. Entrenching tools are lashed against the side of a wagon. But Turkish prisoners and a captured camel show this as a purported episode in the recent war with the Ottomans to which Schoen's Nuremberg contributed troops. There is, too, a German prisoner, hands bound and escorted by provost officers carrying leg irons: a Christian renegade caught serving the Turks. Not just one but two cocks crow from wagon tilts. The pressure applied in these ways upon genre is intensified by the group to which no other figure pays heed (Fig. 17). A skeletal Death, brandishing his hourglass, rides between the two scythe-bearers he has lately enlisted, one a Landsknecht, the other a Turk, both wearing his skeleton livery. Within the wagon train theme genre, *in extenso*, was no longer satisfying.

The second example of the wider pictorial environment in which more-or-less nonchalant, take-it-or-leave-it genre could thrive was the theme of the encampment.

Looking back again to Burgundian precedent, in the background of a 1455

Flemish illuminated bird's-eye view of the Turkish encampment before Constantinople, war vessels ply or lie at anchor in the Bosphorus (Fig. 19). In the midground is the city, with a siege tower being pushed towards its wall. In the foreground the atmosphere, however, is domestic. A woman stoops over a cooking pot besides a shelter containing a table; groups of soldiers chat inside their tents or stroll among the parked artillery and siege engines.

When the theme is treated for its own sake, as it is in one of the Housebook Master's least accomplished drawings (the over-large horseman on his unaccountably sway-backed mount, for instance), *The Camp Outside Neuss* (Fig. 20),[23] depicting an episode during the Emperor Frederick III's campaign against Burgundy in 1475, genre – we are speaking of effect, not deliberate intention – is threatened by quisling groups representing other interests. The long-standing lure of a fascination with the temporary architecture, the instant city of tents and pavilions; the technical interest of the Wagenburg, evinced since the employment of these primitive tanks during the early fifteenth century Hussite wars and here shorthanded into a perimeter of wheeled shutters; the too glib motif of a prisoner brought before the indifferent guards of the camp gate while mourned by two women with a naked child;

18. Hans Sebald Beham, *Baggage Train and Camp-followers*. Woodcut, c.1530.

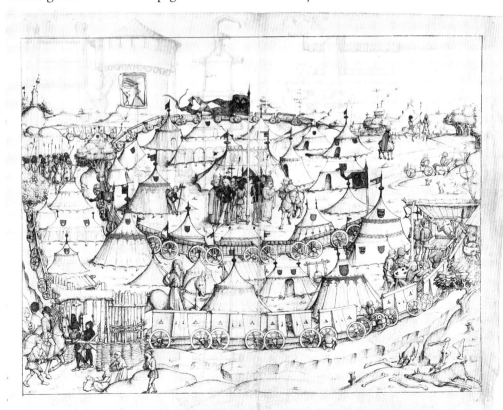

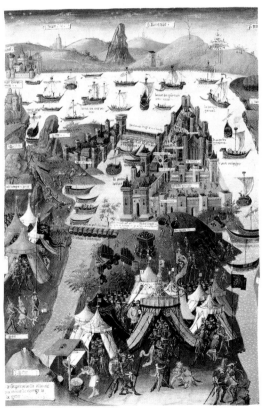

19. *The Turkish Camp before Constantinople in 1453* (detail). Miniature, 1455. Paris, Bibliothèque Nationale, MS. Fr.9087.

20. Housebook Master, *The Camp Outside Neuss, 1475*. Coloured drawing, after 1475. Private collection.

11

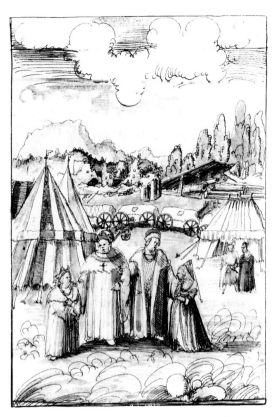

21. Master of the History. *Camp Scene: the Betrothal of the Children of Maximilian and Charles the Bold.* Coloured drawing, before 1515? Berlin, SMPK, Kupferstichkabinett.

the dead horse and the dog that gnaws at the leg and shoulder bones of others; the squatting man defecating beside one of the wheeled shutterings near to one of those 'pleasures of life' scenes – eating and drinking, gambling, love-making – that so edgily haunted the Germanic imagination – there are too many peripheral concerns to allow this scene to be lifelike. Indeed, it is unlikely that the manuscript ateliers' being, albeit lightly, tethered to texts enabled their employees to ignore, or at least resist, the readier response to non-factual ways of depicting life's circumstances and ironies that were freely explored by self-employed graphic artists.

The atelier and the freelance traditions come together in the Master of the History's very free illustrations. The scene showing the ratification, after Frederick's relief of Neuss from Charles the Bold's siege force, of the betrothal of their children shows us once more the *Wagenburg* outside the city (Fig. 21). By the casual economy and the grasp of open-air perspective that are part of the attractiveness of the artist's style, these are now stripped of the Housebook Master's intrusive prolixity of motifs, giving a historical subject the unforced tone of genre. Three covered wagons (real ones this time), a few tents and two burly pieces of artillery, unserved and exposed, suffice to give the atmosphere of camp and war's end. The princes stand alone with their children, Maximilian and Mary (whose marriage was to determine so much of Europe's fortune for the next three generations), watched only by one Burgundian and one Habsburg representative. With a few hooked flourishes of the pen in the foreground, and some swift lines suggesting mountains and trees on the horizon and clouds in the sky, the scene is complete.

The Master of the History was at about this time or slightly later (1513–15) to be involved along with Altdorfer, Lemberger, the Master of the Artillery (a name due to the particularity of his hand in the minutely informed depiction of the artillery train) and their respective workshops in the outpouring of large miniatures on parchment – 57 have survived from the projected 109 – which formed the painted version of Maximilian's pictorial review of his military career, the *Triumphal Procession* (*Triumphzug*).

Extending the idea in the leading portion of Mantegna's *Triumph of Caesar* (*c.*1486) series painted for the Marquis Gianfrancesco of Mantua, in which soldiers march holding standards with paintings commemorating incidents from their victorious campaign, the battle and siege scenes in the *Triumphzug* were borne aloft on poles (unconvincingly, because as important works of record they had to be rigidly flat) by a long file of Landsknechts. These were probably the responsibility of Lemberger and his assistants, who drew freely on the costume and demeanour of the figure of the soldier as it had been developed in prints as well as in his own illustrations for earlier manuscript *Zeugbücher*, or armoury inventories.

The Master of the History's contributions reveal a strong interest in genre details when handling panoramic campaign scenes. In *The Expedition into Lower Austria*,[24] against a mountainous background a town is spread out with many towers and a high wall nibbled at and in parts shattered by Maximilian's siege guns. A large detachment tries to force a breach in the centre against strong opposition. On the right another party with ladders attempts to create a diversion. A Landsknecht strolls across to join the ranks of pike waiting to move forward to the breach. In the opposite direction comes a woman carrying a two-handed sword. The guns, silent during the attack, have their shuttering down. Beside them two men stand leaning their elbows on an upturned barrel while they discuss the progress of the attack.

The moment chosen in *The Second Expedition into Flanders* allows more scope for such genre details (Fig. 23). The chief citizens leave a much-battered town to surrender to Maximilian who is with the bulk of his army on a nearby hill. The Master has concentrated his composition on the tented camp. Against the gabions which protected the gunners as they worked the now silent artillery, groups of men lounge; they chat, or play dice on a drum. A pikeman walks towards them holding up a wine jug. Among the tents others play cards on a cloak spread on the ground. A

cauldron warms over a fire. A man sits in the entrance to his tent with his arm round a woman; another stands talking to two seated women, one with an ostrich-feather head-dress. A similar opportunity to animate the casual details of camp life is taken by Altdorfer in his scene from *The Utrecht Campaign*. Here the besiegers' guns still fire at the city but the interest concentrates on the wagon-girt camp that takes up three-quarters of the lower half of the composition (Fig. 24). Horses are tethered by a water trough. A man and a woman lie beside one of the wagons. A feathered Landsknecht raises his hand in the 'greetings' gesture with which we shall become familiar as two women pass by, and another holds out a glass. Cooking fires burn, men eat, stroll, pause to converse. A cock stands on a wagon. There is a clear appreciation of the moments of domestic peace that can occur amidst the sounds and smoke of war.

It was the siege-piece, with its setting which stood still to be drawn, that offered more purchase for an interest in genre than did the battle, which offered such an amorphous target for the single-viewpoint artist. From the 1520s, as fortifications became modified to counter artillery, pitched battles became rarer, making the siege, as a key to the outcome of a war, more newsworthy. And as the audience for non-devotional prints was primarily an urban one, the depiction of sieges gave stay-at-homes a *frisson* that the necessarily more stylized depiction of battles in the open country could not provide. The siege-piece, then, became a genre subject of its own. As early as *c*.1535 it had become a cliché-ridden one.

For over a year, from March 1534 until June 1535 the Anabaptist headquarters in Münster, to the alarmed scandal of Catholic and less politically radical Protestant sects alike, had held the city against its ousted Prince-Bishop, Franz von Waldeck. At some point during the siege, Erhard Schoen rushed out a 3-block bird's-eye view woodcut to tap public interest in its outcome (Fig. 22).[25] While topographically fairly conscientious, artistically it is a cynical piece of hack journalism. 'Forests' of pike (a shorthand invention which had now become a convention – and was to have a long life because of its diagrammatic handiness), move towards the city; plumes of smoke jet from guns, rise from cooking fires and incendiarized buildings in a

22. Erhard Schoen, *Siege of Münster*. Woodcut, 1535.

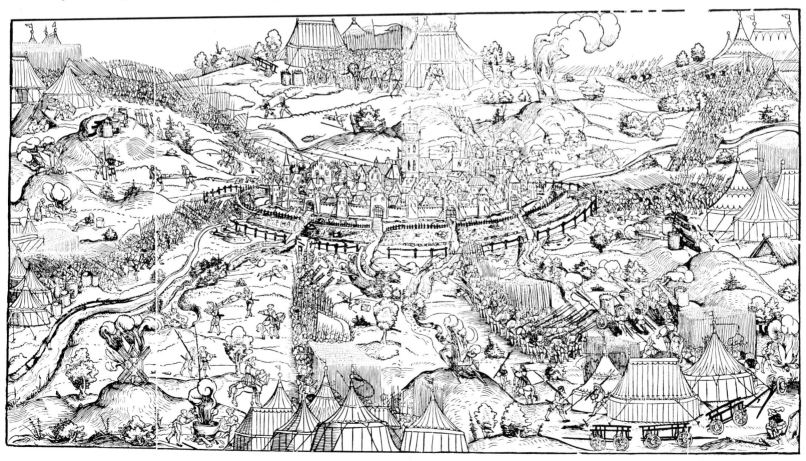

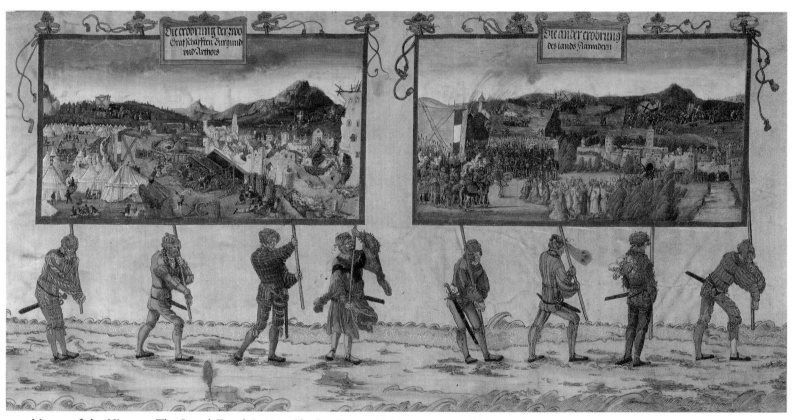

23. Master of the History, *The Second Expedition into Flanders*. Large miniature, *c.*1512. Vienna, Albertina.

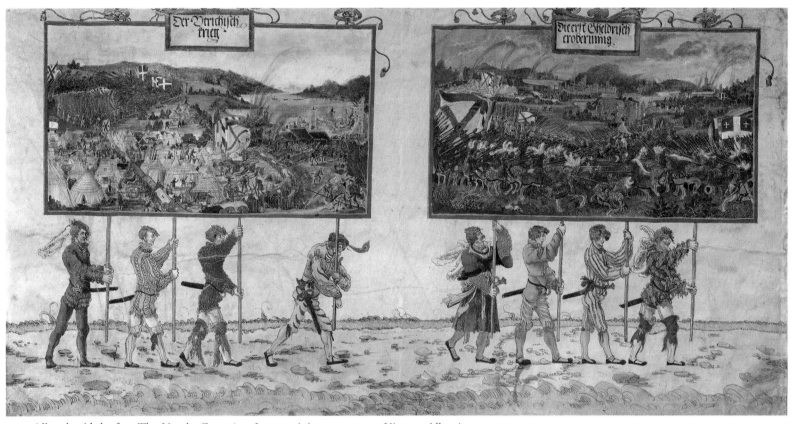

24. Albrecht Altdorfer, *The Utrecht Campaign*. Large miniature, *c.*1512. Vienna, Albertina.

25. Erhard Schoen, *Siege of Münster* (detail). Woodcut, c.1536.

scarcely differentiated manner; soldiers wander about, one is borne away on a stretcher. Almost now by rote, a Landsknecht craps against a tree stump in the lower right-hand corner.

More interesting, from the point of view of the formalization of a military genre that had resulted from the fresh observation of behavioural detail, is his second version, probably later, certainly more considered (Fig. 25).[26]

The format is drastically changed. Instead of a bird's-eye panorama we have a narrow strip, extending over seven blocks, which swings across a selective strip of terrain from a segment of the city defences to the bishop's base camp. The first version had a certain offhand verisimilitude. This has almost none. It is more like a do-it-yourself guide to picturing a siege. When put together the frieze (2.709m long) falls into self-contained blocks. On the left are the city's massive bastions (copied from Dürer's 1527 treatise on fortification and absent from the walls as shown in the first version). Then comes the frieze's redeeming feature, a slice of no man's land. The counter-scarp of the city's ditch rears up with a hastily gouged-back convincingness; the dead sprawl there unrescued, the sconces, or temporary advanced strong points, while not convincing in themselves (the smoke from one points backwards; the gun-ports echo the slits and triangles of the Housebook Master's wheeled shutter defences) acquire resonance from the shape of the sliced tree stump and the temporary defence formed by pleached trees (which echoes the more stalwart barrier erected from trees felled in the ditch by the defenders) and the fire-blasted ones which have been left intact, all give an aura of desolation which wins through the artifice employed. Imaginatively drabber are the segments which follow, all variants on by now familiar concentrations of genre attention: the guns firing through gabions; the carefully differentiated culverins behind them (unrealistic both as a group and in their placing); the over-symmetrical 'forest' of pikemen; the commander's marquee, spuriously naturalized by a figure emerging from its flap. And finally comes the vignette of the base camp: tents, temporary shelters, dicing on a drum, chatting among the wine casks, a woman cooking over an open fire with cauldrons suspended over it; this is a skilled itemization of genre details which, as Schoen combines them, have lost not their appeal, perhaps, but their freshness.

Other treatments of details in siege-pieces retained the liveliness of genre. An example is Dürer's hasty but meticulous drawing of *The Siege of Hohenaspern* (Fig. 26) which he had witnessed in 1519,[27] with its far-off hill town, foreground siege batteries and the tented camp in which off-duty soldiers talk and lounge about while

16

pioneers dig trenches for latrines. And his deft, pauseless notations of tiny figures doubtless came to the aid of his ex-pupil Hans Sebald Beham's unprecedented – in plan and plenitude of detail – *Siege of Vienna* woodcut.[28]

At the time, 1529, this was the siege of sieges: the Imperial capital of the Habsburg heartland threatened then repulsed in the first major Christian rebuff to the expansion into eastern Europe of the Turk. Images of Ottoman soldiers and Turkish atrocities – slaughtered children, impaled Christian civilians – reverberated through the print market. Wolf Huber was moved to sketch a rare, and unpopulated, townscape.[29] Schoen threw an inept (but, again, topographically reasonably correct) progress report at the public.[30] Barthel Beham produced a drawing[31] – presumably from his imagination – of the Turkish camp so crammed with domestic incident that despite the vigour of the scene as a whole, no *Formschneider* took it up for publication.

His brother took a line which was at once more innovative and more informative.

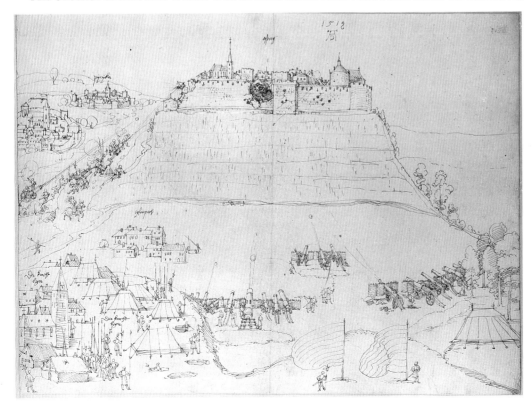

26. Albrecht Dürer, *Siege of Hohenaspern*. Drawing, 1519. Berlin, SMPK Kupferstichkabinett.

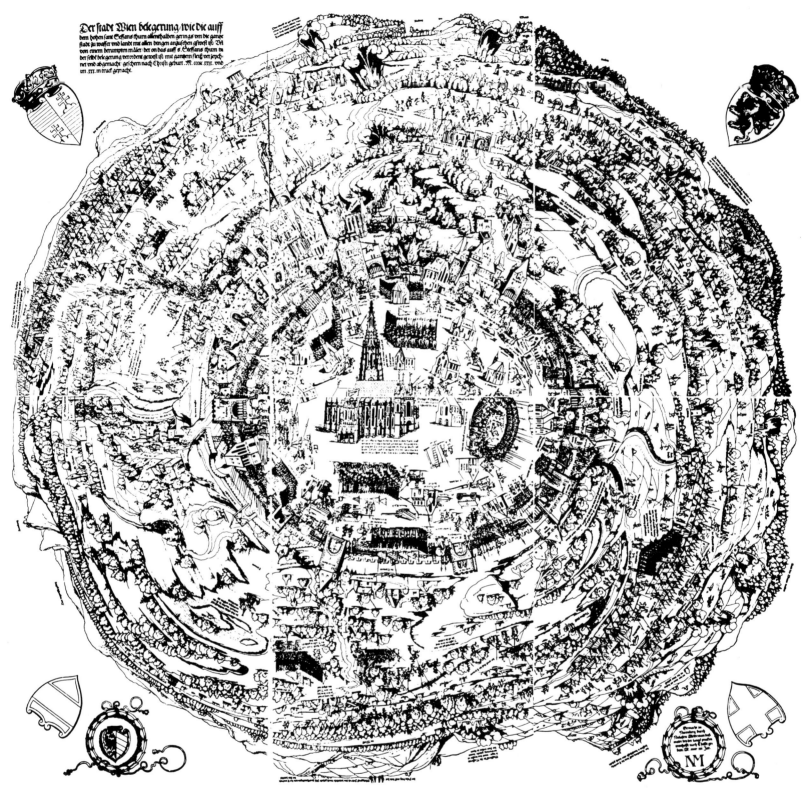

In 1529 he climbed, he says, the tower of the central church of St Stephen's and from
it made a 360-degree sketch of the view which was subsequently worked up over six
blocks, getting on for a metre square (81.2 × 85.6cm).[32] It was published by
Niclas Meldemann in 1530. Though influenced possibly by printed Jerusalem world
maps, showing the Holy City at the centre with the rest of the known earth circling
it, this exploded view is none the less an astonishing *tour de force* (Fig. 27). Beham has
lofted his viewpoint far skywards above St Stephen's and flattened the city walls so

that their inner surfaces are all visible. The city itself is voided of all but location-giving churches, garrison contingents, with the names of their commanders, and the disembowelling of a traitor (?) within, as was Landsknecht custom, a ring of soldiers. Cleared of houses by the artist, the walls show clearly the placing of artillery and the perambulations of the watch. In the concentric zone of countryside reaching to the hilly horizon are Turkish boats on the Danube, skirmishes, the bodies of troops from both sides, peasant families in flight, children spitted on pikes in the ground, a supply train of camels and grazing horses, dead bodies, and the encampments of the besiegers. There is no major engagement in the field; no crucial assault on the walls. What is envisioned here is a major city and the whole of its surrounding countryside as far as the eye could see given up to the pressures of the military and their violent, savage, but at the same time domestic way of life.

Beham does not emphasize details of the latter. But, though the vertically hovering viewpoing he adopted was not followed, his *Vienna* was succeeded by a number of large-format siege scenes which adopted a bird's-eye view and covered the whole tract of countryside affected by the siege. Necessarily the figures in such scenes are tiny. And though no one followed the dehumanizing, pin-man convention invented by Dürer for his 1527 imaginary *Siege of a Fortress* woodcut,[33] it is not unlikely that this work suggested the broad *plein air* setting within which, in other hands, camp life could find extensive deployment and the opportunity to jot in genre detail.

A still fuller exploitation of the genre opportunities within a siege scene came with Lucas Cranach the Younger's 8-block frieze *The Siege of Wolfenbüttel*,[34] the key episode in 1542 of the Protestant Schmalkaldic League's attack on the Catholic Duchy of Brunswick. Only three blocks show the bombardment of the town, while five are devoted to the League's encampment (Fig. 28). Amidst tents and clusters of beehive-shaped huts supported by pikes, fodder, fuel and provisions are brought in by wagon or wheelbarrow, women cook and serve food, sheep are slaughtered and butchered, soldiers talk, gamble, drink, a ring of them listen to a harangue from their captain. No single detail had not been used before: but neither had so many been brought together.

The 1540s brought to the campscape the status of a subject as worthy of extensive treatment as the townscape. Mattias Gerung painted the social life of Charles V's 1540 encampment outside the artist's native city of Lauingen.[35] In a square 10-block woodcut the Master MS pushed the city of Wittenberg firmly into a single block so that the Emperor's vaster, if temporary, city of soldiers could be shown in detail.[36] The decade culminates in that astonishing display of topographical and draughts-man's skill (on the part of both artist and cutter). *The Encampment of Charles V at Ingolstadt* (Fig. 29), drawn by Hans Mielich and published with an Imperial Privilege in 1549 in Munich by Christof Zwikopf.[37]

Composed of no fewer than 16 sheets, two deep and over 3 metres long, this contains far more legible visual information than had been packed into any previous work of comparable size. Like Beham's *Vienna*, it was planned from a church tower, that of the Frauenkirche, though the perspective was then adjusted to a bird's-eye rather than a tower-top viewpoint. The artist portrayed himself on the tower. Smartly dressed, he holds an inkpot and gazes out at the scene before him before adding another notation to the long strip of paper laid out on the parapet (Fig. 30). We look with him at the inside of the city wall, across to the army among their tents or exercising in parade formations, and away to the low horizon beyond. Basic graphic formulae are used for men, animals, wagons, tents, market stalls, horse troughs, blocks of troops and landscape features, but as each is done with care and freshness and with an apparent intent interest, the representations of human figures have a remarkable variety of costume, gesture and gait. Labels indicate where the horses were watered, and which piece of ground was allocated to the artillery and the pioneers, or labour corps. Men stroll and quarrel. The steam rises from cooking

27. Hans Sebald Beham, *Siege of Vienna*. Woodcut, 1530.

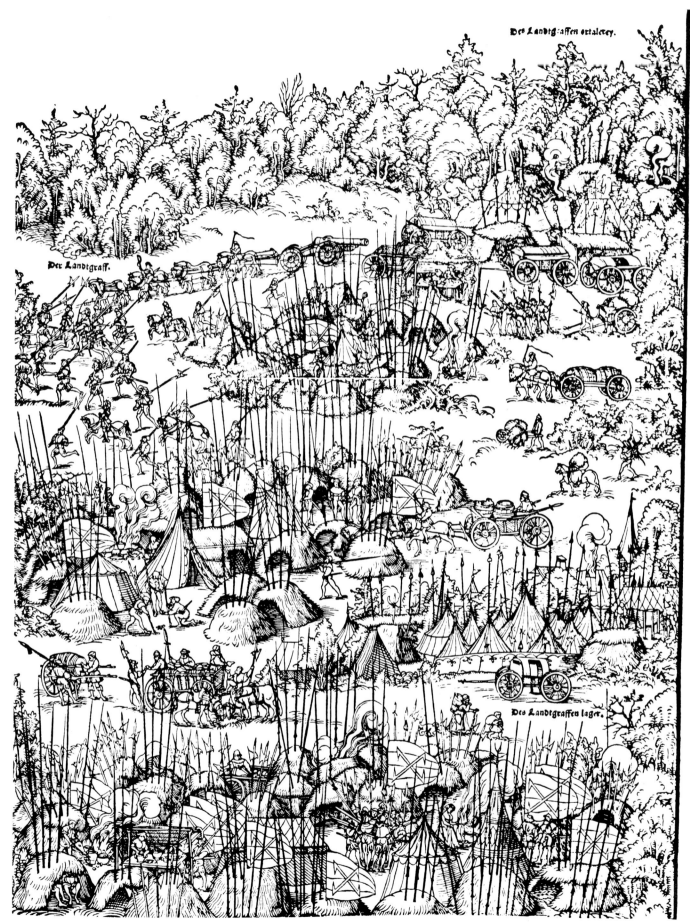

28. Lucas Cranach the Younger, *Siege of Wolfenbüttel* (detail). Woodcut, *c.* 1542–3.

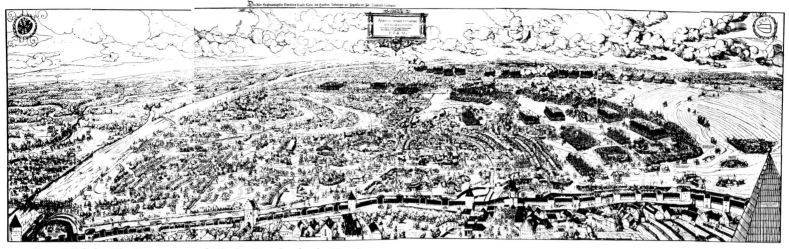

29. Hans Mielich, *The Encampment of Charles V at Ingolstadt*. Woodcut, 1549.

30. Detail from Fig. 29.

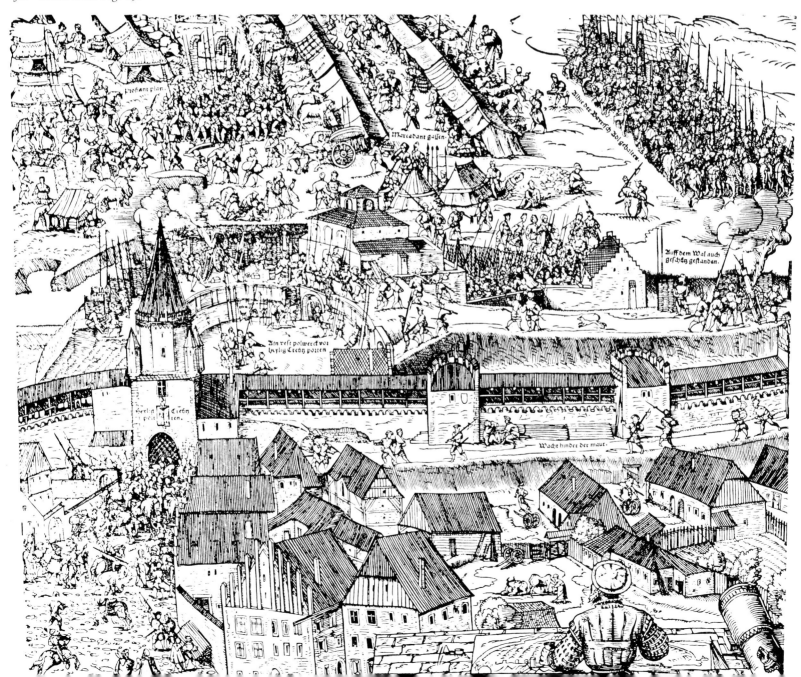

pots. Women wash clothes in the Danube (and use it for less salubrious purposes). Peasant carts rumble in with supplies.

What happened, from the *Siege of Hohenaspern* to Mielich's panoramic campscape, was the reduction of the figure of the soldier to so small a scale that there was nothing for it but suggest how he was. Larger figures invited associations: moralistic, allegorical. At a time when little was left alone by the urge of artists, supported by their audiences, to add comment to description, it was miniaturization that offered cover for the continuance of genre.

But there was another genre vein, reflecting not just the boredom lively artists felt with repeating head-on depictions of a social type and its manner of life once these had been firmly established as motifs, but currents of opinion which called for more slanted viewpoints.

An uneasy, at times hectic, religiosity, a panic felt at the possible breakdown of traditional social hierarchies, an itch to strike moral attitudes, all these marked Swiss and German society at a time when printing presses were readied to utter warnings and denunciations, and they led from the second decade of the sixteenth century to artists taking their tone from moralists like the Swiss Thomas Murner or such satirists as the German Hans Sachs. Alongside the market for pictorial information and for what was straightforwardly pleasing to the eye, arose one that craved something more evaluated, even sensational.

'This famous game of war is played by parasites, pandars, bandits, assassins, peasants, sots, bankrupts, and such other dregs of mankind.' No one heeded Erasmus's main purpose in his 1511 *The Praise of Folly* – to attack war itself.[38] But the cast of characters with whom he peoples his imaginary army came to be picked off one by one.

National rivalry between Reisläufer and Landsknecht, dating from the 1499 Swabian War and kept alive by service on opposing sides during the Italian campaigns, prompted from Urs Graf a satirical drawing *The Vices of a Landsknecht*,[39] with a wealth of symbols derived from popular slang conveying allusions to his sottishness (the hedgehog), avarice (the purse and money-changer's spectacles), lack of potency (the empty salt box and the fettered bird) and subjection to women (the spindle), his nimble cowardice (the halberdier rat) and general sense of failure as the owl screeches him homeward from a defeat. And within the Swiss Confederation, controversies about the political circumstances of service surfaced from written into graphic form. Even before 1522, when the Confederation was no longer fighting in the hope of gaining a foothold in Lombardy, and the patriotic aura faded from the military profession, there was antagonism between soldiers officially enrolled by the cantons and those bands of freelances who offered their services on the free market. This could lead to dog eating dog, as when in 1516 Berne's official force in Lombardy was opposed to, while the unofficial bands were fighting for, the French. In 1521 the Confederation (with Zurich opting out in order to put its alliance with France on a more secure footing), made the unpopular concession that the French could appoint the captains of the bands they recruited.

Zurich had refused to accept the 1521 agreement because of the growing influence there of the Reformer Ulrich Zwingli. As a young man he had, in 1512, served in Lombardy himself, but his experiences and subsequent observation of the corruption of manners caused by military service brought him to the conclusion that men should fight only in self-defence, or at least in a patriotic cause. It was an attitude taken up widely in the cantons that followed Zurich into Protestantism: Berne, for instance, in 1529 made soldiering for others a crime punishable by fines or, in aggravated cases, death. This did not, of course, stop the slipping away of freelances to their fortunes in others' wars. The resulting conflict of opinions is summed up in Hans Funk's painted glass panel of ?c.1532 (Fig. 31).[40] Under a depiction of the 'patriotic' (and anti-French) battle of Novara in 1513, an old member of the Confederation, plainly dressed and utterly worthy in demeanour, confronts a

31. Hans Funk, *The Old and the New Confederate*. Painted glass, ?c.1532. Berne, Historisches-museum.

32. Urs Graf, *Recruitment Scene*. Drawing, 1521. Basle, Kunstmuseum, Kupferstichkabinett.

dandified young one, whose values look no further than finery and profit. Colour and drawing make this not only Funk's masterpiece but also, together with its text, one of the most notable representations of an enduring historical theme, the clash between generations.

That the lure of money led to freelance enlistment is not surprising in a country where there was a predominance of pastoral, non-intensive agriculture, and a burgeoning urban bread-line population. And it is not surprising, either, that it drew the fire of increasing puritanism and political sensitivity. Always as ready to comment as to describe, and perhaps unique in a facility that enabled him to use line as readily as words, Urs Graf, working fast as usual, threw off in 1521 a rich summary of the situation (Fig. 32). At a tavern table, with reserves of wine in a cooler beside it, a French recruiter tempts representatives of those old political antagonists, a Swiss (with his back to us) and a German (at the end of the table) to join up together for the contents of his purse. Representatives of the older generation, perhaps a merchant and a scholar, discuss the nature of the impending transaction. Death warns of the consequences of Swiss trusting German, and Folly cackles to us from his corner. And the Petrarch Master's recruiting woodcut,[41] published in 1532, took up – not directly, in all likelihood – Urs Graf's theme by showing Folly and Death at the recruiting table with its heaps of coin.

Even the most heroic of soldier figures becomes tarnished in the switch from patriotic to freelance service. Hans Sachs's verses above the standard bearer in Erhard Schoen's *Military Unit on the March*,[42] another work contemporary (*c.*1532) with Funk's window and the Petrarch Master's woodcut, ran:

> I have been appointed standard bearer
> Chosen from the noisy ranks.
> Whoever sees the flag flying
> Believes that his side can still win . . .
> Therefore I wave my flag;
> Since it is worth my life and limbs
> I will not retreat . . .

So far so good. Then comes:

Because of this I must be given
Triple pay by a powerful lord . . .[43]

The objection to the mercenariness of mercenaries did not only reflect – in Germany as in Switzerland – religious and political outrage. There was also a social component. Soldiering offered a chance, remote but enticing, to escape from society's taken-for-granted pecking order. To improve one's lot within a category was laudable. To climb over a class barrier was not. Given the informality of military 'uniform', and the minimal equipment necessary, peasants could enlist as soldiers with quite small stoppages from their pay to enable them to pass muster. But they could also, and instantly, fight in their own social cause against the landlords, merchants and priests they saw as exploiting them. During the scattered revolts that preceded the Peasants' War of 1525 it did not cost much to make a standard with 'Freedom' written on it, as in a rough and ready woodcut of 1522.[44]

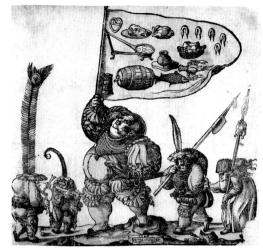

33. Peter Flötner, *The Procession of Gluttony*. Woodcut, 1540.

It was, however, primarily the vices in which the soldier could indulge when free from the constraints of civilian life, that led, as Protestant seriousness increased its demand for a congruence between belief and behaviour in much of southern Germany and a majority of Swiss cantons, to the most persistent anti-soldier themes.

The German soldier songs (more accurately, perhaps, verses that purported to be such), convey the holiday mood of the military alternative society. Buttressed by the conviction that their bravery and stamina made them 'ritterlich', knightly, the songs celebrate the joys of the open road: a dog, a woman, a boy-servant, wine, cash, freedom to roam to the exhilarating sound of fife and drum.[45]

That soldiers gambled and drank outside the restraining influence of pulpit or magistrate was a cause of concern to moralists. Artists by and large took these palliatives of the boredom and dangers of service for granted. Urs Graf somewhat provocatively drew, in a design for a sheath, a sturdy standard bearer whose banner bore a wine flask, a throw of dice and a playing card as the emblems of his trade.[46] As the card he chose was the two of bells he just may have intended compensatingly to suggest the folly of such indulgences, but, especially given his own habits, this is unlikely. Schäufelein in 1517 showed a soldier in conversation with the demon drink himself (or rather, herself),[47] but this was in a woodcut illustration to a heavily moralizing work. Along with gambling and drinking, eating was commonly shown as a routine matter of camp life. The splendid excessiveness of Peter Flötner's woodcut *The Procession of Gluttony* (Fig. 33) of 1540, even though published on the full tide of anti-mercenary feeling, comes as something of a surprise, as he revels in the bulges and slashes of his portly standard bearer, towering above his diminutive attendants and holding aloft the pictorial menu that has so fattened him. Worse was to come with Martin Weigel's ?c.1560 Archimboldo-anticipating Landsknecht[48] who is practically composed of his favourite foods, but well before that the soldier had become a safer target for satire than the equally vice-prone burghers among whom artists lived and sought to please, fewer of whom fought as soldiers themselves than in the previous generation.

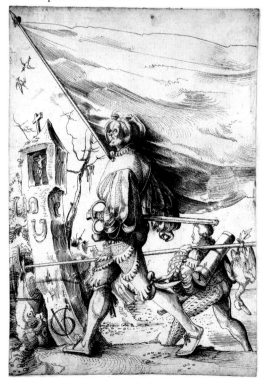

34. Urs Graf, *Standard Bearer Passing a Wayside Shrine*. Drawing, 1516. Basle, Kunstmuseum, Kupferstichkabinett.

That soldiers stole was, again, taken for granted. But when Urs Graf, in a drawing of 1516, shows a standard bearer (Fig. 34), followed by his soldier-servant carrying the routine purloined goose, averting his eyes as he strides, penis at the ready, past a wayside crucifix, did he have that other soldier foible, blasphemy, in mind? Dürer isolated a soldier as the mocker of Christ in the frontispiece to the 1511 book version of his *Large Passion*.[49] And in 1516, in a woodcut in a commentary on the Ten Commandments published in Strasburg, Hans Baldung illustrated 'Thou shalt not take the name of the Lord thy God in vain' with three soldiers reviling the figure on a lakeside crucifix.[50] The full anti-genre Reformation fervour, however, is

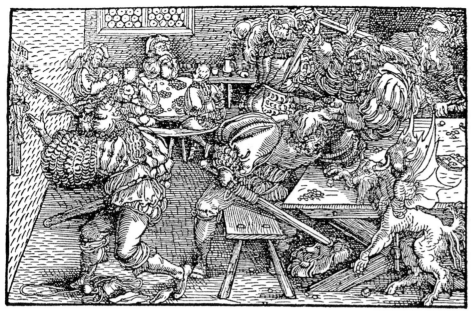

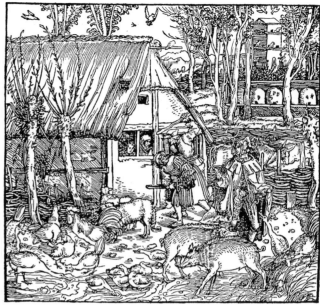

35. Petrarch Master, *Landsknechts in Tavern Brawl*.
Woodcut, 1532.

36. Petrarch Master, *A Peasant Family Persecuted*.
Woodcut, 1532.

37. Wolf Huber, *The Oath: Two Landsknechts in a
Landscape*. Drawing, 1512. Berlin, SMPK,
Kupferstichkabinett.

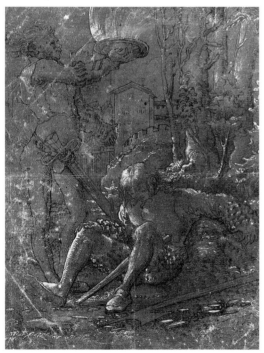

not levelled at soldiers' habits until 1532, when the Petrarch Master presents us with a scene of gambling in a tavern (Fig. 35), with the devil as a triumphant participant.[51] While drunken soldiers fall to sword blows, one of them jets his vomit at a crucifix hanging on the wall. This, too, illustrates a text. None the less, Petrarch's adapter does not mention a soldier in this context; the Master is tuning in to a general buzz of anti-soldier sentiments.

It was, of course, the soldier's literally extra-mural sexual life that aroused the liveliest interest in his vagrant mores. We will postpone for a while the fuller treatment the theme deserves, and look at an aspect of his behaviour which caused such fear and revulsion that it is all the more remarkable that so many representations of him and his way of life remained so unjudgmental.

Soldiers pillaging and committing atrocities against civilians were recorded in Netherlandish manuscript illustrations,[52] frequently illustrated in the Swiss picture chronicles.[53] They were a staple of those representations of Mars which associated him with his violent 'children', at least from the Housebook Master's portrayal of the War God's acolytes looting and killing villagers and setting fire to their houses.[54] Altdorfer drew soldiers stripping a traveller of his possessions and binding him to a tree.[55] A panel in the Great Miracle Altarpiece of Mariazell of around 1520 showed the Virgin saving a woman from a soldier's crossbow quarrel.[56] The Petrarch Master linked the soldier with that other disturber of rural peace, the baronial landlord, by showing a lord's agent and his bully-boy acolyte, both dressed as Landsknechts (Fig. 36), extorting with threats the fruits of peasant industry.[57] But this generalizing form of social comment was rare.

Artists' fascination with the soldier was aroused, less politically, by his being an outsider. This also meant that he could draw the opprobrium of stay-at-homes for other outsiders – armed roamers, gipsies, criminals on the run, even witches. It is not quite unreasonable, given the witch-associated ritual of the fire-bowl offering to the devil, to see Wolf Huber's 1512 drawing in this connection (Fig. 37). A wounded halberdier slumps on the ground. His companion stands beside him in front of the fortified mill from which he was shot, and with an expression of defiant invocation gestures towards him with one hand while the other raises a shallow dish with flames flaring upwards from it. The oath he swears in this ritual is vengeance, the power he invokes against the mill's inhabitants is demonic. Still, we are on firmer ground when looking at works which actually portray the devil as a soldier.

In 1516 and 1518 Urs Graf produced two drawings of soldiers shadowed by, in one case literally tied to, their obscene *doppelgänger*.[58] And some twenty years later Hans Sachs wrote a squib in which Beelzebub decrees that henceforth Landsknechts shall be no longer accepted into hell; their behaviour makes it too hot for the devil himself.[59]

The treatment of soldiers in religious art is the matter of another chapter. But one subject calls for mention here, because it takes up the theme of soldiers as the perpetrators of anti-civilian atrocities.

A striking miniature in the *c*.1450 Llangattock Hours (Fig. 38) firmly contemporized the Massacre of the Innocents in a Netherlands village. Altdorfer's *Massacre of the Innocents* (Fig. 39) woodcut of 1511 is supervised by a Landsknecht captain while one of his men holds up for his approbation a sword-impaled child. But the print stops short of completely updating a past atrocity. The town in the background is firmly of the moment, as are the two military figures we have noticed. But the ruined classical building that dominates the foreground is a routine reference to the old order shattering as it gives way to the new, Christ-illuminated one. One of the soldiers is clad in that 'timeless' eclectic military costume that was so constantly invoked to fudge the issue of historicism. And the impaling motif is another device to defuse the native Landsknecht associations of the scene, foisting that particular barbarism on to the widely assumed and frequently portrayed practice of the Turks who had been threatening Christian Styria from the 1480s.[60]

There were similar reservations among the details of a *c*.1515 drawing of the Massacre by Cranach the Elder.[61] Such waterings down of the Netherlandish nonchalance about exactly conflating then with now can be partly explained in terms of patriotism: German soldiers may behave like beasts on occasion, but they represent our interests. Be that as it may, Cranach's drawing is significant also because it shows, in the top left-hand corner, the Flight into Egypt.

This draws on the Apocryphal linking of the two episodes. The Holy Family escape from the Massacre and set off on the Flight. But, alerted, the soldiers do not give up. When none of the murdered infants turns out to be the Christ-child they set off in search of him. Probably miracle play processions showed one scene hard on the heels of the other. Certainly artists did. But these linkages remained predominantly a Netherlandish speciality, especially in the deep landscapes of Joachim Patenier and Adriaen Isenbrandt and their assistants and copiers. Here the 'miracle of the cornfield' – that second growth of the crop that enabled the reapers to confuse the soldiery as to the timing of the Holy Family's passage across the cultivated landscape – plays a prominent part. The soldiers bully, but are outsmarted – a rare example, apart from the Annunciation shepherds, of peasants being incorporated within the divine plan.

A painter of unknown origin brought the linked themes to Gdansk in his *Jerusalem Triptych* of the 1490s.[62] It remained unnaturalized in Germany proper, though in 1501 the elder Jörg Breu put behind a Flight foreground a mannered delineation of the Massacre going on in the square of a contemporary town, directed – that subterfuge again – by an Ottoman captain,[63] and in the 1530s(?) a particularly lovely painting (Fig. 40) by the mysterious Master of the Female Half-Figures linked – from foreground to background – the Flight with the Investigation of the Reapers and the Massacre of the Innocents with a confidence derived from his Netherlandish models.[64] But otherwise a voluntary self-censorship obtained in this narrative convention as it did in close-up delineations of the Massacre itself.

There were, after all, 'good' soldiers and 'bad' ones. Erasmus's Christian warrior in the *Enchiridion* coexisted with his denunciation of soldiers in his *Colloquies* and *Praise of Folly*. St Florian, that popular northern saint, was both warrior and peacemaker. In Bartholomaeus Zeitblom's late-fifteenth-century altarpiece he is shown fully armoured, lance in one hand while with the other he pours water over a town burning with the flames of war.[65] He is shown (Fig. 41) similarly armed, with lance

38. *Massacre of the Innocents*. Miniature, *c*.1450. Llangattock Book of Hours. Private collection.

39. Albrecht Altdorfer, *Massacre of the Innocents*. Woodcut, 1511.

40. Master of the Female Half-Figures, *Flight into Egypt*, ?1530s. Vienna, Kunsthistorischesmuseum, inv.950.

and bucket, in an earlier popular Rhenish woodcut of a type from which Zeitblom's iconography derived. Aldegrever took up the double aspect in an engraving of 1529 in which a common soldier holds a flames-of-war firepan in one hand, a quenching bucket in the other.[66]

Nuremberg, the source of so many works containing soldiers, owed to them, both as citizens and freelances, the notable extension of its territory during the 1503 War of the Bavarian Succession. It was 'good' Landsknechts who later put the papist horde to flight, while Jehovah held a supportive bolt of judgement and King David approvingly strummed his harp on Baldung's 1521 title page to the knight-Reformer Ulrich von Hutten's *Gesprächbuchlein*, his 'booklet' of anti-papal homilies.[67] In a richly designed double-sheet woodcut by Schoen of 1525,[68] the artillery of the army of the new religion is served by men; that of the old by devils. Patriotism, territorial acquisitiveness, proto-Reformation: all provided ideological screens behind which artists could, even when not enlisted as propagandists, treat soldiers as representatives of an occupation with its attendant vices without necessarily dehumanizing them within the black and whiteness of a cause; they still permitted,

especially before the embattled Reformation sent out its most urgent rallying calls, the expression of personal, idiosyncratic points of view.

Dürer's marginal illustrations to Maximilian's 1515 *Book of Hours* are symptomatic of this freedom. Utterly prejudiced is his decorating of Psalm 91 ('The Lord . . . is my refuge and my fortress . . .') with a victorious encounter between Landsknechts and peasants, even if two of the former are to some extent distanced from current reality by being armed with a javelin and a bow. Elsewhere he falls into a more Erasmian vein: a vigilant halberdier confronts a symbol of sloth, a woman

41. Anon., *St Florian Extinguishing the Flames.* Woodcut, ?mid-fifteenth century.

42. Albrecht Dürer, *Page from the Prayer Book of Maximilian I.* Coloured drawing, 1515. Munich, Staatsbibliothek. (f.34v).

Center top:

¶ Du wirdest sterben vnd nit leben.
Esayas an dem. rrviij. capitel.

¶ Ich hab ain ieding gemacht mit dem tod.

Bottom text block:

Ecclesiastici. r. Aller gewalt ist ain kurtz leben/ das ist er hat bald ain end.

Ecclesiastes. vj. Es stirbt mit ainander der gelert vnd vnglert/ der reich vnd arm.

Im buch von spruchen. vj. Er lat sich nit gewinnen ains yettwederen gebets.

Luce am. rvj. Es ist tod der reich/ vnd ist begraben in die höll.

Esaias am. rrij. Lassend vns essen vnd trincken/ doñ morgens werden wir sterben.

Baruch. iij. Die iugen habñ gesehen die sunne vñ sind verdoibñ/ vermaint er von dē tod.

Job. rrj. Der stirbt starck/gesund/reich vñ selig/als ob er sprech Es hilfft nichts für den tod.

Job am. riiij. Der mensch gat auß als der blom/ vnd wirt dorren/vermaint er von dem todt.

Im büch d weißhait. rvj. Sy namen ab vñ zergiengñ/ vñ kain krut noch malagma hat let sy.

Ezechielis am. rviij. Der böß wirt sterben in seiner boßhait.

Ecclesiastici. vj. Es ist ain freünd nach der zeit/ aber in dē tag der betrübnuß belibt er nit.

Psalm. c. rv. Köstlich ist der todt der hailigen in dem angesicht gottes.

¶ Erschreckung des tods der sünder.

Ir . . . werdt nie sterben/und das f nit erlöschen Esaie. rvj.

Sy sind Aisch/und werdent schneiden die zerstö:lich air. Galathas. vj.

Er wirt d . . . anfachen/und witt wainen vnd klaffen der zen in d pein. Mathei. rriij.

Ain ietlicher wirt tragen sein burdin/das ist sein sünd. Galathas. vj.

Der da fleücht den regen/ witt über yn der schne vallen. Job. rj.

Ich wird yr schandt emplössen vor ynen. Ezechiel. vj.

Er witt klagen alles so er gethan . . .

spinner slumped asleep beside a jug of wine; an upstanding young soldier armed with a partisan confronts a gaggle of unwary chickens beguiled by the music of a fox playing a flageolet (Fig. 42). More enigmatic is the page (which has also been attributed to Kölderer) down whose margin a demon, armed with a halberd, plunges towards the scene along the bottom where Death lunges with his scythe at a light cavalryman on a stumbling horse.[69]

In 1510 Dürer had shown Death pleading with a patiently receptive halberdier – in the appropriate setting of a cemetery – to reconsider his ways.[70] Technically, this is one of the artist's most offhand works, but it is psychologically telling. Scytheless, Death centres his harangue on his hourglass. It is still half full; this is not the moment of arrest. But because of the ornament on top – either a pyx, which would add a Christian force to the argument, or a supplementary time symbol (one of those watches for which Nuremberg craftsmen were famous?) – it cannot be reversed.

An old tradition lies behind this print, that of the Dance of Death, in which representatives of each order of society are crudely reminded of mortality. But that tradition had, in medieval Three Estates fashion – clergy, nobility, commoners – identified Death's military victim as the Knight. It was as the fully armoured *Ritter* that the soldier was snatched untimely away, as in the c.1465 Heidelberg blockbook,[71] or the 1489 Lübeck version of the Dance.[72] And this convention continued: in Holbein's famous *Dance of Death* series of woodcuts, made about 1526 though not published until 1538, it is an aristocratic man-at-arms who is skewered with his own lance by a mocking Death.[73]

From about 1485, however, the military category of victims broadened. In a woodcut series published in Strasburg in around 1485 Death takes a *Ritter*, but he also moves down the social scale to pick off a crossbowman,[74] as he had done in an illuminated manuscript version of c.1470 which shows a crossbowman debating Death's summons with considerable nonchalance.[75]

1500 is the probable date of a woodcut (Fig. 43) showing a halberdier acknowledging the contract he has made with Death in a broadsheet otherwise covered with Old Testament texts and references to Death's omnipresence. The footsoldier in this context has become something of an Everyman figure. The verses on another broadsheet (Fig. 44) showing Death and a halberdier in 1504 particularize the soldier's service in Germany and the Valais, but make the more general point that hardihood is no prophylactic against the grave.[76] And Baldung's drawing of the previous year (Fig. 45), which has Death lightly fingering the edge of a halberdier's cloak while he holds a parody of his weapon, a staff composed of bones, anticipates Dürer's woodcut[77] in the calm but more provocative significance the theme conveyed when detached from its setting within the Dance of Death series. In contrast, Niklaus Manuel's mural series of c.1517, painted for the Dominican church in Berne, has a halberdier, in all the pride and strut of his finery and accompanied by his midget soldier-servant carrying a cock and goose, led away by a mailshirted and helmeted Death. The accompanying verses concentrate on his professional demeanour: 'In combats I have always been in the front rank, comporting myself like a faithful soldier. I have never retreated a single step. Now I would happily flee; but I cannot.' And the traditionally moralizing context is sharpened by the linking of the soldier to Death's next victim, a prostitute camp-follower.[78]

In a rare example of the northern processional *danse macabre* straying south of the Alps, the 1485 fresco version at Clusone,[79] north of Bergamo, no soldier is recognizably shown, but in the *Triumph of Death* above it Death brandishes scrolls proclaiming his power while two skeletal henchmen pick off victims in the crowd, one with a bow the other with a handgun – incidentally a very rare accurate depiction of how these clumsy weapons were shouldered and supported while igniting the charge. The weaponry at Death's command, like the arrows of Plague or Divine Justice, was a familiar theme. A new one appeared in a coarse and vigorous popular woodcut of c.1460–70.[80] Here Death beats a military side-drum with thigh bones

44. Anon., *Death and the Halberdier*. Woodcut, 1504.

45. Hans Baldung, *Death and the Landsknecht*. Drawing, 1503. Modena, Galleria Estense.

43. Anon., *Death and the Soldier*. Woodcut, c.1500.

46. Hans Baldung, *Death as a Standard Bearer*. Drawing, *c*.1505–7. Basle, Kunstmuseum, Kupferstichkabinett.

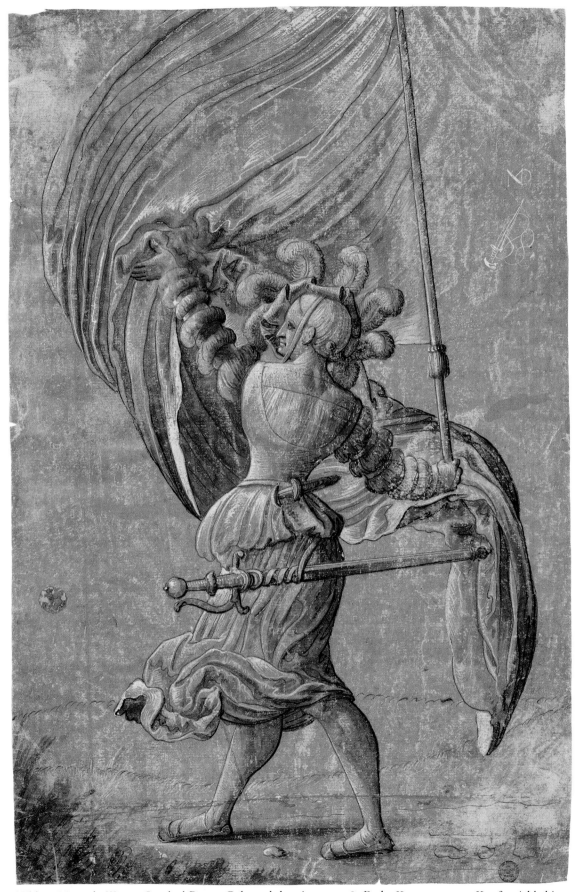

47. Niklaus Manuel, *Woman Standard Bearer*. Coloured drawing, *c.*1518. Basle, Kunstmuseum, Kupferstichkabinett.

for sticks, and in *c*.1505 Baldung horridly refined the motif (Fig. 46) by drawing him as a standard bearer, but with the standard upside-down and held in such a way as to suggest that it is also a shroud. The starting point for his image was the code that a standard bearer should die wrapped in his banner rather than surrender it. What is remarkable is the speed with which the footsoldier image, once established as the representative of warfare in lieu of that of the knight, and accepted as the prime representative of war itself, could be used for allegorical purposes by the merest hint.

Given the vulnerability of genre-like, straightforward depictions of social reality to the tugs of moralizing or allegorizing impulses on the one hand, and, on the other, to art's natural desire to improve on nature, it is worth concluding this survey with what was potentially the most volatile aspect of all – the sexual mores of the soldier.

Armies, as populous as all but major cities, were ill-policed, self-contained societies on the move. Like other populations they included wives and children, sweethearts, prostitutes both official and supernumerary, plus a more miscellaneous collection of women camp-followers who foraged and cooked, laundered, humped burdens and cared for the sick and wounded. The women may have carried weapons, out of jauntiness, or when their menfolk were ill, but they were not there to fight. Late medieval governments tried from time to time to keep down their numbers – between a quarter and a third of the number of men – by allowing only identifiable wives and a restricted number of prostitutes, and by attempting to improve their own measures for provisioning and medical care. Joan of Arc's expulsion of prostitutes from her camp was illustrated, with an apparently approving vigour, in a French miniature of 1484.[81] But the women still came, the men welcomed them, and, in practice, the authorities gave in, providing, by around 1500, the *Hurenweibel* to be responsible for the women within the baggage train.

Texts of histories and chronicles provided an opportunity to portray women but only through generic references to baggage trains and camps which artists populated for themselves. Throughout the development of the theme, which we shall trace, the artistic record consistently led the literary one.

Given the popularity of contemporary misogynist themes – the battle over who is to wear the trousers, husband or wife, or the cynical greed of young women in representations of the Mismatched Couple, or the deployment of women's sexuality to idiotize an Aristotle, a Samson, or a Virgil, it is interesting to look again at the depiction of atrocities.

The visual theme of war's by-blows against raped, humiliated and slaughtered women is visually almost silent when compared with the atrocities inveighed against or recorded by moralists and chroniclers. Niklaus Manuel, author as well as artist, could voice the savagery of the soldier:

> We'll move against your enemy
> till the very women and little children
> Cry Murder!
> That is what we long for and joy in;[82]

– but he did not illustrate it. Miniatures illustrating the storming of towns and villages concentrate on the ravaging of crops, the driving off of cattle and the looting of citizens' possessions, or on the killing of civilians in general without singling out women as of special concern. In one Swiss miniature from the *Bernerchronik* of 1483[83] captured women, after the battle of Murten, are shown being enjoyed by their captors, and smiling; but as they have been among the Burgundian camp-followers, the artist may be excused for his assumption that one pair of martial arms was much like another.

Apart from this, exceptional, instance, abduction appears as an unemphasized aspect of the major theme of the suffering of civilians at the hands of soldiers. And

this parallels the episodes of violence shown as responses to the influence of the planetary Mars. It is not so much in scenes that respond to the reality of warfare, as in representations in contemporary, or near-contemporary, costume of the slaughter by the Huns of St Ursula's virgin companions or of the Massacre of the Innocents, that echoes of the brutality of soldiers towards women sound most clearly in the arts.

Only one image, Urs Graf's customarily swift, and piteous drawing of 1514 (Fig. 48), was designed to shock. Armless and with a wooden leg, a young woman stands disconsolately before a lakeside village. One breast is deeply wounded; she appears to be partly blind. These are the signs neither of birth defects nor the pox. The military have been sadistically in her and at her, and have moved on. If we want a title, then: *A Casualty of War*. Yet we must beware of according pity an anachronistic emphasis. Given the context of Urs Graf's *oeuvre* as a whole, it is more likely that she was a horrifically abused camp-follower than some abducted citizen's daughter.

Women, indeed, fared judgmentally better in a military than in a civilian context. There is no implied comment in the illustration in Johannes Stumpf's *Schweitzer Chronica*[84] on their eagerness to help their soldier comrades to sack a peasant village, though later, and further north, the motif was to reach a bitter apotheosis in Breughel's vision of war-crazed Mad Margaret (*Dulle Griet*): a desexed harridan wearing a man's armour and sword along with the kitchen utensils of the camp-follower, ravenously leading a looting party to the very mouth of Hell.[85] And in the teeth of contemporary prejudice some role-reversal was accepted. Miniatures in the *Bernerchronik* show women strolling in the van of military companies rather than bringing up the rear with the baggage.[86] Altdorfer's *Woman Standard Bearer* drawing of 1512 is a bouncy image bereft of satire.[87] And, though Niklaus Manuel in one awkward drawing expressed embarrassment at cross-dressing between the wielders of distaff and pike,[88] in another, of *c*.1518 (one of his most ebulliently successful compositions) he allowed an armed woman to flaunt the standard without a trace of criticism (Fig. 47).

These particular images may pay tribute to women as mascots rather than equals. But though the enforced camaraderie of campaigning contained its own sexual censoriousness and antipathies, it would not perhaps be going too far to suggest that within that necessary, mutually supporting, extra-urban environment, women's roles were assessed in a less prejudiced manner than they were in a domestic setting.

We have witnessed this dispassionate observation. In depictions of the wagon train a woman's beauty may earn her a lift in a cart, or (against regulations) a ride on a horse, while others bend under burdens or chat as they pace along. They care for children or the walking or mounted wounded. They are directed by men, but they are not shown as exploited. However discriminating the functions, the mood is one of camaraderie. Men, too, carry burdens as well as weapons. Women may wear kerchiefs across their faces to keep out the dust of the march, but it is men who are swathed in bandages. In campscapes the subordinate role of women as cooks, laundresses, wine-pourers, child-minders, cuddlers, is taken for granted without any sense of the Eden-frail sex being kept in their proper station. But in these long-focus views of co-operative life there is little room for detailed comment. What do close-ups reveal?

The very costume of soldiers, as we shall see, implied an association with women that was not simply companionable. So too did the popular view of soldiers as outside the normal restraints not just of the sumptuary laws but of moral conventions. But too much must not be made of the division between civilian and military society. Campaigns were normally seasonal, with many soldiers blending back into their rural or urban occupations. Even on campaign, armies were subject to the comings and goings of civilians with goods, services or diversions for sale. Some of the *Soldatenleben* scenes we have looked at are, like Urs Graf's drawing of

48. Urs Graf, *A Casualty of War*. Drawing, 1514. Basle, Kunstmuseum, Kupferstichkabinett.

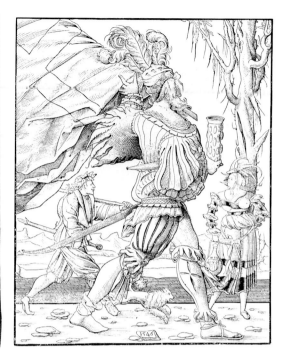

49. Georg Lemberger, *Landsknecht and Female Companion*. Drawing, *c*.1515. Berlin, SMPK, Kupferstichkabinett.

50. Albrecht Altdorfer (attrib.), *Camp-follower leading Landsknechts through an Archway*. Drawing, 1516, copying original of *c*.1508. Berlin, SMPK, Kupferstichkabinett.

51. Hans Rudolf Manuel, *Standard Bearer and Camp Prostitute*. Woodcut, 1546.

52. Albrecht Altdorfer, *Landsknecht paying off a Woman beside a Wood*. Coloured drawing, *c*.1508. London, Private collection.

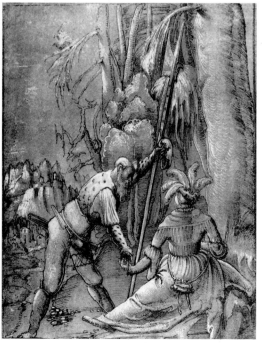

soldiers gossiping in a field while a young woman serves them with wine and a dog lies curled in sleep, are little more than transpositions from the holiday mood of civilian life. All the same, when the move from one society to another was made the role of women did become more interesting.

We have seen that Manuel's sketchbooks show men hugging and kissing and whispering to their girlfriends in a military environment in a way which artists found too routine to record in a civilian one. And though 'wife' was a category treated with a natural scepticism by military codes which accepted their presence while attempting to ration that of prostitutes, this mutually supportive bond, exemplified in such works as Georg Lemberger's *Landsknecht and Female Companion* (Fig. 49) was satirized – again in a manner that encouraged artists to 'see' normal societal relationships within the heightened interest of military communities – in Erhard Schoen's depiction of a basket-laden wife's eye-scratching attack on her Landsknecht husband's camp pick-up.[89] And yet another aspect of commonplace inter-sex relationships was pictorialized only because of the theatrical appeal of the mores of a society set apart from the over-familiar community life from which it was leached. In every rich town there were classy courtesans and casual sex-vendors. Only in a military context were these contrasts pictorially recorded. We have already noticed the scarcely sexual, drum-majorette-like motif of the female standard bearer. But there was also the contrast between the feathered, side-saddled queen who leads a victorious army out of a conquered town at the head of her soldier votaries (Fig. 50),[90] and, at the other extreme (Fig. 51), a slattern hopefully baring a breast and dangling a wine flask, as a standard bearer, his dog and boy-of-all-work, stride on to less tawdry conquests.[91]

It is within the zone of a straightforward physical sexual exchange, out of mutual appetite or for cash, that military genre reflects a self-sufficient world because transactions common to normal society were more readily illustrated within the permissive atmosphere of an abnormal one. Some of Urs Graf's drawings of 1516–18 give the impression that they were dashed off (but doubtless subsequently redrawn more carefully) to flatter companions who fancied a particular camp-girl; one, of 1518, is shown vouching her passion for him in the bodice-band equivalent of a slogan on a T-shirt.[92] Some hundreds of miles away, Altdorfer, a non-

combatant and an altogether more refined artist of landscapes and altarpieces, showed a comparable interest in military sexual commerce. Few compositions (and this is one of great beauty) show the conclusion of a sexual bargain more directly than the drawing of *c.*1508, in which a pikeman, about to move off to the morning's rendezvous, dumps his payment into his erstwhile companion's palm (Fig. 52); in another drawing, of 1506,[93] two halberdiers converse in the foreground of a landscape while in the background a third reaches under the skirts of a compliant young woman sitting beside him.

These scenes, which bring normal sexual traffic out of the urban closet, as it were, into the field of view of the military mores-watcher, were supplemented by others that reflect another, less genre-bound, play of associations between soldiers and sex.

On an early sheet of trial drawings by Hans Schäufelein (one of those artists who returned time after time, amidst his religious paintings and portraits, to the figure of the soldier), two clothed women fill the top of the paper, two nude ones the middle, and at the bottom is a halberdier.[94] Among Niklaus Manuel's quick sketches of camp life are two more formal drawings. In one a soldier watches appreciatively as one nude woman pours wine and another strums a lute (an allusion to sexual caresses).[95] In another, finished to a degree that could be passed to a *Formschneider*,[96] but apparently was not, he shows three attractive figures who could be described – not misleadingly, as we shall see – as the three goddesses of camp life: Fortune, Love and Death.

As casual sex in armies was beyond the reach of the rudimentary public health regulations applied within urban bath-houses and red-light districts, syphilis brought a special hazard to the commingling of soldiers and camp-followers. First noticed in Naples at the end of 1494, it was recorded in Bologna early in 1495, in Geneva in the following January. Quarantine precautions were ordered in France and Scotland in 1497. At first physicians attributed the new sexual disease to astrological influences. It was for a Nuremberg broadsheet to this effect that Dürer contributed his woodcut, *The Syphilitic Man* (Fig. 53), in 1496. It was also noted that the disease's progress followed the withdrawal of the French army from the Kingdom of Naples and the pattern of the disbandment of its constituent units. There was, then, a reason for syphilis to be identified with soldiers and their way of life. The disease progressed rapidly through civilian society through heterosexual and homosexual contacts (Dürer teased his learned patrician patron, Willibald Pirkheimer, for his taste for young soldiers),[97] but, in yet another displacement of domestic mores into the life-style of outsiders, syphilis, in its first generation at least, was pictorially exiled to armies.

Niklaus Manuel's *Dance of Death* linking of a soldier with camp prostitute was glossed in a later sketch which shows a girl being propositioned by a soldier and then embraced by death.[98] Another sketch, of a skeleton nuzzling under a girl's skirt, was developed into one of the most brilliantly shocking graphic images of the Germanic Renaissance (Fig. 55); a skeletal figure, still wearing the shreds of his soldier finery, mouths a young woman whose free hand tentatively joins his bony fingering of her genitals.[99] On the capital of one of the columns framing the design on the left a cupid transfixes himself with one of his own arrows; on a detached column on the right a nude Venus stands as though shuddering before a fire-pot from which belch the flames of war.

Syphilis was a two-way exchange. Manuel's equally carefully finished drawing of a man split up the middle (Fig. 54),[100] his left half a young, plumed and conventionally bedizened Reisläufer, his right a prematurely aged pauper with a misshapen foot, and sores on his leg resembling those on Dürer's *Syphilitic Man*, is not simply a comment on the riches-to-rags fortunes of war to which the accompanying verses (not securely attributable to Manuel) allude, but on the incalculable fortunes of camp recreation at its most hazardous. Mockingly, this pathetic before-and-after figure is framed by columns topped by a Virgin of Mercy confronting the

53. Albrecht Dürer, *The Syphilitic Man*. Woodcut, 1496.

54. Niklaus Manuel, *The Fortunes of War*. Drawing, *c.*1514–15. Berlin, SMPK.

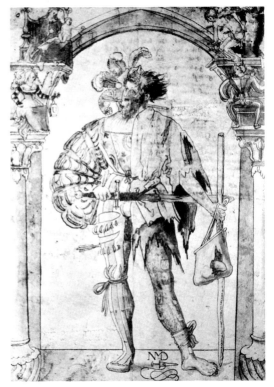

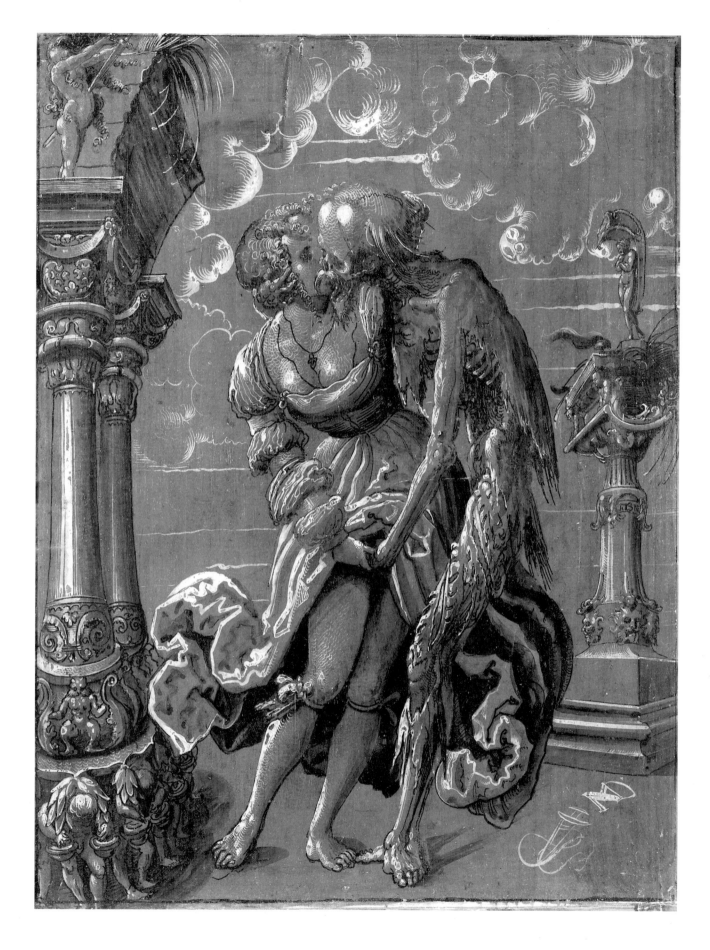

38

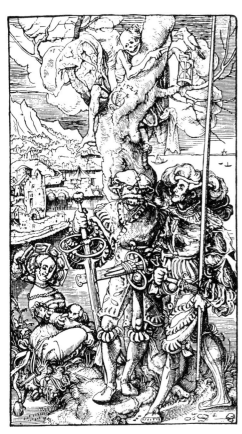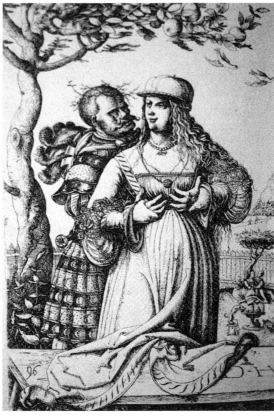

56. Urs Graf, *Death and the Soldiers*. Woodcut, 1524.

57. Daniel Hopfer, *Soldier Embracing a Young Woman*. Etching, ?*c.*1530.

plague saint Sebastian slumping forward under the impact of the arrows which were part of his martyrdom and, below them, a pretty camp-tart holds out a flower and wine flask to an eagerly receptive soldier.

Into this moralistic aspect of the relationship between women and soldiers one must be cautious not to read an angry heterodoxy or a straightforward significance that the artist did not intend. It is with some diffidence, therefore, that Hans Burgkmair's similarly classically framed chiaroscuro woodcut, *Death and the Amorous Couple*[101] should be read. But the figure of Death who wrenches apart the jaw-bones of the stricken soldier while at the same time trapping between his own jaws the thigh-revealing skirt of his fleeing consort is a comment on this new shared danger of camp life – even without the gloss added by the architectural conjunction of cupids with skull and crossbones. And when Urs Graf, in a woodcut of 1524 (Fig. 56), sends two soldiers, with codpieces carefully emphasized by the circlets of their sword-guards, past a tree in which Death perches, pointing to his hourglass and raven, towards a smirking camp prostitute and her simpering lap-dog, are we not intended to see that the pox is not only carried by but transmitted to the military? The generalizing force of this image is reinforced by the artist's marking one of his soldiers as Swiss (the St George's cross on his doublet) and the other as his ancient adversary the German (the St Andrew's cross on his thigh). Syphilis has become another weapon in the armoury of death the leveller. Calmer is Daniel Hopfer's etched warning to young women against the acceptance of a soldier's advances (Fig. 57). He grasps her breasts. She musingly restrains his hands. From a tree above the couple dangle apples, the old warning against illicit experience. In the background – anticipating the moralistic material of Dutch seventeenth-century genre – a couple embrace while a dog devours the al fresco meal from which their alternative appetites have diverted them.

We have looked at aspects of the workings of two of Manuel's camp goddesses,

55. Niklaus Manuel, *Young Woman and Death as a Soldier*. Drawing, *c.*1517. Basle, Kunstmuseum, Kupferstichkabinett.

58. Albrecht Altdorfer?, *Fortuna and the Mounted Halberdier*. Coloured drawing, 1514. Berlin, SMPK, Kupferstichkabinett.

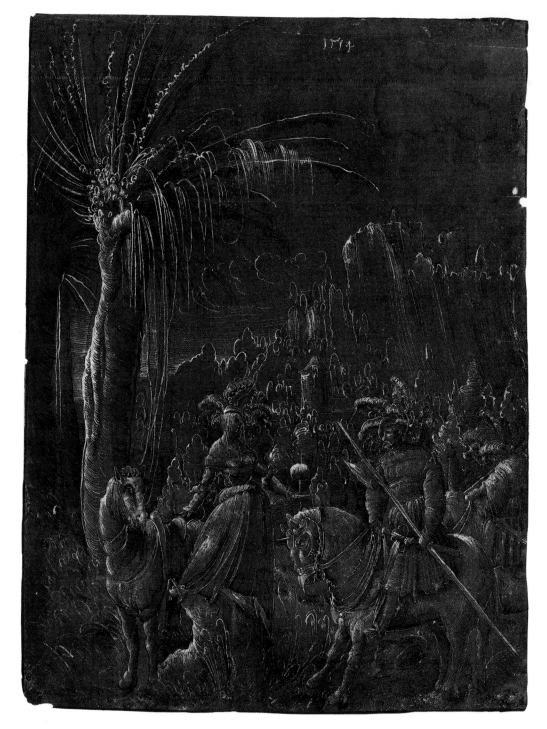

59. Niklaus Manuel, *Military Fortuna*. Drawing, c.1513. Basle, Kunstmuseum, Kupferstichkabinett.

Death and Love. What of the third, Fortune, the whimsical dealer-out of luck in both love and war?

From soon after 1500 anonymous carvers and designers showed a nude Fortune offering her goblet – the large covered *Pokal* of formal celebration – on the sides of powder flasks and dagger sheaths.[102] In a particularly lovely drawing of 1514 (Fig. 58) by Altdorfer (or the Master of the History?)[103] a halberdier riding off to war into a forest trail is confronted by a feathered young camp woman who has dismounted in his path to offer him a *Pokal* in the suggestive shape of an apple. But

it is, understandably, the soldier-artists themselves who play most freely with the image of a specifically military *Fortuna*.

For Manuel in *c.*1513 (doubtless affected by Dürer's widely influential *Nemesis* of *c.*1501–2) she is a young woman (Fig. 59), nude save for a harness of looted chains and bracelets, who sails across the landscape seated on a combination globe and stool.[104] On one knee smokes the fire-pot of war. She looks towards the hourglass she holds in one hand; in the other she carries a skull with the familiar soldier's ostrich plume. Close to this vision of military Fortune is Urs Graf's more highly finished drawing.[105] In this, similarly nude save for the chains and baubles representing soldiers' favours, she stands on a globe that floats on the waters of a lake and gazes into an hourglass the flow of whose sand she appears to be slowing by tilting it; the other hand touches the hilt of the large Reisläufer's sword that stretches across her belly from a scarf.

In a later drawing (Fig. 60), Fortuna is again a camp tart, clothed this time, but using her purchase on the globe she soars on amidst the clouds to twirl out her skirt so that she is bared to the crotch. She looks aside, past the point of the dagger she wears on her hip. Perched on the broad brim of the *Pokal* she holds out, a little demon-familiar kicks askew the war flames that gout from it.

This is the soldier's Lady Luck at her most incalculably provocative. But the artist loads her apparent flippancy with the fire-pot image which, though employed as a straightforward reference to the flames of war, was also used – for example, in Hans Baldung's orgiastic *Three Witches* of 1514[106] – to fuel the airborne lubricity of the night-hags who forced dreaming men to pollute themselves. Yet Lady Luck, imagined, as in all these images of military Fortuna, in the context of the soldiers' and camp-followers' alternative society, was a concept based on a believable type of individual. And it is as a person, a woman as vulnerable to war's chances as were her menfolk, that Urs Graf chose to present her in an especially careful and serious drawing (Fig. 61). She sits at the end of her bed. Post-coitally vulnerable, her toes nervously intertwined, she is better described as naked than nude, in spite of the allegorical *Pokal* she holds. Given the gesture with which her free hand clutches one of the ribbons on the sleeve of her now-dressed soldier sleeping companion, who points with some world-weariness to the coins he has left on her table, the inscriptions on the bed's tester, 'God give us luck', 'May luck favour me', express her personal hope rather than standing for her destiny-dealing omnipotence. When he leaves, will he return? Lady Luck, in this view, is as vulnerable to what she personifies as are the men she entices and challenges.

What is, indeed, remarkable about the images we have reviewed is the steadiness, indeed sympathy, with which women are portrayed, whether as real or value-conveying figures; an absence of contempt or prurience. And it is noticeable that while the figure of the soldier could be caricatured (for ostentation or gluttony) or moralized in terms of blasphemy, cruelty, drunkenness or gambling, he was seldom used as a pointed warning against lechery as such and his women were not exploited for sermonizing purposes. The human core of military genre held its own with a steadiness that has never been surpassed in the work of artists of high calibre.

60. Urs Graf, *Military Fortuna*. Drawing (copy), *c.*1520. Nuremberg, Germanisches National-museum.

61. Urs Graf, *Landsknecht with Prostitute Fortuna*. Drawing, *c.*1514? Frankfurt, Städelisches Kunstinstitut.

CHAPTER 2
The Germanic Image of the Soldier

S O MANY INFLUENCES came together, affecting artists working in so many different places, that it would be naïve to suggest that this chapter could provide the explanation for the phenomenon of the military genre we have reviewed. But it could not have taken place without two components with which we shall now deal: earlier manuscript illumination, to which occasional reference has already been made, and the emergence of the image of the infantry soldier as one of the most potent inventions within the repertory of social types accepted by artists of all grades of accomplishment as interesting for pictorial purposes. Without the genre suggestiveness of Netherlandish and Swiss illuminations it is doubtful whether the figure of the soldier would have become as intriguing to artists as it did. Without the interest shown in that figure it is unlikely that genre would have continued to surround it with a socialized and moralized aura.

By the mid-fifteenth century the work of Netherlands manuscript ateliers was, while never homogeneous, characterized by a fusion of French and Flemish traditions into a painting-imitating style in which spatial depth offered room for the deployment of anecdote subsidiary to the main, textual, call for the subject. Whether the scenes illustrating chronicle, history or romance were battles, sieges or confabulations of heroes, and whether the text dealt with the ancient or the medieval worlds of militancy, both the taste of artists and the wish of their chief patrons, first Philip the Good and then Charles the Bold, joined to show them as contemporary events. However attuned these warlords were to the social and emotional usefulness of chivalry, they, like their successor Maximilian I, wished to be known to be abreast of changes in the tactics and technology of war.

Representation of battles changed from a compact frieze-like mêlée of horseman to a more spaced-back depiction of horse v. horse and foot v. foot, the latter in the foreground. Dead or alive it was now the infantryman who lay invitingly at the bottom of the composition. But it was not from this position that he was to roll into the attention of the celebrants of the soldier. What awoke that attention was not so much the individual as static image as his immersion in a task: serving a cannon, gossiping away the time on the march, pitching camp, lolling within the opening of a tent, looting.

We have looked at the baggage train miniature of 1448[1] illustrating an updated version of the *Chronicle of Hainault*. The new panoramic sieges and sacks provided rich illustrative hints, because these could only be carried out by footsoldiers (Fig. 62). There was room in the Girart Master's view of the siege of Jerusalem (produced in the late 1440s for Philip the Good) for soldiers to shelter behind the over-massive shuttering that protected the artillery from answering fire, to carry fascines, to confer about the next move, to take ladders to supplement the wholly impracticable siege vehicles which were derived less from crusading chronicles than from medieval versions of the classical *De rebus bellicis* manuscripts. And in an earlier (1410–15) Flemish illumination (Fig. 63) portraying the sack of Alost, while the last

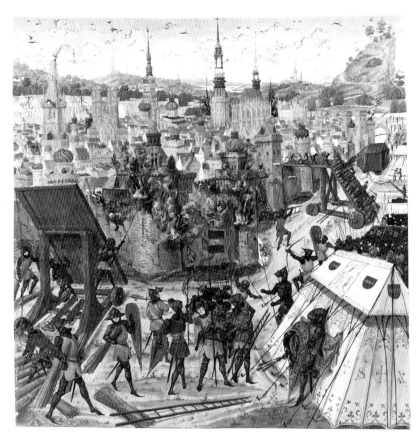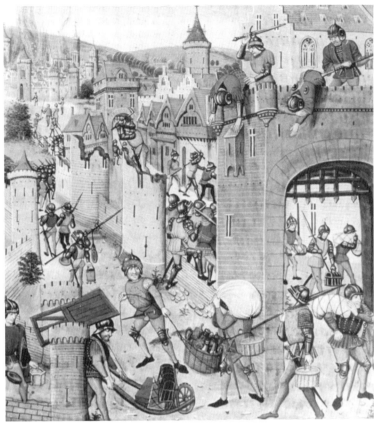

defenders are finished off, cheerily vacant-faced troops climb through the breach, break down doors, and emerge with bundles, chests and baskets, one helped by a commandeered wheelbarrow.

An embarkation scene in a *History of Alexander* made for Charles the Bold (Fig. 64), showed some of the soldiers firing or serving the guns in the dandified costume later to be characteristic of the mature Landsknecht or Reisläufer figure including, in two cases, the slashed sleeves and doublet and the sweeping ostrich feathers that were to become their identifying insignia. If we add the more muted, seen-out-of-the-window soldiers in, say, the Ghent *Jouvencel* of 1486,[2] we have noted a fair range of the activities and images that were to be taken up outside the page format of the illustrated manuscript.

But not before both had become democratized, as it were, and given a patriotic hallmark, by a later, *c.*1470–90, generation of illuminators, those of the Swiss picture chronicles.

How far these rough but often vivid works were directly affected by Burgundian antecedents is unclear. No relevant manuscripts were recorded or exist amongst the wide-ranging booty taken after the 1476–7 Burgundian defeats by the Swiss at Grandson, Murten and Nancy.[3] Nor has the possibility of transmission through German provincial ateliers, such as Hektor Mülich's establishment in Augsburg in the 1450s–60s,[4] been traced. Yet it is difficult to believe that without some prompting from Netherlandish example the successive pictorializations of the history of the cantons' wars against outside enemies and amongst themselves could have been carried out with such confident and copious address.

Clumsy as it is, and until then unique as to its subject, the scene in the earliest of these chronicles, the *Tschachtlan Berner Chronik* of 1470 (named from its compiler, Bendicht Tschachtlan), in which succour is being offered to a wounded or exhausted

62. Girart Master, *The Storming of Jerusalem.* Miniature, *c.*1450. Vienna, Österreichische Nationalbibliothek, MS.2533, *Chronique de Jerusalem,* f.162.

63. Anon., *The Sack of Alost,* Miniature, 1410–15.

43

64. Anon., *Contested Landing of Alexander the Great in Scythia*. Miniature, ?c.1480. Paris, Bibliothèque Nationale MS. fr.6440, f.173.

65. Anon., *Succouring a Soldier Fallen out from the Line of March in the Eschental in 1411*. Miniature, 1470. *Tschachtlan Berner Chronik*.

handgunner while the troops of the forest cantons move on, headed by fife and drum, to Eschantal in 1411, may show an interest independent of the text (the arms, wallet, knife, bottle, beaker), but as a whole is unlikely, for all its fairly spontaneous, sketchy quality, to be independent of earlier pictorial hints (Fig. 65). And this is, surely, true of other Tschachtlan novelties: soldiers dancing in a ring to fife and drum; the administering of the host to the wounded; a sermon in an occupied village; prisoners queueing up to be confessed before execution.[5] For whereas the extension of military subject matter in the north was largely the result of an interest in transport, encampments, the servicing of the guns and other military machines, or the activities involved in sieges, the Swiss illuminators extended the range by also focusing attention on the social and personal aspects of army life.

A review of the next of the illuminated chronicles, Diebold Schilling's *Berner Chronik*,[6] will suggest the range of what it had to offer independent artists who were attracted to military genre or the individual infantry soldier as the typical representative of warfare; neither its variants (the *Spiezer Bildchronik* of 1485), nor its continuations (e.g. the *Luzernchronik* of c.1513), added anything of significance.

The *Berner Chronik*, finished in 1483–4, covered the events in Swiss history in

which Berne played a part from the 1230s. Even given the necessarily bellicose, political postion-finding stance of frontier countries in these centuries, the numbers of campaigns, or small-scale expeditions against a neighbouring town or magnate stronghold, is astonishing. Each was granted an illustration. It is not suprising that northern formulae for battles and sieges were called upon, or that many representations were so repetitive that they could have been substituted for one another, or that the figure style was on the whole stereotyped, faces simpering and unexpressive, bodies anatomically weakly considered; or that landscape and architecture were hurried into place without much attention to spatial perspective or scale. All the same, a veristic pulse is discernible, mainly activated by the actions of troops *en masse* but also by the lulls between, or the consequences of engagements. Especially from events after 1456, when a new and robuster illuminator takes over and Schilling, later on, accompanies the armies whose activities he is describing as official *Feldschreiber*,[7] genre subjects become more frequent, figure types less conventionally etiolated, however rough and ready the overall style of draughtsmanship remains. An increasing amount of anecdotage becomes independent of the text.

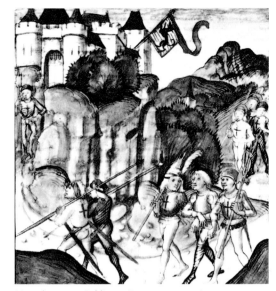

66. Anon., *Soldiers Conversing with a Prisoner.* Miniature, c.1483. Schilling, *Berner Chronik.*

67. Anon., *Soldier Supporting the Standard and Arms of Berne.* Miniature, c.1483. *Berner Chronik.*

The northern interest in technology remains, but is intensified from the point of view of the user. We get another indication that handguns could be fired from the shoulder as well as tucked under the armpit, the first (exaggerated) indication of a foresight, the first depiction of canvas-bagged 'cartridges' of powder for medium-sized artillery, a delineation of the ideal protected firing position for gunners (a waist-deep pit and a bullet-proof shutter lowered for loading and raised for firing) that has been accepted as accurate in a reconstruction in the Zurich Landesmuseum. The interest in the carrying off of booty remains, though a characteristically inconsequential Swiss not is sounded in the pikeman who pours wine into his mouth from his flask as the booty-laden wagon trundles past. The motif of two or three soldiers conversing in off-duty moments is repeated, but their rapport becomes more animated, and there is no precedent for the detail of two soldiers apparently sharing a conversation with a prisoner who walks between them with his wrists bound (Fig. 66).

Other new subject matter varied from the recovery of bodies from the lake and their burial in pits after the defeat of Burgundy at Murten (Morat) in 1476, to a soldier fallen out from the line or march, defecating by the wayside with flies buzzing towards his excrement. And it included the new theme we have examined: the extent to which women camp-followers shared the lives of their menfolk. And their inclusion within the subject matter of warfare led to the introduction of two fresh tones, appeals to audience reactions that were to be taken up and more thoroughly exploited later on.

One was humour, though this is often difficult to evaluate at some centuries' remove, either in intention or effect. Formerly located in art in the blunt shock of the grotesque, or in images that were playfully fantastic, this now arises from realistic, or real-seeming narratives. Soldiers discover one of their number making love in a tent while the rest of the force begins the assault on the robbers'-nest castle of Schwanau am Rhein. While the camp women taken after Murten file through the Swiss camp, headed by a dowager-like figure who clearly disdains any advantage to be gained by changing sides, younger ones stroll off amicably with their captors or can be seen within the flaps of tents unprotestingly transferring their favours. In another Swiss picture chronicle one of them is shown in more domestic guise delousing her captor's hair.

The other was pathos. We are not to expect that wounds, executions or burials were found 'pathetic' then, but surely readers were meant to be moved by the consecutive scenes in which a woman is shown smilingly bringing her lover a plate of chicken as he lounges in his tent before an action and, then, after it, flinging up her arms in anguish as she kneels beside his dead body? (Figs. 68 and 70).

Such characterized incidents were rare. Only one illustration (Fig. 67), the front-

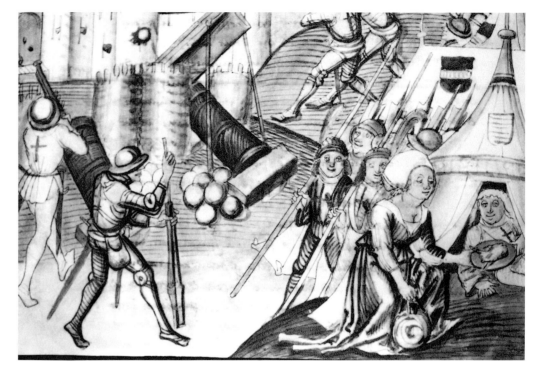

68 and 70. Anon., *A Woman Feeds, then Mourns her Soldier Lover*. Miniatures (details), *c*.1483. *Berner Chronik*.

69. Anon. (Swabian), *A Studio Model Posed as a Foot Soldier*. Drawing, *c*.1480–90. Veste Coburg, Kunstsammlung.

ispiece to the second of the three books into which the *Berner Chronik* was divided, shows a single figure representing, as he holds the standard and supports the arms of Berne, the soldier on whom the canton's fortunes in war had come to depend. He has something of the swagger of the soldier later artists were to find so fascinating and their ostrich feathers jut from his head-dress. But though not sabotoned nor spurred, he is armoured in the guise of a traditional knight-supporter of a heraldic coat.

What the chronicles offered, then, was not so much a single, recognizably typical figure on which variations could be played and values imposed, as a view of the social reality of campaigns dominated by infantrymen, and of the private lives of those engaged in a public service. But we do not know how accessible they were.

The transmission belts between Burgundian and Swiss illumination, and between both and the genre development described in the previous chapter remain elusive. The figure of the soldier which we shall be following emerged during the first decade of the next century. By then public, purchasing, interest had been stimulated by events: the bitter Swabian War of 1499 in which the Swiss forced recognition of their independence from Imperial Germany; Maximilian's consequential organization of the first true 'German Army', that of the Landsknechts, between 1500 and 1507;[8] their engagement in his essays in Italian conquests from 1508, and their subsequent employment in Italy against the Swiss who were fighting either for their own share of Italian spoils or in the service of France's determination to control Lombardy.

There was no comparable input of realistic observation into chronicle manuscripts; nor, for that matter, into the printed books which Germans had pioneered. Their illustrations, when military events summoned them up in Old Testament, chronicle or chivalrous romance contexts, remained crude and unspecific.[9]

On the other hand there is sporadic evidence that artists were accepting foot-soldiers as subjects acceptable within the repertory of pictorial individualization, and were putting observation, or knowledge derived from others, above traditional artistic formulae or deference to the values of a horsed minority. We may, not altogether fancifully, take an anonymous Swabian drawing of *c*.1485 (Fig. 69) as a

symbol of this hesitant stage before the infantryman was accepted as a matter of course and worthy of close scrutiny for his own sake. Presumably this is a workshop study made to speed up the production of a religious or heraldic subject. It is taken from a posed model. From the mail shorts upwards, the armour is that of a cavalryman; gauntlets, tasses, reinforced cuirass, the visored helmet and the gorget that offered protection to the horseman at a cost of the freedom of glance essential to the man fighting on foot. But the pole-arm with which the model steadies himself while being drawn is not the cavalryman's lance. And the bare legs and civilian floppy boots make the presence of a horse unthinkable. No doubt the workshop's wardrobe was merely without armour. But the careful, if not particularly sensitive, rendering of the model's nether half, and the fact that his weapon was finished off with a halberd-like blade rather than being allowed to 'finish' beyond the top of the sheet as a draughtsman with a cavalry lance in mind would have allowed, suggests a state of mind far from envisaging cavalry engagement or aristocratic joust.[10]

Dürer's early (1489) essay in infantry types is, again, tentative.[11] The figures are undoubtedly infantrymen (Fig. 71). But Dürer, interested as he is in physiognomy, stance and rapport, does not trust the subject as 'art' (the drawing is clearly not a study for a detail within a painting), he gives the soldiers weapons to hold which, while diverting to the eye, are wholly unreal. Uncharacteristically even so early in his career, he pops in the logically and stylistically unjustified banderols that stream from the elbow of the right-hand figure. But in the welcoming gesture of the raised arm of the central figure he is not only anticipating comparable gestures a decade hence whereby the 'real' infantryman drew attention to himself, but signalling his awareness of the inviting nature of a new genre subject of which he, as yet, was wary.

All the same, while the figure of the soldier had by about 1490 become as confidently defined as it was in the left-hand lobe of a quadrifoil stained glass panel (associated, again, with the Housebook Master),[12] where one of the Magi is accompanied by a thoroughly contemporary guard with feathers in his cap, sleeves slashed at the elbow, and armed with sword and halberd; and while it had acquired a public acceptance that justified the earliest of what was to be a long series of

71. Albrecht Dürer, *Three Soldiers*. Drawing, 1489. Berlin, SMPK, Kupferstichkabinett.

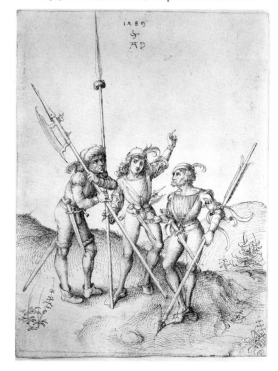

47

bronze statuettes,[13] it was, from the *Berner Chronik* onwards, by winning a place as a heraldic supporter that it gained the panache that was an important ingredient in its subsequent popularity.

This is attractively present in a painting on paper stuck to the lid of what appears to be the earliest (1497) example of a travelling case for a moneyer and jeweller's weights and scales. It shows the arms of its owner, the prosperous Nuremberg mint-master Hans Harsdorfer, supported by two exuberantly feather-headdressed, glowingly confident halberdiers (Fig. 72). They were chosen not as the armed escorts needed to accompany the silver from the mines he owned in Bohemia, but to demonstrate his allegiance to the militant traditions of his city and to the Emperor for whom he acted as adviser in minting matters: the left-hand figure has the St Andrew's cross cut into his hose at the thigh. This miniature lid (17.4 × 10.3cm) is one of those small private objects that can store a large amount of information – in this case influences, some no longer recoverable in their original form – and transmit pulses of understanding about what is to come. In this case it is not just the cocky stance, the limber flashiness of costume with its calculated out-at-elbows semi-bohemianism, but, on the other side of the lid, battling Wild Men, hairily naked against their stylized forest background. The theme, chiefly in tapestries, was a familiar northern one. Now for the first time they are directly associated, as though the lid were the obverse and reverse of a coin, with another race of outsiders, soldiers.

The Swabian war of 1499, with its shocking revelation that Swiss soldiers could beat German ones, was not, of course, a turning point in the history of artistic style. But, apart from sharpening for artists the national identities of the soldiers they portrayed, its two chief pictorial memorials reveal a latent energy within the appeal of soldiers and their testing ground, war, as subjects for art which helps to explain the quickening pace with which military images were produced after 1500.

The lesser memorial, an undated and unattributed woodcut inscribed 'Dorneck 1499' of which there is a fine and contemporarily coloured version in Basle, concentrates on the defeat of Maximilian's army at the neighbouring town of Dornach (Fig. 73).

The battle itself is shown in a huddled, formulaic pattern which exaggerates (for

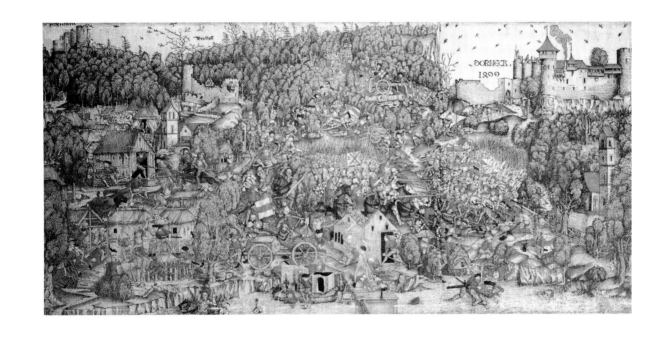

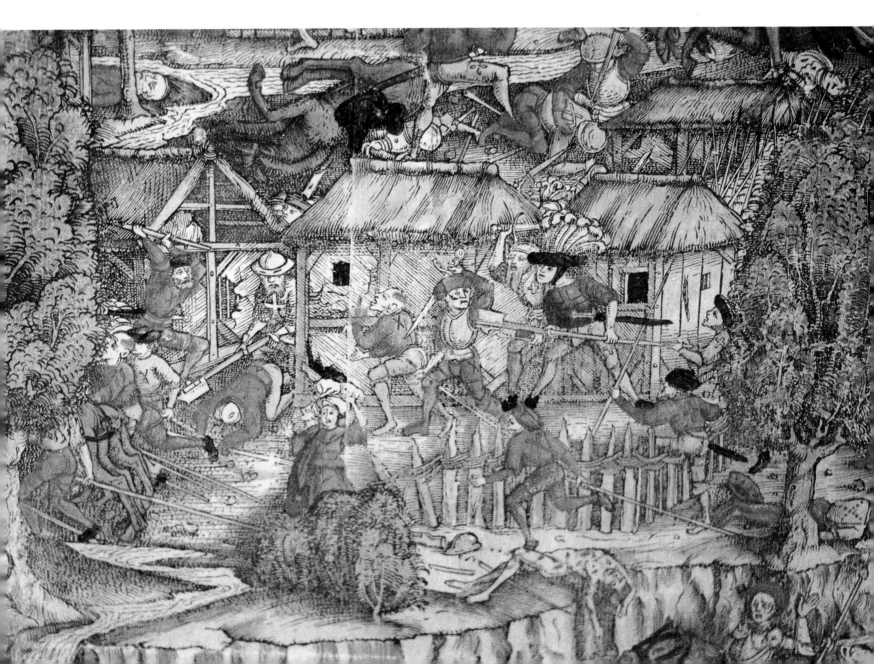

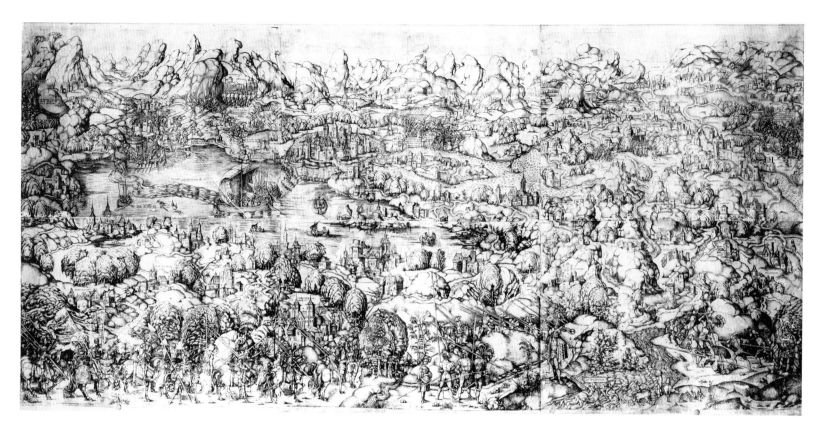

75. Master P.W., *The Swabian War*. Engraving. ?1502–3. Basle, Kunstmuseum, Kupferstichkabinett.

this is surely a Swiss, probably Bernese work) the cavalry element in the Imperial army which was to be, like its Burgundian predecessors, wrecked on the pike-reefs and handgun bullets of its infantry opponents. But what interests the artist more is the extended aftermath hunt of the fleeing survivors through the streets of the town (Fig. 74), and into the stream that flows past it, and among the trees in the neighbouring woods between the castle and the town. Episode by episode, the St George's cross of the victor is contrasted with the St Andrew's cross of the man he is striking at or has slain. Bodies lie stripped and bleeding. Women wail in gestures of despair. Crude, vigorous, aswarm with animated detail, *Dorneck 1499* sums up the manner and the mood of the picture chronicle tradition, and closes it.

In contrast, the 6-sheet engraving of scenes from the war which were infiltrated into a bird's-eye view of the campaign area as a whole, is a work that looks forward rather than back (Fig. 75). It is the masterwork of the still anonymous Cologne Master P.W., unique for the time – it is undated but probably *c.*1502–3 – in its intellectual grasp of a necessarily stylized topography (south is conventionally at the top), and for the refinement of its profusion of detail.[14] It is not pictorially 'pure'. Towns and rivers (the Rhine and the Danube are compositional organizing features) are labelled, and brief captions identify the major engagements, including 'Dornek' in the upper right-hand sheet. And to preserve the overall human interest, different scales of recession are used for figures and towns, and for the landscape piling up into the distance. But quietly at odds with these conservative aspects of the work is a quite new sense of imperturbability.

The Master was German, from Cologne, though he may have been working in Basle around 1500, indeed must have been, for no contemporary maps or chronicle available in Cologne mentioned so many Swiss villages. Yet there is none of the savage patriotism so evident in *Dorneck 1499*. He does not mark his soldiers with × or +. There are savage moments (Fig. 76): pikes rammed into throats and chests in skirmishes; army swaying convulsedly against army. But while war splutters here and there and large forces ford rivers to reach the shelter of their artillery or

76. Detail of Fig. 75.

pour through defiles to clot into combat formations, the ordinary life of the countryside goes on. A deer sniffs another's hindquarters. A rabbit hides in a tree root while another peeps out over it. A fine lady rides side-saddle accompanied, as in Dürer's so-called *Knight and Landsknecht*, by a mini-lion dog and an armed servant on foot, and they surprise a wagoner defecating by the roadside. On another road a woman of another class trudges with a bundle on her head. Trading boats ply the Bodensee; fishermen cast their nets; birds dive and one emerges with a fish in its mouth. The military are intruders here, but they also become part of the scene. A party of officers rides in; every detail of caparison, trapping, armour, plume, blazon is exactly rendered as though the frieze they make were a self-contained work of art; yet the Master has the knack, rather, the intellectual point of view, to make them at home within the landscape they have entered. Further across from the left, also in the foreground, is another set piece (Fig. 77): three pikemen, artfully posed, one with his back to us, one facing us, one in semi-profile, their individual tension, and that uniting the group, contrasted with the sullen stance of their female companion, a picked-up gypsy to judge from her turban-like headgear. Yet they, too, fit into the Master's vision of a countryside occupied, but not taken over, by warriors and conflict. Technically abreast of what the Housebook Master had done, and what

77. Detail of Fig. 75.

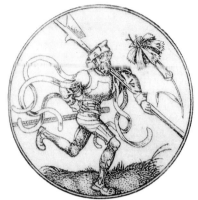

78. Master P.W. *The Knave of Pinks*. Engraving. *?c.1500*.

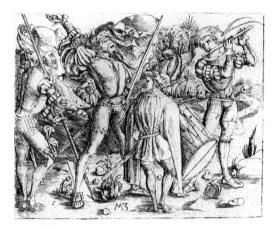

79. Master M.Z., *Four Soldiers*. Engraving. *?c.1503*.

80. Albrecht Dürer (attrib.), *Standard Bearer with Beard*. Drawing. *?1502*. Vienna, Albertina.

Dürer was doing, at this moment the artist was Europe's outstanding pictorial philosopher of war.

Meanwhile, after *Dorneck 1499*, in Switzerland custodianship of the soldier image passed to the designers of heraldic glass,[15] stimulated not only by civic commissions but by personal ones from the increasing numbers of minor nobles (those with a 'von' in their names) who went to war as captains of infantry units. It was a time when in churches, town halls and private dwellings, saints were out and soldiers were in. Foremost amongst the early designer–glassmakers were Hans Funk of Berne whose somewhat wooden works from *c.1501*, and those of the livelier Lucerner Oswald Goeschel from *c.1505*, served at least to keep the soldier figure prominently displayed before it was redeveloped in a more relaxed manner by freelance artists of the calibre of Urs Graf and Nicklaus Manuel Deutsch. It was in Germany, and especially in Bavaria, where the Master M.Z., Dürer, Hans Schäufelein, Altdorfer and Hans Süss von Kulmbach all worked, that the image was given an imaginative stature, and a flexibility, that determined its subsequent elaboration.

The most adventurous and committed images were those on paper. Meanwhile, the figure was becoming fashionable. The Knave of Pinks (Fig. 78) in a series (*c.1500*) of round 'playing card' designs was a footsoldier.[16] Life-sized frescoed infantrymen decorated the facade of Maximilian's summer residence, the early-sixteenth-century Golden Roof (*Goldenes Dachl*) house in his strategic centre at Innsbruck. They were stamped into oven tiles. They jauntily topped silver-gilt goblets on patrician tables.[17] Private observation and personal fantasy played upon a surface of public acceptance in a decade not new to the political role of the soldiery but freshly alert to its visual interest.

Not long after 1500, the Munich engraver M.Z., one of the many mildly talented Bavarian artists who had fallen in thrall to the prints of the young Dürer, produced a second-rate but exuberant prospectus (Fig. 79), as it were, of the military figures that were increasingly going to engage his contemporaries' imagination: the halberdier on the left leans against his reversed weapon and indulgently watches the operatically self-indulgent stance of a standard bearer, while on the right a drummer, shrunk to dwarf rather than youthful size so that the landscape can play its part in the composition, and a fifer – his instrument is the standard shrill-pitched military transverse flute – sound the march.

Dürer himself, though technically so dominating an influence on collaborators or colleagues who devoted attention to soldiers and their ways, was, in the long run, chiefly interested in war as a phenomenon. Though he mastered the appearance of soldiers as a necessary ingredient of crowding humanity, for him war had primarily an abstract, logistical fascination: so much flesh against so much stone. From his cool rendering of the *Siege of Hohenaspern*, and his later vision of a coastal fortification like a grounded flying saucer, to his last large woodcut showing pinmen swarming towards and out of a massive defensive structure, his imagination was seized by number and mass rather than by the dramatized individual.[18] None the less his alertness to topicality was such that in around 1502 he engraved a feebly posed peacetime standard bearer (plumed cap pushed back and hanging sideways, and holding the short-staffed parade standard rather than the long-staffed one used in action).[19] A far more energetic drawing of a standard bearer has been fathered on him (Fig. 80). This work's emotiveness, the illogicality of a short-staff standard bearer adopting such a snarling (and bare-chested) tigerishness of stance, and some pictorial equivocations (his midriff, his left knee) make an autograph attribution conjectural. The drawing has also been dated 1502 in spite of the '1513' above the monogram, and this is not unreasonable, given the frequency with which dates on drawings have been added or altered. A third drawing ascribed to 1502 shows a halberdier seen from the back;[20] a fourth, of *c.1504* of a walking halberdier wearing a cloak, is only cautiously given to him.[21]

It is with Lucas Cranach the Elder's woodcut of *c.1505*[22] that the figure received

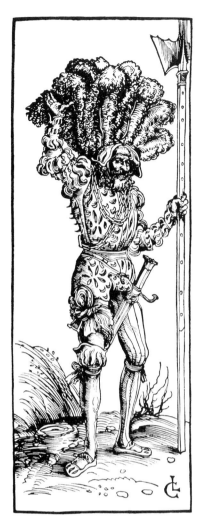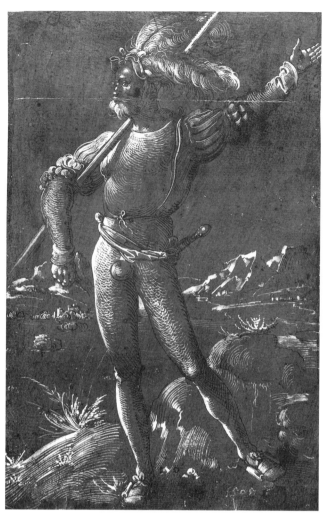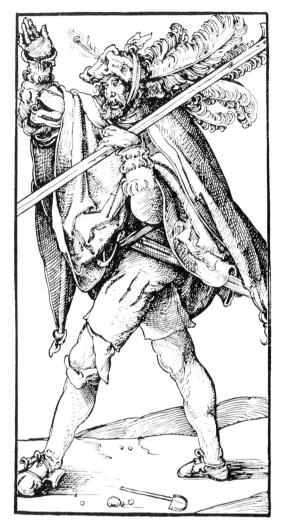

an interpretive characterization that contributed to the Landsknecht stereotype of the future (Fig. 81): the mismatched hose, slashed and cut-out costume and towering ostrich feathers; the phallic association of sword hilt and codpiece; the 'Wild Man' greeting gesture. This last hint of the soldier's potentially dangerous, outsider status also characterized the chief figure on an early sheet of soldier sketches by Hans von Kulmbach,[23] as well as the first finished 'presentation' drawing devoted to the single figure of a soldier, Hans Baldung Grien's *Landsknecht in a Landscape* of 1505 (Fig. 82). In the same year Baldung produced a thoughtful pen sketch of a soldier head, clearly taken from the life.[24] But his *Landsknecht* is a larger-than-life figure, his pose and poise conveying a baleful glamour. And some two years later the 'greetings' image was again given wider circulation in a striking woodcut (Fig. 83) by Hans Schäufelein,[25] which derived from a group of pen studies he made of halberdiers at the very outset of his career.[26] Nor is this the end of the *c*.1505–7 cluster of single images for in 1506 Altdorfer, who was to become one of the most fascinated observers of soldiers and their lives, engraved his powerfully brooding *Swordsman* (Fig. 84).

Altdorfer's interest continued to grow. In 1510 he produced, in two engravings,[27] the first representations of the military drummer and fifer as separate subjects. In 1512 his drawing of an exhausted soldier leaning over his broken pike introduced a note of sentiment which was to be an enriching ingredient within the concurrent development of military genre (Fig. 85). He had already, in an engraving of *c*.1505–6,[28] contributed to those conversation pieces which were another stimulus to the

81. Lucas Cranach the Elder, *Landsknecht Halberdier*. Woodcut, *c*.1505.

82. Hans Baldung, *Landsknecht in a Landscape*, Drawing, 1505. Basle, Kunstmuseum, Kupferstichkabinett.

83. Hans Schäufelein, *Landsknecht*. Woodcut, *c*.1507.

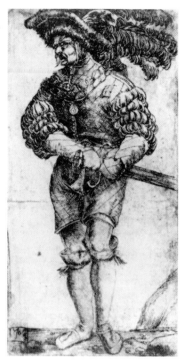

84. Albrecht Altdorfer, *Landsknecht about to draw his Sword*. Engraving, 1506.

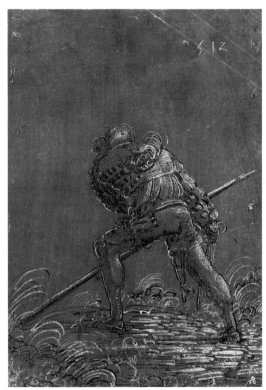

85. Albrecht Altdorfer, *Exhausted Landsknecht*. Coloured drawing, 1512. New York, Frick Collection.

86. Hans Süss von Kulmbach, *Landsknechts*. Drawing, ?c.1508. Vienna, Albertina.

genre treatment of soldiers' lives and relationships which we have looked at. These also intrigued Kulmbach (Fig. 86), who in c.1508 linked two themes – the drummer-fifer–halberdier group and the conversation piece – in a single, remarkably observant drawing. And into a series of boldly designed larger woodcuts that clearly took public interest in representations of soldiers for granted, Schäufelein[29] in around 1513 included the novelty of a scene of three handgunners (Fig. 87), with shouldered matchlock arquebuses, chatting as they walk along.[30]

The decade 1505–15 is one of great fascination in the context of the image of the soldier. The 'Danubian' network of artists has been primarily associated with pioneering a new, because at the same time descriptive and empathic, concentration on the depiction of landscape for its own sake. But it was not only Altdorfer who looked at, and thought about soldiers and came to see their lives and destinies as part of the natural, non-urban world. In 1513 his brother Erhard made landscape, though subordinated in his drawing to the conversation between a Landsknecht and his officer, more than a merely conventional back-drop to a figure study (Fig. 88). Even without a knowledge of Wolf Huber's purely landscape drawings, it is clear that his sketches of soldiers were seriously considered (the *Landsknecht drawing his Sword*[31] is signed and dated 1512) and, if based on studio models, were imagined in terms of the open air. It is there that the three strolling pikemen of his 1515 woodcut (Fig. 89)[32] gain their freedom to argue, adjust a slipped-down stocking, lift – is this the first example of an artist showing how people really walk? – feet from the ground as they proceed.

This knack of imagining soldiers as the most interesting of wayfarers (the Danubians were not concerned with the traffic of lawyers, merchants, clerks, scholars, or artisans tramping on their *Wanderjahre*), led to notable fusions of soldiers with landscapes. In a drawing of c.1515 a halberdier scrutinizes the ground for foot or hoof marks that will reassure his mounted companion that they are following the main body of their unit.[33] In a contemporary drawing (Fig. 90) commonly attributed to the Master of the History[34] the swirling pen strokes, and the overall dif-

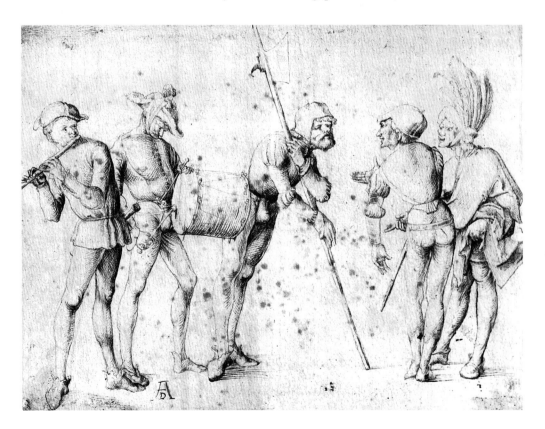

fusion of the highlighting additions of white pigment, and the deliberate stylistic identification of the ostrich plumes of the right-hand figure with the pollarded plumage of the tree behind him, link soldiers to nature with a casual mastery that would, alone with its assuredness, establish the appeal of the soldier figure within this new and creative zone of the German response to the natural world.

These years also witnessed the transference of an interest in soldiers from the naive and text-prompted imaginations of picture chronicle illustrators to the inventions of independent Swiss artists, foremost amongst them Niklaus Manuel and Urs Graf, which added a fresh impulse to the elaboration of the image of the footsoldier.

Both served as soldiers themselves. This did not, in itself, necessarily prompt their interest in the theme. None of the German artists whose work we have followed knew military service at first hand, though the Housebook Master's likely occupation as a *Buchsenmeister*, or arms store administrator, could have moved his recording impulse to show the weapons and military machines in his charge brought into action by the soldiers who used them. Hans Leu, Manuel's and Graf's most distinguished artist contemporary, fought among soldiers but never depicted them.

Both had a mental slant which, like the Master P. W.'s, can loosely be called philosophical. Once intrigued by the soldier-as-subject they worried their way into a consideration of his peculiar manner of life and used him as an agent through whom they could transmit, with an appropriate pictorial focus, their views about wider issues: patriotism, the role of chance in human affairs, sexual relationships, death. For this reason most of their works have been considered in relation to genre and comment.

Both, Manuel in Berne and Graf in Basle, portrayed soldiers before they themselves marched into action. The former, reasonably well connected, may have had access to the *Berner Chronik*, but both were attentive to German prints and the profit to be derived from producing designs for the painted glass panels which commenorated patrician military service or featured soldiers as the supporters or standard bearers of cantonal devices in churches and town halls. From 1494 Swiss units had served in the wars of Italy as French or papal auxiliaries or as part of the eastern cantons' determination to wrest from the duchy of Lombardy an extension south-

87. Hans, Schäufelein, *Three Handgunners*. Woodcut, *c*.1513.

88. Erhard Altdorfer, *A Landsknecht and Officer*. Drawing, 1513. New York, Metropolitan Museum, Lehman Collection.

89. Wolf Huber, *Three Landsknechts*. Woodcut, 1515.

Hans Segufele von herrenberg.

56

wards into the Ticino and the trade route commanding the hinterlands of Lugano and Bellinzona. Manuel's first signed drawing, of 1507 (Fig. 91), with its hero-halberdier home from his service in French pay at the energetically portrayed siege of the Ligurian town of Castellazzo, which is shown above the arch under which he stands, is surely a response to the demand for commemorative windows. His independent drawings like the lively *Four Soldiers* of *c*.1510 (Fig. 92), again pre-dating his own military experience from 1516, clearly respond to German interest in the subject.

The most memorable Reisläufer images, however, were those of Urs Graf. Unlike the securely connected apothecary's son Manuel, who achieved minor governmental posts while steadily being offered major commissions for paintings, Urs Graf, after his arrival as a young man in Basle from Solothurn, never settled comfortably in that sober, prosperous and scholarly city. Restlessness and a hard-drinking, brawling temperament which led to a number of prosecutions, made military service both attractive and convenient. He enlisted in 1510, again in 1513. In 1515 he was present at the shocking French defeat at Marignano of the papal army whose backbone was formed by Swiss infantry. This was not only a severe blow to Swiss esteem, but the end of the Confederation's hopes of winning territory in northern Lombardy. In 1521–2 he was lucky to remain alive after another catastrophe: the defeat by an Imperial army of a Franco-Swiss one at Bicocca.

The slaughter, the tarnishing of national pride, the change after 1515 from patriotic, politically approved service to purely mercenary soldiering, were all to leave

91. Niklaus Manuel, *Young Halberdier and Siege Scene*. Design for glass, 1507. Basle, Kunstmuseum, Kupferstichkabinett.

92. Niklaus Manuel, *Four Soldiers*. Drawing, *c*.1510. Erlangen, Universitätsbibliothek.

90. Master of the History(?), *Two Landsknechts in a Landscape*. Coloured drawing. Vienna, Albertina.

57

93. Urs Graf, *Seated Soldier*. Engraving, 1513.

94. Urs Graf, *Striding Standard Bearer*. Drawing, 1514. Basle, Kunstmuseum, Kupferstichkabinett.

95. *Soldier with Fool's Cap*. Fresco, Turku Castle, c.1530.

their mark on Urs Graf's later prints and drawings. But before Marignano he produced, in the engraved *Seated Soldier* (Fig. 93) of 1513, the very emblem of mature, sturdy, thoughtful resolution. And among his Reisläufer drawings of the following year is the well-known figure of the virile *Striding Standard Bearer* (Fig. 94). Between them, these figures wonderfully sum up both the steadfast and the glamorous aspects of military service.

From 1515, in both Switzerland and southern Germany, the creative steam

gradually evaporates from the depiction of soldiers as individuals. Variants of pose, demeanour and implied significance had been explored, and were losing the flavour of challenge. But by now firmly inscribed on the flywheel of popular taste, they still regularly return. Heraldic glass painting, whether cantonal or personal, both continued to call for halberdier supporters and escaped the shut-down on demand during periods of post-Reformation religious iconoclasm. Oven tiles kept the image warm in private homes: a Swiss pattern of c.1519 showing a town's battlements valiantly defended by the figure of a Reisläufer; a German stove (Fig. 99) of about the same date decorated with rows of coats of arms and saints all arising from a frieze at the bottom which replicates the figure of a halberdier – albeit a sleeping one.[35] In 1519 the Basle publisher–printer Thomas Wolff commissioned a trade-mark from Urs Graf.[36] It showed a Reisläufer protecting the linked arms of the city and Wolff's own monogram. By about 1530 a doorway in the remote castle of Turku, in Finland (Fig. 95), was guarded by a crudely painted Landsknecht arque-busier figure, though he was by now wearing, deflatingly, a fool's cap.

Warfare continued. So did Swiss–German rivalry, more acutely than ever now Reisläufer and Landsknecht were competing in a cash-based military market and clashed at the recruiting table as well as on the battlefield. The free, dangerous 'wild' life of the soldier, and the defiant, sloppy extravagance of his costume, became even more intriguing to stay-at-homes infected by a heightening of pre-Reformation religiosity and then by that proto-puritanical post-Reformation demand for a con-gruence between behaviour and belief.

The figure of the standard bearer, even though no longer standing officially for a Swiss cantonal, or German city or *Land*-based unit, remained an important witness to unit loyalty, symbol of the do-or-die ethic that was at once grossly flamboyant and bitterly real. In engraving[37] and woodcut[38] Altdorfer pursued the subject, in muted, serious mood. Urs Graf, disillusioned with war's panache, caught, as late as 1527,[39] the strutting appeal of the subject's silhouette, though in his woodcut the standard itself has shrunk to a small token compared with the whiplash exuberance of its folds in his pre-Marignano drawing of 1514.

Both he and Niklaus Manuel, though their main commitment to military subjects had turned elsewhere, continued to draw soldiers – but no longer for block-cutters or engravers. For Urs Graf this was an aspect, relished, but frequently offhand, of his self-adopted role as the military equivalent of a street artist: a keepsake portrait here for a soldier's girl, a New Year's greeting there for a friend. All is harmony on this auspicious day, he appears to imply in his 1523 drawing of *Four Fifers*, ad-dressed in its banderole to the goldsmith Zorg Schweiger (Fig. 96). Two Swiss, a Frenchman and a German sound their shrill instruments together. The careful detail with which he delineated the group suggests, none the less, the scepticism towards patriotic and personal motivation which was to mark his most considered work. Manuel's drawings of soldiers,[40] which continued from 1518 to 1529, suggest, rather, studies which might prove adaptable to other contexts: glass painting, for instance or the religious and mythological subjects on which his reputation and income really depended. Yet they were conceived in a continuing spirit of atten-tiveness to the soldier's appearance and character.

In Germany a new infusion of interest was provided by Dürer's ex-pupils, the brothers Barthel and Hans Sebald Beham. Two engravings by Barthel of 1520,[41] one of a soldier seen from behind, the other of a soldier crouching in front of a tree, reveal – especially the latter – a fresh eye for the plasticity inherent in the image, and for its still not fully exploited range of expressiveness (Figs. 97–8). His *Soldier Sitting on a Tree Stump* of 1524 probably (he was a political radical) reflects his disgust with the brutality of the Landsknechts hired to quell the peasant revolts which broke out in that year. Beer-bellied, with glazed eyes, slumping from self-indulgence – the force of this engraving resides in its indignant avoidance of caricature. Similarly unheroic is his slightly later engraving of a halberdier riding spiritlessly along as

96. Urs Graf, *Four Fifers*. Drawing, 1523. Basle, Kunstmuseum, Kupferstichkabinett.

97. Barthel Beham, *Landsknecht by a Tree*. En-graving, 1520.

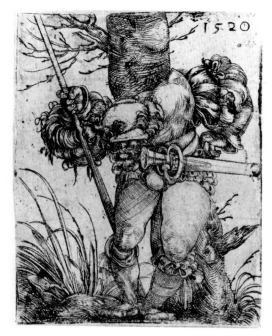

98. Barthel Beham, *Crouching Landsknecht*. Engraving, 1520.

99. *Tiled Stove with Frieze of Sleeping Halberdiers.* Würzburg, before 1519. Nuremberg, Germanisches Nationalmuseum.

100. Hans Holbein the Elder, *Crossbowman Aiming*. Drawing, c.1516. Copenhagen.

101. Hans Weiditz, *Caricature of Halberdier and Boy Servant*. Woodcut, c.1521.

102. Jan Sanders van Hermessen (attrib.), *Tavern Scene*, c.1540. Berlin-Dahlem.

though automaticized within an occupation that is letting him down. Hans Sebald, on the other hand, the less thoughtful but more intellectual and, at the same time, commercially alert of the brothers, continued to turn out engraved, etched and woodcut images with a routine panache.

Apart from the work of the Behams, between 1514 and 1529 – when the mustering of troops to relieve Vienna from its siege by the Ottoman Turks caused a new flurry of interest – the image of the soldier had reached a lacklustre plateau. An occasional drawing stands out, but the air of gleeful menace has been replaced by formal rhetoric. It again becomes appropriate, as before 1500, to wonder whether drawings of soldiers were not done for their own sake but as studies for religious paintings. A clamant example is the elder Holbein's brilliantly deft and exact sketch of a crossbowman sighting his target (Fig. 100): one eye closed, thumb pushing aside the nose, the air of concentration absolute. Done in the year after his arrival in Basle from Augsburg, this could easily be read as homage to some member (it is sharply characterized) of a shooting company or military unit – the butt of the weapon could equally be that of the Landsknecht's or Reisläufer's arquebus. Only the survival of his *Sebastian Altarpiece* reveals it as a study for a work within which the target is a saint.[42]

The image's dwindling power to rivet attention is further suggested by such vulgarly caustic dismissals of its interest as Hans Weiditz's caricature (Fig. 101) of a halberdier and his boy servant of c.1521,[43] and by the failure of the Augsburg block-cutter and publisher Jobst der Necker to get off the ground his project of the later 1520s to launch a series of 50 woodcuts of Landsknechts, even though his contributors included artists of the stature of Burgkmair, Jörg Breu and Hans Sebald Beham.[44]

For from that decade until the mid-century we encounter a new phenomenon: an outpouring of soldier images, but a minimum of the searchingly personal involvement in their subject matter that marks most, if not all, of the works we have reviewed. In Switzerland, no artist of comparable genius followed Niklaus Manuel and Urs Graf; Holbein the younger, an honorary Swiss, was not tempted save in larger or heraldic contexts. The demand for soldier heraldry continued but the verve had gone. More protectively armoured figures, more socially acceptable in demeanour, became the norm. This was true, too, of Germany.

Routine images of soldiers, in the form of portable bronze sculptures[45] or decorating tiles, dishes and jugs, continued to demonstrate their popularity. What was new, however (and the shrewdness of the move is evinced in the frieze of Landsknecht images on the wall in Jan Sanders van Hermessen's *c.*1540 *Tavern Scene* (Fig. 102),[46] was the initiative of Nuremburg woodcut publishers, the *Briefmäler* Hans Guldemund, Niclas Meldemann and Hans Glaser, in commissioning broadsheet series less ambitious in number and less finely designed than those proposed by Jobst der Necker.

For if artists felt that the image had exhausted its appeal to their own creative curiosity, an audience remained. Fighting in Italy had stopped with the peninsular peace settlement of 1529. But right up to the more general European settlement of Cateau-Cambrésis in 1559, Swiss and German troops were involved, via the military employment market, in the wars between the kings of France and their allies and the Spanish–German–Netherlandish Habsburgs and theirs. Landsknechts were not only marching off abroad and returning home, but fighting in the wars for religious definition in their own country that followed Charles V's determination to keep Germany faithful to Catholicism, and in the inter-state rivalries that kept the political mosaic of Germany constantly ajudder. And the Turkish failure before Vienna in 1529 did not lead to a feeling of security in the eastern borderlands. Though increasingly the Landsknecht companies were treated as living investments

103. Niklas Stoer, *Turks and Captives*. Woodcut, 1530.

104. Erhard Schoen, *Field Surgeon*. Woodcut, c.1535.

by capitalist military entrepreneurs, this if anything intensified the efficiency of an organizational structure that marked them ever more fascinatingly as outsiders subject to their own codes of both licence and savage self-discipline – witness the *Spiessgericht*, the fatal running of the gauntlet of pike. It was not due to the circumstances of political or social history that aesthetic interest in the figure of the soldier ran out; it had simply gone flat from overuse. The hero-artists, the independents, changed course, leaving the field of public demand for soldier images to hacks, their entrepreneurs, and to a broadsheet tradition that added written comment or description to image: oddly, it may seem, for products aimed quite far down the literature market, but perhaps explained by the appeal of a double visual value for money as well as by a continuity with earlier image-plus-text broadsheets of saints, monsters, portents and astrological forecasts.

The interest of the history of an image does not, after all, run out when its quality diminishes. It shifts its ground. The series-prints put on by Meldemann and others were not, with the word's connotation of high quality and committed attention, 'Art'; nor can they easily be typed as 'Illustration', for they are not sufficiently careful and exact records. Their interest lies in the falling between these two stools. They constitute among the plethora of contemporary politico-religious news-sheets, the most remarkably coherent body of pictorial journalism: topical, informative and, with their hurriedly versified captions, editorializing.

The first, and worst, of these series was the 10-sheet one drawn by Niklas Stoer for Hans Guldemunde in 1529–30[47] to coincide with the Turkish campaign against Vienna. Reflecting the Free City of Nuremberg's sense that pressure on the Habsburg homeland was not altogether against its own interests, its mood, graphically and verbally, is far from hysterical, though it is rounded off with obligatory scenes of parents, virgin daughters and children being drawn away to captivity (Fig. 103). Stoer's next series, (12 sheets printed by Meldemann) of the late 1530s,[48] was somewhat more carefully executed, and catered for an audience intrigued by the home product: the ranks and functions of members of Landsknecht companies, and of the tradesmen and women they absorbed to cater for their needs.

Meanwhile, more elaborate was another Meldemann project, the long series – 27 sheets – designed by Stoer's fellow Nuremberger, Erhard Schoen, and published separately between c.1530 and c.1536.[49] While not representative of a highly competent, if not distinguished, artist at his best, this was a notable gratification of interest in the composition and life-style of Landsknecht units and greatly extended the range of military categories within which 'art', with its concentration on standard bearer, halberdier, pikeman, arquebusier and drummer and fifer, had confined itself.

Now we have the *Brandtmeister*, the official deputed to set fire to recalcitrant houses and villages; the armoured double-pay man who bore the brunt of an attack; the provost, or military judge; the field surgeon (Fig. 104); the servant-scavenger; the commissary-accountant; the female camp-follower as wife, mistress, minister-at-large to a wide range of male needs; the quartermaster; foreigners, from Switzerland to Bohemia, who gained acceptance among the Landsknecht ranks; artillerymen. In pictorial popularizing terms we are en route to the densely written descriptions of military organizations by Leonhart Fronsperger (the *Fünf Bücher von Kriegsregiment und Ordnung* of 1555) and the comparable *Acht Bücher . . .*, 1559, of Reinhart von Solms.

A set of ten full-sheet single figures followed at intervals between c.1523 and c.1540, designed by Hans Sebald Beham and published some by Meldemann, others by Guldemund.[50] Several of the categories of service represented were among those selected by Schoen. Others were not: the *Wachmayster* (responsible for the alertness of the watch at night), the *Prabantmaister* or quartermaster, for instance (Fig. 105).

With their bold unsubtle large-scale design and doggerel verse (not always present), these series round off our narrative survey of the image of the soldier. The

editorial policy which encouraged their production, the relationship between artist and writer and, a recurrent puzzle, their price and the numbers in which they were bought, remain uncertain. Their influence can be traced through both separate woodcuts and book illustrations in the 1550s and 1560s, and they are not far below the surface of the military subjects offered in Jost Amman's book of models for aspiring artists and illustrators in his 1578 *Kunstbüchlein*. But, repeatedly reworked, they lost even the semblance of life that the journalistic series had sucked from their independent, more closely visually involved, forebears.

For an image to last so long, there must be causes which belong to the market, operating outside or alongside the artist's personal concern for it. Later, we shall try to judge what these were. For the moment we may look at two sources of appeal common to both audience and artist, one visual – the soldier's costume – the other social, the soldier's otherness from the communities within which works of art were produced and bought.

Master craftsmen, even their apprentices and journeymen, had holiday finery of a sort; even peasants did. And artists could show them either – as in the Mendelsche Housebook[51] – at the workbench or in festival guise. But no other had such a pictorially provocative style of dress as the soldier's, or lived so far outside the familiar routines of street, shop, market and farm life.

In the mid-fifteenth century the sumptuary laws of Swiss and German cities emphasized the connection between costume, role and status. They were detailed, and had to be; through a loophole, in 1468 an angry dispute arose between the journeymen tailors and the journeymen bakers and shoemakers of Frankfurt am Main as to who was allowed to wear 'divided', i.e. one black and one white, shoes.[52] The laws also demonstrated the equation between appearance and morality, forbidding the proud display of luxury unsuited to a man's rank; penalizing bodies which revealed too liberally the tops of the breasts and the short doublets and coloured jutting flies that drew attention to male genitals; fining the wearers of those shoes with such long points that they ridiculed the honest trudge of the working day. And this legislation became all the more detailed (and unenforceable on any regular basis) because of the pace of changes in fashion as, fostered by increasing prosperity, costume became rapidly de-gothicized and various. By the early sixteenth century an interest in what people of different stations and from different places wore, evinced for instance by Dürer in his costume drawings, was at its height, and no other costume was regularly portrayed with such care and glee as the deliberately provocative and rakish garb of the soldier.

There were, save occasionally at the whim of a rich company captain, no uniforms. Men fought in their civilian clothes. As Machiavelli approvingly noted, armour was little used. It had to be paid for by the individual. It inhibited movement. By around 1500, while breastplates were worn by the double-pay front-rankers and colour guards, most infantry fought unprotected, discarding even helmets apart from a leather cap lining the feathered head-dress frequently worn. Identity in action was established by the company and civic standards, the recognition of faces (unobscured by the closed helmets used by the cavalry) and by devices: a coloured scarf or armband or a national emblem: the Swiss St George's cross, the Burgundian St Andrew's cross adopted by Maximilian for the Empire as a whole and used by the Landsknechts raised under his direction.

These emblems were probably applied to the costume before *c.*1500 and then slit (and presumably hemmed to prevent tearing) into doublet and hose. The St George's cross appears on soldiers' costumes from at least the Tschachtlan illuminations of 1470. It is legitimate to see its employment thereafter as at times an artist's device to identify his subject rather than as something actually worn. The point of many of Urs Graf's drawings would be missed if those looking at them could not – in those of satirical or polemical intent – tell the difference from otherwise identical Reisläufer and Landsknecht. No clothing has survived. Many of the works

105. Hans Sebald Beham, *Quartermaster of a Landsknecht Company*. Woodcut, *c.*1540.

106. Georg Lemberger, *Three Landsknechts.* Woodcut, 1515.

we have seen do not show the crosses. On the other hand, the St Andrew's cross is etched into the field armour made by Konrad Seusenhofer for Maximilian shortly after 1500,[53] and some of the most serious and 'objective' studies (including, for example, Urs Graf's engraving of 1523), show one or other of the devices. The balance of probability is that they were used, if not as frequently, or in as many places (hose and shirt-sleeves and, rarely, codpieces as well as doublets), as the pictorial record suggests.

It was not, in any case, the emblem that caused the dress of soldiers to stand out from the costume of civilians. It was the combination of extravagant stylishness with defiant sloppiness. With no undress uniform to single them out from the civilian crowd, on leave, their special status as peril-facing, reckless-living individuals could only be visually differentiated from such similarly poorly paid folk as armed servants, peasants on holiday outings or snug home guards by purloining what was worn by others, and exaggerating or deforming it.

Georg Lemberger's spirited woodcut of 1515 (Fig. 106) sums up the chief features of what, during the previous ten years, had come to be the standard costume of soldiers whether German, as in this case, or Swiss: the ostrich feathers (where, in their hundreds of thousands, did they come from?), the tiered ribbon-sleeves, the trapdoor codpiece (for quick wayside release; Lemberger does not stress the sexual swagger of the soldier), the slashed trews, the defiantly picturesque disintegration of respectable leg-wear. He adds the 'greetings' gesture which, from Cranach in 1505, artists had associated with the free life of the soldier; and the air of absorbed but devil-may-care camaraderie as they walk along also draws on a short but already rich pictorial tradition. The woodcut neatly represents the conjunction between observation and manipulation which was accelerated by artists' interest in what soldiers looked like, what they wore.

Today, surrounded by the preening definition of out-groups through the wearing of cast-off finery and the patching and ripping of 'square' clothing, we can sense the mood in which the Reisläufer-Landsknecht costume was adopted, and the sumptuary rule-breaking fantasy (and pathos) that attracted the attention of artists. Maximilian, conscious as a war leader of the breadline level of soldiers' pay, exempted them in 1503 from the sumptuary laws.[54] In response, soldiers took sartorial quirkiness as compensation for meagre wages into their own hands. By 1532 the conservative satirist Hans Sachs was complaining that the non-militant youth culture of his day was getting away with a copying of soldier's defiant parody of decent apparel.[55]

In spite of suggestions that earlier sixteenth-century civilian costume aped that of soldiers,[56] this is both inherently unlikely and unsupported by the visual evidence. From the 1480s Swiss soldiers are shown in picture chronicles aping the feathered *panache*, the helm-plume of the knights they had defeated in the Burgundian wars. Ostrich feathers were an old battle and tournament helm decoration, and a badge of court service. That Hermann VIII of Henneberg was sculpted on his superb funerary monument of c.1507 by Hermann Vischer wearing the *panache*,[57] that Martin Schaffner of Ulm should show, in a painted epitaph of 1514,[58] a patrician with a feathered bonnet, or that the Emperor Charles V should reward the military service in 1530 of another patrician, this time of Nuremberg, with an addition to his heraldic arms and the gift of a ceremonial sword and a velvet beret with ostrich plumes,[59] hardly suggests a borrowing from the sartorial repertoire of the common soldiery.

The same point – and it is made because the 'Landsknecht' costume has aroused controversy that echoes the fascination it held for contemporary artists – applies to the soldier's codpiece, denounced in civilian costume well before the development of the soldier image and shown conspicuously in aristocratic portraiture and armours well into the 1540s.

Less easy to decide is civilian or military precedence for the fashion for slashed

clothing – slits in doublets and in separate sleeves and upper hose, or trews, through which a contrasting lining was pulled or simply revealed, giving a puffed or see-through effect.

It has been suggested that slashes arose from soldiers' not repairing cuts and tears received in combat, for motives of economy and bravado. But while artists did show tears in clothing that was out at elbow or knee through long use, slashes when they appear in soldiers' costume from *c.*1505 are clearly tailored for effect. By then patrician and aristocratic taste had responded warmly to north Italian slashed fashion, as it did to the shape of Italian armours. Slashing, or appliqué work designed to look like slashing, appears in sketches of costumes for the Nuremberg Schembart festival from 1503.[60] By 1514 Cranach portrayed Duke Henry the Pious of Saxony in a costume entirely composed of slashes;[61] two years later Holbein shows pupils wearing them in the signboard he painted for a schoolmaster.[62] Once again, it seems unlikely that court and petit-bourgeois circles should have taken up, at considerable expense in tailoring, a style invented by the military rank and file. This does not rule out the possibility that once established amongst Landsknechts the slashed style did not add, by association, a martial whiff to the civilian model. Duke Henry, after all, is clearly prepared to draw his sword; and his hound, juxtaposed with the tiny lapdog in the companion portrait of his wife, may stand as much for war as the hunt. That the astonishing *Kostümharnisch* made by Kolman Helmschmied in 1523–4[63] for Wilhelm, Freiherr zu Roggendorf is 'slashed' all over at a time by which civilian observance of the fashion was becoming more subdued, may be accounted for by Wilhelm's career as a commander of Landsknecht companies. What is clear is that having adopted the fashion soldiers hung on to it well after it had dropped from favour, under the influence of Spanish and Protestant sobriety, among civilians; retaining it until adopting from the mid-century the baggy 'Turkish' knickerbockers – to which they also added slashes and ribbons.

For while soldiers adopted – as they also did with particoloured hose – items of civilian costume which were in colour, cut and display the most flauntingly above their wage-earner status, they made the ensemble very much their own through exaggeration and distortion, evolving what was to all intents and purposes a recognizable uniform.

As early as 1503 Valerius Anshelm of Berne castigated them for standing out so conspicuously among civilians, criticizing in particular the ostentation of their ostrich feathers.[64] Even Urs Graf thought that military dandyism could go too far, and his 1523 drawing caricaturing a Reisläufer showed him sprouting feathers all over (Fig. 108). The discrepancy between costume and trade was, however, undoubtedly one reason for the continuing interest in the figure of the soldier, leading to such fashion plates of what the well-dressed infantryman was wearing as Daniel Hopfer's etchings of?*c.*1530[65] showing two familiar groups: halberdier, arquebusier and pikeman, and, in the second (Fig. 109), captain, fifer and drummer, standard bearer and halberdier. These are soldiers in cleaned-up finery, and they hint, as does Peter Flötner's dandified Steffan Goldschmidt, who confesses in the caption that his motive in enlisting is to better his wardrobe, now that the heroic days of brazen tatters are over (Fig. 107).[66]

There was, of course, some interplay between the actual and the artist's soldier.[67] The social cross-dressing was adopted at least in part to veil ignominious origins: Swiss soldiers, the majority of whom were pastoralists taking advantage of womenfolk tending their cows while they were on campaign, resented the contemptuous nicknames – 'cowmilker', 'cow tail' – thrown at them, and dressed to rebut it.[68] Though Swiss and German companies contained craftsmen, burghers and men of aristocratic or patrician birth, the majority were peasants and unemployed or marginally employed urban dwellers: and there were, as always, those misfits who, like Urs Graf, chafed at the restrictions of law-abiding civic life.

Soldiers, therefore, presented the image, consciously, of an outsider class: necess-

107. Peter Flötner, *Steffan Goldschmidt*. Woodcut, *c.*1535.

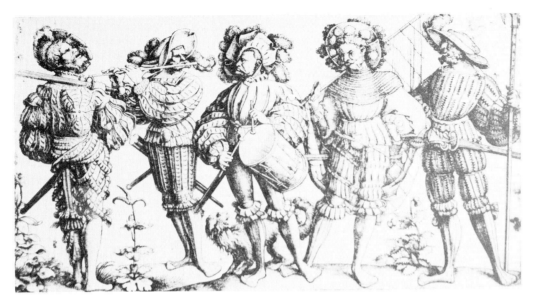

108. Urs Graf, *Be-feathered Reisläufer*. Drawing, 1523. Basle, Kunstmuseum, Kupferstich-kabinett.

109. Daniel Hopfer, *Five Landsknechts*. Etching, ?c.1530.

ary, but at the same time licentious and scary. It was the essence of their outsider-hood that prompted the wealth of allegorical and moralizing scenes we have looked at. It also to some extent affected the way artists saw – or, rather, drew – the soldier: the proud sleaziness, the erectile codpiece or fly-flap, the arrogant stride, the cheery conversability of near-outlaws nonchalantly, almost unethically at ease.

The northern model for the outsider was the Wild Man,[69] the mythical, hairy denizen of glades whose illegal hunts, sylvan festivities and lawless matings had long possessed the romantic imagination of the north, and whose sudden jumpings out into the paths of wayfarers is captured from a long tapestry tradition (Fig. 111) and a more recent one of bronze statuettes, in the extrovert greetings gesture used in delineations of soldiers from the 1490s.

In his works of around 1509, Ulrich von Hutten, primarily a scholar in the vein of Christian Humanism but also, for a reluctant while, a soldier, saw in the *Germania* of Tacitus the picture of a free, natural, courageous albeit primitive way of German life that countered Italian claims to base national superiority on urbanized cultural sophistication.[70] The vision can be seen to be all the more telling because Italians were to become increasingly concerned, as they lost territory, battle after battle, to the 'barbarians', lest they had become enervatingly overcivilized. But the connection between Wild Men and soldiers had been made at least from the c.1450 infantry *Setz-Tartsche* (the shield fixed in the ground to protect an archer or cross-bowman while he reloaded) on which was painted a Wild Man supporting the arms of Daggendorf, and, in a more upmarket context, from the Wild Man holding up his standard on the tomb of the knight Ulrich Busch, who died in 1458, in Vilsheim.[71] By 1480 or thereabouts the Wild Man and his weapon (represented always as a club, to reinforce his abstention from the civilized foundries which produced weapons of iron and steel) was linked to amorous scenes whether associated with 'natural' sex, an embracing semi-nude couple for example, or 'bad' sex, Delilah emasculating Samson. Thereafter the imagery cascades onwards, either in the form of shield supporters, or as images on their own, or, as in an anonymous Basle window design of c.1510, representing a society vigilant, swiping at intruders, protective of their naked women and their broods (Fig. 112). It is not surprising that among the earlier 'named' soldiers in single-sheet woodcuts with texts is a figure – attributed insecurely to the Master of the Miracles of Mariazell and dated c.1520 – emerging from a wood (Fig. 110),[72] feathered, slashed, jutting of codpiece and mismatched of hose and shouldering a pike, who proclaims

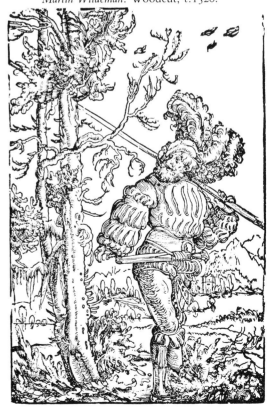

110. Master of the Miracles of Mariazell (attrib.), *Martin Wildeman*. Woodcut, c.1520.

111. *Wild Folk in the Forest*. Tapestry, early 15th century (detail). Regensburg, Museum.

My name is Martin Wildeman
Well known to all fighting men.
I have fought in every land
And have never fled the foe.

The image of the northern soldier, finally, owed much to the tumbling from its pedestal of that of the cavalryman knight as the characteristic representative of the military profession. Instead of being confined to commemorating the deeds and values of knights whom town-based artists had little opportunity to know personally and whose status – as natural predators on townsmen – they could only formulaically identify with, artists could now record their reactions to the infantry, drawn from a more familiar level of society, and whose growing tactical importance coincided with the development of the techniques of draughtsmanship and printmaking.

The days of the cavalry were not over, though its role diminished. And throughout the fifteenth century and somewhat beyond, the appeal of chivalric themes, the tournament, the tenderness of courtly love, the love garden, remained strong, reflected, however, more in engravings than in the cheaper woodcuts. Artists, Dürer and Burgkmair among them, made studies of cavalry armour in connection

112. Anon. Basle artist, *Design for Heraldic Window with Wild Men* (detail). Drawing, c.1510.

with current or future commissions for parade armours or portraits. The possession of a war charger and a full suit of armour remained a badge of caste. But from the posthumous painted portrait of Georg von Frundsberg (d.1528)[73] and the later woodcut ones of such warrior princes as the Elector John Frederick of Saxony (shown as the Champion of Protestantism),[74] the showing of the cavalryman's acceptance of an infantry role reflects an age in which knights trod the ground along with peasant and journeymen recruits. But though the knight came, as it were, to step down, this did not reinstate his image as war's representative. Commoner soldiers were found more intriguing for social as well as aesthetic reasons, and their appeal gained something from a declining respect for the knightly class as a whole.

Representations of tournaments suggest that this may have been the case. Maximilian himself, both 'the father of the Landsknechts' and 'the last of the knights', while encouraging his artists to be up to date in stressing the predominant role of the infantry in his campaigns, was also an aficionado of the tournament. *Weisskunig* illustrates him learning about its rudiments with the aid of models (some of which, not necessarily his own, survive).[75] This alone suggests the shift of emphasis from taken-for-granted practice to home study for special occasions. The heyday of tournaments as part of the routine of aristocratic life in southern Germany was, indeed, petering out in the 1490s, its glamour being perpetuated in *Fechtbücher* (tournament books) rather than in practice. Yet at the same time horsed mock combats – an admixture of the tournament with the mêlée – were becoming popular, as they were in Italian republican cities, Florence and Venice, as part of the late infection of prosperous urban patriciates with pretensions derived from feudal-chivalric manners.

To judge from representations of them, Cranach's free-for-all of 1506,[76] Schäufelein's more orderly *Tournament* coloured drawing,[77] and Erhard Altdorfer's impracticably decorative woodcut scenes of horsed tumults (Fig. 113),[78] they were not, by these artists, taken with much seriousness. They are shown as civic amusements to which attention is due but in no respectful manner. Spectators loungingly watch, or turn away to chat. Windows overlooking the scene are crammed, but

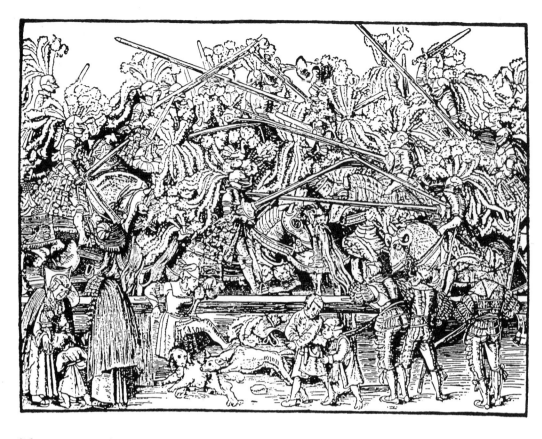

113. Erhard Altdorfer, *Tournament*. Woodcut, 1512.

114. Albrecht Altdorfer, *Knight Confronted by a Landsknecht in a Forest*. Coloured drawing, 1512.

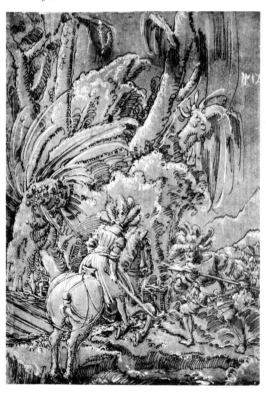

life goes on. Shops do not close. Conversations are not interrupted. Infantrymen quietly watch the antics of the men, features of whose costume – save for the all-enclosing armour – they have themselves adopted. The atmosphere is indulgent rather than respectful. If their betters wish to play quite entertaining knightly games, why not? Jousting, too, went on. On the side tower of the Katzungshaus in Innsbruck, a few minutes away from the Landsknecht murals of Maximilian's *Goldenes Dachl*, are relief carvings of *c*.1530 of horsemen charging at one another with elaborately blunted weapons. Servants help their masters into the saddle, pick up dropped weapons. It is not a war game but a prestigious sport.

A vein of visual parody marked the waning of public respect for the knightly class. Jokes at the expense of the tournament had occurred at the foot of the pages of medieval illuminated manuscripts: but, designed for the perusal of the few, this was equivalent to court-jester's licence. Printing took mockery into the public domain. It started with the engraving of *c*.1475–80 by the Housebook Master – himself leading an imaginative life divided between chivalric court and down-to-earth military technology – of a tourney, witnessed only by an enthusiastic dog, between two elaborately becurlicued Wild Men;[79] it is a work surely seen by the Urs Graf of the befeathered Reisläufer. We are still near to medieval jester fun here. But there is surely more than a spirit of collusive gibe in Burgkmair's drawing of a *Peasant Jouster*,[80] satirical of social pretension as part of its motivation may have been. And are Dürer's 'collapse of both parties' woodcuts for Maximilian's *Freydal* bereft of irony? Is no more than the universality of Folly implied in Erhard Schoen's drawing (1527)[81] of a jousting knight waved forward by a fool carrying an umpire's baton or Jörg Breu's drawing (Fig. 115) of a joust where the umpires wear fools' caps?

The prowess of the infantry was established both in the Swiss campaigns against Burgundy and in Maximilian's in the Netherlands, where he had to fight city-raised armies to establish his claim after his marriage to Duke Charles the Bold of Bur-

115. Jörg Breu, *The Jesters' Joust*. Coloured drawing, ?c.1530. Berlin-Dahlem.

116. Peter Flötner, *Allegory of Tyranny*. Woodcut, 1525.

117. Anon., *Allegory of the Christian Knight's Ascent to Heaven*. Woodcut, ?c.1540.

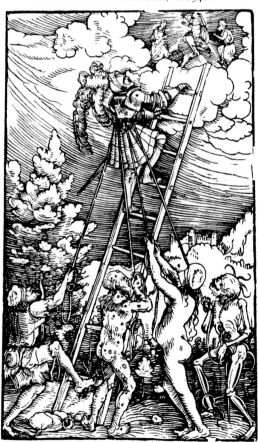

gundy's daughter Mary in 1477. It was during this time that the economically pinched landed aristocracies of Switzerland and Germany increasingly took on, in the eyes of their urban competitors, the image of the robber baron. Altdorfer's 1512 drawing (Fig. 114) of a halberdier defying a knight in a forest – both, it may be noted, plumed and slashed – illustrates and illuminates a fact of life. The woodcut of *c*.1519–20 by The Petrarch Master (Hans Weiditz)[82] which shows a knight trying to reason his way out of a confrontation with armed peasants, leads naturally to Peter Flötner's allegorical illustration (Fig. 116)[83] to Hans Sach's denunciatory poem, by portraying the knight (with Usury clinging to his crupper) as *Tyran*, the enemy of charity, reason and the law both of man and of God.

So while members of the caste continued to serve as heavily armoured men-at-arms, or as commanders of light cavalry or bands of infantry, and had themselves commemorated in full panoply on tombs and in church windows, in the more popular arts, when the knight was not criticized he was allusively turned into a symbol of the selfless service of God. Thanks to the confluence of the ideas of Erasmus's popular 1504 *Enchiridion Militis Christiani* with Maximilian's self-promotion as Europe's premier Christian Knight, Hans Burgkmair's two-toned woodcuts could record the Emperor and St George as mirror images of one another.[84] It has been surmised that it was the *Enchiridion* that prompted Dürer to set his engraved knight pacing past the devil and death, secure in the passport of his faith.[85] Protestantized, the image of the wayfaring, warfaring soul was taken up in increasingly allegorical terms, as it was in the woodcut illustration (Fig. 117) showing the Christian Knight's ascent of the ladder to heaven hampered by ropes tugged by poverty, sickness, lust and death. With the representatives of the Second Estate removed in these ways from the human-interest aspect of the graphic arts, the field had been cleared for a scrutiny of the way of life of the footsoldier, and the social and moral world that he inhabited.

CHAPTER 3
Italy: Soldiers and Soldiering

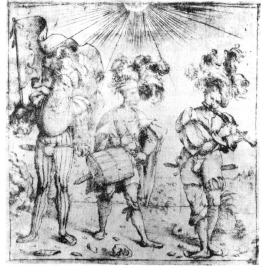

W E HAVE SEEN that many of the outstanding artists of the northern Renaissance took time off from their major commissions to contribute to the figure of the infantry soldier, and to the genre that brought him to life and used him as the focus for a variety of moral and social points of view. With artistic genius and endemic warfare common both to the Germanic lands and to Italy, it may have seemed artificial to have stayed for so long north of the Alps. But no degree of comparative cross-cutting between zones could have done much to enrich the subject. Indeed, to move from north to south is like leaving a vividly crowded street for a nearly empty room.

We are not to expect that in the Italian peninsula, any more than in Germany, the figure of the ordinary infantry soldier would be made the self-sufficient subject of a major commissioned work of art, a painting or a large sculpture. Its province, as we have seen, was chiefly among the graphic arts. For Italy these have been explored with a unique intensity. And what is found there, or, rather, what is not found, is so startlingly at odds with the wealth of relevant Germanic material as to call for the explanation essayed in the following chapters.

In the first place, only one print, the engraving of c.1510–20 (Fig. 118) attributed to Martino da Udine[1] shows contemporary soldiers. Here is that familiar northern trio, standard bearer, drummer and fifer. Only the pose of the fifer, and the curved sword he wears and the buildings on the horizon to the right suggest an Italian origin. Certainly it is not a work of indigenous inspiration. That, though again sparsely, was represented either by the hero of a popular romance like the anonymous *Guerino dit Meschi[no]* engraving[2] of the late fifteenth century (there were Venetian editions in 1493, 1508 and 1522 of *El libro de Guerino chiamato Meschio*, each with a different woodcut of a figure in plate armour[3] which appears to be taken almost verbatim, though in reverse, from a Pinturicchio drawing of a group of men in armour);[4] or by academic images of Roman soldiers. Benedetto Montagna's *Kneeling Warrior* engraving, with its air of giving permanence to a detail from a larger composition which would explain the pose (Fig. 119), suggests that he felt that there was an audience for images of ancient soldiers, however inconsequential. And a similar assumption informs the more artifically self-contained images of Marcantonio Raimondi's nude Roman *Standard Bearer* of c.1516,[5] and Agostino Veneziano's 1517 *Roman Soldier Dressing for Combat*.[6] In both cases their purchasers were invited not only to consider the past rather than the present but to see the figures in the light of art – in the first case that of Raphael, in the second that of Michelangelo – rather than war. These, too, were engravings. No woodcut suggested an interest in contemporary soldiers lower down the print market. Neither did 'popular' ceramic imagery; it Romanized or prettified the images of soldiers. Bertoldo's small bronze *Shieldbearer* of c.1470–5[7] blended imported Wild Man lore which was popular in the court entertainments of northern Italy, with the resonance of the feats of Hercules. But it was the mythical, antique resonance that became the norm in Italian cabinet sculpture.

118. Martino da Udine (attrib.), *Three Soldiers*. Engraving, c.1510–20.

119. Benedetto Montagna, *Kneeling Soldier*. Engraving, c.1510–20.

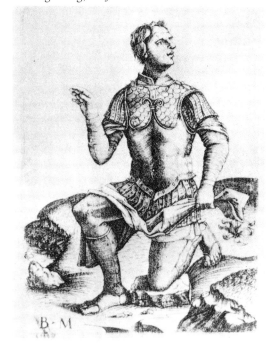

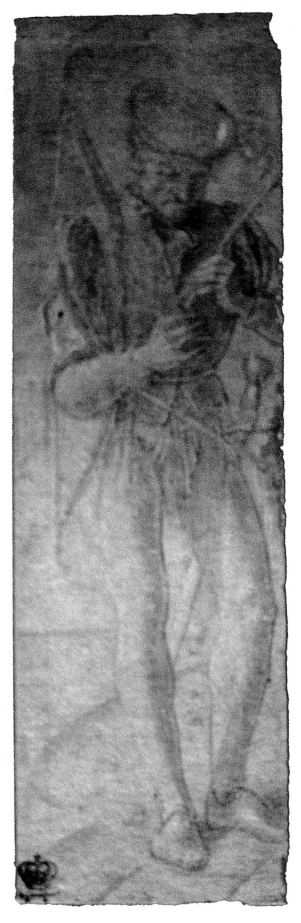

And though more Italian than Germanic drawings survive, none – and this is a key cultural difference because the initiative lay in the hands of artists rather than in the purses of patrons – shows a soldier for his own sake rather than as a detail study for a painting.

Perhaps there is one exception, the drawing of *A Bowman* in the Hermitage,[8] which has been attributed to Uccello but not associated with any of his works (Fig. 120). Clearly a study from the life, it shows, in pen and brown wash heightened with white on pink prepared paper, a fairly elderly man (no other Italian preparatory work for a larger composition shows a contemporary soldier as other than young) looking down in close concentration as he tests the points of two arrows for the bow he holds clamped under his right forearm. He wears a loose shirt under a stiff, sleeveless doublet, the front of the shirt hanging down to cover his genitals. His legs are bare above comfortably fitting shoes. On his head is a flat cap; a sword of unremarkable shape hangs on his left side. Though the whole range of the artist's paintings has not survived, including battle pieces lost since Vasari praised them for the 'armed men wearing the beautiful costumes of those days', it is unlikely that this sombre, preoccupied and unromanticized figure was destined for a use beyond the gratification of a half-hour's intense interest on the part of the artist. In itself, this justifies our having lingered with it.

The few other drawings of soldiers are either life sketches for paintings destined to be edited into the 'timeless' or classicized garb considered suitable in the quattrocento for religious scenes, like Ercole de' Roberti's for a lost *Betrayal of Christ* (Fig. 121), or, later, are clearly, whatever their purpose, not independent works.[9] Neither, surely, for all the degree of finish given to it, is Lotto's posing *Pikeman*,[10] nor the anonymous *Standard Bearer and Drummer with a Pet Monkey* in the Uffizi (Fig. 122), whose function is the least clear of all the works in this group.

What they have in common (apart from the Martino da Udine print) is not only the sense that the figure of the contemporary soldier was not a subject for an independent work of art fit to leave the workshop, but (with the exception of the Uccello drawing) a shared origin in northern Italy, the area most receptive to the fallout from German secular graphic production. When reviewing the depiction of soldiers in Italian religious art we shall see that it was above all north of the Po that antique or 'timeless' figures gave way to contemporary ones. So it is unsurprising that the only Italian echo (an oblique one, it is true) of the façade paintings of the *Goldenes Haus* in Innsbruck is the soldier fifer (Fig. 123) from Cariani's decorative scheme for the façade of the Palazzo Roncalli in Bergamo.[11] Pontormo's so-called *Halberdier*[12] is *hors de concours* in this connection, being clearly a commissioned portrait of a rich young man who chose to be shown as a member of the Florentine ducal guard if it is not, as has recently been claimed, a portrait of Cosimo himself, which seems unlikely. But Dosso Dossi's clumsy *Standard Bearer* of *c.*1519,[13] though as a painting presumably a portrait, may well reflect an interest in the swagger and resolution of Germanic graphic images that was certainly evinced by the artist (and his brother-assistant, Battista) and was perhaps shared by the patron. It is not inconceivable that in Tintoretto's assumed *Self-Portrait as St George* of *c.*1546–8,[14] his decision to hold a standard rather than a lance, though the dragon is shown emblematically beside him, is due to the influence of those German prints which had no native rivals and which, with little reinvention, were drawn on to represent the stereotype European soldier (and his familiarly burdened wife) in the 1563 Venetian edition of Enea Vico's *Omnium fere gentium nostrae aetatis habitus*.[15]

This lack of concern for the soldier figure naturally inhibited an interest in military genre. The texts of a few trecento manuscripts had – very sparingly – prompted illustrations of *Soldatenleben*. A Vatican copy of Giovanni Villani's *Chronicle* shows Frederick II's soldiers buying amulets from a stall while off duty in Rome.[16] A Neapolitan 1350–60 manuscript of the *Romance of King Meliadus* portrayed soldiers relaxing within their tents while their betters dine in an al fresco arbour.[17] And with

123. Giovanni Cariani, *Soldier Fifer*. Fresco, *c.*1531.

120. Paolo Uccello (attrib.), *A Bowman*. Drawing. Leningrad, Hermitage.

121. Ercole de' Roberti, *Betrayal of Christ*. Drawing, *c.*1480. Florence, Uffizi.

122. Anon., *Standard Bearer and Drummer with a Pet Monkey*. Drawing, ?*c.*1530. Florence, Uffizi.

124. Anon., *March of the Lucchese Infantry to Pisa*. Miniature, after 1400. Lucca, Archivio di Stato.

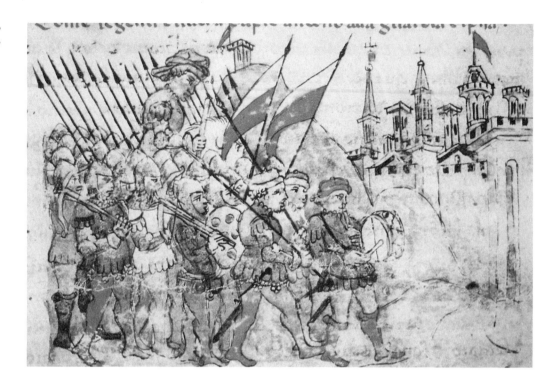

the early quattrocento manuscript of Giovanni Sercambi's *Chronicles* there was an anticipation of the naïve illustrative richness of the Swiss picture chronicles and their inclusion of genre details not directly called for by the episodes described in the text. Three generations ahead of them, the artist shows a drummer leading the Lucchese infantry towards Pisa (Fig. 124), Florentine troops illegally minting money for their pay and whiling the time away with a horse race, soldiers signing in at the recruiting table, terrorizing peasants and looting their livestock, watching from behind their pavises the execution by *mannaia* (a primitive form of guillotine) of traitors.[18] But the Sercambi manuscript was not only the first native chronicle to be lavishly illustrated but had no successor until the gauchely illustrated *Chronicle of Naples* at the very end of the century.[19]

The chief interest of the coloured drawings here is their unexpectedness. There had been no precedent for the strips that illustrated the entry of Charles VIII's army, the French and their Swiss contingents, into the city (Fig. 125). Hitherto military procession had been, as in Mantegna's *Triumph of Caesar*, reconstructions of classical ones. Some 'northern' details are present: soldiers converse with one another, a young woman rides with her protector, there are drums, fifes and standards. But there is no trace of any familiarity with Germanic graphics. The impulse is more decorative than reality seeking and the crude confidence with which some groups are recorded (like the frieze of Swiss sauntering behind their St George's cross standard), and the 'pattern' soldiers who, doll-like, reproduce themselves, in a mode echoed in later majolica dishes, across another frieze, suggest a native, popular interest in soldier images that has vanished among discarded woodcuts and broken pottery. Given the 'high' tone of the dominant cultural influence in Italy, the economic level that affected the replacement rate of commonplace objects, and the selective values of later collectors, it is not unlikely that more will be missing on the Italian side in this and subsequent chapters, than from the material adduced for a concern with contemporary military matters drawn from the north.

To return to what does remain, Italian artists, however affected by their own ideas or what they learned from conversations with patrons about what made for respectable humanistic art, did not follow the genre suggestiveness of the main

125. Anon., *The Army of Charles VIII enters Naples*. Miniature, 1495–1500. New York, Pierpont Morgan Library, Ms.801.

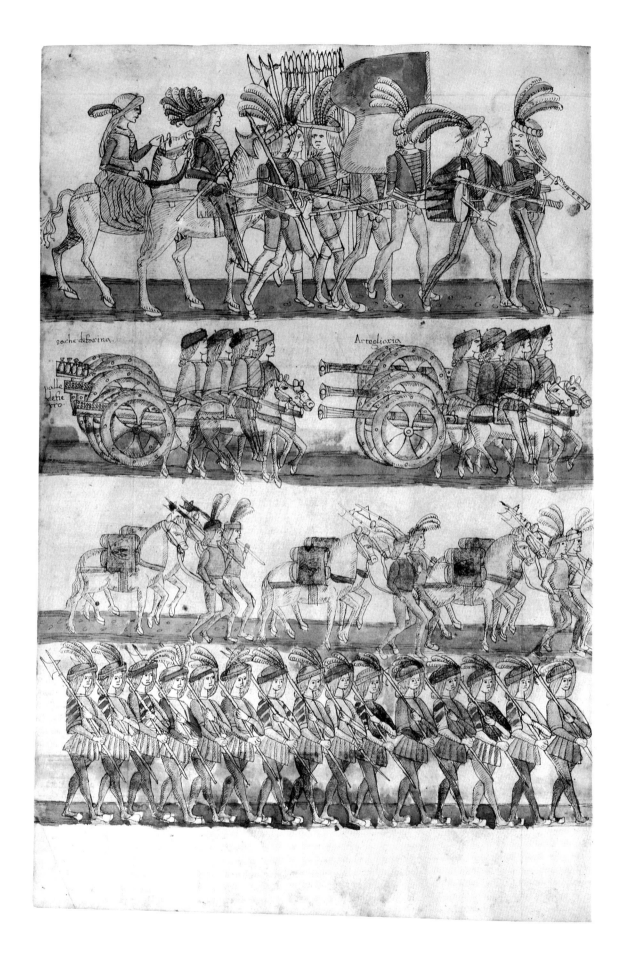

classical exemplars: the coiled frieze that creeps up Trajan's Column or the reliefs on the Arch of Septimus Severus; the baggage train, for instance, so prominent on both, held no attraction. Some artists did, however, follow up the appeal of tents and portable pavilions that was registered by medieval illuminators of all nations, together with, though to a more restrained extent, the sort of open-air military life that radiated from them.

Thus in about 1475 Paolo Santini elaborated the sparse impedimenta shown around tents in his copies of a pair of drawings (now lost) from Mariano Taccola's early fifteenth-century treatise on military machines with genre motifs:[20] military exercises for horse and foot, hunting forays, men resting and gambling, a group in civilian clothes discussing plans with a baton-holding senior officer. Though the intention of the Sienese painted *gabella* (tax record) book cover of 1479[21] is no more than to provide an *aide memoire* or souvenir of the chief historical event of that year, the capture by their Calabrian ally Duke Alfonso of the Florentine border town of Colle, it is the presence of the camp – albeit unpopulated – on the bank of the river Elsa rather than the out-of-scale troops filing through the city on the other side that gives an air of verisimilitude to the depiction. And it was tents, and the chivalrous aura they trailed with them from an earlier manuscript convention, that formed the hub of the *Camp Scene* drawing in the British Museum (Fig. 126) which has, on grounds of style and costume, been attributed to a Veronese artist of the second quarter of the fifteenth century. Brought to a high, if not complete, state of finish, the narrative is not self-explanatory, in terms of either a central episode or identifying insignia. It appears that a skirmishing party has emerged from a besieged town and is on its way back from a failed engagement; isolated horseman from its rearguard are still under infantry attack, while prisoners and horses are being led back to the commander's tent where other soldiers idly gossip, as at an action's end. There is no indication of the time of day. The action was a surprise one – the commander registers the account of it, dealt with effectively, one assumes, by his subordinates, calmly waiting while a squire secures his saboton before taking his

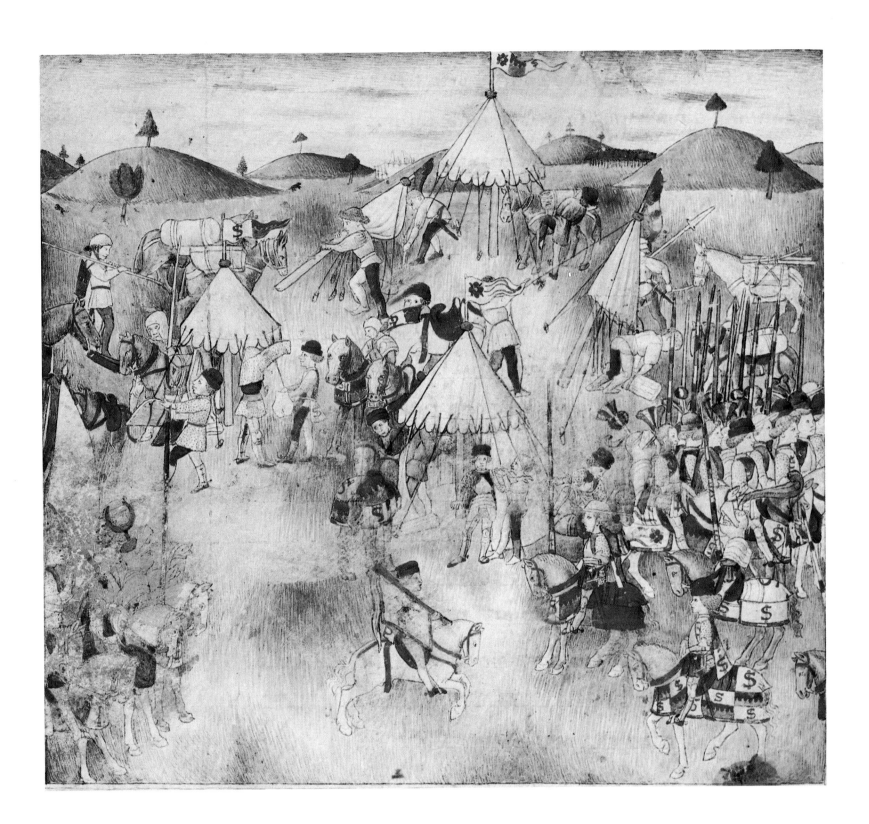

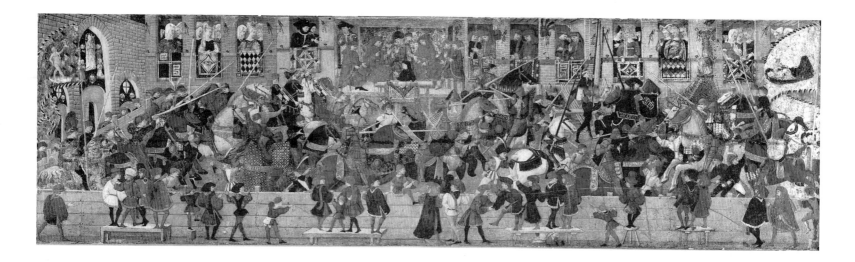

128. Master of the Jarves Cassone, *Tournament in Piazza Sta. Croce*. 1439. Yale University Art Gallery.

129. Antonio Rizzo, *A Roman Warrior*, c.1476. Venice, Palazzo Ducale.

helm from another member of his entourage. There are details still to be added; neither the ridden nor the captured horse, for instance, is harnessed.

It is a work of high accomplishment, but not done for its own sake (for it would then be without a parallel in western art), nor for a printer (it antedates the necessary reproductive techniques), nor for a large commemorative panel or fresco (the action it describes is too inconsequential and genre-like). Crying for an explicative text, it is surely a careful, but not over-wrought *modello* for an illumination.

For though the civic chronicle between Sercambi's and the Neapolitan one remained unillustrated, there was a mid-quattrocento moment in which at least one princely chronicle-eulogy was illustrated in a far from naïve manner: Basinio Basini of Parma's verse epic commemorating Sigismondo Malatesta of Rimini's 'Italian' triumphs over the 'foreign' power of Aragonese Naples. Shortly after Basinio's death in 1457, this was illustrated by Giovanni di Bartolo Bettini (Giovanni da Fano). He made three versions before 1468 which survive.[22] They tap, with great skill, the residual taste for the particularity of contemporary Burgundian illumination among a circle which liked to be reminded of the details of their accomplishments while yielding, in more formal, public works, to the increasing fashion for compositions that subordinated 'accidents' to harmoniously orchestrated, dignified and, it must have been thought, enduring summations of glorious deeds. This is not to conjecture a *locus* for the Veronese *Camp Scene* (the Carrara lords of Verona had been expelled by the Venetians as early as 1405). But given the existence of other humanistic eulogy-chronicles (for Sforza, Gonzaga and Montefeltro princes), Bettini's illustrations suggest the possibility that there was a court market for small-scale military scenes, some of which, as with popular imagery, we may have lost due to the non-completion of illustrated versions for princes whose careers were subject to abrupt changes of fortune and solvency.

Basinio's poem is the work of a professional humanist. Sigismondo has his protector gods and is even lifted to the Elysian Fields to be briefed by them. Yet Bettini's depictions of his military operations, which centre on the campaign in Florentine pay against the Neapolitan attack on the Orsini rulers of Piombino at the mid-century, submerge the protagonists in an overall, detailed and practical view of the actions. He lacks the nimble verisimilitude of the Veronese master's figures, and has an infirm sense of scale, but his grasp of overall spatial perspective and his empathy with the process of carrying out military tasks make these illuminations descriptions rather than – as in contemporary large-scale battle scenes – commemorations. The scene in which Sigismondo's army strikes camp (Fig. 127), with men busily bundling the canvas, pulling up tent pegs and lowering the centre poles before loading the waiting horses, or the interest shown in the handling of weapons

– pike, bow, arquebus as well as lance – in Sigismondo's flank attack on a Neapolitan storming party:[23] these works appear *retardataire* against the general drift of Italian aesthetic taste, which owed much to the humanistic cult of ancient values on whose fringe Basinio stood. But that they appealed to Sigismondo, the patron of Leon Battista Alberti, the arch-classicist creator of the Tempio Malatestiana, is shown by his sponsorship not only of the version in Oxford from which this illustration is taken, but by the similarly detailed ones in the manuscripts at Bologna and Paris. They represent the last gasp of what was in any case a frail plant – southern Renaissance military genre: the embracement of the experience rather than the significance of an event.

There were, of course, many contexts in which Italian artists were called on to represent soldiers: chivalrous, mythological, religious, historical. All tended to switch direct observation into their own modes of fitting pictorial discourse.

The chivalrous romance and, more interestingly, the Romance of Chivalry, retained its influence throughout this period of serious humanistic nostalgia and Machiavellian *realpolitik*. Muted eroticism and forthright armoured bloodlust were transported from late trecento Lombard illuminations not only into Pisanello's Tristan frescoes for the Marchese Lodovico Gonzaga in the ducal palace of Mantua, which offered to potential hirers of his services as condottiere an analogy of his prowess and a witness to his immersion in the chivalrous counter-culture that coexisted with humanistic values.[24] The pageant-tournaments of republican (and in this social respect neo-feudalized) Florence continued well after the picturesque confusion represented in the 1439 *Tournament cassone* front at Yale (Fig. 128),[25] a composition both steadied and mildly mocked by the spectators in the foreground. Early sixteenth-century woodcut frontispieces,[26] in books printed not only in princely Milan but in republican Venice, represent their heroes – Baudouin, Meschino, Orlando, Drusiano, Fioravante, Falconetto, Morgante and others – usually in contemporary heavy cavalryman's plate, but sometimes in Romanizing or purely make-believe guise or, as in the illustrations to the 1521 Venetian edition of Boiardo's *Orlando Inamorato*,[27] show soldiers, horse and foot, at times in contemporary at others in Roman costumes within the same covers.

The chivalrous strain did not affect the way in which contemporary infantrymen were depicted, though its emphasis on friendship and loyalty may have influenced the popularity of such knight and squire (or page) portraits as Cavazzola's misnamed *Gattamelata* with its Christian warrior overtones, or Paris Bordone's noble *Portrait of a Man in Armour with Two Pages* of c.1540.[28] Nor did the humanistic one, though from the mid-quattrocento it was practically axiomatic that the appropriate non-cavalry representative of war was a Roman soldier; and not just when in a classical setting like the soldiers guarding Michelozzo's Roman gateway to the Medici banking palace in Milan, but in images of a more generalized force, like Bramante's burstingly resolute *Warrior* (the detached fresco in the Brera) or Antonio Rizzo's large niche-figure of the late 1460s, *A Roman Warrior*, cast in the guise of the uncalendared patron saint of a city some of whose militant citizens' tombs were watched over by Roman rather than up-to-date sentinels (Fig. 129).

It may be conjectured, however, that both strains tempered artists' interest in the footslogger of here and now. A convention for rendering him emerged from the sanitized background of cassone painting: that soldiers looked like the svelte, youthful, neatly colourful figures who as privileged upper servants or young men about town populated the piazzas and street corners of secular quattrocento painting, with a polearm placed in a hand and, sometimes, a helmet on their heads.[29] This is the figure that so feebly came to mind when the inept painter of the Hermitage *Magnanimity of Alexander* (Fig. 130) imagined the scene in up-to-date terms. It sways across the foreground of the influential Florentine *Children of Mars* engraving of c.1464–5[30] as they unconvincingly brutalize the peasantry. It characterized the earliest (last quarter of the fifteenth century) infantryman to walk across a majolica

130. Anon., *The Magnanimity of Alexander*. 2nd half of the fifteenth century. Leningrad, Hermitage.

131. *Infantryman with Shield*. Majolica (Deruta) plate, last quarter of fifteenth century. London, British Museum.

132. Anon. Sienese, *Battle Scene* (detail), late fifteenth century. Florence, Accademia.

133. Anon. (Paduan), *A Man taken Prisoner by Two Soldiers*. Drawing, 3rd quarter of fifteenth century. London, British Museum.

dish (Fig. 131).[31] It is the characteristic soldier type in the several military scenes in the Bible illuminated in 1476–8 for that hardened campaigner the condottiere Duke Federico of Urbino.[32] It populates the combat scenes in a late-fifteenth-century Sienese panel in the Florentine Accademia (Fig. 132), and such thin, natty soldiers take part in Carpaccio's *Massacre of St Ursula's Companions* of 1493.[33]

The direct depiction of professional combat soldiers was further slanted by showing them in the guise of the less disturbing and more conventionally clad domestic police forces. Though the subject of a late-fifteenth-century Paduan drawing in the British Museum has been identified as *A Man taken Prisoner by Two Soldiers* (Fig. 133), he is a malefactor who has been arrested by those mounted (the spurs on the figure on the left) *bande di campagna* who were responsible for law and order, and especially for the detection of *banditi*, those exiled for crimes from Venetian territory. The so-called 'soldiers' in the woodcut in the 1521 edition of the comedy *La Calandria* by Bernardo Dovizi (Il Bibbiena)[34] which shows the point in the plot when it is necessary for Calandro to be smuggled out of trouble in a coffin, are, as the text makes clear, *sbirri di dogana*, customs officers. Similarly, the 'soldiers' in the 1498 *Biccherna* cover attributed to Giacomo Pacchiarotti[35] are members of the municipal guard escorting the Sienese magistrates to meet an embassy from Louis XII. If Raphael's depiction of the papal Swiss guard in his *Mass of Bolsena* fresco is to be trusted, personal or civic guards were not dressed for the field but for the ante-rooms of authority. In appearance they resembled those personal attendants who, as in the quayside scenes of Carpaccio's St Ursula cycle, were granted permission to bear arms as a concession to important visitors to Venice, or, in their masters' homes, were dressed as is the kneeling valet on the left of the 1511 fresco attributed to Francesco Vecellio in the Scoletta at Padua, *The Finding of the Miser's Heart*.

For reasons that we shall consider later,[36] we are hardly to expect to find between the mid-quattrocento and the mid-cinquecento studies as close to the actual observation of costume, stance and the muscular balance of soldiers fighting on horse and foot as in the later fourteenth-century Paduan sheet of drawings from the workshop of Altichiero,[37] which were presumably done when the Master was working towards his wonderful frescoed war piece, the *Battle of Clavijo* for the Santo.[38] And it does not follow, later, that an acute interest in the technology of weapons – often shown in scenes of the martyrdom of St Sebastian, for instance, which could be studied in the workshop – went with a parallel interest in the men who wielded them.

Yet in certain paintings believable contemporary soldiers appear. As a rough rule of thumb, the more peripheral to the main subject, and the less aesthetically serious the artist, the more likely it is that we shall glimpse them. And in no case do they suggest the degree of interest that in the north led artists to isolate them as individuals and dwell on the circumstances of their lives. Infantry probably did look like the little figures with which Uccello, from memory rather than from study, peopled the backgrounds to the *San Romano* panels in the London National Gallery and the Uffizi. In an anonymous cassone panel in the Cà d'Oro of the mid-quattrocento depicting *The Victory of Alexander and the Construction of the City of Alexandria*, (Fig. 134) an infantry member of the victor's 'lance' (the scene is envisaged in contemporary terms) is armed with a pike and sword. Over a white shirt he wears a grey doublet with puffed and slashed sleeves, red and grey with the shirt showing through. His hose, one leg red the other white, are drawn up over his thighs to reveal the V of his breeches. He wears a helmet designed to protect the neck and cheeks. The pointed shoes do not ring true to the needs of a soldier who fought on foot, but all the same this is a credible figure. So are those in the band of pikeman in the little frieze escorting their Hungarian(?) captain along the outskirts of Ferrara in the lower band of Francesco del Cossa's *c.*1470 *June* fresco in the Palazzo di Schifanoia.[39] Perhaps the most convincing of all these examples, the halberdier in the troop leaving Calvary in Andrea Previtali's *Crucifixion and Lamentation* of *c.*1520 in the Venetian

134. Anon., *The Victory of Alexander and the Construction of the City of Alexandria*, mid.-fifteenth century. Venice, Cà d'Oro.

135. Andrea Previtali, *Crucifixion and Lamentation* c.1520. Venice, Accademia.

136. Giovanni Cariani, *The Way to Calvary* (detail), ?c.1520. Milan, Ambrosiana.

Accademia (Fig. 135), rings true to a presumed reality which cannot, alas, be checked from documents; these give details about many aspects of a soldier's armament and terms of employment, but leave his costume to common knowledge: that is, what he arrived in at the point of recruitment plus what he was given, or adopted from the mores of his new confraternity when he could afford it.

The documentary evidence for the costume of Germanic soldiers, while equally slim, is at least compensated for by the sheer volume of images; these cannot have struck their purchasers as falling too short of the mark, especially as some were supplied by serving artists. And the comments of moralists support a belief that we do know fairly precisely what the 'basic' Reisläufer and Landsknecht looked like within the variations played on their appearance for aesthetic or emotional effect.

From the 1520s Italian artists used another convention to avoid rendering the military hoi polloi directly. From the second French invasion, under Louis XII of France in 1499, the campaigns of the Wars of Italy became, in one theatre or another, almost continuous until 1530. By the early 1520s however, the numbers of Swiss troops involved had dropped to a few freelance companies, and though it was a predominantly Landsknecht army that sacked Rome in 1527, few German troops had been engaged since Maximilian I withdrew his troops from the Veneto in 1516. French, Spaniards, Italians and Balkan light cavalry formed the overwhelming majority of the armies that still competed for territory in the peninsula. Yet, as we shall see in more detail in a subsequent chapter, Italian images of the modern soldier took on a Germanic cast. And this owed more to the observation of prints than of men. The stooping Landsknecht figure on the left of Giovanni Cariani's *Way to Calvary* of ?c.1520 (Fig. 136), even influenced an early attribution to Dürer. It was surely Lorenzo Lotto's known interest in German prints that led him, in his 1524 *St Barbara* fresco in Trescore,[40] to confront carefully observed market women with soldiers derived from Landsknecht models. The miniature army in Battista Dossi's *Hercules and the Pygmies* (Fig. 137) of 1535 or thereabouts, is composed of engaging Germanic derivatives; in the right middle ground (Fig. 138) there is even that by now familiar trio: the plumed standard bearer, drummer and fifer.

Much of this chapter has been concerned with proposing indications that Italian artists on the whole preferred culturally or pictorially mediated images of soldiers to the direct depiction of those who fought among or for them, and that they were unconcerned with giving prominence to the image as a subject worthwhile for its own sake. There was, however, one notable exception to these generalizations: the emergence in northern Italy of the 'pastoral' soldier as the equivocal guardian of the countryside and of love.[41]

As landscapes had come to be more precisely rendered, roads and meadows called for a modest population of background characters, typically those shown in a work like Bonifazio Veronese's *Adoration of the Shepherds* in the Hermitage: a party of mounted huntsmen followed by a servant on foot; a shepherd seated among his sheep; a traveller on foot; and walking past the hummock on the right, a bareheaded but armoured soldier carrying a pike. Staffage figures could, of course, be relevant to the narrative. Shepherds occur in landscapes behind the Virgin and Child because of a natural association of ideas: the Adoration, the Lamb of God. Or they could be part of it, as in work that linked the Massacre of the Innocents to the soldiers' subsequent search for the missing child. But quite commonly staffage figures were not relevant to the story, and simply represented the cast of characters the artist thought of as the natural traffic on the roads or in the fields: labourers; travellers laden or unladen, on foot or on horseback, escorted or alone; huntsmen; and as the number of men walking to join, or returning after being disbanded from armies or reviews of the militia increased, the cast came to include soldiers. They must not be identified too readily as such, for the laws prohibiting the carrying of arms were suspended or were, at least, less rigorously enforced for travellers. When in

the company of civilians a man carrying a pike or halberd is likely to be a retainer or a hired guard. Nevertheless, the staffage population came to include them.

Not all artists added staffage figures to their works. Montagna, Alvise Vivarini, Catena generally preferred empty roads. Bellini was sparing in his use of subsidiary characters, though two groups of infantrymen appear in the landscape behind his *Madonna of the Pear*.[42] Cima was liberal with travellers but eschewed contemporary soldiers save in his London *Virgin and Child*. In works of *c.*1503–5 the Ferrarese Domenico Panetti scattered across his brightly lit landscapes a sprinkling of soldiers on horse or on foot (Fig. 139), armoured or merely weaponed, striding or conversing with one another. Previtali favoured staffage characters and his display two tendencies discernible in other works of the early cinquecento: to show travellers or shepherds sitting relaxedly in fields or under trees or at roadsides instead of, as formerly, simply walking along, and to introduce more women amongst those who were 'at home' out of doors. The first becomes the actual subject in his London National Gallery sequence portraying the Sannazarian mood of personal, emotional tragedy as coexisting with an otherwise 'safe' and protective pastoral world. The second supplies a grace-note to Panetti's fellow countryman Lorenzo Costa's *Pope Urban calling on Valerianus to become a Christian*, of 1505–6.[43] In the foreground group on the left a young man wearing only a loincloth leans on a staff in front of a clothed young woman embracing a naked child; behind them is an older man, suggestive of a pilgrim. Given the subject, perhaps we are meant to see them as Baptist, Virgin and Child and Joseph, but there is no special indication that they are. In any case, among the staffage characters in the landscape background are a group of conversing travellers, an elegant blade leaning against a tree and a young woman, sitting at the roadside with a child on her lap.

Among works that have been attributed to Giorgione, two soldiers appear behind the shepherds in the meadow outside the town that forms the background to the

Judgement of Solomon,[44] two more appear, armoured, beside the lake in *The Testing of the Child Moses*,[45] and on the right hand of the *Castelfranco Altarpiece*[46] two plate-clad lancers have left the road for the meadow where they converse, one standing, one sitting (with no sign of the horses such heavily armoured men must have ridden) in an otherwise empty landscape.

Of particular interest is a group of works from *c.*1510–11. In the landscape behind Palma Vecchio's charming *Portrait of a Women* in Budapest,[47] three soldiers talk to a shepherd seated on the ground. Another rides across the background of his *Diana*;[48] in the foreground a blonde young woman, nude, sits facing us on a flowery bank. A naked boy emerges, faunlike, from a thicket and touches her shoulder. She half turns her head to him, her right hand grasping a quiver of arrows lying on the ground, though in her left hand she holds not a bow but a thin wand. Is she Diana? Is he warning her that the landscape is not as peaceful as it seems? The mood is that of an idyll lightly threatened by the representative of war. In the frescoes of the Scoletta of S. Antonio, Padua of 1510–11, depictions of contemporary soldiers were, in these years of war and military crisis, not surprising, and in Filippo da Verona's *S. Antonio Prophesying the Liberation of Padua* and Giannantonio Corona's *Meeting of S. Antonio with Ezzelino* they are shown with, for the time, an unusually genre-like particularity (Fig. 140), though in the latter Corona, obedient to convention, adds to his landscape two shepherds watching their sheep. Caught in the same Paduan post-conquest and re-conquest mood, Titian makes the central figure in his *A Jealous Husband Stabs his Wife* a soldier (with chain shirt and leg armour) and brings in two soldiers as witnesses when *A Newly Born Child Proclaims the Innocence of its Mother*. But again, in sympathy with staffage convention, he shows in the landscape background to *The Saint Re-attaches a Young Man's Foot* a shepherd with his flock as well as a soldier sitting on the ground on the fringe of a wood.[49] And in another work of this period, the *Gipsy Madonna*, a soldier sits quietly under a tree in the landscape background.[50] Later, as his landscapes came to reply more on colour and atmosphere and less on paths and roads as topographical indicators,

140. Giannantonio Corona, *The Meeting of S. Antonio with Ezzelino* (detail), 1510. Padua, Scuola del Santo.

138. Detail of Fig. 137.

139. Domenico Panetti, *Virgin and Child* (detail), *c.*1503. Ferrara, Museo della Cattedrale.

141. Lorenzo Lotto, *Deposition*, 1516. Bergamo, Accademia Carrara.

Titian eschewed staffage figures and among the few he did use, the shepherd was preferred to the soldier.

Staffage figures allowed – as in the background to Uccello's battle scenes – an artist to note visual impressions which did not have to be 'improved' to satisfy the prevailing canvas of taste. But the interpretation of staffage has its hazards. Often thinly painted on top of the main surface, the characters are subject to rubbing and consequent (and because of their miniscule status, careless) restoration. They, too, are not immune to convention: some staffage soldiers follow the unnaturalistic 'thin' mode; others are given a cuirass because it will harbour a useful highlight; some are simply too small to be positively identifiable. Nevertheless, in the miniaturized society of staffage, more recognizable soldiers appeared, and in two guises: as military travellers and as presences who, as they sit meditatively or in conversation with one another or with shepherds, contribute another note to the chord struck by the southern associations of the word pastoral. Even in Lotto's *Deposition*, where a prominent, 'real', pikeman beckons on the Jews (Fig. 141), the staffage convention holds: on the slope above, a minute soldier stands conversing with a seated shepherd.

This too was the time of the Italian soldier who seems dreamily, to the point of melancholy, aware of his dual nature as scourge and guardian. The Braunschweig *Self Portrait of Giorgione* is in this vein,[51] as is Savoldo's so-called *Portrait of Gaston de Foix* in the Louvre,[52] Dosso's *Soldiers and Girl with Flute*,[53] and Licinio's *Concert*,[54] with its lute-playing girl and her friends guarded by a ruminative halberdier.

The soldier as guardian of pastoral security occurs (in particularly vapid guise, holding a toy halberd) on the left of the anonymous *Al fresco Concert of the Court of Caterina Cornaro*;[55] and in Costa's 1505–6 *Allegory of the Court of Isabella d'Este* (Fig. 142). Here, though holding a halberd, he is in the classicized armour of Cadmus the dragon-slayer. He stands prominent in the foreground, guarding the ascent

from the coast, where a cavalry engagement is taking place, while he looks across the peaceful coronation ritual, which is proceeding to music further back in the landscape, to the semi-nude figure of Diana who closes the foreground on the right. Between them and looking out at us, two young women sit on the grass; one of them caresses the head of a goat that nestles against her like a child.

The soldier-and-shepherd motif becomes the actual theme of Domenico Campagnola's engraving of 1517, *Shepherd and Old Warrior* (Fig. 143). In a scene made crepuscular by heavy hatching, the landscape on the right reaches to a Germanic farmstead on the horizon. The two figures, though so near together, are divided by their glances, the tree they stand beside, and the dog. The shepherd fingers his pipes while broodingly averting his eyes from the landscape. The old soldier (he wears thigh armour of tasses) gazes quietly into the distance while his right hand none the less reaches towards the sword which projects out of the frame. Though the theme 'Et in arcadia ego' was not to be spelled out before Guercino's picture of 1623 in the Corsini gallery in Rome,[56] it is surely latent here. Put within bounds by arcadianizing literature, economic advantage (the villa farm) and an enrichment of pictorial diction, the countryside was not only a place for love, and for conversational and music-making picnics, or for the mourning of self-inflicted emotional wounds, but at the same time a zone of potential danger. In 1499 Turkish incursions had penetrated Friuli and caused panic in the Trevisana. In 1508 Maximilian's invasion had involved military action from Cadore to Gorizia. Thereafter, before the general peace settlements of 1529 and 1530, there were to be few years in northern Italy which were not palled by mobilizations and a sense of impending crisis. Pastoral sentiments and military activity were coeval.

It is not surprising, then, that in Cariani's *Reclining Woman in a Landscape*, painted

143. Domenico Campagnola, *Shepherd and Old Warrior.* Engraving, 1517.

in Bergamo between 1520 and 1522, while the young woman gazes back calmly at us over her bared shoulder and breast, a party of stradiot cavalry prances into the landscape on the right (Fig. 144). And when he returned to the theme some ten years later, this time in the form of a female nude stretched with her body facing us across the landscape, there is a soldier in the mid-ground on the right, both in the painting and the preliminary sketch.[57]

It is within this context that we can consider two earlier paintings that have women, children, soldiers and landscapes in common. In the *Landscape with a Woman, Two Children and a Halberdier* (Fig. 145), which is in a manner close to Palma Vecchio's in 1510–20,[58] a young, clothed woman gazes thoughtfully, in profile, at the ground. She is the subject of the gaze, equally thoughtful, of the halberdier who stands on the right. Between them two naked children playfully embrace. The subject has

been identified as Romulus and Remus between Rhea Sylvia and Mars, and as St Theodore regarding the mother and her children he has saved from the dragon. Neither explanation is particularly convincing.

The second work, recently dated 1505–8 and impressionistically entitled *Idyll: a Young Mother and a Halberdier in a Wooded Landscape* (Fig. 146), has gone the attributional rounds: Palma Vecchio, Sebastiano del Piombo, Giorgione, most recently Titian. Behind the seated young, fully clothed mother, a naked child leans into her lap. She gazes towards the armoured soldier who stands on the right looking downwards and out of the painting. With his finicking backward-turned left hand, the affectedly pointing forefinger of the hand which grasps his weapon, with its etiolate shaft which would snap off below the blade if it were used, he is unconvincingly imagined as a real warrior. But he is thematically adequate as a guardian soldier in a landscape.

Giorgione's young man (Fig. 147) in the *Tempesta*[59] of (probably) 1506–8 is not. No other 'soldier' in a painting of the period, however unarmoured and civilian his costume, was left without a weapon or an overt military context. None merely held that traveller's companion-of-all-work, a staff. And, clearly, when Giorgione considered populating his landscape he did not choose at random. His overpainting of the first-thought female nude, now covered from his chest down by the young man, complicates matters for those who wish to read the painting as illustrating a subject within which all features cohere to tell a soldier-based story.[60] Second thoughts commonly being more deliberate than first, it also suggests that he had no intention whatsoever of conveying the impression that his young man was a soldier; he was simply an alternative figure appropriate to a landscape, providing a sexual and, through his stance and costume, a pictorially richer balance to the nervily feral, white and flesh-toned young mother and baby.

Yet when the eager recorder of works of art, Marcantonio Michiel, saw it in 1530

146. Titian, *Idyll: A Young Mother and a Halberdier in a Wooded Landscape*. 1505–8. On loan to the Fogg Art Museum, Cambridge, Mass.

147. Giorgione, *Tempesta*. 1506–8. Venice, Accademia.

144. Giovanni Cariani, *Reclining Woman in a Landscape*. 1520–2. Berlin-Dahlem.

145. Circle of Palma Vecchio, *Landscape with a Woman, Two Children and a Halberdier*. ?1510–20. Philadelphia, Museum of Art.

in the house of its owner, Gabriele Vendramin, in his laconic account of the work he described the figure as a 'soldier'. And upon that identification, so seductively early in date, and so suggestive of a clue to the meaning of the grandest, most hauntingly beautiful landscape of its age, towering 'explanations' have been raised: allegorical, religious, historical.

Michiel's mistake (corrected, if still not convincingly, by the next description, in 1569, of the figure as a shepherd)[61] was understandable: by 1530 so many soldiers had been associated with landscapes, with or without towns or buildings in the background, and with young women, clothed or unclothed, with or without a child. And we have looked at only the survivors from what was obviously before 1530 a popular motif; the clumsy *Landscape with Two Soldiers and a 'Dragon'*,[62] with its background town, distant shepherd and woman, and foreground halberdier and swordsman contemplating the dispatch of the contaminating dragon-spawn, suggests why other works would, the vogue passed, have been relegated to the decaying damp of cellars.

Geographically the guardian theme was restricted to northern Italy east of Milan. This was the foremost area through which Germanic prints and, possibly, drawings flowed southwards. But while in Germany the soldier image, even when placed, as it so often was, in a landscape, was increasingly incorporated into genre scenes of *Soldatenleben*, here – and this was part of a general Italian reluctance to pursue genre subjects for their own sake – it was used not to satisfy interest in the appearance and behaviour of representatives of an occupation group, but to aid the diffusion of a mood deriving from a non-military theme, the attractions and hazards of country life.

Though the only testimony to an original Italian contribution to a concern for the contemporary soldier as a fit subject for art, it confirms the fundamental difference between the assumptions that lay behind the treatment in the arts of soldiers north and south of the Alps.

CHAPTER 4
North and South: Contrasts I

T HE DISCREPANCY BETWEEN the interest in soldiers shown in northern and southern art is so dramatic that it is worth stopping short to seek an explanation which may throw light both on this and on the other aspects of warfare which found artistic expression and which we have still to review.

It is tempting to turn to the simplest of solutions: the inhabitants of the Germanic countries, for all their regional particularities were, in opposition to other ultramontane and cisalpine peoples, inherently more preoccupied with the social here and now, and possessed a native militancy that selected from it, as a favoured subject, the soldier, his appearance, his life and his deeds. This was, after all, an age in which the differences between 'national' characters and habits were, in a rough and ready and prejudiced manner, popularly bandied about; in particular, the valorous but clumsily barbarian northerner was compared with the intellectually refined but irresolute Italian. This approach, which has been explored (not always with due tentativeness) by those intrigued by the differences between northern and southern 'styles', leads towards the dark swamplands of *post hoc* racialist characterization. It may be that we will have to set foot there. But first, quite apart from accepting the unanalysable filtration process which can separate art from its ambient society, there are pragmatic issues to explore.

It was a period in which there were few years without wars or preparation for wars in some part of western Europe. The incidence of campaigns, however, has no bearing on our subject. During the period crucial to the development of soldier images and themes, from the mid-1490s to *c.*1530, the centre of almost unremitting European military activity was, after all, Italy. From Genoa to Venice and from Milan to Naples armies marched, towns were taken, battles were fought. But the image remained, as we have seen, more or less off limits to the imagination of Italian artists. Nor does the visibility of soldiers, the opportunities for town-based artists to observe them, have any bearing on it. Garrisons, recruiting and mustering procedures, billeting, troops returning wounded or turned off at the fighting season's end, armies treating towns as staging posts on the march or camping outside them to renew supplies and – keeping the civic authorities on tenterhooks – seek diversion in taverns and red-light districts: these occasions explain, for example, not only the soldiers ambling along the Rhine embankment in the anonymous late-fifteenth-century *Panorama of Cologne with Saints*, (Fig. 148) but those in Bernardino Lanzani's bird's-eye view (*c.*1522) of Pavia, with its soldiers leaving their billets and moving through the streets towards their roll-call and exercises outside the castle (Fig. 149). Diarists make it plain that few inhabitants of Italy's chief print-producing centres, Florence and Venice, lived such within-doors lives that they did not know what their cities' hired and native soldiers and militiamen looked like. That Germans should have learned to speak 'Lanzi',[1] a form of pidgin Italian, itself proclaims the pervasiveness of the military traffic.

More relevant than the incidence of campaigns or the observability of those who

fought in them was the attitude adopted towards both. Here the Alps did tower as a divide.

Although in the early stages of the Wars of Italy, when the issue was fairly uncomplicatedly to keep 'barbarians' out of the peninsula, an inter-state army could use 'Italia' as a common rallying call, within the continual seasonal drizzle of foreign interventions the different states sought increasingly to secure their own positions within alliances which were formed, reconstituted or broken in alignments which were motivated by the need for self-preservation. In the language of poetry, or in the rhetorical blaze or certain passages in the last chapter of Machiavelli's *The Prince*, 'Italy', 'Italians', could link divided Italy to its common heritage, the glories of ancient, world-dominating Rome. But under this varnish the political surface remained cracked into a dozen self-contained and self-protecting areas. And each, to raise a force on its own account or as its contribution to the alliance of the moment, sent its agents to trawl the common recruiting grounds: those rural areas whose surplus manpower made up the mongrel ('Noah's Ark' was the phrase used by the Venetian diarist Marino Sanuto) forces that may have been more or less Italian in composition but were in no sense patriotic emanations from the paymaster's native soil. It was, then, difficult for a Milanese, a Florentine, a Venetian or a Roman to identify with 'his' common soldiers. What is more, apart from the equivocal outcome of Fornovo in 1495 where Charles VIII's French army, returning from Naples was, though maimed, able to continue its withdrawal across the Alps, battles and sieges were either defeats for all-Italian forces or, if victories, won by armies in which Italians fought as the temporary allies of foreign rulers. Reflecting the Italians' lack of military success and increasing dependence on the 'barbarians', Castiglione's Count Ludovico of Cannossa (a typical representative of the patron class) remarks in *The Courtier* when the topic of Italian prowess in war is verged upon, that 'it is better to pass over in silence what we cannot recall without sorrow'.[2] While this reaction does much to explain the near silence of brush and engraving tool as far as the commemoration of contemporary battles in Italy was concerned, it offers little, surely, to an explanation of the visual silence that sent hundreds of thousands of soldiers to Coventry. Venetian forces, for instance, though drawn from Liguria, Romagna, the Marche and the highlands of the Abruzzi, and fighting alongside allied contingents, were still recruited and paid by Venice. By boat or on foot they arrived for mustering on the Lido, review in the Piazza. They were accompanied on campaign by Venetian secretaries, accountants and patrician liaison officers. They could on occasion be singled out for promotions or pensions. Their fortunes, as components of an army, were avidly discussed in Venetian Councils. They were not ignored by artists because they were not seen or known about.

None the less, north of the Alps, the mood was different. It cannot be summed up in terms of victories. German armies did not always win. Maximilian's troops had a patchy record in his Netherlands campaigns of the 1490s. They were drubbed by the Swiss in the Swabian War of 1499. They were turned back from their Italian adventure of 1508, checked and then forced to withdraw from their renewed and more penetrative attempt to secure Venetian mainland territory in 1509–16. Yet it was within these bracketing years that the German image of the soldier acquired its fullest momentum.

However, there was, but in the vaguest of senses (Germany being even more complicatedly split up among competing cities and princedoms than was Italy), something patriotically meaningful about the term Landsknecht. As the word gained currency in the 1470s and as the companies' organization became more firmly defined between the next decade and the legislation passed in 1507 by the Diet of Worms, it was identified with the idea that German territory, the *Land*, should have a force, permanently in being, and raised by all the mini-powers within the broad concept of Empire, that could both protect and extend it. In spite of the separatism that characterized most aspects of German life, public, private and dialec-

95

tal, five centuries of association with the Holy Roman Empire had given 'German-ness' a slightly stronger charge than 'Italianness' gave to Italians, and Maximilian's military reforms played directly on this common chord. But this is not the explanation we are searching for. Maximilian's first Landsknecht force was 'patriotic' in that he used it to bring his Netherlands marriage portion firmly within his native German sphere of direct control. The Swabian War was patriotic in the sense that Landsknechts fought, unsuccessfully, to keep the uppish Swiss from breaking away from the German Empire. And because the Landsknecht armament and organization reflected the practices that had saved the cantons from being dominated by Burgundy, there was a professional pride that kept national rivalries alive while Landsknechts and Reisläufer confronted one another later on Italian battlefields. Later still, Landsknechts fought to protect the Christian German Empire from the infidel Ottoman Turks. But it is surely unlikely that artists, dyed in the particularist colours of native cities which looked askance, even in the Habsburg homeland of the south-west, at imperial pretensions, produced their records and interpretations because the Landsknecht was a national symbol. The permanent, police-*cum*-striking force of Landsknechts was small. Far more numerous were the infantrymen who adopted the Landsknecht appearance but who fought simply as freelance mercenaries, bound into 'Landsknecht' companies by military entrepreneurs who hawked them as desirable commodities on the international military market – which included German states that were resisting imperial authority.

More can be claimed from the patriotic association of the Swiss infantry. Booty taken from the Burgundian army at the battle of Grandson (1476) was displayed in the Town Hall of Lucerne, for the public to gloat over (Fig. 150). The anniversary of the next victory over Burgundy, at Murten (Morat), was made a public holiday in the Confederation, as was the major victory over Maximilian's army in 1499, the battle of Dornach. The soldiers who headed the Swiss *Drang nach Süden* into Milanese Lombardy between 1496 and 1516 sustained this patriotic identification. And because Swiss troops in Italy were frequently confronting Landsknecht contingents, a nationalistic rivalry accompanied and came to overtake a patriotic one when the Confederation ceased to aim at acquiring territory and Swiss-German professional competitiveness in the mercenary market became sourer.

Machiavelli remarked on this rivalry in his *Report on the Affairs of Germany* of 1508–9.[3] For one Swiss to taunt another by calling him a Landsknecht was considered so galling as to cause Urs Graf to be fined when he uttered this secular blasphemy, in 1514.[4] But the 'patriotic' Reisläufer, formally enrolled by the Cantons, were, as in Germany, easily confused with the freelances, the *Friharste*, who fought simply for their wage and enlisted with the entrepreneurs whose recruiting network competed with the Cantons'. In this way, as we have seen, Swiss could find themselves confronting Swiss and serving amongst Germans. The image of the soldier as a representative of the spirit of Canton or Confederation was thus blurred by common knowledge that he may have been nothing of the sort. In addition, the majority of images do not place him in a politicized context, finding him interesting as a type rather than as a symbol.

How far was the contrast due to the actual military service, at which we have only glanced, of artists and patrons?

The Swiss experience is conspicuous here. Apart from the influence on picture chronicles of Schilling's experience in the field,[5] there are the contributions from Urs Graf, who served as a soldier in Italy in 1510, 1513, 1515 and 1521, possibly too in 1516 and 1519.[6] On some occasions he was accompanied by Hans Franck, whose campaign experience is somewhat weakly expressed in his *Soldiers Storming a Fortress* drawing.[7] Niklaus Manuel served in 1516 and 1522.[8] Hans Leu the Younger fought in Italy in 1515 and 1519.[9] He was actually killed in a local combat in Switzerland in 1531. But his work contains no echo of his military experience. And though the Swiss images of soldiers and their lives are of absorbing interest, the north–south contrast would be hardly less acute if we ignored them.

150. Anon., *Booty from Grandson displayed in Lucerne*. Miniature, c.1512. Lucerne, Stadt-bibliothek.

For no German artist served as a soldier for gain. Hans Sebald and his brother Barthel were emotionally caught up in the socio-military issues of their lifetimes but had no first-hand experience of war. Joerg Ratgeb, the greatest visionary artist of his day after Grünewald, was horribly executed by drawing and quartering for his involvement as a military adviser in the peasants' cause of 1526.[10] He depicted no soldiers outside his religious works. Neither of those two notable contributors to soldier imagery, Dürer and Altdorfer, had any practical experience of war, though the former was closely linked to friends who either fought for Nuremberg as a patriotic patrician (Willibald Pirckheimer) or advised the government on military affairs (Johannes Tscherrte), and Altdorfer participated in discussions about strengthening the defences of his native city, Regensburg. In Protestant cities affected by the iconoclastic fervour of the 1530s, artists suffering from the disappearance of commissions for religious subjects sought second or alternative occupations. It has been claimed that some served as soldiers, but this is frailly substantiated.[11]

No Italian artist apart from Agostino di Duccio[12] and Pisanello[13] joined up as a soldier. But Antonio Rizzo served, and was wounded as a military engineer.[14] And Leonardo's interest in military technology is well known; his letter of self-recommendation to the Duke of Milan, Lodovico Sforza, stressed his qualifications in this respect and he served Venice, Cesare Borgia and Florence as a military adviser, particularly on fortifications. The involvement of artists in this aspect of war went back at least to Giotto's supervision of Florence's third circuit of walls.[15] Of Leonardo's contemporaries, or near-contemporaries, Francesco di Giorgio designed fortifications and was interested in the development of artillery. Bramante was the architect both of the new St Peter's and of the Rocca at Civitavecchia – a work completed by Michelangelo, who directed the strengthening of Florence's fortifications when it was besieged by an imperial army in 1529. In his *Autobiography* Benvenuto Cellini recalled that when he was asked to take over the artillery defences of Castel S. Angelo by Pope Clement VII, who had taken refuge there from the troops who sacked Rome in 1527. 'I was only too eager to do so, being perhaps more attracted to soldiering than to my real profession.'[16] He was helped to serve the guns by another artist, Raphael da Montelupo, who, in his own account of his life, revealed an addiction to reading books about battles.[17] So though there was no Italian parallel to the committed military careers of Urs Graf and Niklaus Manuel, the contrast in this respect between north and south is unremarkable.

The same can be said of those who commissioned and purchased secular works of art, whether as aristocrats or princes to whom military service was part of an old pattern of caste and profit, or as patrician or burgher participators in military planning and administration, or as printer-publishers, or as those who bought, to paste or pin up, the cheapest prints on the market.

There was, however, one source of patronage which, with regard to the diffusion of the image of the soldier, was so outstandingly unusual, and chronologically so central, as to demand some scrutiny.

'The last of the Knights'; 'the Father of the Landsknechts': the chequered career and the contradictory ideas of the Emperor Maximilian I (1459–1519) have conspired to make him the most fascinating and puzzling of early modern rulers, perhaps the only true representative of the notion of 'transition' between the inheritance from one age and adjustment to the conditions of another. Plagued by the disparity between his role (inherited from his father in 1493) and his power, Maximilian incorporated the ideals and practices of chivalry with a shrewd awareness of the changed conditions of warfare. A work commissioned by him, the *Freydal*,[18] illustrated with great splendour the warlike games – tourneys, tilts, barriers, an assortment of 64 foot and horsed combats – in which the Emperor participated and which enshrined the rank and training of the would-be crusader class. And when he summered in his Tyrolese hunting refuge at Runkelstein (Castelroncolo) he was surrounded by ineptly energetic fresco cycles depicting the dashing exploits and

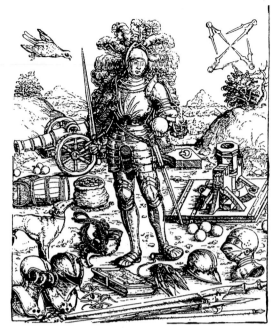

151. Wolf Traut, *Maximilian Surrounded by the Implements of War*. Woodcut, *c*.1505.

152. Albrecht Altdorfer (attrib.), *Maximilian in a Park of Artillery*. Woodcut, *c*.1505.

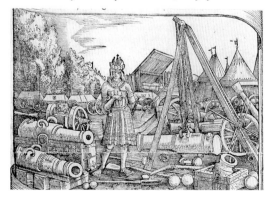

heaped-up mêlées derived from versions of Arthurian romance: bright, violent but on the whole bloodless reminders, painted between *c*.1350 and *c*.1405, of what chivalry – and the response of ladies to its flamboyant display of caste-conscious masculinity – was about.[19]

Yet we have seen[20] that on the façade of another summer residence, decorated in his lifetime, the Innsbruck *Goldenes Dachl*, were Landsknechts.

In a woodcut of *c*.1516 produced for another of Maximilian's projects, the *Ehrenpforte*, or Gateway of Honour, the Nuremberg artist Wolf Traut produced the best summary of where the Emperor stood as a warrior.[21]

Tapping a motif which showed Hercules at the Crossroads hesitating between the routes that led to duty or pleasure, the laborious Traut shows a young, armoured Maximilian weighing in the one hand a cannon-ball, in the other a sword (Fig. 151). He is surrounded by the symbols of conflicting alternatives. For the chivalrous sword speak the tournament helms and lances, the anti-cavalry caltrops, the partridge plunging through the air, the falcon lure, the expectant bird-dog. For the cannon-ball speak the symbols of expediency: the cannon, the mortar, the barrel of gunpowder, the mercenary sack of coin, the compasses in the sky that betoken a rational, mensurated approach to making war. Summary, as always, is best exemplified by second-rate talent.

What, the clasped book in the foreground suggests, will be the hero's choice?

Within the divided world of his imagination, Maximilian came down firmly on the side of the cannon-ball: as a landowner he was, after all, preoccupied with keeping his Burgundian–Netherlands marriage portion from slipping back into its traditional independence, with bullying the neighbours to his Austrian Habsburg homeland, particularly Bavaria, into acknowledging his pan-German rights as Emperor; and he had, or chose, to exert the rights of the Empire over Hungary and northern Italy as well as its Christian leadership against the Ottomans. From his campaign-battered father-in-law, Duke Charles the Bold of Burgundy, he learned that while chivalry might be cultivated at home, the challenge of modern tactics and technology had to be met in the field. And this was a source of pride. In both of the autobiographical works whose outlines he dictated, the *Historia* and *Weisskunig* (the White King – the God-protected virtuous ruler) and whose illustrations he approved, he was anxious to show the practicality of his education as a warrior. He plays with tournament models but he also takes part in target practice with the crossbow and has model cannon. He visits a gun foundry and takes a hand in tapping a bronze furnace. Even in his most cloudily allegorical and romantic version of his life, the verse *Theuerdank*, among the almost countless accidents destiny delivers him from, one is connected with a faulty steel crossbow, several with defective or deliberately overcharged cannon. In a woodcut (ascribed to Altdorfer) probably made in connection with the *Ehrenpforte* but not included in it, he stands as a young man (Fig. 152), sword-girt and imperially crowned, in a park of artillery, surrounded by cannon mounted on chocks or dangling from a windlass. In the foreground there are balls, a device to insert the charge, and a rammer to push it firmly into the breech; in the background are tents, ordnance wagons, a shuttering for siege guns. He is very much the aristocratic boffin. In planning another notable and elaborate work of self-image enhancement, the *Triumphzug*, he is careful to specify that along with the participating princes, counts, barons and knights, there should be shown the common infantrymen on whom his victories had in large part depended. Some of them, too, are named, and we get a glimpse into the breadth of recruitment amongst the Landsknechts: amidst the Germans there was 'Mang von Schafhausen' and two other Swiss, 'Juan Talsat, Spaniard, Richard Vantos, Englishman'.[22] And the whole procession was to be concluded with the personnel of the baggage train and – it was a touch so demotic-romantic as to be ignored by his team of artists – 'all shall be wearing laurel wreaths'.[23]

The large coloured drawing in Vienna (Fig. 153) of the enthroned Emperor

153. Jörg Kölderer?, *Maximilian Dictating to his Secretary*. Miniature, *c.*1512. Vienna, Österreichische Nationalbibliothek, Cod.2835, f.2v.

dictating these instructions to his trusted secretary and artistic intermediary Marx Treitsaurwein, who kneels before the throne, paper and inkpot at the ready, shows in the foreground four pikemen animatedly discussing what is going on. While not reading into this particular representation more than is there, it does suggest the nature of Maximilian's activity as a patron. While giving houseroom within his patronage budget to sculptors, panel-painters, goldsmiths and medallists,

his chief interest was propagandistic – for his station, deeds and aims – and, uniquely in his age, he grasped the opportunity for the replication of messages outside court or church or precious manuscript that was offered by the print, particularly the woodcut. In spite of his high-minded idealism he might, by this choice, be labelled an opportunist Philistine, were it not for the artistic calibre of the stable he chose to collaborate in his publishing ventures.

While allowing for the constraints of its context, the single illustration, a woodcut by Hans Burgkmair[24] in the *Weisskunig*, that demonstrates the artistic side of his education, has him in the workshop of an artist who, palette and brush in hand, sits at an easel on which is perched a canvas pinned to a board. On it is a mélange of images which clearly represent (and one remembers Traut's crossroads vision) not so much what the artist wants to put on an expensive piece of prepared cloth but what Burgkmair had heard about the subjects that interested Maximilian: heraldic images, lion, boar, stag; and military ones, cannon, mortar, halberd.

In 1501 Maximilian chose as his court painter Jörg Kölderer, a minor artist but an attractive and flexible illustrator with a strong taste for genre and some flair for co-ordinating the graphic contributions to the Emperor's literary and commemorative works. That Maximilian did not want chivalrous or hieratic 'court art' from his court artist is shown from two early commissions.

In 1504 Kölderer illustrated the Emperor's taste for fishing expeditions to the rivers and lakes of the Tyrol. His full-page illuminations (Fig. 154) are full of anecdote: boating and netting parties, men fishing from the bank with rods, others hawking and hunting in the surrounding countryside. And there is a genial sense of picnic. The fish is cooked and served, wine barrels mingle with fish traps, servants carry dishes, men and women stand about conversing, and among them are members of the guard of halberdiers.[25]

From 1502 Kölderer was charged with a job that was to occupy him and his assistants on and off for a decade. Needing an oversight of what artillery, weapons and equipment was available, and in what state of utilization in the eight arms stores he maintained in his hereditary lands (and, between 1509 and 1517, Verona), Maximilian ordered the compilation of inventories. These were to be illustrated so as to bring the items readily to the mind of himself and his surveyor of armouries, Bartholomäus Freysleben, and, when distributed in sections, they were to serve as visual as well as numerical reminders to arsenal keepers of what they were responsible for.

Nothing on this scale had been attempted before, and nothing – including the technical 'inventory' drawings of cannon and equipment in the Housebook – had anticipated the way in which Kölderer chose to illustrate the military matériel. Not only do the coloured drawings show the courtyards into which heavy artillery could be dragged for inspection, racks of portable arms, harness, barrels of nails, chests of horseshoes and caltrops, pulleys, coils of rope and lengths of chain, powder casks, leather buckets, tents and transport wagons, but men demonstrating how the weapons – pole-arms and firearms – should be handled (Fig. 155). And this was done with great genre verve. The masterpieces of artillery were lovingly painted and given their pet names (there was a series dedicated to famous women: Lucretia, Thais, Faustina and others) and accompanied by doggerel verse in their praise;[26] even the pikes and halberds were given both a visual and a spoken voice:

> We long pikes and halberds
> Are also present in this Paradise Garden.
> The Emperor Maximilian
> Has won victory and honour from us.
> We wait for the time
> When he brings us into action again.[27]

154. Jörg Kölderer, *Scene from Maximilian's 'Tiroler Fischereibuch'*. Miniature, 1504. Vienna, Österreichische Nationalbibliothek.

There is no doubt that Maximilian's stable of artists and versifiers knew that they were serving the Father of the Landsknechts.

The pioneer student of these *Zeugbücher*, arsenal inventories, claimed that it was here, rather than in the 'enhanced, transfigured' images of Dürer and other artists more conscious of their high calling than Kölderer, that the infantry of Maximilian's time were realistically represented.[28] Given the immaculacy and colourful fancifulness with which the *Zeugbuch* figures are portrayed, this is, pardonably, a specialist's

Kannobuchsen

exaggeration. But it returns us to an assessment of the influence of Maximilian's patronage.

This was exerted, as in contemporary woollen manufacture, on the farming-out system.

The *Fischereibuch* and the *Zeugbücher*, which called for illumination, were done 'in house'. So was the *Historia Friderici et Maximiliani*, illustrated throughout by the wonderfully gifted Master of the History. The Emperor's *Gebetbuch* (Prayer Book) of 1514–15, on the other hand, was farmed out in manuscript sheets to artists who in their own homes would add the requisite marginal illustrations (Dürer, Cranach, Burgkmair, Hans Baldung, Jörg Breu, possibly Altdorfer) before returning them for binding at headquarters. And this followed the pattern set by the works Maximilian determined were to be supplemented or shaped by woodcuts.

The ones that chiefly concern us are the *Weisskunig*, the *Triumphzug* and the *Ehrenpforte*.

The text of the first, the exemplary story of Maximilian's education, loves, wars and imperial destiny, called for 251 woodcuts. They were commissioned from Burgkmair (118) and Leonhard Beck (127); the remainder were contributed by Schäufelein and Hans Springinklee. The first three were resident in Augsburg (Schäufelein on a temporary basis), and Springinklee was then an assistant of Dürer in Nuremberg. Perhaps Dürer, who was in receipt of a pension from Maximilian from 1512, suggested him as a makeweight. The book remained unfinished at Maximilian's death, and was not issued, with the prints taken from the blocks which had been stored at Graz, until 1775.[29] Their quality can best be judged from the collection of sparklingly crisp proof copies of 119 of them now at the Boston Museum of Fine Art.[30] With its pen sketches for other woodcuts and annotations in Maximilian's hand, the Codex shows his overriding concern: that the stages of his military training, his battles and sieges, should glorify him while at the same time being true to actuality in terms of weapons, costumes, engagements, the everyday life of encampments. While the text, to refer to Traut again, held the chivalrous sword, the woodcuts clove to the cannon-ball. The text could fudge the outcome of a conflict, but the print designers, though not present as war artists, were expected to represent it in up-to-date terms, not in those of a glamorously antique or chivalrous past.

For the *Triumphzug* the stable of contract artists was extended from the Augsburg team, Burgkmair, Beck, Schäufelein, to Dürer and Springinklee in Nuremberg, Wolf Huber in Passau and Altdorfer in Regensburg. It was an enormous undertaking, especially as it took two forms – the private, painted version of 109 miniatures in which the household painters, Kölderer, the Master of the History, the Master of the Artillery participated, and the public woodcut one: some 54 metres long if the 137 prints of the still incomplete procession were to be displayed as a continuous frieze after their publication in 1526.[31] As it tramps along, the cortège shows not only representatives (usually named) of Maximilian's interests in hunting, falconry, music, instruction in specialist weapons and the recreation provided by wise jesters and natural fools; but also his subject territories (their arms borne aloft by mounted standard bearers) and his faithful footmen: halberdiers, pikemen, double-hand swordsmen and arquebusiers; it also manages to include another review of his victories. In the painted version this is achieved, as we noted, by following the example of Mantegna's series of canvases at Mantua, *The Triumphs of Caesar* (c.1486), where depictions of actions are borne aloft on standards carried by legionaries – transformed into Landsknechts in the *Triumphzug*. In the printed version they are shown on the tiered sides of triumphal chariots.[32] In both cases, in spite of the oddity of their framework, the scenes of battle and siege have a strong sense of *wie es eigentlich gewesen*.

Yet another review of Maximilian's major military engagements was called for by an almost equally massive graphic project devised for Maximilian (in this case

155. Jörg Kölderer workshop, *Arquebus Racks in the Tirol Armoury*. Miniature, c.1502–8. Vienna, Waffensammlung.

by Kölderer and the court astronomer Johannes Stabius): the *Ehrenpforte* (Fig. 156). Some 11.5 feet high and 9.5 feet broad when mounted, this comprised 192 blocks contributed by Dürer (with whom the Emperor discussed the project during a visit to Nuremberg in 1512), Springinklee, Altdorfer, Traut (whose *Maximilian at the Crossroads* we have looked at: left, in the fourth frieze over the left-hand arch), and others working as assistants. And again, though the context – a fantasticated commemorative triumphal arch[33] – is *all' antica*, the contemporary scenes on its surface are shown in contemporary terms.

Altogether then, Maximilian's projects constitute an endorsement on a numerically grand scale, and expressed through the services of a wide range of artistic talent, of the notion that soldiers should be shown as members of a recognizable occupation group doing things that actually happened.[34] The influence of his patronage has to take account of works of restricted circulation (the *Zeugbücher*, the *History*, the *Gebetbuch*) and posthumous publication (the printed *Triumphzug* in 1526, the *Weisskunig* not until 1775), but, above all, we have to note the fact that though some projects were long in gestation (*Weisskunig* was planned in 1505), the woodcuts were all produced between *c.*1514 and 1517. And by this time the figure of the soldier had become not only established and elaborated, but military genre had been explored within the very circles Maximilian called into his part-time service.

That he accepted the genre element in, for instance, Altdorfer's work for both versions of the *Triumphzug* is not, surely, because he or his advisers called for such everyday details as cooking pots and betwixt-actions saunterings and conversations, but because he accepted what Kölderer and his outside artists had already made their own, and what strengthened his self-image as a soldier among soldiers. The influence of distributed proof copies, or of working contacts between 'Maximilian's' artists in such centres as Nuremberg, Augsburg or Regensburg and others working there or actively collaborating with them, cannot be guessed. The price of the one major project published in his lifetime (the *Ehrenpforte*, in 1518) put it, as a whole, beyond an artist's pocket. Proofs or separate printed woodcuts may, for example, have stimulated the inclusion of the battle scenes in Swiss painted heraldic glass from around 1520, and may have more generally endorsed, possibly even extended, the pre-existing interest in soldiers and their lives, but Maximilian's patronage does not turn out to be a really significant factor in explaining the markedly different reactions to depictions of the soldiery north and south of the Alps.

We have seen throughout that this difference was above all expressed through the medium of prints. Does its explanation to any significant extent lie in the difference between the number of prints produced north and south of the Alps? Without essaying a comparison we would evade an opportunity of matching like with like.

Though engraving in Italy got under way (in the 1460s) rather later than in Germany, if we take the period as a whole there was almost a parity of numbers. Certainly it was not a scorned medium. One of the earliest Florentine prints, the *Planet Children of Mercury*,[35] shows an artist-goldsmith graving a copperplate. In the 1470s the medium was adopted (though only once) by Italy's first *peintre-graveur*, Antonio Pollaiuolo in his virtuoso *Battle of Nude Men*[36], and by its second, Mantegna, who did seven engravings himself and passed other designs to printmakers. The third, Jacopo de' Barbari, even went to Nuremberg to glean advice from Dürer's workshop. Thereafter, the major artists, like Parmigianino and Beccafumi, who made their own engravings were few, but Raphael's frequent passing of designs to be engraved by Marcantonio Raimondi suggests the repute of the medium – as does the unusually long account of Marcantonio's career given in the 1568 edition of Vasari's *Lives*. Nor was the Italian cultural zone closed to the influence of northern engravings.

That these circulated freely in the north itself is to be expected: the trade fairs drew separate prints as well as book publishers (the Frankfurt book fair has a history going back at least to the early years of the sixteenth century). Artists sent

156. Albrecht Dürer et al., *The Triumphal Arch of Maximilian I*. Woodcut, 1517.

prints to one another, or swapped when meeting, or, when travelling, acted as agents on their own behalf. This sort of traffic and trafficking emerges clearly from Dürer's unusually copious literary remains, and cannot have been peculiar to him.

The Alps were no barrier to this transmission of engraved images. Even Vasari, wedded to the idea that God had chosen Italy (and especially his home patch, Tuscany) to be the favoured spot where the triumphs of ancient, pre-barbarous–Gothic–Byzantinizing art were to be revived, acknowledged the helpful influence of engravings by northerners: he named Schongauer, Dürer and Lucas van Leyden, among those whose works had 'opened the eyes of many [Italian] painters'.[37] Later research has only broadened the cast of transmitters and the repertory of the receivers of northern prints in Italy. And in a hustling mercantile age this was no one-way traffic. Lucas van Leyden's *Lucretia* engraving of *c*.1514 reflects the influence of Marcantonio's *Venus and Amor*, engraved scarcely a year earlier. Some time in the 1460s a Florentine engraver resuscitated one of the many myths that had in the Middle Ages made Virgil as much a magician as poet.[38] He had lusted after the daughter of the Prefect of Rome. She gave him a rendezvous, but left him hoisted in a basket only half-way up to the tower room in which he expected to enjoy her – to the mocking hilarity of the populace who saw him dangling there next morning. In revenge, he wizarded the extinction of all lights and fires in the city. The only source from which Romans could light their lamps and start their ovens was the misguided fieriness of the pudenda of the Prefect's daughter. She was forced, by public clamour, to expose herself to the crude contact of the candles and lampwicks of the populace. The story of Virgil's Revenge then went undergound until it was rephrased in a Roman engraving of *c*.1520.[39] Altdorfer picked this up in a more reticent but clearly dependent engraving shortly afterwards,[40] and it surfaced again, this time with little change, in a Swiss design for a painted glass heraldic panel of 1544 (Fig. 157).

That engravings were produced in and passed freely between north and south is not, then, in doubt. Neither is the fact that in spite of northern influence on Italian engraving techniques and aims, and on the quickening of interest among Italian artists in according more prominence to landscape (Giorgione, Titian) and more emotionalism to religious subjects (Rosso Fiorentino, Pontormo), military motifs did not find a welcome. Probably no Italian was more familiar with northern prints than Marcantonio. The only reflection of their soldier subject matter in his work was his reversed image of Dürer's *Soldier's Farewell*.[41] To compare like medium with like, this, and the Martino da Udine engraving we have looked at, reinforce an indifference close to outright rejection.

The real imbalance within the world of print production was represented by the woodcut, not in terms of book illustration but of self-sufficient single sheets, carriers in the north of so many soldier images. The imbalance was partly numerical (the volume of Italian works is only gradually coming to be recognized),[42] but to a still more striking degree one of quality. It is not that Italian artists could not produce designs for block-cutters that were suited to the medium: in their radically different ways, Jacopo de' Barbari's 1500 *View of Venice*[43] and Titian's probably 1508 *Triumph of the Faith*[44] were masterpieces; but in Italy there was no sense of that northern ease with which painters could turn from panel to block. Nor was there a lack of available cutting skill: for purity of line and the use of blank space in a way congruent with the appearance of letterpress on white paper, Italian book illustration – not only in such superlative instances as the 1499 Aldine *Hypnerotomachia Polifili* – was unsurpassed. Nor was there a shortage of imaginative technical skills. Nowhere else were the difficulties encountered in the production of several-toned chiaroscuro woodcuts so convincingly mastered. Nor, finally, were Italian artists unaware of German single-sheet woodcuts. Vasari's regret that the emotionally unstable Pontormo was over-influenced by them is only one witness in his book to their circulation in the peninsula. Another comes from his own working practice. When he

was hard put to it to record in the Palazzo Vecchio the achievements of Cardinal Ippolito de' Medici's 'crusade' in Hungary, he calmly blew up in fresco Dürer's 1527 woodcut *Siege of a Fortress*, and crowned his composition with it.[45]

The market for relatively cheap art, woodcuts or engravings, north and south of the Alps was probably identical. It could be profitable. Dürer regretted, or, at least, said that he regretted, having neglected it for the time-consuming and less profitable business of painting. And artists, in the south as in north, could fall on hard times. Lotto, between commissions, painted speculative works for Italian trade

fairs in Brescia and Venice; he even enlisted merchant friends to hawk them as far afield as Sicily. Yet he never thought of the demand for prints, though he bought or at any rate knew about German ones.

An explanation for this fastidiousness is relevant to our inquiry. For the print did something to break down the distance between everyday life and the conventions of the expensive arts. The northern print embraced the soldier and found a ready market for what it had to say about him. The initiative came from the artist, however dependent he may have been on block-cutters and printing entrepreneurs to reach his audience. And this initiative came neither from the hack freelance, nor, in the first instance, from printer-publishers, but from the *peintres-graveurs*, men conspicuous then and since as among the leaders of the community of artists. Why was it lacking in Italy?

Answers have been proffered in regard both to the general imbalance between the numbers of 'serious' woodcuts produced in north and south, and to the more restricted subject matter of southern engravings.

From the past there is the ambivalent opinion of Vasari. Woodcut he dismissed as involving a technique too simple to fascinate a real artist. Copper engraving was a respectable challenge, but he restricted its function to advertising at home and abroad the wares and styles of established painters and proffering stylistic hints to tyros. He saw the market as anxious for prints whose exemplification of '*buon disegno*' would douse the appeal of northern crudities. It was with a rare concession to the quasi-journalistic function of the print that he allowed himself an approving reference to Enea Vico da Parma's series that portrayed the costumes of various nations – potentially useful to the history painter.[46]

Since then other suggestions have been offered. Suitably soft but firm grained woods (chiefly non-European boxwoods) were in short supply – in Italy, that emporium of imported exotica? Italian artists were more fully employed than their northern counterparts – on what evidence? – and did not have to grovel to the level of the graver (even if wielded by someone else). In Italy Art despised Labour – but what of the hours spent (by Raphael, for instance, the 'easiest' and most aristocratic of artists) in studio sketches? There is a more serious side to this argument. Was there not a difference between the practice of *disegno* in the intellectualized Vasarian sense and the attitude to drawing that enabled the northern artist to get out tools, or imagine how the tools employed by a sympathetic technician would embody his idea? Still, the 'muscle' argument, which draws conjecturally on the contemporary debate about the comparative dignity of fluent painting and labour-intensive sculpture, is unconvincing. So is the suggestion that respect for the painted miniature held back an appreciation of the black and white substitute.

These are all suggestions which draw attention to a problem while doing little to solve it. The contrast between north and south, within the context of our inquiry, is not readily explained in terms of the incidence of wars, the operation of patronage or, in any significant way, by the relative numbers of prints that were issued. It is not resolved if two other media contrasts are made: the greater number of finished drawings of secular subjects, produced for sale or as gifts, in the north, and the demand there for secular painted glass panels, though both, especially the former, enabled artists to express interests of their own, and both included notable contributions to the northern record of soldiers and military genre. To get nearer a solution involves turning to a more general zone of inquiry.

CHAPTER 5
North and South: Contrasts II

SOLDIERING WAS AN occupation, a paid job as well as a way of life. It is, then, essential to look at the conventions that kept alive a pictorial interest in occupational types. The degree of their vigour did much to determine the soldier's admissibility into the subject matter of art. The difference between north and south in this respect has been perceived, but it has not been explored.

In Germany the interest had flourished at least from the illustrated manuscript (c.1330) of the compilation of earlier – by a hundred years – Saxon customary laws that came to be influential in other Germanic regions. The *Sachsenspiegel* shows, in drawings of the crudest nature, the parties likely to be involved in lawsuits, whether king, bishop, prince, or priest, merchant, peasant.[1] The same inclination to illustrate a text that provided a survey of status and occupation types was exemplified in manuscript versions of Jacobus de Cesulis's late-fourteenth-century treatise on chess. This is far less an introduction on how to play the game than an extended meditation on the socio-symbolic meaning of the pieces, and how they demonstrate that all ranks and occupations should work together, while the rules nevertheless accept the dire consequences for the privileged of unwariness, and the promising but dangerous possibility for others of improving their status if they drive ahead. Some of the back-row pieces were identified now as King, Queen, Knight, though the text and its recensions variously held the bishop to be a civilian judge or philosopher and represented the castle as a legate or emissary executant of the king's command, travelling as he could the length or breadth of the royal domain–board. The chief difference lay in the characterization of the pawns.

In Spain, for instance, they were equals; all footsoldiers, if they crossed the board unscathed they could expect promotion to the not very prestigious station of ensign. But Swiss and German illustrated texts followed, and elaborated on, Jacobus's insistence that they represented at least some of the occupations through which society was characterized. Typically, they were: merchant, physician, scribe (or notary), innkeeper, town watchman responsible for civic law and order, blacksmith, peasant, and – a fascinating figure who surely played a part in the development of the northern Renaissance personification of Folly – a messenger who was also a rogue and a gambler; the joker in the pack of pieces, tempting the others to succumb to the lure of his dice.[2] Though based on a game, this was a fairly sophisticated model of society. But what is of interest here is the alacrity with which in Germany, from the late fourteenth-century, it was given a pictorial form.

By the late fifteenth-century, the literature dealing with the tasks and duties of the Third Estate had broadened its range. The *Speculum vitae humanae* of Rodericus Zamorensis, printed in Augsburg in 1485, illustrated the contributions to society of lawyers, notaries, town councillors, artisans, wool workers, blacksmiths, ship-builders, ploughmen and herdsmen and, to lighten the daily round, actors.[3]

The first occupation group to figure on their own in separate prints was the

158. Anon., *Armoursmith*. Miniature, 1533. Nuremberg, Stadtbibliothek.

159. Anon., *Resurrection of the Dead*. Miniature, 1469. Neustift, Augustiner-Chorherrenstift. Stundenbuch of Georg Hölzl.

peasantry. But Dürer's *c.*1495–7 engraving of *The Cook and his Wife*[4] catches a growing taste for the delineation of social types; that his interest in the different costume worn by people of the same status in different countries was not peculiar to him is suggested by the fine anonymous German drawing of *c.*1517 of *Stablemen of Various Nations* (which bears a false, later, AD monogram).[5] Even clearer evidence of the taste, because expressed in more expensive form, is the Wallace Collection's closely observed early-sixteenth-century wood sculpture, *An Elderly Forester*.[6]

Meanwhile, some illustrated texts dealing with occupation groups had escaped from their medieval moralizing, mirror of society context, and reflected the life of guildsmen in terms of their working conditions determined by their own statutes. The Behaim Codex, written in German but compiled in Cracow and given its final form in *c.*1505 by a local notary, Balthasar Behaim, contains anonymous illuminations amassed during the previous half century.[7] They show the workplace and activity of a wide range of craftsmen and providers of services in what was then Poland's most prosperous city: innkeeper, haberdasher, baker, tailor, goldsmith, bowyer, painter (shown at work on a wall painting), metal founder, carpenter, sword and knifesmith, nailmaker, cooper, potter and tanner. The only soldier appears as a halberdier supporting the arms of the magistrate to whom the compilation was dedicated.[8]

The same omission occurs in the compilation, similar in origin but cruder in execution, that illustrates 127 trades- and craftsmen of Nuremberg who had fallen on hard times at their former work. The drawings in the Mendelschen *Hausbuch*[9] were accumulated between *c.*1425 and 1545. They include armoursmiths (Fig. 158) and armour polishers, mailsmiths, daggermakers and swordsmiths, spurriers and harnessmakers, and a single ex-soldier. In a sketchy illumination of a prayer for the humble dead in a 1469 Book of Hours (Fig. 159), as the devout reader prays beside a charnel house, skeletons arise from the cemetery bearing the symbols of the occupations they pursued during their lives: a rake, an axe, a baker's shovel, a flail, but also a bow, a halberd and a pike.

They were striking exceptions. Soldiers were excluded from the categories of occupations. They had no guild to protect and regulate them. They were not, like peasants and artisans, productive members of society. Unlike the Knight they were not, when they fought, obeying an obligation imposed on them by birth. In practice indispensable, in the categories of social order they had no ordained place. As late as 1568, in the most complete of all illustrated surveys of occupation groups, Jost Amman's *Ständebuch*,[10] they were absent. All the crafts that made war possible were there, from gunfounders and armourers to tentmakers. This banishment of the soldier from the normal, useful pursuits of men (114 occupations were described) was all the more telling in that Amman was, in other works and in independent prints, one of the most copious illustrators of military scenes of his generation.

It is not unreasonable to suppose that one element in bringing to the fore images of the soldier was the interest shown in depicting the 'normal' representatives of the Third Estate. And it is likely that the peasant played a mediating role between them. No working occupation was more frequently cited than that of the peasant, on whose labour the rest of society depended for its sustenance. No other representative was so familiar a pre-Renaissance figure: in the Adorations of religious and the Labours of the Months of secular art. Yet, detached from narrative, he became an equivocal personage.

The 'good' peasant toiled on. The woodcuts in the 1502 Strasburg edition of Virgil's *Eclogues*[11] use the daily occupations of the Alsatian peasant cultivator and craftsman to bring to life the rural occupations of ancient Rome. Dürer called on their rustic music and clumsy junketings to illustrate the margins of the *Jubilate* page of Maximilian's prayer book,[12] as Holbein the Younger had done in his *c.*1502 frescoes on the now destroyed *Zum Tanz* house in Basle.[13]

Yet from the first independent portrayals of peasants in the 1460s and 1470s – in

160. Master, bxg., *A Peasant and his Wife*. Engraving, *c.*1480.

the work of the Housebook Master, Schongauer and a number of anonymous engravers – there was a note of mockery: of their ragged appearance, their clumsy uxoriousness, their avarice, their love of a quarrel, their pretentious imitation of the manners of their betters. And later a veritable wagonload of urban vices was discharged upon them as social scapegoats: rowdyism, drunken vomitings, fisticuffs, and a slatternliness at once pathetic and overweening. Even Dürer, normally a fairly neutral observer of the social scene, could not resist a cool snideness in some of his depictions of their appearance and manners.[14]

Visually, peasants, more than other occupation groups, resembled soldiers. Isolated in the fields or in the remote lanes that led to market, they carried swords to protect themselves from the robber riff-raff spawned by rural and urban poverty. The tattered finery that endeared the soldier figure to artists was already there in the *c.*1480 virtuoso engraving by the Master bxg. *A Peasant and his Wife* (Fig. 160). He has the bells of Folly on his slashed jerkin, but the flute stuck into his boot, the sword in its worn-out sheath, and the goose in his basket, and his hand-clasp on an older woman who is nevertheless apparently content to follow his fortune, all identify him as a peasant in moneymaking but holiday mood. Fanciful as it is, the engraving is not far in spirit from some of the images of soldiers – recruited almost certainly in the majority from those who would have been viewed as peasants – that we have reviewed.

Images of the peasant-in-arms strengthened the association. From a woodcut of around 1490 which showed a peasant with a pike displaying the *Bundschuh*,[15] the emblem of his calling, standing on guard in defence of his growing crop and his harvested sack of grain, the identification became closer as the peasantry became, in sporadic revolts, more militant even before the linked series of revolts that became the Peasants' War of 1525. Throughout the period during which the alienated soldier image was elaborated, that of the semi-alienated peasant, both needed and scorned by the society which saw itself in terms of orderly urban society, was pursued with a breadth of pictorial interest withheld from the depiction of other occupations. In Sebald Beham's *Large Peasant Holiday* woodcut of 1535 (Fig. 161)[16] the two rogue categories are joined in a shared enjoyment of raucous recreation. Too much must not be read into the presence of Landsknechts at this festival occasion. Peasants became soldiers and returned on leave. But the print does suggest that the parallel deployment on the market of peasant and soldier images was not without some interaction that favoured the latter.

More significant was the tide that kept afloat in the north a general interest in the depiction of social types and their habits. It included the growing interest in chorography,[17] the physical description of countries and an inquiry into the manners of their inhabitants, and it contained three text-based themes that called for illustration and supported the production of single social images: the Dance of Death, the role of Folly, and the linked theme of the Pleasures of the World.

We have seen how the first came to include the soldier among death's targets. Neither the notion of Folly nor the persona of the Fool was peculiar to Germany, but it was there and in Switzerland that, thanks in part to his role as a familiar carnival figure and to the publication in Basle in 1494 of the *Ship of Fools* by Sebastian Brant (with woodcuts some of which have been attributed to Dürer),[18] images of the fool in a social genre context were most frequent.

The fool, both *agent provocateur* and critic, was an advocate of a naturalistic view of life. He could only make his point if what he was inciting or mocking was instantly recognizable as real, whether it was the folly of getting involved in an amorous party, as portrayed by Kulmbach,[19] or of joining the army. *The Schlüsselfelder Nef* (Fig. 162), a Nuremberg table centre of 1503 in the form of a silver gilt ship, presents in toy-like form a lively miniature of the teeming life on board. Sailors, some carrying weapons, serve the ship, tend its gear and guns. Others, off duty, play drums and pipes. A washerwoman launders their clothes. And, incon-

161. Hans Sebald Beham, *The Large Peasant Holiday*. Woodcut, 1535.

162. *The Schüsselfelder Nef*.

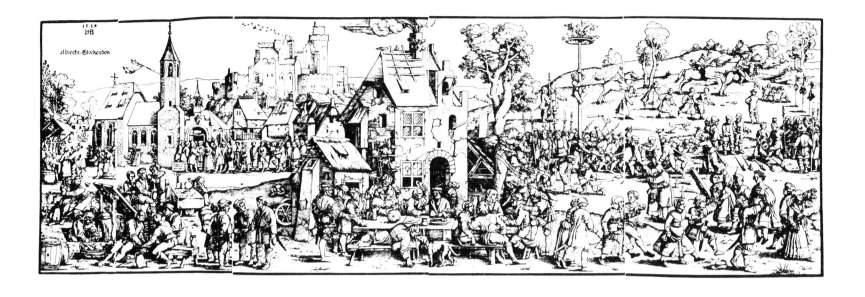

163. Albrecht Dürer (attrib.), *The Pleasures of the World*. Drawing, ?1496–7. Oxford, Ashmolean.

spicuous amongst them, is a fool. What does all this bustle, this risky venturing across the seas for profit really add up to in a sensible view of human values? That such a precious object almost certainly must have sailed across the table of a merchant whose success involved a dependence on overseas trade is no cause for surprise; this was the circle which, a century later, was to embrace, in the same mildly masochistic spirit, those still lives of heaped fish, fowl and vegetables which contained within their prosperous bounty a worm, a butterfly, a skull: symbols of the evanescent worthlessness of materialistic effort and accumulation.

The gathering of pictorial motifs of a moralizing nature into a composition that was 'descriptive, not prescriptive', has been primarily associated with Holland in the seventeenth century: Gerard Dou's *The Quack* of 1652 has been cited as an exemplary case.[20] But already by ?1496–7 Dürer, in his (if it is his) drawing *The Pleasures of the World* has made the formula his own (Fig. 163). In a swathe of meadowlands outside a town and framed between a lake and rocky hills, society is in holiday mood. A dignified couple stroll in their best clothes, followed by their attendant servants. Men and women eat and drink round a low table. A public bath has been installed under a rustic pavilion and men and women chat in and around it; wine flasks in a cooler are near at hand. Others visit a fountain that has been set up on the grass. A pair of young lovers are so wrapped up in one another that they do not notice two women quarrelling over a man who seems reluctant to be dragged off by

114

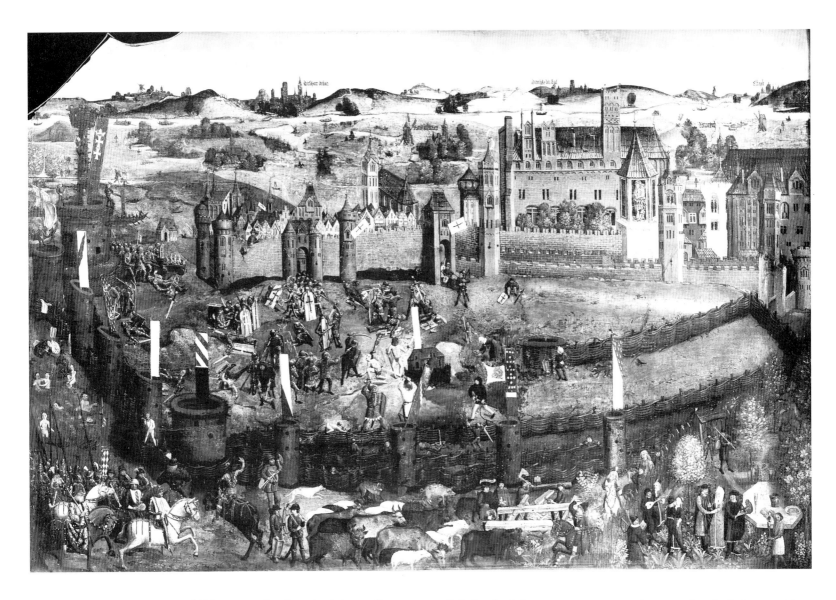

either of them. Drum and fife entertain the picnickers. Some men fish in the lake. One practises with his bow. Nearer the town a tournament is taking place within a square of spectators. The scene can be broken down into separate moral motifs: the pretentious merchant, the implicit licentiousness of the bath, the love garden meal, the unchaperoned young couple, the Fountain of Life (which kept alive the myth of sexual rejuvenation), the battle for the trousers. The existence of war is hinted at: the tournament, the target practice, the martial instruments, the St Andrew's cross on the back of the doublet of one of the picnickers identifying him as a soldier on leave. But it still looks like a scene of habitual human behaviour on a sunny day which can be read as genre.

Until, that is, it is read again. Then the inconspicuous figure of death, stealing in from the lower right-hand margin, emerges. In the picture he is noticed only by a dog who shrinks back, growling – and by a fool who, standing by a tree the artist decided not to go ahead with, extends a gesture of welcome. For they are old accomplices. The fool indicates mankind's absurdities and death comes in to reap when, preoccupied by the pleasures of the world, men are most ripe to pluck. For the artist, this complicity was one that linked the genre reporting of everyday life to moral rigour.

In a somewhat earlier, anonymous work (Fig. 164), painted for the guildhall of

164. Anon., *The Siege of Malbork*, ?c.1495. Now destroyed.

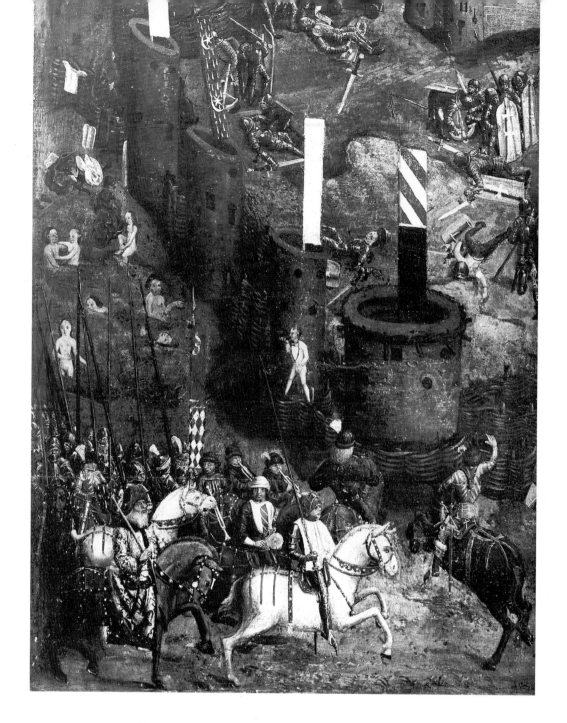

Danzig (Gdansk),[21] the horrors of warfare are shown shockingly juxtaposed to the Pleasures. Danzig is on the skyline – it is 40 kilometres away – from the fortified town of Malbork, a strategic base of the Teutonic Knights, who are shown defending it during the siege of 1410. The enemy has broken through the outer defences, planting their banners in its odd, tube-like towers, and fight with a skirmishing party from the town in the bailey. Swords swing, soldiers reload their crossbows behind the shelter of pavises, bodies litter the ground. Only feet away, in the moat on the left are other bodies, naked ones. But these are not drowned soldiers but men and women bathing, embracing. Into the picture, along the nearer bank, rides a group of cavalry (Fig. 165) to the sound of trumpets, following a drove of cattle, sheep and pigs. A nude woman, the water up to her knees, stands watching them as the procession passes carpenters at work on a (?)siege machine (Fig. 166) and approaches a paled-in garden on the right. Here a merchant feeds a monkey at a

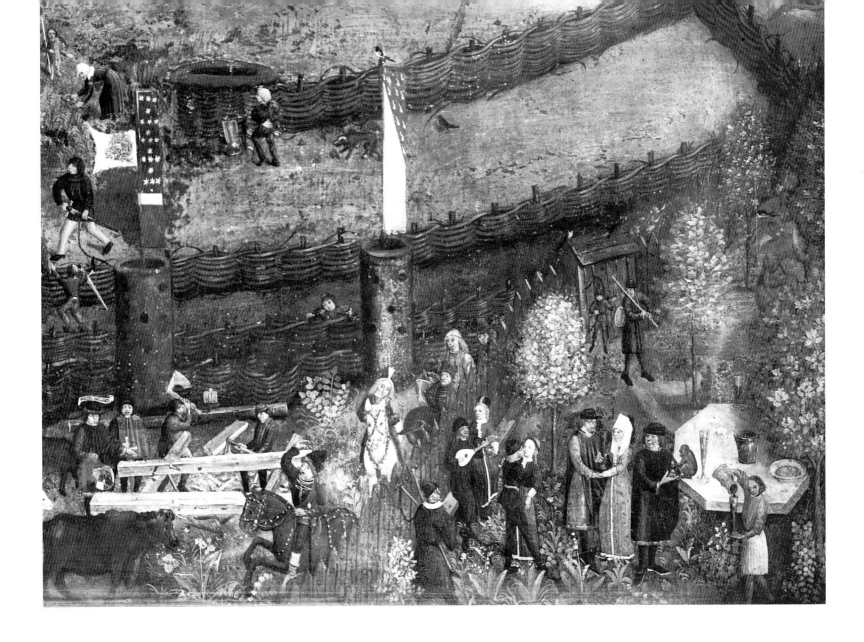

166. Detail of Fig. 164.

table while a servant pours wine. A middle-aged couple hold hands, a young one embrace. A musician plays a lute.

The overall drift of this strange painting, destroyed or lost during the last war and known only from photographs, is not easy to decipher: a warning that the military security of a crusading order in a hostile territory should go hand in hand with moral probity? The artist appears to have been familiar with Burgundian illumination, to have picked up themes most developed in Germany, and to have lived long enough in the zone of the Knights to have picked up the features, build and costume of their uneasy Polish-Lithuanian neighbour-antagonists. So much has perished in this unstable part of Europe that pictorial analogues in any medium are too few to illuminate either author or intention.

In Germany the connection between the Pleasures and the soldiery continued. In Hans Schnitt's 1521 drawing, *An Allegory of Human Life*,[22] soldiers, in the area allocated to early maturity, are among the occupations that cluster round a statue of Fortuna, drinking, listening to the fife, and dancing. On the right side of a 1520s painting by Hans Schäufelein (Fig. 167), the theme comes up intact: al fresco meal (with wine conspicuous), embracing young couple, fife and drum, bourgeois strolling in their finery, horsemen tilting. Beside them, and on a menacingly larger scale

167. Hans Schäufelein, *Christ on the Cross and the Pleasures of the World. 1520s.*

than the other Pleasures figures, Landsknechts gamble. And above them, reproachingly, towers Christ on the Cross.

In Italy the Pleasures theme found few echoes after its appearance in the Pisan fresco of the Triumph of Death (*c*.1350), to which it acts as a foil. Folly was not registered until the 1560s.[23] So two genre-inducing moral themes were weakly or not present there in our period.

Neither, to all intents and purposes, was that of the Dance of Death,[24] with its singling out for recognizable representation of a wide swathe of society. There was one print (a Venetian woodcut of *c*.1500),[25] but no drawings. The few frescoes that showed it were in marginal regions susceptible, because 'uncivilized' in terms of the native culture, to foreign influences, French or German: in Carisolo, Pinzolo, Como and in churches in the Tyrol or Istria.[26] And only at Clusone was there a veritable frieze of ranks and occupations shadowed by their personal deaths: emperor, pope, gentleman, magistrate, philosopher (or jurist?), student, merchant, alchemist (that tamperer with what God had made), artisan – and soldier.

Significantly, this frieze is a subsidiary motif to the main one, the *Triumph of Death*. Following the textual influences of Petrarch's *Triumphs*, and an instinct to follow a generalizing rather than a particularizing theme, the Triumph was more popular than the Dance; it made its way into many illuminations and prints. We noticed in passing that the 1485 Clusone figure of Death Triumphant[27] is served by two skeleton marksmen who fire at random into those who beg for mercy at his altar: one is armed with a bow, the other with an arquebus. And we can look back to another work, of about 1445, from a 'marginal' site, Palermo,[28] where a frescoed Death rides over a heap of victims on a horse stripped to muscle and bone into the fullest and last Italian version of the Pleasures of Life: a garden with a fountain, lovers and music. And we can draw the same conclusion: that in Italy neither the Dance nor the Triumph moved artists to treat the social scenes of their time in terms of genre; a laconic reference to identifying costume or activity was enough.

118

The organization and variety of crafts and Third Estate occupations were very similar north and south of the Alps even if, as in Nuremberg, guilds were not always self-regulating legal entities. On both sides the prosperous cities, which were the centres of both cultural production and consumption, echoed to the same sounds of artisanal labour, witnessed a similar traffic in the streets of porters, governmental officials, lawyers, doctors and merchants.

The delineation of ranks and occupations, however, appealed much less to southern artists in this period. The only programmatic series was contained within the sets of 50 'Tarocchi cards', engravings, perhaps Ferranese, made apparently for some partly instructional game. They show pope, emperor, king, doge, knight, gentleman (*Zintilomo*); below the salt only merchant, artisan (?goldsmith), a serving man and a beggar.[29] Other trades were illustrated, and delightfully, by woodcuts in books whose texts called for them; Masuccio's *Novellino* (Venice, 1492),[30] for instance, or the 1493 Florentine edition of Cesulis's book on chess (a blacksmith is an interesting innovation here),[31] or the moralizing *Contrasto di carnevale e quaresima*,[32] produced in post-Savonarolan Florence (*c*.1500) and containing a woodcut of a fishmonger's shop with a woman spinning and a girl selling strings of onions and other vegetables. But such scenes did not escape from their texts into the marketing of independent prints.

Similarly in painting, genre occupation scenes occur when the story calls for them. When Antonio Vivarini has Peter Martyr healing the leg of a carpenter, the wounded man is in his shed surrounded by planks.[33] In a carefully observed scene attributed to Spanzotti, the shoemaker saints Crispin and Crispianus are shown with their apprentices convincingly making and selling their shoes.[34] While the representations of St Augustine or St Jerome at work – Colantonio, Botticelli, Antonello da Messina, Carpaccio – make it clear that their writing is divinely inspired and part of the intellectual structure of the Church, the conditions in which they write are described with a particularity that gives any academic observer a pang of sympathy, if not of downright envy. But it is worth remarking that the most thorough depiction of a scholar's study is by a less talented artist, Giovanni Mansueti.[35] Generally speaking, while the artist of real genius could show the representative of a secular occupation convincingly when the story, or a compositional gap called for one (both surely produced the offering-seller old woman in Titian's early *Presentation in the Temple*), few, apart from such painters as Lotto whose imaginations dwelt outside the mainstream of aesthetic norms, saw the workplace or the street as appropriate settings for their art. And, in any case, the dwindling taste for small predella panels as loci for anecdotal reference to the careers of the subjects of altarpieces led the imagination of artists and the devout away from the recognizable here and now.

The two 'common man' themes that had engaged the imagination of Italian artists previously were, by the mid-fifteenth-century, dying out. Giuliano Amidei's miniatures in a 1460s manuscript of Pliny's *Natural History*,[36] with its pretty scenes of country tasks, a surgeon treating a patient, a smith working at his forge and so forth, suggest an approach to genre which now apologizes for its subject matter. The Planet Children illuminations (Fig. 168) in the early 1450s–60s *De Sphera* manuscript, place – as in the case of *The Children of Mercury* (those of productive intelligence) – craftsmen (scribe, painter, clockmaker, sculptor, armoursmith, a maker of musical instruments, a potter working at his kiln) in rooms within an eccentrically tiered classical architectural structure that expresses an impatience with the convention of showing, as in earlier Lombard miniature painting, men at work in separate scenes. This convention, as in the landscape settings for the engraved Planet Children, signifies a move away from those thematic support systems which, at almost this very moment, were increasingly sustaining in the north a scrutiny of the soldier's role alongside the more orthodox occupations of society.

A genre theme that did find continued patronage in Italy, and for large-scale cycles, was the Labours of the Months or Seasons. As in the north, this appealed to

the landed nobility, whose hunting excursions made them familiar with country people and their tasks and among whom the convention ministered to a pride of possession. A few cheap prints reflected its glamour, a series of clumsy woodcuts produced in Venice *c*.1500[37] exude an unsteady point of view which has, under the sign of Leo, coopers tamping down the binding rings on casks in preparation for the vintage, while under Gemini men ride out in pursuit of a unicorn. But this was above all a princely subject – as in Francesco del Cossa's frescoed *Months* (completed 1470) for Borso d'Este of Ferrara's Palazzo Schifanoia with its peasant pruners – and from then on, as courtly culture saw sophistication as lying elsewhere than in country matters, a geographically peripheral one, restricted to the northern borderlands of 'Renaissance' Italy: the Franco-Lombard Val d'Aosta, and Friuli, a region where itinerant Austrian and Bohemian artists touted for hire among remote castles and rural churches.

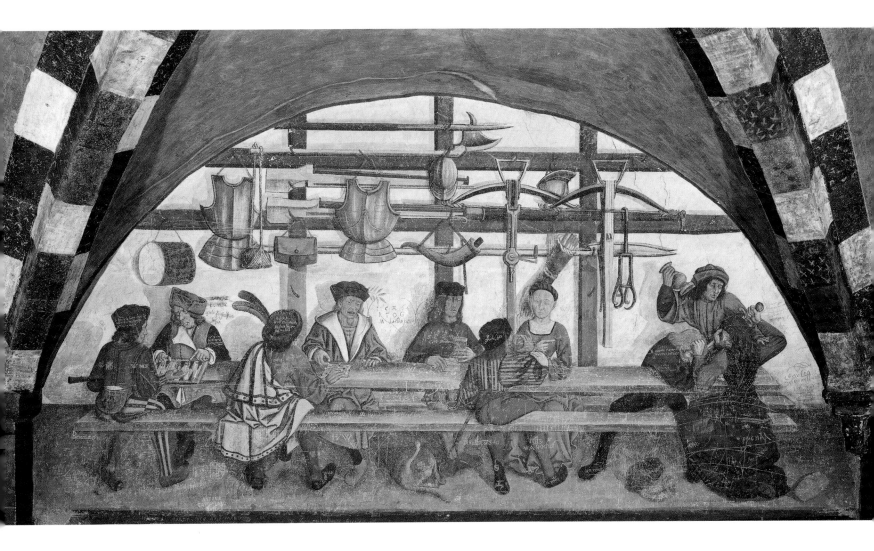

It was in the former, in the castle at Issogne, owned by the Piedmontese de Challant family, that in around *c*.1500 two pictorial traditions, the Labours and the shopkeeping Vendors that had been the stock-in-trade of late-fourteenth-century Lombard illuminated texts, surfaced together a century later to winning effect.[38] The work of mural painters, anonymous, and of rather more than adequate talent, and seemingly aware not only of Lombard tradition but of current German practice *à la* Kölderer, this Val d'Aostan outstation constitutes the high point of later Italian genre painting on a large, serial scale.

Among the courtyard paintings are represented the shops of piemaker, greengrocer, apothecary, draper – populated rather than animated by their assistants and customers but based on fresh observation as well as trecento manuscript tradition. Here, too, is a scene without precedent (Fig. 169). Members of the castle guard and a woman, presumably housekeeper to the out-servants among whom the guard would have been numbered, sit talking and drinking at a long table. At one end two men play backgammon, at the other – a German grace-note – three fall to blows. All are in civilian clothes. But behind them, on wooden racks, hang weapons, armour, drum.[39] The scene records a rare moment of tranquil co-ordination between the northern and southern approaches to the treatment of everyday genre subjects.

Similarly betwixt national conventions are the open-air scenes in the baronial hall. The Months formula, so determinant in the *c*.1406 frescoes in that other 'baronial' residence, the Castello del Buonconsiglio in Trent, has been dissolved into travelling and hunting scenes reflecting no schema, but the leisure pursuits of the owner.

169. Anon., *Guard Room*. Fresco, *c*.1500. Castello di Issogne.

Again, Kölderer's work on the hunting and fishing books he illustrated for Maximilian come to mind, perhaps shifting the conventionally accepted date for the Issogne frescoes a few years forward. Characteristic among them – and particularly suggestive of the *Fischereibuch* – is the *Hunt beside the Estuary*. There is no hunt in full cry here.[40] Huntsmen tend their dogs. One, watched by an expectant hound, bangs on a tree to startle the birds. Boats ride on the water. Men stand around, peer into bushes. No astrological sign parades in the sky. No one has an occupation that is related to productive work. In another landscape scene,[41] also devoted inconsequentially to huntsmen rather than to the hunt itself, a falconer, it is true, twirls a lure to call in a hawk that has struck down a heron or crane, but elsewhere couples ride or walk, a man, in the course of conversation, cocks a crossbow, another sounds a horn, watched by passers-by. In the road in the foreground a huntsman with leashed dogs meets a peasant with a basket on his back followed by a wagoner perched side-saddle on his horse.

Peasants here, as they were to be in later Giorgionesque pastorals, are suitable furnishings of a rural scene rather than figures representing, or even merely symbolizing, a toiling order of society. At times the peasants in religious painting give the sensation, because of the deliberate uncouthness of their features, of genre: those for instance in Pinturicchio's *Adoration of the Shepherds* fresco at Spello of 1501.[42] Of the small group of later-fifteenth-century peasant prints all produced in Ferrara, which remained, in spite of its princely court, a market town, or in Padua, in whose *contado* wealthy Venetians first made their purchases of country estates, although one, Benedetto Montagna's *Peasant and his Wife Quarrelling*,[43] was clearly of German inspiration, others are studies from the life which, apart from the Mantegnesque *Two Peasants* of *c.*1480–1500,[44] which would have been a useful model for any painter's workshop, reflect the condescension or invitation to ridicule (in one case pornographic) that was part and parcel of the Italian literary attitude to the peasantry. Allowance must be made for the rarity of these prints; there may have been others, though the infrequency with which they were collected and cherished suggests an indifference to this as to other 'occupation' subjects, which have been lost. The beautiful small bronze of a *Peasant Boy* by Severo Calzetta da Ravenna[45] (but made in the later fifteenth-century when he was working in Padua) and the calmly realized peasant figures carved into the Paduan chimneypiece in the Victoria and Albert,[46] stylistically tied to the workshop of Andrea Riccio, point to a steadier vision. But even if the less ephemeral evidence of illustrated books – the woodcut of a peasant sowing seed in the Florentine *Operetta delle Semente* (*c.*1500),[47] for example – is added to these instances, it does not appear that there was much interest in the occupation category of genre which in the north encouraged artists to include, indeed promote, the figure of the soldier.

This imbalance, the unlikelihood, for instance, of an Italian illuminator producing the range of genre scenes of industrial technological and working practices illustrated in the late-fifteenth-century Kutná Hora Gradual in Vienna,[48] or a printmaker issuing anything like the *c.*1480 woodcut, by Hans Paur *The Household Utensils Necessary in Married Life* (Fig. 170) (which includes weapons and armour along with cooking utensils, casks and salt-box, scissors and combs), ceases to surprise within a longer perspective of the Italian interest in representing scenes of everyday life.

By 1450 this had already had its heyday. The relief sculptures on the Fontana Maggiore in Perugia itemized the Labours of the Months in the 1270s. Giotto planned in 1334–7 the reliefs of trades and occupations at the base of his campanile in Florence. Both reflected not so much an interest in the artist's fellow men as a concern for the range of human activities that constituted the baseline of laborious existence after the Fall and that deserved inclusion in any definition of protective justice. The same point of view was absorbed with astonishing visual precocity into the town- and countryscape of Ambrogio Lorenzetti's *The Effects of Good Govern-*

ment fresco (1337–9):[49] shops thrive, school is open, peasants toil unmolested, merchants confidently ride abroad with their wares. Justice ministers to gainful employment. And the soldiers are there – and in their dual role: they apprehend villains when government is good, they kill the innocent and 'arrest' women in order to rape them[50] when Lorenzetti turns to *The Effects of Bad Government*.

None of these artists walked abroad blind to the appearances of day-to-day life. But journalistic observation was subordinated to schemata. The many craft and commercial occupations illustrated in the Florentine commodities tax survey manuscript of the *Stratte delle Porte*[51] are there because they are all subject to import dues or the equivalent of VAT. The humorous genre-like 'strip' at the bottom of a famous illumination in a *c*.1380 manuscript of a Bolognese chronicle,[52] showing a shopping street in which a countryman is inserted into an ill-fitting coat and presented with his bill while the draper purringly rolls up the rest of his bolt of material, is there because the genial artist's job was to portray an aspect of the city's prosperity. By 1400, within the flourishing late trecento vogue in Lombardy for herbals and more specifically medical treatises,[53] there are signs that the illuminations of peasants gathering various crops, of customers purchasing at shops such health-giving commodities and condiments as meat, fish, bread, cheese and salt, or of stores vending medicaments and bottles and jars to store them in, are becoming stereotyped from workshop models, lacking the surprised, constantly refreshed sense of visual awareness that was to underlie the later northern observation of soldiers.

From the early quattrocento the flight from genre is exemplified in successive manuscripts of the *Decameron*. From echoing Boccaccio's interest in the pots and pans, the beds, chests and cupboards amidst which many of his bourgeois characters plotted their lives (or were plotted against) the scenes become refined towards more courtly or classicized settings.[54] Anyone who has sought to illustrate the everyday life of Renaissance Italy has noticed how progressively difficult this becomes, though there was plenty of fresh, genre-like observation when called for by a specific narrative. Thus Salimbeni clearly relished the opportunity to show the

171. Lorenzo Lotto, Study for intarsia. *Judith with the Head of Holofernes* Drawing (detail), *c.*1524. London, Philip Pouncey Collection.

rowdy children of the indigent in his *St John Evangelist distributes Coins to the Poor*.[55] Pinturicchio, in the background to his 1501 fresco at Spello, *The Annunciation*,[56] depicted a vignette of life around a country inn that strikes a convincingly unjudgmental, unaestheticizing truth to social life. Granacci hit the same note of verisimilitude in his glimpse of a riverine mill in the background to his roughly contemporary *Birth of the Baptist*.[57] But it was north Italian contact with German prints that led, as we shall see, to a stronger vein of contemporaneity and naturalism in religious painting, though seldom together with the strong genre content of Lotto's *Judith with the Head of Holofernes*.[58] While his interest in everyday life and occupations was unusually alert, as in the bending line of men and women reaping or the row of chaffering market women in his *Legend of Santa Chiara* frescoes at Trescore Balneario, near Bergamo,[59] the 1524 *Judith*,[60] which follows the German practice of combining the decapitation with the (subsequent) battle of Bethulia, picks up hints from German military genre across the whole composition but most notably on the right (Fig. 171), where as dawn breaks some soldiers still sleep on while others bestir themselves and one ostentatiously urinates outside his tent. This, from a major, if at the time not fully appreciated, artist of the Italian cinquecento, was an astounding detail.

It remains surprising even when recognizing the *Judith* as not for a painting but a

124

design for intarsia: for a choirstall, executed by Gian Francesco Capodiferro, in Bergamo's S. Maria Maggiore. Lotto's approach, therefore, was much more akin to the printmaker's than an artist's. Though he made no prints himself, he was, when a commission made it appropriate, sympathetic enough to lean towards their genre content rather than – as was the commoner reaction – to take hints for landscape, distant buildings, or an overall, revivifying emotionalism.

It is the rarity of this reaction that brings us back to the question of imbalance.

If we were to survey German/Swiss painting as we have Italian, the genre pickings would be equally thin. The selective expectations of patrons, the time and money consumed in preparing walls, panels and canvases for the paint surface, in grinding pigments and preparing emulsifying and binding agents, scaffolding or framing costs, the wages, in many cases, of workshop assistants: all these factors combined to create a frontier between on the one hand what subject matter was appropriate to cheap art and, on the other, what to expensive art. North of the Alps this was a frontier easily crossed; we have seen how painters from the Housebook Master to Altdorfer could keep a foot in both camps. In the south it was not. With few exceptions the painters who crossed the media divide did so not to pick up new subject matter but to propagate their own wares. Those who worked on the print side either waited for book publishers to tell them what to do or catered for a gift-shop version of sophisticated taste: unenergized religious tokens, fashion plates, pretty love scenes which, if they acknowledged carnality, made of it an acceptable form of play. What survives may not, particularly in the case of woodcuts, represent the full range of what was produced, but it does seem that the print market neither asked for nor was offered images reflecting everyday scenes and occupations other than the few we have noticed. Neither in paintings and drawings nor in prints was there an easy point of entry for the image of the soldier.

In 1503 an active Venetian publisher, Christophorus de Pensis, produced a woodcut frontispiece to *La Spagna Historiata* which incorporated a number of military genre motifs (Fig. 172). In the centre, three officers sit on chests in a tent. Beside it a soldier adjusts a guy-rope; another pulls on a shoe. In front a soldier rests on the ground; two others sit on a dismounted cannon. Further back, soldiers stand conversing, a drummer strikes his instrument, a trumpeter sits on his shield, a crossbowman cocks his weapon, another soldier sits drinking. The effect, though scrapbook-like, is contemporary. But the book is one of the many variants of chivalrous 'Charlemagne' romances. And the woodcut is not a fresh interpretation of medieval romance in terms of modern observation. The captains in their tent derive from the frontispiece to a 1493 edition of Antonio Cornazano's rhymed treatise *Del arte militar*[61] which was in turn taken from that prefacing the Veronese 1483 edition of Roberto Valturio's *De re militari*, one of the most famous of fifteenth-century Italian illustrated books, and which in its turn drew on earlier, manuscript, models. The resting trumpeter, the standing soldiers conversing on the left and the men sitting on the cannon are transposed from another famous prototype: the frontispiece to the verse romance *Altobello*, published, also in Venice, in 1499.[62] This was reused in other romances: *Aspramonte* in 1508, *Danese Ugieri* and a new issue of *Aspramonte* in 1532. Meanwhile, however, it had also been used as the frontispiece (Fig. 173) to a poem which did record a contemporary event: an anonymous commemoration of the May, 1509 Battle of Agnadello.[63] Issued in Vicenza probably – it is undated – before the end of that year, it records the protagonists in a campaign that forced the Republic's army, or what was left of it, to the very fringes of the lagoon, and created the nearest approximation to a breakdown of public morale that Venice experienced before Bonaparte's extinction of its independence in 1797. Vicenza itself was then under German occupation.

The reuse, adaptation and pirating of book illustrations is a familiar aspect of the early press. Still, the point that the story of the Agnadello frontispiece makes is not unindicative. It was published by a German, the little-known Rigo Todesco, in a

172. Title page, *La Spagna Historiata*. Woodcut, Venice, 1503.

173. Title page, *La historia de tutte quante le guerre fate el fato darme fatto in geradadda . . .*, Venice, ?1509.

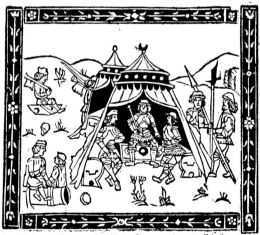

year outstanding in the history of Venetian art. Giorgione and the engraver Giulio Campagnola were in their prime, though both were to die young and untowardly in the following year, 1510; Giovanni Bellini and Carpaccio, though ageing, were developing in unexpected bursts of originality, Titian and Palma Vecchio were completing their eager, tyro years; Sebastiano del Piombo had not yet decided to quit Venice for Rome. Yet the frontier held between 'art' and 'genre', and grim Agnadello was served up with the automatically rehashed smiling face of medieval romance. In spite of ingenious attempts to show that Agnadello and its aftermath did break in, if only via allusion, to the imagination of artists, even determining the subject matter of Giorgione's *Tempesta*, the arguments are unconvincing.[64] Nor did Italian artists respond to the next most famous military catastrophe, the brief siege and consequentially prolonged Sack of Rome by Charles V's loot-mad army in 1527.[65] To contrast this visual silence with the number of drawings produced by German artists in connection with the Turkish siege of Vienna two years later is perhaps unfair. The Sack of Rome was an Italian humiliation; the raising of the siege of Vienna a cause of German pride. The contrast is, in any case, irrelevant. Well before the 1520s a far more general factor had come to influence the discrepancy we are investigating.

If the arts in Italy were, as far as contemporary soldiers were concerned, 'Off Limits to Military Personnel', this was partly because in Italy there were theoretical notions about what art should look like, and what subjects it should deal with that were scarcely echoed in the north before the figure of the soldier and the variations played on it had acquired a momentum fuelled by an absence of rules about pictorial decorum. In a country 'averse to theorizing about art', as Erwin Panofsky put it,[66] artists recorded, played with what interested them without glancing over their shoulders towards the figure of Aesthetic Respectability. Dürer, who had long worried at intervals about his naïvety vis-à-vis the rule-respecting south, commented in 1525 that

> up to now many able boys in our German lands were placed with a painter to learn the art, where, however, they were taught without any rational principle and solely according to current usage. And thus they grew up in ignorance, like a wild and unpruned tree. Thus it is, that some of them acquired a ready hand by steady practice, so that their work was produced powerfully, but without forethought and simply as it pleased them.[67]

It was these unpruned trees that burgeoned with a permissive brio that allowed the jagged silhouette of Hans Leinberger's statue of Albrecht of Habsburg (*c.*1514–18)[68] for Maximilian's monument in Innsbruck, and iconographical extravagancies such as Baldung's operatic *Christ lifted to Heaven* woodcut,[69] and his later, by then flagrantly anti-Italian, painting of *Hercules and Antaeus* (1531)[70] with its blubber-like treatment of gripped flesh and grimacing sense of strain.

In his 1557 dialogue on painting, *Aretino*, Lodovico Dolce said of Dürer himself that 'had he been born and educated in Italy I am inclined to think he would have been inferior to none',[71] and this was Vasari's opinion, too: 'truly, if this man, so singular, so diligent and so universal, had been a native of Tuscany . . . and had studied the works in Rome as we have, he would have been the finest painter in our lands'.[72] According to Francesco de Hollanda, Michelangelo, while granting that Dürer was 'a delicate painter in his way', wrote off northern art because 'it is practically only the work done in Italy that we can call true painting'. As for other artists, 'if by some great miracle one of them attains excellence in painting, then, even though his aim were not to imitate Italy, we say merely that he has painted as an Italian'.[73]

Criteria of excellence had been applied at least from the competition for the Florentine Baptistery doors in 1401. They were elaborated in Leon Battista Alberti's *Della Pittura* of 1436. In 1442 Angelo Galli praised Pisanello's work with the easy

sophistication which Dürer found so lacking among his fellow countrymen over sixty years later; heaven had granted him, Galli wrote, skill in 'technique [*arte*], proportion, poise [*aere*], draughtsmanship, personal impress [*manera*], perspective and naturalness.[74] Deriving from Alberti, and more important than such categorizations for our topic, was the development of an aesthetic that stressed the selective refinement of raw nature by the exercise of the intellect, the avoidance of confused compositions or distortions of the human figure ('I have observed from Nature,' noted Alberti, 'that the hands are very rarely lifted above the head, or the elbow above the shoulders, or the foot lifted higher than the knee'),[75] and the overall need for a delightful effect of grace and decorum.

The untidiness of war, and the strained movements of men fighting for their lives, were, as we shall see, in need of considerable chastening to bring them within the rules. This was also true of emotive religious subjects. Michelangelo, again according to Francesco de Hollanda, admitted that northern art will 'please the devout better than any painting of Italy, which will never cause him to shed a tear'. Its appeal, however, was restricted 'to women, especially to the very old and very young, and also to monks and nuns and to certain noblemen who have no sense of true harmony'.[76]

As for the soldier, whether soiled peacock or reach-me-down slattern, he was also unwelcome in an aestheticized view of art in which – *dixit* Alberti – 'everything should . . . conform to a certain dignity'.[77] Such a view was inimical to everyday genre in general. And it was socially as well as aesthetically selective. In another influential mid-century (*c.*1460–4) work devoted to artistic rules, Filarete's treatise on architecture, the author throws off the assumption that the lowest social orders 'are not so beautiful to look at as the higher groups'.[78]

Reflecting and intensifying the influence of classical sculpture, Alberti had recommended that 'for a clothed figure we have first to draw the naked body beneath and then cover it with clothes'.[79] This advice was taken seriously. Raphael made nude studies (Fig. 174) for the soldiers in a projected *Resurrection*. He sent as a gift to Dürer other nude studies from his workshop, including one for a soldier in the *c.*1515 *Battle of Ostia* in the Vatican Stanza dell' Incendio.[80] By the time of Vasari's battle frescoes in the Palazzo Vecchio it had become habitual to sketch soldiers in the nude and then clothe them as minimally as possible.[81] Soldiers were thus removed from reality by being imagined (in art) as first and foremost bodies, the supreme challenge to an

175. Pesellino, *Scipio Africanus*. Miniature, mid-fifteenth century. Leningrad, Hermitage

artist's taste and skill and therefore, in form and gesture, to some extent idealized. And this aesthetically motivated device was seconded by the concept of heroic virtue that became associated with the nude, whether in Donatello's bronze or Michelangelo's marble *David*, or in Bronzino's portrait of Andrea Doria as a nude Neptune or Poggini's statue of Duke Cosimo I standing naked in the Boboli Gardens.

Social, aesthetic, conceptual considerations all dropped as so many screens between the real soldier and the 'soldier' of the artist. And they were, as has been hinted, connected with a fourth: the humanistic admiration for the soldiery of classical antiquity. Whereas in the north the word 'soldier' in a cultural context signified the Reisläufer or the Landsknecht, in Italy the more congenial association was with the Roman legionary.

Aesthetic principles played a part in identifying Roman soldiers with the costume least frequently shown in the chief sources of knowledge about their appearance, the reliefs on sarcophagi, Trajan's and the Antonine columns and the Arch of Constantine. Rather than representing the most common combat equipment – the hooped *lorica segmentata*, scale or mail armour, or the simple short tunic – the cuirass, a parade piece reserved for senior officers, was favoured because it most nearly approximated to the nude torso. Prominently nippled and navelled, the developed *cuirasse esthétique* in which Vasari represented Cosimo I as Augustus,[82] becomes no more than a film of paint cosmetically emphasizing the body beneath. In similar vein, the frescoes by Perino del Vaga and Pellegrino Tibaldi in the Sala Paolina in Castel S. Angelo leave little to be guessed at anatomically beneath the lusciously revealing Roman 'armour' of Alexander the Great.[83]

The Romanized princely portrait drew on values arising from a long tradition of representation of ancient heroes: valour, leadership, magnanimity. Reacting to the humanistic apprehension of the nature of historical time, artists took some pains to show them appropriately clad. In an anonymous early-fifteenth-century Paduan drawing[84] the armour of Marcus Aurelius and Vespasian are carefully distinguished from the medieval plate worn by Edward the Black Prince and – a leap in the dark, this – Tamerlane. In the mid-century Pesellino saw his task as the illustrator of a manuscript of Silus Italicus's *De secundo bello punico* to be to extract from the story simply the figures of its heroes; rugged warriors like Hannibal and Scipio (Fig. 175) emerge romantically as slim Florentine youths with resolute expressions and wearing the glued-to-the-body cuirass with a nonchalant indifference to what the restricting effect of the real thing would have been, whether of metal or heavy leather. In a set of *c*.1500 engravings of heroes, Achilles and Troilus,[85] though lumpenly drawn (the inept musculature of the thorax reflecting the spell of the cuirass) popularize still further the chronological location of the Antique already recognized in a host first of cassone scenes and then of book woodcuts of scenes from ancient history and myth. And whereas Pisanello had been called to Mantua in the 1450s to display Gonzage military culture in terms of the then fashionable Arthurian chivalry, the ruler of Mantua in the 1530s chose to associate his military values with the renown of Caesar.[86]

In the north the figure of the knight was maintained in portraits and tomb sculpture throughout the period in which the image of the ordinary soldier established itself. In Italy the representation of a commander in the armour he actually wore remained a valid alternative, indeed the dominant one, alongside that of the hero as classical warrior *redivivus*. Duke Francesco Maria of Urbino, though a student of classical warfare, was as happy to be portrayed in contemporary heavy cavalryman's armour in 1536 as had been his predecessor Duke Federico of Montefeltro in *c*.1475, patron of humanists though he had been. Yet in Italy the leakage from the humanistic interests of the patron class either etiolated the figure of the ordinary soldier or semi-classicized it. Typical of the representational no man's land in which artists of average ability found themselves is Biagio d'Antonio's 1480s panel *The Departure of Sextus Tarquinius from the Roman Camp at Ardea*.[87] In the fore- and middle-ground

the troops are fairly fully realized with classicizing care. In the background their colleagues approximate to the 'thin' contemporary convention we have already noticed.

Below the level of the formal commission for tomb or portrait there was a real split between reality and culturally determined fashion.

In what were still small centres (Florence had about 65,000 inhabitants in 1500) artists were unlikely to be unaware of the growing taste for such antique artefacts as gems, coins, ceramics and statuettes, as well as for architecture and monumental sculpture, or the parallel admiration for the methods, morale and achievements of Roman armies that was established well before Machiavelli in his *Art of War* (1521) made of them a stick with which to beat the soldiery of his own day. Riccio's Paduan bronze statuette of a Roman *Warrior on Horseback*[88] was quite possibly executed in the year, 1513, in which Venice's Commander-in-Chief Bartolomeo d'Alviano proposed brigading reforms *more antiquo*; this was four years after Aldus had dedicated to him an edition of Sallust's *De coniuratione Catalinae*. That 'Roman' soldiers from around 1500 were increasingly shown in woodcut frontispieces to medieval romances, contemporary military chronicles and up-to-date handbooks to military practice suggests the extent to which the ancient took precedence over the contemporary soldier. The parallel taste for performances of classical plays and pageant-processions *all'antica* could also have spread the fashion, especially in republican cities where the associations of the 'knight' were either suspect or merely honorific. It is tempting, if no more, to think of such theatrics as underlying that unusual subject, the arming of Hector in the Florentine Picture Chronicle and its successor, an absurd engraving of *c*.1500[89] which shows two young women putting finishing touches to a young man's Roman parade armour, and to assume that both link directly to such meticulously annotated costume drawings as Perino del Vaga's glamorous *Roman Warrior* (Fig. 176).

Less conjectural are other aspects of the process whereby 'soldier' came to mean 'Roman soldier'.

In the pile of bodies shown in illuminations, woodcuts and engravings of Petrarch's *Triumphs* during the quattrocento, the representative soldier is a Roman one. The poem's subject matter is, it is true, heavily classical. Still, the soldier stands out among contemporarily clad prelates and merchants and other victims of the chariot wheels. The militant virtues that princes appropriated to bolster their own from Alexanders and Augustuses had been anticipated with the anonymous Roman soldiers who were considered the most appropriate guardians of the entrance to Michelozzo's 1462 Medici bank in Florence and we have noticed Rizzo's superbly nude-cuirassed sentinel of *c*.1476 who watched the approach of visitors via the Arco Foscari to the Venetian Ducal Palace: the Medusa-headed shield he supports does little to detract from his generalizing presence not as Perseus but as a Roman soldier. From the 1423 tomb of Tomaso Mocenigo in the Frari, Venetian tombs had employed Roman, rather than contemporary soldiers to symbolize the defunct's valour and fortitude; their presence on the tomb of Pietro Mocenigo erected in 1485 and that sculpted around 1493 by Tullio Lombardo of Andrea Vendramin reflected what was already a convention.[90] The true, the trustworthy, the admirably value-laden soldier was not the one whose services you negotiated for in the present (all these tombs were erected to doges who chaired the Collegio's troop-raising function) but men who had fought a millenium and a half ago. No wonder that in the 1530s and 1540s Roman façades (Palazzo Spada, Palazzo Gaddi)[91] drew on associations of virility from the soldiery of Antiquity rather than on that of their modern successors. Whoever held the parade shield of *c*.1550 in Glasgow's Kelvingrove collection was encouraged by the scenes on its inner surface to give confidence to his stride by considering the valour of the Romans (Fig. 177).

North of the Alps humanism in its studious, rather than merely allusive namedropping form, came late and was fraily established before the 1530s alerted artists

176. Perino del Vaga, *Design for Costume: Roman Warrior*. Drawing, ?1530s. Paris, Louvre, No.624.

177. *Pageant Shield.* Italian, *c.*1550. Glasgow, Kelvingrove.

178. Thomas Hering, *Judgement of Paris.* Hone-stone relief, *c.*1530. Berlin, SMPK.

to the historicist issue. It was then, and in the 1540s that Roman soldiers appeared as representatives of civic virtue (Holbein the Younger's design for the Basle Rathaus-saale of 1530)[92] or reliable custodianship: the guardian figures of the inner gateway of Schloss Hobentübingen of 1538 or of the tower stairway (1549) of the Dresden Residenzhof.[93] Till then, as we shall see, artists felt little reticence about keeping the present in mind when showing soldiers in biblical or mythological subjects (Fig. 178).

Throughout our period humanism in the north did little to wall off artists' subject matter from the military world of the present. In Italy it did. There humanism widened the gap between art and life. Its aestheticism cut interest in the inferior social origin of the common soldier and in the unkempt outline and asymmetry of his costume. Its historicism, coupled with a nostalgia for a time when Italy had ruled the roost of the known world, connived at his virtual exclusion from polite pictorial discourse. It dissipated, far more radically than did the northern itch to moralize, the genre interest in the here and now that in the north had supported the emergence of the figure of the soldier as a subject to cherish and develop.

But have the factors reviewed in this chapter adequately explained the discrepancy which is its subject? Did, in addition, the Alps constitute a temperamental as well as an acculturated divide? And, if so, might this have a bearing on the divergent reactions of artists to soldiers?

179. Frontispieces: St Augustine, *De Civitate Dei*, Basle, 1489; Venice, 1490.

The 'spirito nordico' which has recently been evoked[94] to explain aspects of the style of artists working in north Italian centres like Bergamo and Brescia, and their treatment of subject matter (which, in the case of Romanino, Pordenone, Lotto and Cariani includes – in religious works – soldiers)[95], is a phrase devised to bypass an almost irresistible confusion of terms; that between racial 'character', which, however modifiable by circumstance, has a basic gene set, and 'temperament' which tends to ignore race and sees the nature of art as balancing pictorial tradition with current social and religious assumptions and practices.

Writing in 1917 by the flames, as it were, of an incendiarized Reims cathedral, that hitherto delicately dispassionate art historian Emile Mâle wrote off German art as the derivative self-expression of potential vandals.[96] Four years later Friedrich Winkler, comparing fifteenth-century German with Italian art, carefully avoided confusing racial characteristics with artistic style.[97] But in 1931 Heinrich Wölfflin, in a book comparing north with south, fused the two concepts with references not just to 'the German imagination', 'the German nature', 'the German feeling for landscape', 'northern man', but with indications that 'the Italian man as a racial type' necessarily produced art of a different kind, that distinctions 'reach too deep to be grasped merely by consideration of society or the history of religion'; art, notably the instinctive way in which forms are rendered, follows racial nature, 'the natural feeling of the race for the body and for movement'; compare the gestures or the gait of Germans and Italians or 'the way a man leans against the door jamb of a house; the way a woman lifts a jug from a well – these things look different in the South than in the North'.[98] However, in his article 'Italian and German Art' of 1941 (not an easy year for Italian intellectuals) Roberto Longhi was, in a 'cautious comparison',[99] heedful to avoid leakage from tradition and temperament to character. And the distinction has usually been observed.

The difference in the appearance of a 1489 Basle woodcut title page (St Augustine, *De Civitate Dei*) and a Venetian redrawing of it (Fig. 179) in the following year – which, incidentally, retains the anachronistic handgun fired at the City by a demon – had been explained in terms of a 'contrast of temperaments'. 'The Germans of the Renaissance had one kind of vision and drawing and the Italians had another' wrote another expert on prints.[100] Speaking of the northern and Italian attitudes to genre, a

third author remarked that 'the two groups are temperamentally at opposite poles in the human experience of reality'.[101] A critic of Renaissance literature has explained that 'the Italian temperament' modified certain qualities of the northern chivalrous poems that were so influential in the peninsula;[102] the point is the same as that made in terms of the two *City of God* prints.

Given the restricted scope of this book such an exposition may seem laboured. But in the context of warfare national character is readily invoked and tugs hard at the more cautious notion of acculturated temperament. Were Swiss and Germans more militaristic by nature than Italians, and is that why their artists produced and gratified a public demand for images of soldiers?

Contemporaries would not have supported such a suggestion. Although, smarting from the defeats inflicted on them by their 'barbarian' invaders, from 1494 writers like Machiavelli, Castiglione and Guicciardini deplored the effect on the Italian character (particularly its leadership) of prosperity and the etiolating over-civilization this had led to, they saw the superior valour and discipline of their northern victors less as character traits deposited during the *Völkerwanderung* than as conditioned habits and traits resulting from differing forms of social stratification and civic organization, whether in Germany and Switzerland or in France, that other, equally 'barbarian' adversary. And no Renaissance traveller, however intrigued by the different manners and costumes, diets and monuments of the peoples amongst whom he passed, linked these colloquially to the notion of race. Today, though weighted by the heritage of Prussianism and two World Wars, we have only to remark the fading of northern interest in the figure of the soldier from the 1540s to see that 'character' is hardly relevant to our inquiry; and 'Prussia' is a reminder that neither in political nor artistic terms was Germany a unit to be freely generalized about any more than was Italy, with its 'schools' of art which, isolated in separate rooms in art galleries, are a reminder of the still perceived differences between the personalities and tradition of individual regions.

Discounting 'character', then, and turning to 'temperament', we need not follow on the one hand the austerely formalistic 'contrast between north and south' offered by the professional art historian Svetlana Alpers[103] or on the other the engaging impetuosity of the young amateur Patrick Leigh Fermor for whom 'the Landsknecht formula – medieval solidity adorned with a jungle of inorganic Renaissance detail'[104] provided the key to an understanding of southern German art as a whole.

Still, the latter's recognition of the Landsknechts' 'blinding haberdashery', their 'swashbuckling, exuberant and preposterous outfits' does dramatize the point that the Germanic affection for broken outlines and response to nature's proclivity to surge into excess helped artists to accept the soldier as he was and, indeed, joyously to embellish him still further.

Another relevant aspect of the Germanic artistic temperament was a concern for the communication of real sensory experience. There was no Italian parallel, for instance, to Hans Wechtlin's suggestion in his chiaroscuro woodcut of *c*.1512 (Fig. 180) of what it meant to St Christopher to realize that the child he was carrying across the river represented the full weight of the world. He staggers forward, nearly dumping Christ in the water, while his cloak billows upwards to emphasize his near collapse. Even so decoratively poetic a painter as the Master of the Bartholemew Altarpiece had St Thomas sink two fingers almost up to the knuckles in Christ's side in his *c*.1499 *St Thomas Altarpiece* (*c*.1499).[105] When St Erasmus's intestines are being wound out in an anonymous altarpiece of *c*.1520 in Graz and one of his executioners rummages thoughtfully inside his belly, we are not to see this in terms of sadism or the macabre but of a market town congregation containing farmers, butchers and housewives who would appreciate matter-of-factly how such things were done.[106]

Part of this way of communicating a sense of the real was based on a substratum of literalness. Thus a *c*.1470 relief illustrating the Ten Commandments from St

183. Michael Ostendorfer, *Pilgrims at the 'Schöne Maria' in Regensburg*. Woodcut, *c.*1530.

Peter's, Frankfurt,[107] has a hand, or hands, carved in front of each holding up the appropriate number of fingers. The reliefs of the Stations of the Cross commissioned in 1505 from Adam Kraft[108] were spaced from the Tiergärtnertor in Nuremberg to the Johannesfriedhof according to the number of paces between each stage measured by pilgrims who had walked the Passion route in Jerusalem. In similar vein is the crossbow in the hand of an executioner in a *c.*1490 sculptured group of *The Martyrdom of St Sebastian* (it lacks a working trigger but otherwise is identical with the rough military weapon of the time),[109] or those small, jointed and exquisitely carved wooden lay-figures like the 1520s example in Hamburg (probably from Salzburg)[110] with its individualized bearded face and meticulously rendered genitals. This head-on-ness, this permissive attitude to art as replica as well as refinement (it was Dürer, at the height of his preoccupation with Italian aesthetic theory, who invented the notion of camouflage – painted canvas screens to give the impression that battered fortifications were still intact), encouraged artists not to exclude what was ordinarily, obviously *there*, from admission to their subject matter. Of course Germanic art was selective, elaborative, personalizing as 'art' must be, but it was less excluding of what was familiar, coarse, ugly than were the more self-consciously tuned antennae of art in the south.

It was also – temperament again – more emotionally empathic. Religious art, as we shall see in Chapter 9, was commonly quite unhushed in its jabbing identification with scenes of distress and torment. These, in their search for immediacy, came, cautiously, to include the soldiers of everyday. A wider point is intended here. Quintessentially Germanic as a work midway between the near-sensationalism of a Jörg Breu and the measured distancing of artist from subject of a Dürer is Baldung's *Pietà* (Fig. 181) of *c.*1513 in Innsbruck. The sense of relevance to the viewer is not brought home by grimace or the updating of costume, but by the spatial nearness of the group who share their grief with us, the intense identification of the event with its landscape setting, whose forests have provided living crosses, and what are literally Grace-notes: the nailed foot of the Good Malefactor and the bulging wound in Christ's side. In spite of its concentrated stillness, this is not an imaginative world that would exclude other emanations, the soldier, for instance, from its naturalness. We have seen soldiers before lakes, beside trees, in glades.

Because of his ambivalent position in society (defender, destroyer, outsider), the soldier was potentially an emotive subject. So he was more readily accommodated than in the south within an art that was frequently overtly emotional itself and which accepted such scenes of genre emotionality as Michael Ostendorfer's view of pilgrims clutching wildly towards the image of 'Mary the Beautiful' in Regensburg (Fig. 183), or tumbling about before it in paroxysms of devotion. Such a scene would not have been allowed through the portals of art in the south.

Another image that could not have been produced there was the woodcut *Vanitas* (Fig. 182), an illustration to Geoffroy de Latour Landry's popular *Ritter von Turn*, published in Basle in 1493.[111] The woodcut (which has not been totally barred from the Dürer canon) shows a young woman pausing while combing her hair before a mirror. In it is reflected not the usual skull but the anus of the devil posturing behind her.

Less scatological than good-humouredly indecent in a moralizing cause, the image none the less is part of recordable subject matter in the north. We have seen a soldier fall out from the line of march to defecate by the roadside, women camp-followers crapping in rivers, soldiers vomiting. The parallel peasant genre points up their drunken gushings and cattle-like turdings. All this is very un-Italian. And no Italian torturer spits or farts at Christ while He is crowned with thorns.

The most interesting bodily function, then as now, was sex. We have noted how northern military genre emphasized this aspect of the soldier's life: the priapic codpiece, the cuddles, the companionship, the payments in cash or disease that were part of it.

182. Anon., *Vanitas*. Woodcut, 1493.

184. Hans Wydyz, *Adam and Eve*. Boxwood, *c.*1505. Basle, Historisches Museum.

185. Hans Baldung, *Fall of Man*. Chiaroscuro woodcut, 1511.

Pictorially expressed sexuality ran in different channels north and south of the Alps. A sex-in-the-mind pornographic prurience was common to both. In general, however, sexual diversion and provocative genital display was reserved in the south for classical heroes or the gods and their court entourages of satyrs, nymphs, nereids. Sexual dalliance avoided references to ordinary life. There is a north-south world of difference between Jacopo de' Barbari's nereid cupping a triton's genitals in her hand[112] and Beham's image of death interrupting a married couple while they caress one another's.[113]

If the Landsknecht's and Reisläufer's dealings with women enriched the scope of military genre it was because this was merely an extension of the interest in everyday sexuality that was part of the vocabulary of northern art. It lay behind the stereotyped theme of the Unequal Lovers, young women trading their bodies for old husbands' cash. It was generalized in that of the Fountain of Youth, with its assumption that the only thing that made life worth living was sex. The Fountain got as far south as Piedmont (a fresco in the Castello di Manta, near Cuneo)[114] but its temperamental home was Germany. The theme drew more generally on its commonplace analogue, the public bath. Italy had its spas. Literary sources suggest their curative and social importance. Visually they are unrecorded. When an Italian artist wanted to show a bathing scene he turned to northern prints.

Again, that concupiscence was a sin was a doctrinal truth universally acknowledged. Yet even if the distinction between pre-Fall innocent caressing and post-Fall intentional, appetitive coition had been known to artists, northern empathy saw the Fall in desert island terms: isolation, a virile man, an attractive woman, no clothes, a flashpoint – the serpent.

In Hans Wydyz's astonishingly naturalistically rendered boxwood group of *c.*1505 (Fig. 184), there is a note of apologetic comment: Eve is made to look seductive as she offers the apple, Adam apprehensive. Dürer, always fastidious about overt sexuality, none the less in works of 1510–11 shows the couple entwined as they approach the tree.[115] Baldung, rephrasing a motif from his *Unequal Lovers* engraving of 1507, shows in the *Fall of Man* woodcut of 1511 (Fig. 185) Adam taking the initiative with his hand cradling Eve's breast. A follower who adapted the composition was drastically franker about the pre-lapsarian goings-on in Eden.[116] The examples multiply, with varying degrees of freedom or moralizing iconographic comment. What they have in common, and what distinguishes these Eden scenes from Italian ones however anatomically free and easy (Jacopo della Quercia's *Temptation* relief)[117] or arguably coded to imply sexual appetite (Michelangelo's *Temptation* in the Sistine Chapel),[118] is their sense of congruence between the ineffable and the actual.

So, guardedly, 'temperament' may be accepted as among the many routes that led soldiers and their way of life with more welcome into the Germanic than the southern repertory of acceptable pictorial images.

CHAPTER 6
The Representation of Battle: Italy

T HE CONTRAST BETWEEN the approach to the representation of battles north and south of the Alps was less sharp.

Artists on both sides were faced by comparable problems, especially where the representation of recent combat was concerned: the technical impossibility of achieving verisimilitude, and the selective requirements of patrons.

Battles sprawled. Art condensed. Miles had to be shrunk to feet, even inches. The panoramic solution, highly developed in Machiavelli's prose description of an imaginary battle[1] and in Altdorfer's painted vision of an ancient one, *The Battle of Issus*,[2] were by definition distancing effects. To bring battle alive as remembered or imagined experience was to concentrate on persons or incidents and have recourse to conventions: modes as true to the drama of battle as is a curtain-call tableau to the substance of a play.

Eramus had a theatrical character, the Braggart Soldier, in mind when he had Hanno quiz Thrasimachus in his colloquy, 'The Soldier's Confession', but what the latter says is a fair estimate of the artist's dilemma.[3]

> *Hano:* Tell me, how went the battle? Who got the better of it?
> *Thrasimachus:* There was such a hallooing, hurly-burly, noise of guns, trumpets and drums, neighing of horses and shouting of men that I was so far from knowing what others were a-doing that I scarcely knew where I was myself.
> *Hanno:* How comes it about, then, that others, after a fight is over, do paint you out every circumstance so to the life . . . as though they had been nothing but lookers on all the time, and had been everywhere at the same time?
> *Thrasimachus:* It is my opinion that they lie confoundedly. I can tell you what was done in my own tent, but as to what was done in the battle, I know nothing at all of that.

Another estimate comes from the journal of a non-combatant eyewitness of the 1515 battle of Marignano, Pasquier Le Moyne.[4] He can't, he says, describe it. The distances were great, vision was limited by the dust raised by feet and hooves, reports that came into his headquarters unit (he was with the entourage of the Duke of Orleans) were conflicting and, in any case, were concerned with deeds rather than troop movements, anecdote rather than tactics.

Another, much later, writer spotted the same problem. In the Ducal Palace of Venice Charles Dickens raised an ironical brow when he noted 'the slaughterous battle pieces, in which the surprising art that presents the generals to your eye, so that it is impossible to miss them in a crowd though they are in the thick of it, is very pleasant to dwell upon'.[5]

Battles and sieges, extensive in area and time, had when represented to be fudged to the small scale and stillness of art. And, unlike soldier figures or essays in military genre, they were induced by commissions. Except as multi-purpose combat tokens for book illustrations they required a minimum at least of research and a repression

of spontaneous improvisation that made artists wait for secure orders for their wares. The battle piece had not yet acquired the decor status of the flower piece; that status only came with the mid-seventeenth century when it sustained the output of marketeer artists like the southerner Aniello Falcone[6] and the northerner Philips Wouwerman.

Unlike the soldier image, which was originated by artists, battles were reconstructed from written sources known to or shown to the artist. Medieval illuminators worked in as well as from texts; we know the chronicle accounts of Anghiari that formed part of Leonardo's brief for his fresco of the battle in the Palazzo della Signoria.[7]

By the mid-fifteenth century, chroniclers and humanistically influenced historians had worked out ways of controlling a description of the flux and complexity of battle through conventions: here a steady flow of the names of the commanders and civic or national units taking part, there a close-up of some moment of special crisis or gallantry; general impressions of swords clashing and horses colliding; standards raised aloft and the dead under the hooves; a list of notable captives; reasoned harangues and rallying war cries. There were few precise references to arms and equipment, almost none to tactics. There were rare references to the sounds of battle; it was artists who commonly showed trumpet and drum. Though surviving standards, such as those captured by the Swiss from the Burgundians in the 1470s, bring alive the Song of Solomon's 'terrible as an army with banners', little interest was shown in the colourful aspect of conflict, an omission compensated, indeed, overcompensated for in veristic terms, by artists.

Within the Netherlandish manuscript ateliers of the 1440s–70s that introduced a genre-like element into their adaptations of the conventions of earlier battle scenes, modified compositonal conventions were worked out which remained valid as basic organizing points for almost a century. Thus, foregrounds were for victims, scattered weapons, close-ups of commanders whether in discussion as allies or in combat as enemies. In the mid-ground came the clash between troops either shown as the clots of men ticked off as units by the chronicler or as a mosaic of single combats as celebrated by the author of a chivalrous romance. Whether the battle was ancient, medieval or recent, the contemporary reliance on a majority of infantry brought the reinvention of a shorthand device, the 'forest of pikes', as old as the tenth-century Joshua Roll, though it was German early-sixteenth-century woodcut artists who extended this with the 'fall of pikes' motif that signalized the encounter of two forests, the leading ranks lowering their shaft weapons for conflict. And other conventions remained because they could still be observed by town-based artists: the single combats of the joust, the pell-mell of the mêlée, with squires dashing in to pull the fallen out of danger. Into the background, emphasized by a new interest in the bird's-eye view if not by a conscious perspectival technique, stretched the landscape setting of the combat. Increasingly this included a town. As illuminators drifted towards a more realistic approach to the spaces left for them on the page, presumably with the connivance of scribes who shared their interest in the civic observation points of war, the battle in the open field became less attractive than the combat outside a city or a formal siege.

Here the artist could paint more of what he knew; the civic procession, in the guise of a troop issuing for skirmish from, or entering in triumph, a town gate; the besieger's bombards and ladders, so familiar from civic armouries; the siege towers, akin to the carpenter's work of normal building operations; the entourage of the general commanding the operation, extrapolated from the town guard or lord's *meinie*.

Transformed familiar scenes, provenly useful stereotyped devices which gave a readable syntax to a sprawl of narrative that had to be shrunk from epic to sonnet compass: these offered solutions, points of selection from flux, that hardly needed a provenance to occur in an artist's independent calculation of his approach. The

problems were as common to the commissions German artists were faced with as they had been to the classical sculptors and painters Italians drew on or, in the latter case, read about. Everywhere, the multifarious raw ingredients of battle had to be rendered down before being served in a guise manipulable by artists and palatable enough for patrons.

Like that other experience-tested subject, the portrait, the battle piece in our period represented a close alliance between an artist's instinctive urge to make sense of appearances and a patron's satisfaction in such a sorting process. Both looked for solutions within mutually congenial parameters. Classical battles should catch the exemplary disciplined valour of the ancients without losing an emphasis on the commanders who produced it. More pertinently to this alliance, representations of actions recent or within living memory should recall the scope and purpose of an enterprise, the key figures and components that led to its success, awaken in easily readable form pride in the past, and offer an example for posterity to do as well when need arose. Patrons were as anxious to see a selective pattern emerge as were painters. And this encouraged artists who had no wish to be merely pictorial chroniclers, to put Art well above Record. This was an impulse exemplified in many of the works we shall see and was actually given a voice by Vasari; writing of his large *Battle of Lepanto* in the Sala Reggia, he referred to the problem of sorting out his composition from such a mass of detail, oars, masts, rigging and the rest, but added that 'I hope, with the favour of God, that as this was His doing He will assist me to win such a victory with my brushes as the Christians did with their weapons'.[8]

So art was not to be the mirror of war's climaxes. Representations of battles did not express an artist's attitude to warfare, though in a later chapter[9] we shall encounter one work that points towards the disgust expressed later by Breughel, possibly Callot, certainly, later again, by Goya, Picasso, Dix, Bomberg, many others – the point is only worth extending so far forward in order to emphasize the ethical vacuum within which Renaissance artists did their best to make sense of formal, not moral, values. And we are not, before representations of battles were commissioned out of regimental pride in members' valour or from nationalistic appreciation of a display of valour in adversity, to look for commemorations of defeats, however worthy: there was no Renaissance *Charge of the Light Brigade* let alone a *Retreat from Moscow*.

From 1494 to 1529, Italy was the arena where the age's foremost conquests within Europe, most numerous momentarily decisive battles, most influential changes in weaponry and tactics were confirmed, most ghastly sacks took place. And these events coincided with the culminating phase of the Vasarian Rebirth, the acquisition by the peninsula's artists of an unprecedented mastery over the recording of visually perceived reality.

On the eve of the wars, the Marquis Gianfrancesco Gonzaga of Mantua, himself a military leader of distinction, commissioned from one of the city's most respected artists, Domenico Morone, a painting commemorating his family's establishment in 1328 of their power: *The Victory of the Gonzaga over the Bonacolsi* (Fig. 186). Morone rendered this civic mega-brawl in the main piazza in 1494 terms, as far as costume and architectural setting were concerned. Produced by the artist at the height of his powers, and accepted by Gianfrancesco at the height of his, the work exemplifies the battle painting's recourse to the sorts of convention we have been considering. Its composition has been analysed by Rudolf Wittkower:[10] the litter of victims and arms in front of the combat; in the mid-ground the chronologically sequential investiture of Luigi Gonzaga as governor of the city; in the background the enclosing townscape. In the foreground the fallen and the combatants have been arranged to lead the eye inwards and to provide symmetrical and ingeniously varied stances. In sum, 'every conceivable pose and action connected with battles has been brought together here'.

186. Domenico Morone, *The Victory of the Gon-zaga over the Bonacolsi*, 1494. Mantua, Palazzo Ducale.

This was a slice of dynastic history designed to be read as such, and Morone, though a fine painter, was a provincial conservative, a marginal figure in any account of the startling developments within the arts during the war years.

It should be noted at once that the wars hardly affected those developments. Here and there a commission was held up or cancelled. The 1527 Sack of Rome dispersed the artists working there, traumatizing, it has been claimed, the careers of some and in any case interrupting for some years Rome's status as a key market for the vending of artistic talent.[11] The effects of the earlier 1512 Sack of Brescia have not been charted. More generally, some careers were diverted for a while, as when Leonardo served Cesare Borgia as a military engineer or when Michelangelo was called to design new fortifications for Florence. Others came to be extended – as in the cases of Cellini, Rosso Fiorentino and Titian – by the enhanced possibilities of patronage that followed French and Imperial intervention in the peninsula. But the commissioning and creation of works of art continued and, apart from looted goldsmiths' work, remarkably little of what was produced was destroyed.[12]

Yet during those long years 1494–1529 with their battles which included some of the most decisive and renowned of any that had occurred in the peninsula (Fornovo, Agnadello, Ravenna, Marignano, Bicocca, Pavia), and with the almost constant trailing of large armies this way and that, only three direct records of military events were recorded by Italians for an Italian market. Two were on paper, an engraving and a woodcut. One was a painting on the wooden cover of an account book.

The engraving (Fig. 187) – the only one of the several hundred produced in Italy during the period which referred specifically to a military event – was by an artist known only from the unexplained 'Na Dat' and the rat trap which he adopted as his signature. Apart from the cannon and its ball, which were awkwardly introduced at

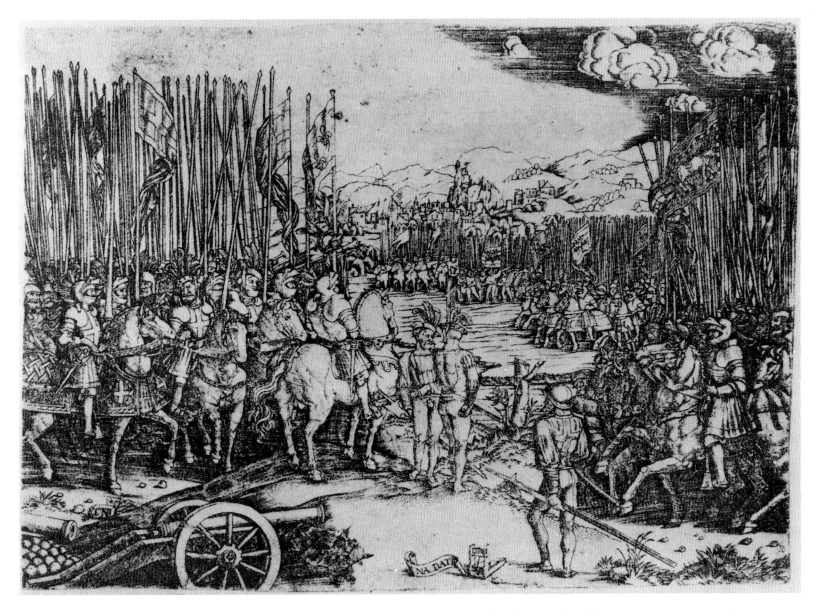

the bottom left as an allusion to the role (which was unusually determinant for the time) played by artillery in the action, it is a pictorially sophisticated vision of the curtain rising on a significant military engagement, the 1512 battle of Ravenna.

On the left, a French cavalry contingent reins to a halt, approached by their still-hurrying colleagues on the right. Between them, three representatives of their Landsknecht allies steady – in compositional terms – the gap. Beyond there move into action the Spanish and papal forces, horse and foot. With its combination of pause and movement, its reticence in displaying identifying marks (costume and standards), and its perspective deployment of the ground of the battle to come, this engraving, for all the flimsiness of the paper it was impressed upon, is artistically the outstanding visual document of the wars that we have from an Italian source. Possibly that source was Ferrarese; the Landsknechts reflect the German prints that were used by local artists in that city and the entirely un-Ravenna-like landscape background has a northern flavour; Duke Alfonso d'Este contributed cavalry to the French forces and it was his artillery, displayed here so emblematically, which, positioned by himself, forced the Spanish and papal cavalry to leave their stations before they were ready to, thus contributing to the victory of the French.

187. Master Na. Dat., *The Battle of Ravenna*. Engraving, 1512 or shortly after.

141

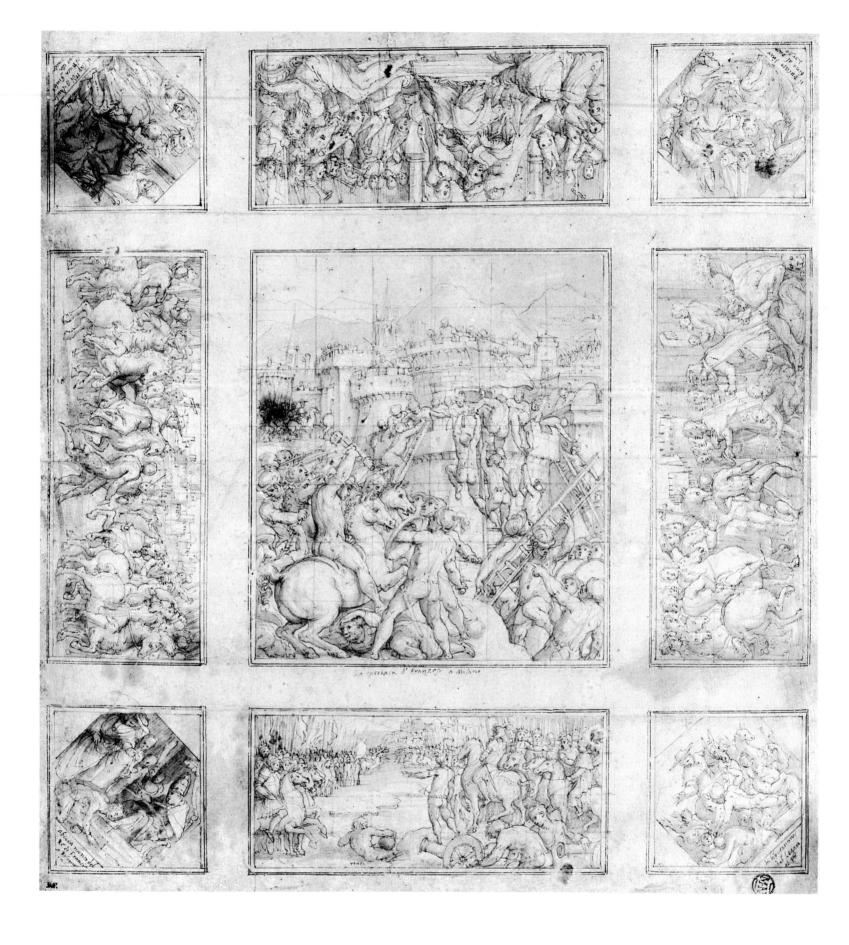

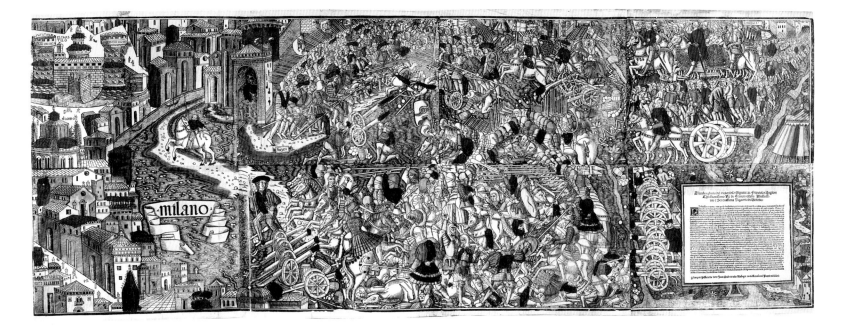

That the pictorial authority of this eve-of-combat scene was recognized as something quite unusual is shown by a 1518 copy, in reverse, by Agostino Veneziano,[13] which in its turn was copied north of the Alps – in a most unusual tribute to an Italian historical image – by Georg Hopfer.[14] And much later, in 1560, the composition was reused as the basis for a redrawn 12-block Venetian woodcut (of which only eight sections remain in the single copy known)[15] that for the first time identifies the subject as 'El fato darme da Ravenna'. Nor is this the end of the story of this remarkable image.

When Vasari designed the ceiling of the Sala di Leone X in the Palazzo Vecchio, he included the battle of Ravenna because Cardinal Giovanni di Medici, as he was in 1512, had been present as legate with the papal and Spanish forces. For his design (Fig. 188) he was content to copy the Agostino Veneziano version of the Na Dat engraving, with two modifications; he substituted a pointing soldier and a river god for the Landsknechts in the centre, and introduced two figures crouching over the guns.

It is instructive to listen to him explaining this largely stolen scene to Duke Cosimo, as he does in his third *Ragionamento*.[16]

Yes, he replies, that is Gaston de Foix in the right foreground on horseback; he is accompanied by his colleagues, Ives d'Alègre and Jacques de Chabannes, Seigneur de la Palisse. Prompted by Cosimo's question as to whether he has not included any other portrait of a famous commander, he identifies the young Alfonso d'Este among those in Foix's entourage, and the new figures, with the guns, as the bombardiers who re-sited them on his orders to such lethal effect. What is more, when asked who the river god is, he not only says that he stands for the tactically important Roncone (which, having invented the figure he was entitled to do), but goes on to invite Cosimo to admire 'the countryside and the city, which is represented from observation on the spot' ('*ritratta di naturale*'). This disingenuity, it should be said, is not characteristic of Vasari, who did, when time during the demanding Palazzo Vecchio programme permitted, visit and sketch the sites of the combats he depicted.

The second work on paper was the 8-block woodcut – contemporarily coloured in the sole complete copy in Zurich – of the 1515 *Battle of Marignano* (Fig. 189). Printed in Venice by Zuan Andrea Vavasori, this is the unique example of an Italian woodcut dealing with a battle that was an independent product. If Alfonso's artil-

189. Anon., *The Battle of Marignano, 1515*. Coloured woodcut, 1515–16. Zurich, Zentralbibliothek.

188. Giorgio Vasari, *Design for Ceiling of the Sala di Leone X*. Drawing, Paris, Louvre. Cabinet des Dessins.

190. Giovanni di Lorenzo Cini (attrib.), *The Victory of Camollia*, 1527.

lery gave a local-patriotic motive for the publication of the Ravenna engraving, then the last minute pro-French Venetian intervention under Bartolomeo d'Alviano on the second day of the engagement (represented in the block on the upper right-hand corner) might explain the print's place of origin.

It is a puzzling work. Whereas the Ravenna engraving was competently abreast of current artistic conventions, *Marignano* is confused, albeit vigorous, *retardataire* hackwork, sacrificing an adequately deployed presentation of the battle's phases itself to the presumably borrowed or pirated blocks on the left. These represent Milan – the object, but not the site of the battle – in the topographical convention of the later quattrocento (skilfully 'bled' into the adjacent blocks) and designed by a different hand working on a different scale. The Milan blocks may have increased the market, for the French victory did lead to their occupation of the city, but the 8-block format for a work so unfashionable in style implies a category of Italian purchaser that has not yet been defined, unless those who bought Titian's multi-block woodcuts which narrowly preceded it in Venice (*The Triumph of Christ, The Crossing of the Red Sea*) were less interested in artistic quality than is generally assumed. For *Marignano* is merely a conventionalizing broadsheet writ large, sparingly labelled and glossed by a written insert that glorifies Venice's ally Francis I and records his passage across the Alps but does little to explain the action itself as it is portrayed. If 'zuan Andrea dito Vadagnino di Vavasori' had as shrewd a business eye as did the Giovanni Andrea Valvassore who published roughly a book a year in Venice from 1532 to 1570, then rather than his riding on the temporary vogue for large 'art' woodcuts, we might assume losses over time of comparable works that could change our estimate of the Italian lack of interest in contemporary battle scenes.

The third record, a depiction on the wooden panel (Fig. 190) forming the cover to the Sienese customs acounts (*gabelle*) for 1527 of a citizen force's successful capture of the papal guns, when in 1526 Clement VII sent a force to compel Siena to join the Medicean politico–military axis, was patriotic in a more self-contained sense.[17] The action, known locally as 'the battle of Camollia' after one of the city gates that had been threatened by the guns, was of little historical interest save to the Sienese regime of the moment. Pictorially it is intriguing merely for the 'pin men' convention used in the same year by Dürer in his *Siege of a Fortress* woodcut, and for its reminder of the private towers which gave Siena's urban fabric so drastically different an appearance from the 'Renaissance' city centre that is cherished today.

If these were the sole records, they are not the only references to the wars. Proud of his role within the Venetian–Papal Holy League army which mauled Charles VIII of France's army at Fornovo in 1495 on its return from his conquest of Naples, the Marquis Gianfrancesco of Mantua sent Francesco Bonsignori to make drawings of the site, possibly with a view to a pendant to *The Expulsion of the Bonacolsi*. What survives, however, is the very different commemoration of his role in the Louvre *Madonna della Vittoria* by Bonsignori's teacher Mantegna, which was installed – with Mantegna working uncommonly fast – in the church of S. Andrea on the first anniversary of the battle. Armoured, the Marquis kneels in adoration in the company of Mantua's protector-saints, Andrew, the converted Roman soldier Longinus, and two other saintly warriors, Michael and George. His successor, Federico II, commissioned Lorenzo Costa in 1522 to commemorate not his military deeds, (which were performed on the Imperial side against the French) but his presence among troops in a mood of Roman triumph that alluded to the *Triumphs of Caesar* painted by Mantegna for his ancestor, the excuse perhaps being his appointment in 1521 as Captain of the Church.[18] And among other portraits of leading soldiers, Titian's of Francesco Maria della Rovere[19] is typical in that while the baton held by the Duke, and the row of others on the shelf behind him, refer to the commands he held in papal and Venetian service, no specific reference is made to any of the campaigns in which he served.

Other references were made through historical allusion. After the Venetians had raised the 1509 imperial siege of Padua, Gianantonio Corona, in the following year, contributed *The Meeting of S. Antonio with Ezzelino da Romano*[20] to the frescoed tributes to the saint's powers of miraculous intervention then commencing in the Scoletta. The defeat in 1259 of the Emperor Frederick II's tyrannous henchman was seen as prefiguring the city's recent liberation, a point strengthened by putting Ezzelino's retinue in Landsknecht costume. Again, Raphael's *Repulse of Attila* fresco, commissioned in 1511, 'refers to the divine sanction for the defence of the States of the Church, and particularly Rome, against the barbarian invasion'.[21] Such deliberate historical allusions to contemporary military crises have led to some perhaps overimaginative parallels-spotting: Titian's *Crossing of the Red Sea* as a reference to Venice's escape (still incomplete in 1514–15, however, the woodcut's probable date) from foreign occupation of the *terra firma*; Palma Vecchio's devil-raised *Sea Storm* as a reminder of St Mark's protection of Venice from being overwhelmed by its enemies. But such attempts are understandable. They reflect a feeling of bafflement; so much war, so much art: why did the two meet so rarely? The founding moment of the wars, the entry of Charles VIII's invasion army into Florence in 1494 en route to the conquest of Naples, was, indeed, recorded by Francesco Granacci.[22] But this, the feeblest of all the works attributed to a delightful and highly competent artist, was a piece of truckling homage to a threatening force that was now a friend. Its most likely date is 1526, when the Medici Pope Clement VII bound Medicean Florence into the pro-French League of Cognac. As they enter down Via Larga, the faces of the invaders turn respectfully to the empty palace of the then exiled Medici, where Charles was to lodge. This was to massage, rather than to accept a message from, the past.

To 'see' some of the major engagements of the Italian wars we have to look elsewhere and to a later chapter.[23] But to point the contrast we may briefly anticipate. Fornovo (1495), which was regarded in France as a triumphant feat of extrication from a hazardous situation, was recorded there within months in an engraving which sorted out its main incidents with masterly control over the composition as a whole, and in an energetic if over-generalized woodcut of *c.*1503 and yet another of 1506 which picked up organizational hints from the 1495 engraving. Marignano (1515) was celebrated by French miniaturists and in a medal, which surrounded a contemporary armour sprouting palm leaves with an inscription recalling the deeds of Caesar in a nice reversal of his Rome-based conquests. Pavia (1525) was the most widely reported battle of the wars because of its extraordinary conclusion: the capture of the King of France, Francis I, and his despatch into captivity in Spain where he was held fast by his victor (*in absentia*) the Emperor Charles V. German prints were rushed out to record what was guessed had happened in the field. Painters of the stature of Huber, a close imitator of Joachim Patenier and an effective but anonymous and otherwise unknown Flemish landscapist seized on the topographical hints in accounts of the action to produce bird's-eye-view panels of what very well might have happened. The major and most trustworthy record was the series of seven Brussels tapestries produced for the art patron participant on the winning side, Alfonso d'Avalos, Marquis of Pescara, from well briefed, if tactically Spanish biased, designs by the south Netherlander Barnaert van Orley.[24] And there are two large panels, one now in the Tower of London and the other in the Ashmolean Museum, which, though they differ in their reading of the incidents of the battle, employ comparable topographical and troop formation conventions, liberally labelled in the mode of the Marignano woodcut. Anonymous and, indeed, impersonal in manner, their reconstructions of the combat may well have been composed shortly after the event by Milanese sympathizers with the Imperial cause.

It was not that Italian artists were too fastidious to take on battle commissions. Titian may have reneged on his undertaking in 1513 to contribute to the decoration of the hall of the Great Council in the Venetian Ducal Palace 'the battle scene

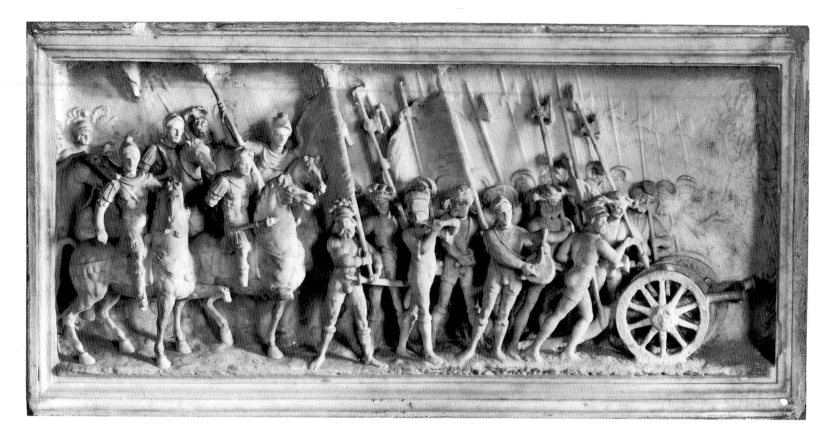

191. Il Bambaia, *The Battle of Ravenna*. Marble relief, after 1515. Turin, Museo Civico.

192. Anon., Title page, *La obsidione di Padua . . .* Woodcut, 1510.

La obfidione di Padua ne la quale fe tra
ctano tutte le cofe che fonno occorfe dal
giorno che per el preftantiffimo meffe
re Andrea Gritti Proueditore ge
nerale fu reacquiftata: che fu
adi.17.Luio.1509.per infi
no che Maximiliano
imperatore da quel
la fi leuo.

[twelfth-century Battle of Spoleto] on the side towards the Piazza, which is the most difficult, and nobody yet has wanted to attempt such a task',[25] but Agostino Busti, il Bambaia, accepted in 1515 Francis I's order for a tomb to commemorate the young general Gaston de Foix and was still working on it, together with assistants, when the French were forced to withdraw from Milan in 1521. It was never completed, and its panels have been dispersed.

These, from the sides of the tomb on which the effigy of Gaston was to have rested, constitute one of the loveliest and most skilled of Lombard Renaissance sculptural ensembles, and one that with a remarkably unjarring address combines an approach based on classical relief sculpture with contemporary detail.[26] Cannon and firearms are effortlessly absorbed within the antique tradition of triumph friezes. In the depictions of Gaston's three victories in 1512 – the strategically crucial breaking of a Venetian force at Isola della Scala, the conquest of Brescia which was thus made possible, and Ravenna (Fig. 191) where, in the closing stages of the battle, he was killed – 'Roman' figures are given weaponry and hints of Landsknecht costume in a balance that satisfies both the ideal gravity suited to a tomb and the violent actuality within which its hero lived and died. It is not surprising that in c. 1516 Francis entrusted the monument in St Denis[27] to his precursor warrior monarch Louis XII to an Italian, the Florentine émigré sculptor Giovanni di Giusto Betti (Jean Juste) and his workshop in Tours. Here, on the panels of the plinth, the Italian exerted his or his colleagues' not inconsiderable skill to celebrate events unrecorded pictorially in Italy: the conquest of Milan in 1499, the defeat of Venice's army at Agnadello in 1509. Actuality is, however, now overwhelmed within the classicizing mode. When Francis died his tomb, commissioned by his successor Henry II, was entrusted to a Frenchman. Pierre Bontemps's campaign reliefs dropped the antique for a manner of almost documentary contemporaneity. Marignano, its prelude, the battle itself, its consequence, gets minute attention. Needless to say, there is no reference to his defeat at Pavia.

For while there was a spate of military news pamphlets produced in Italy during the wars, some in prose, others in excitedly clumsy verse, that bore token woodcuts to advertise their wares (only one, the title page of an account of Venice's recapture of Padua in July 1509, made an effort to be a real illustration (Fig. 192)), non-ephemeral memorials of battles were commissioned not as records of events but as trophies. We have noted that there were no clear victories for all-Italian armies during the wars of Italy and, after Fornovo, none that could be interpreted as such in which the commissioning agent, whether prince or republic, fought without the assistance of Italian or 'barbarian' allies; patriotic pride was diluted by dependence. Even before we encounter Paolo Giovio's bitter comment at the mid-century on the wars, 'we have come to be despised by foreign nations whom we had intimidated until then',[28] Giovanni della Casa's reference to 'our poor country,

which has been debased and humiliated in the course of events',[29] and Benedetto Varchi's rejection of war from any catalogue of 'useful arts' because of the distress it caused,[30] there was Machiavelli's reproach that Italians put brains above valour and Castiglione's fastidious reluctance to have the shadow of the wars of Italy cloud the happy mood of the conversations in the palace of Urbino. It was a frame of mind that was to be given a graphic representation in a woodcut of 1554, which invited the viewer to mourn with the sorrows of the central figure; 'Italia fui' (Fig. 193). Produced in Venice ('Sola filia intacta manet'), this gives a biased view of the subjected state of the rest of the peninsula, but it does sum up a period in which shifting alliances, transitory victories and constant uncertainty about the morrow inhibited the making of specific pictorial statements about the progress of military events.

The same inhibition applied to decorative cycles calling for the depiction of historical events.

When, just before 1527, Count Martinengo commissioned from Girolamo Romanino and Marcello Fogolino a new decorative scheme for Malpaga,[31] the castle-court of the great condottiere Bartolomeo Colleoni, he allocated the greatest wall space to recording episodes in the visit paid by Christian, King of Denmark, to his grandfather (for no great military commander would have wished to be remembered simply as a habitué of camp and field), but four of Colleoni's major engagements were also shown, with considerable attention to the accuracy of costume and topography. These, however, were battles safely tucked away in the past. When, two or three years later, Francisco Maria della Rovere called Girolamo Genga, Dosso Dossi, Bronzino and others to decorate his Villa Imperiale at Pesaro,[32] the scheme was still more evasive. War is now seen in the general terms of its relationship to love and peace. When the Duke's military career is alluded to it is in scenes doubly removed from reality by being on the ceiling and in feigned tapestries, and they are not scenes of battle, but of his being invested with military commands or accepting an oath of fealty from his troops. As in his portrait by Titian[33], one of the outstanding commanders of the Italian wars did not choose to be associated with military actions which had been inconclusive or, in the case of the 1527 Sack of Rome, disastrous. The better to understand the pictorial reticence of the war years 1494–1530, however, and to grasp the nature of the greatest works produced during them – the non-contemporary battles depicted by Leonardo, Michelangelo and Giulio Romano – it is helpful to review the earlier history of the Italian battle-piece.

'The crossbow quarrels fell like rain . . . the clouds hung low, and the air was thick with dust . . . the Aretine infantry, knife in hand, crawled under the bellies of the horses and disembowelled them'.[34] Dino Campagni's Florentine chronicle of 1311–12 was the work of a major writer, whose alertness to appearances and emotions make him a worthy contemporary of Giotto. Within both their skills there was an almost rough-and-ready recognition of what would count as real. And this approach, which was in part an instinctive acceptance of the obvious, continued to characterize much of the secular art of the trecento and continued into the first decade of the quattrocento, especially in northern Italy, where an unworried-about Gothicism protected artists – not necessarily to their advantage in the eyes of posterity – from overmuch concern with being up to date with the most admired humanistic canons of art.

We have seen something of this in the context of genre. We can look further through two early-fifteenth-century drawings. One,[35] by Stefano da Verona, shows the mugging by one mounted infantryman of another; a third rides up to help his colleague, a fourth reins in and looks back to watch the outcome. The other is a Veronese sheet of studies (Fig. 195), anonymous but of deft quality. At the top soldiers, their actions carefully observed and taken from a high viewpoint so that each can be fully seen, skirmish in an area defined by shading. Two pairs of figures are shown in deliberately reversed poses (the outer figures at the top and the fallen

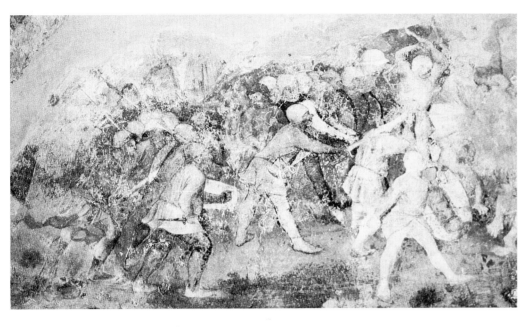

194. Jacopo Avanzi, *Battle*. Fresco, ?1370s. Castello di Montefiore Conca (near Forlì).

men in the middle) but the action none the less appears vigorous and naturalistic. Other groups (four soldiers talking, the stripping of armour and clothing from the dead, an officer speaking to two soldiers, a group standing in a wood) suggest details for incorporation into a large battle composition. The sketch of a man tying the points of his hose to his doublet and the quick drawing of a hen locates the sheet within an imaginative world in which informal everyday observation still plays a part.

No such finished work has survived but the spirit of these drawings flowed from a number of earlier, late trecento battle paintings.

Several frescoes in castles towards the northern borders of Italy survive, as at Sabbionara (near Avio, on the Adige south of Trento), or are documented. These record local feuds or combats from chivalrous romances and are, in both cases, primarily cavalry engagements. A conspicuous exception is the nameless *Battle* (Fig. 194) in the castle of Montefiore Conca, near Forlì. What is left of it shows an exclusively infantry engagement, and the soldiers are shown contemporarily and informally, as though they have just snatched up weapons and the odd shield and helmet and come in from the fields. Undated, possibly of the 1370s, this is the work of an outstanding artist, Jacopo Avanzi, who has gone straight for the disorder as well as the brutality of combat. It is one of the last Italian battle scenes to which the term realistic can be fully applied. And it is the only trecento battle painting of high quality that was not triggered by an episode in the life of a militant saint.

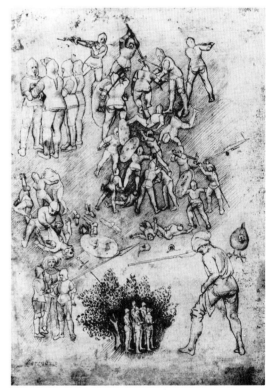

195. Anon. Veronese, *Soldiers*. Drawing, mid-fifteenth century. Fritz Lugt Collection.

Such a trigger led to the commissioning in c.1379, by the condottiere Bonifazio de' Lupi of Soragna, of Jacopo's colleague, the Veronese Altichiero da Zevio, to paint the *Battle of Clavijo* (Figs. 196–7) in his patronal chapel of St James (now S. Felice) in the church of S. Antonio, Padua.

Clavijo in Spain was where St James in c.930 intervened to give victory to the Christians over the Moors, thus denying them the hundred virgins a year they had been taking as tribute. The widespread cult of James made the subject a fairly popular one in Italy. In a formulaic fresco now in Pinacoteca Nazionale of Bologna of the mid-trecento for instance, the saint on a white horse bounds ahead of the Christian ranks to strike confusion among those of the Moors.[36]

Altichiero, however, chose to represent the battle as a siege, with the saint casting down the walls of Clavijo from within to ensure its surrender to the Christian. Given Padua's fears of being taken over by Venice this was a puzzling decision. But our concern is not with the saint as a quisling. It is, rather, with the artist's ability

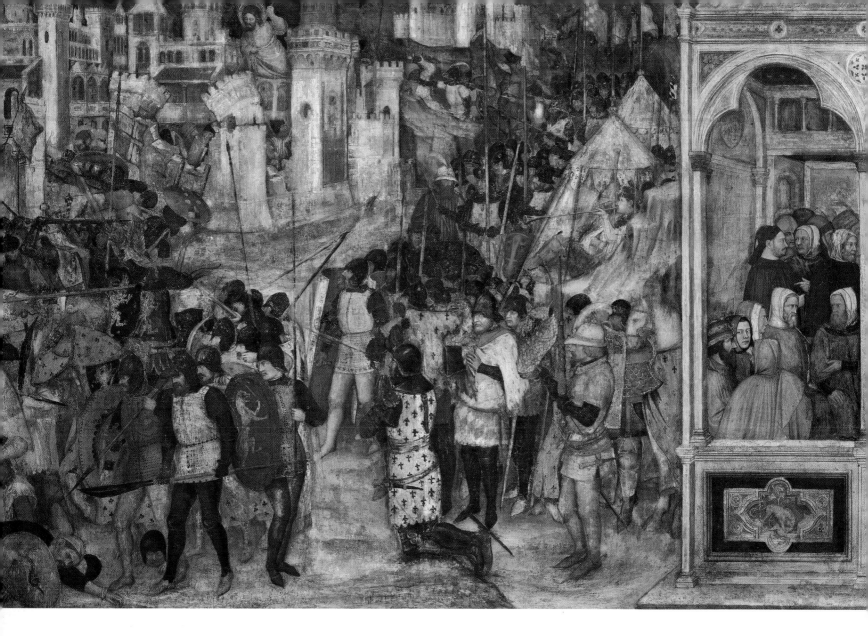

196. Altichiero, *The Battle of Clavijo*. Fresco, *c.*1379. Padua, Santo, Capella di S. Felice.

197. Detail of Fig. 196.

to combine the sacred – the central space across which King Ramirez kneels in adoration of the apparition of the saint above the battlements – with the profane recording of the pre-miracle actions (the scotched sortie at the top left, the checked sortie on the bottom right, the movement on the left of the main body down past its camp for orders) of the opposing forces which were halted by the miracle, and with his representation of the whole scene in thoroughly contemporary terms. In spite of the overall composition, with its falling-into-place masses of troops before a conventionally white, though architecturally strongly particularized city, and the positive but carefully subdued coloration which together suggest a hugely blown-up miniature, there is a naturalness, an intimacy, a sense of what individuals were thinking as well as doing, a plain-man empathy with what military operations were like that couple *Clavijo* with Jacopo's *Battle* as the end rather than the beginning of pictorializations of battles that were true to life. Vasari's somewhat unexpected tribute, nearly two centuries later, was that Altichiero had demonstrated 'liveliness of intellect, judgement and inventive talent, having taken into account all the components that one can bring to bear on an important military event'.[37] Coming from an artist-critic who used these very components to such art-adjusted and therefore different effect, this is a striking tribute.

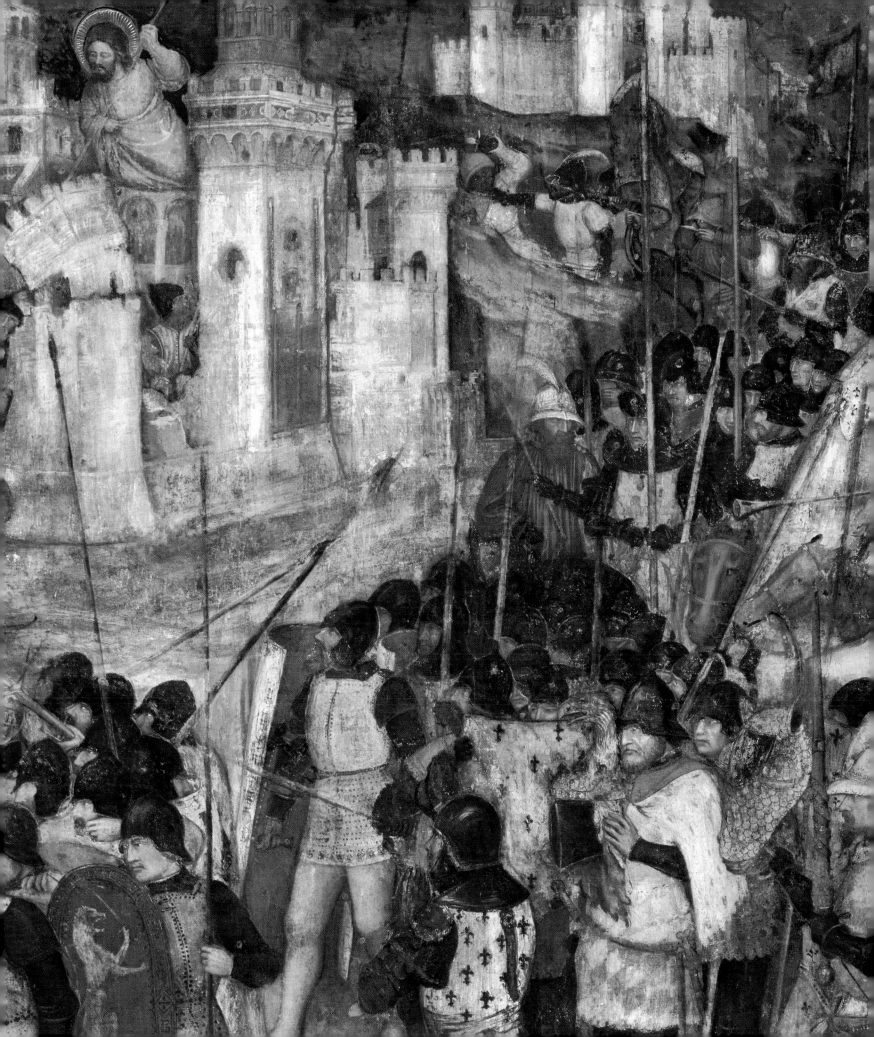

198. Spinello Aretino, *St Ephesius at the Battle with the Saracens*. Fresco, 1391–2. Pisa, Campo Santo.

More prophetic of the conventions towards which the battle painting was to move was a work of a decade later, 1391–2, Spinello Aretino's fresco of St Ephesius's *Battle with the Saracens* (Fig. 198) for the Campo Santo in Pisa.

The Pisan Ephesius (according to his legend) was one of the Emperor Diocletian's militant persecutors of Christians. One day, however, St Michael appeared to him, promising the support of an angel as second in command if he would smite instead the Saracens in the Holy Land. This he successfully did, and Spinello shows the two charging (this is a cavalry battle) side by side to victory. He puts the action, apart from some modifications, in modern dress and in spite of some obvious patterning of lances, swords and ranks, and the cliché of the fallen horseman in the foreground, gets to the heart of the mass and shock of confrontation while retaining glimpses of more personalized encounters. There is at least a sense of reality here quite missing from his later (1408) design for an episode from the conflict between the Sienese Pope Alexander III (1159–81) and the Emperor Frederick I Barbarossa, the latter's defeat at sea by the Pope's ally, Venice.[38] Charity must assume that this tiered wooden comic strip in Siena's Palazzo Publico was executed entirely by assistants supervised by his untalented son Parri.

Because of their sacred and allegorical or remote historical nature the scenes by Altichiero and Spinello were timeless, not subject to the almost immediate reversals of fortune, and therefore significance, to which contemporary battles were all too prone. And it is interesting that the first more or less contemporary secular battle scene commissioned for a civic hall, Lippo Vanni's 1373 lacklustre fresco of the battle of Torrita in the Val di Chiana,[39] also for the Palazzo Publico of Siena, was sponsored by a saint. Blessed by the outstretched sword of St Paul, himself backed by armed angels, the Sienese force moves towards the army of Niccolò da Montefeltro, engages and then routs it. The fresco is only ten years later than the battle. But even if later events were to tarnish its memory, the scene validated Siena's right to invoke a spiritual reinforcement not bound to temporal chronology.

It was perhaps the sense of political uncertainty that during the succeeding three generations of inter-state warfare inhibited the commemoration of contemporary battles. The quattrocento as a whole has little to offer in this respect, apart from the stilted *Defeat of the Florentines at Poggio Imperiale in 1479* which Giovanni di Cristo-

199. Anon., *The Conquest of Pisa*, *c*,1443. Dublin, National Gallery.

foro and Francesco d'Andrea painted,[40] again for the Sienese Palazzo Publico, as soon after the event as 1480. There is no timeless appeal to divine aid here. But there is still a built-in precaution against the reproach of changing circumstance. With its plethora of labels identifying not only places but commanders, the fresco is firmly linked to the annalistic approach of the chronicle, precisely on the analogy of the contemporary *biccherna* panel of 1479 which illustrated another episode in the same war, the surrender by the Florentines in that year of Colle Val d'Elsa to Siena's allies.[41] If we are looking for a tradition of public commissioning of contemporary military engagements that kept abreast of artistic interest but suddenly broke off when the Wars of Italy began, we shall find little to go on. Benedetto Bonfigli's fresco of between 1457 and 1477 in the Palazzo dei Priori of Perugia, for instance, of a drably animated *Siege of Perugia*,[42] was simply a revival of the morale-inducing invocation of the protection offered in the present by a long dead but timelessly concerned patron saint.

There was, meanwhile, an area of art production where paintings for incorporation in furniture, principally cassoni, were produced in the fifteenth century for a private market. Among these panels the taste for battle representations was not subject to considerations of a sacred or political nature. Production was centred in Florence, so cannot be considered representative. All the same, certain generalizations can be made which are relevant to the paucity of artistic records during the later Wars of Italy.

The majority of cassone battle scenes reflect not current affairs but either the humanistic fascination with the wars of classical antiquity or the neo-chivalrous interest in the tournaments of the present. Decorating marriage chests containing the expensive worldly goods of a bride's trousseau, they cheerfully reflect intellectual and social fashions rather than politico-military headlines. Images of even comparatively recent battles were few: Charles of Durazzo's capture of Naples in 1381 was the subject of a cassone front of a generation or so later;[43] Florence's victory over Pisa in 1406 was portrayed in *c.*1443 as a celebratory, relaxed *fête-champêtre* (Fig. 199).[44]

Nearly contemporary battles were painted more rarely still. A lively, anecdotal account of *The Conquest of Trebizond* (the city labelled on the right)[45] by Muhammad II in 1461 was produced in the Florentine workshop of a major cassone painter, Apollonio di Giovanni, probably before the master's death in 1465. This gold, blue, green and white storybook illustration may, however, refer to the 1402 battle near Angora between Bajazet I and Tamerlane, whose name is written beside the chariot-borne conqueror. With so imprecisely rendered a military operation, it was possible to get two famous events for the price of one and thus extend the work's

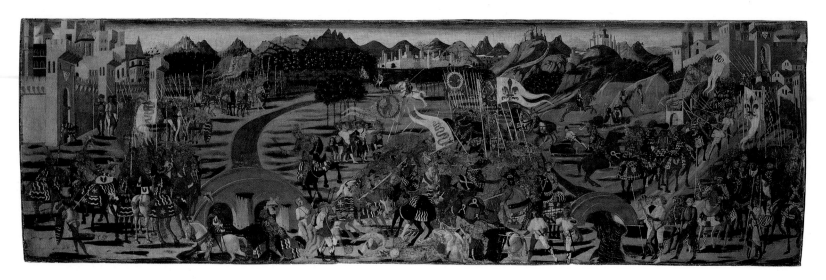

200. Anghiari Master, *The Battle of Anghiari, 1440, c.*1443. Dublin, National Gallery.

reminiscent value for the patron. From the heraldic devices on the ends of the chest, this was a member of the merchant banking Strozzi family, whose firm had many dealings with Constantinople.

The only nearly contemporary Italian battle to be represented was the action from which the Anghiari Master has been given his name. Florence's victory over a Milanese army in 1440 at Anghiari was painted in *c.*1443 (Fig. 200), for this was made for the same cassone as the victory over Pisa. There is no realistic *rapportage* here. Though so recent, the battle is given a remote, storybook appearance, with the chief actors (identified by their standards and helm devices or carefully static mini-portraits) playing their parts on a stage of arbitrary dimensions in disjunctive episodes which would guide the finger of a narrator explaining the occasion more surely than they would enable his auditors to imagine what the engagement had been like. It is probable that the cassone was produced for a wedding in the Capponi family, members of which had been involved in both campaigns. The narrative technique shared by historical and religious storytelling is invoked here, not the grunts and blows of actual combat, nor the summation of detail into the common purpose of assault. What happened to whom is more interesting than the happening itself. And the same intention is apparent in the second version,[46] which the Master – or, more probably, an assistant – produced, for all its tightening of the combat action and infusion of genre detail.

The same desire to prettify and anecdotalize conflict in cassone panels applies to the treatment of classical subjects. The victories of Caesar or Scipio were designed as stories to be read and delighted in, and the reading was made more agreeable by linking them ahistorically to the costume and armament of the present, and presenting them as imaginable within the terms of contemporary pageant and tournament. This was the mode adapted by the Anghiari Master in his *Battle of Zama*.[47] And in the teeth of all likelihood Horatius, in an anonymous panel of the late 1470s,[48] defends the bridge crossing the Tiber against the Etruscans on horseback, and, indeed, when the bridge is destroyed behind him, swims back to safety on the same chivalrous steed. On an earlier panel, of *c.*1450,[49] the Emperor Constantine's entourage rides towards a besieged Jerusalem in the fantasticized parade headgear that so fascinated Uccello.

It is at this point that we encounter the cluster of works that are considered *the* battle paintings of the quattrocento. The range of talent that has been brought to bear on their evaluation and elucidation in so broad and distinguished that I will keep them briefly within the framework of this chapter's argument.

Paolo Uccello's three-part *Battle of San Romano* has been variously dated from as early as *c.*1435 to the late 1450s.[50] It would have been unusual, as we have seen, to

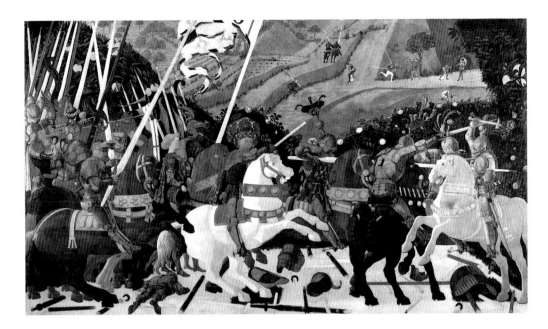

201. Paolo Uccello, *The Battle of San Romano*, ?1450s. London, National Gallery.

record an historical event – and on so grand a scale – soon after its occurrence in 1432, especially as it was an episode from the unpopular and eventually unsuccessful Florentine war with Lucca. A later date would make better sense, given Cosimo de' Medici's carefully low political profile and the probability that though intended for his own home it would be seen by rivals as well as friends; a date in the fifties would also allow for some influence from the preliminary drawings associated with Pisanello's Arthurian *Tournament* in the Ducal Palace in Mantua which has been held to date from about 1447–8, as well as for the absorption into Uccello's compositions of elements that were developed from earlier illuminated manuscripts into cassone conventions during the 1440s and 1450s, particularly those representing classical battles, tournament scenes and triumphs. It is from these, surely, that in the National Gallery panel (Fig. 201) Uccello derived the litter of bodies and weapons on the ground, the stages – mêlée and single combat – of the tourney, the processional entry from the left in parade rather than combat head-dresses. Though from identifying crests and banners the scenes could be read as fact, the whole work shows battle as episodes in a pageant, well removed from any apprehension of the reality of war, let alone from the fairly copious documentation of the action that was, possibly, available to the artist. If, with reference to military probabilities rather than pictorial devices, we alter 'will to' to 'allowance for', John Pope-Hennessy's comment on the panels admirably fits our own context: 'again and again the artist's will to realism is mitigated by his all-pervading decorative sense'.[51]

How far the condottiere Marquis of Mantua, Lodovico Gonzaga's commission to Pisanello[52] was to buttress his own sense of belonging to a chivalrous profession, or to impress potential north Italian employers with his rapport with the chivalrous aspect of their own culture, is unclear. If the latter, then it was perhaps tactless to choose a tournament from the Tristan legend in which the hero proves himself by leading first one side and then the other to victory (Fig. 202). But the interest of the work to us is that the medieval mêlée type of tournament, though a mock battle, was one in which wounds were frequent and death not uncommon. Unlike Uccello, Pisanello had experienced war himself, serving with Ludovico's father against Venice in 1439, and by leaving compositional 'holes' between his surface episodes of single and group combat he could show genre-like glimpses of individual suffering. Even these, however, with their foreshortenings, put art above heart. Like *San Romano*, from which in theme and source of patronage it was so

202. Antonio Pisanello, *Tournament Scene*, c.1447–c.1455. Mantua, Palazzo Ducale.

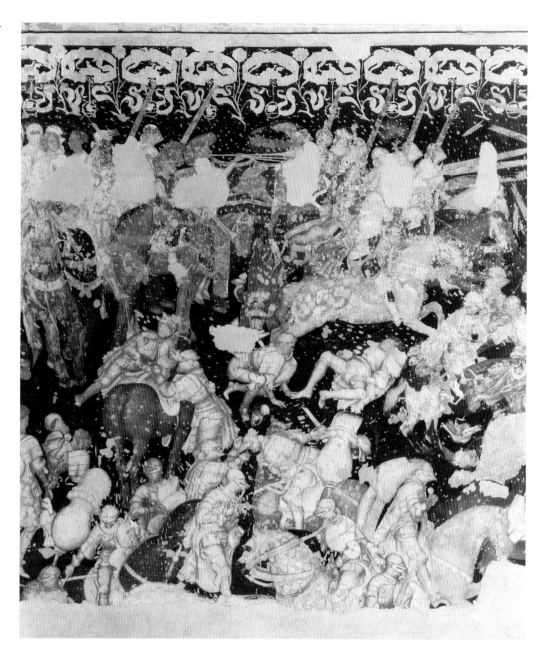

different, Pisanello's version of Tristan's fictional tournament was a formalized vision of violence, a ritualization that has more to do with those emblematic conflicts we are about to look at than with either Uccello's interpretation of a recent, or Piero della Francesca's of an ancient, historical event. We might, however, note that in 1453 Ludovico wrote to his wife of his victory over the forces raised by his rebellious brother Carlo that from the 'fine vantage point' from which he watched the action 'it was one of the most beautiful battles we have ever seen'.[53] It is a mistake to think that connoisseurship is a prerogative of art historians, or that artists were unaware of this patronal attitude.

Piero della Francesca may have been an observer, or at least an immediate listener to survivors of a battle, for Anghiari is only 15 kilometres from his home in Borgo San Sepolcro. However, in the better preserved of his two battle scenes (c.1460) in the history of the true cross series in the cathedral of Arezzo, the *Victory of Heraclius over Chosroes* (Fig. 204), he has spaced his composition in terms of five single-combat

scenes, and it is to the frozen quality of the warriors' gestures that the picture owes much of its impressive monumentality. We cannot judge how the clues to reality in such paintings struck those who looked at them. A century later Vasari wrote of this grandly static work, some of whose details reflect Piero's knowledge of the battle reliefs on the Arch of Constantine in Rome, that the artist expressed 'very effectively fear, animosity, alertness, vehemence, and other emotions typical of man in combat. He also showed the various incidents of the battle, depicting the wounded, the fallen and the dead in scenes of almost incredible carnage'.[54] What we can surmise is that these three roughly contemporary works, grand in scale, prestigious in site, and made by artists of outstanding reputation, confirmed the belief of those who knew them that while battle scenes were about war, they were also, whether dealing with the present or with imaginary or remote times, about art.

About art, that is, in the sense of the self-conscious imposition of harmony and refinement upon observed reality, and of selectivity and order within the material of narrative, that were taken over in Alberti's writings on art from Pliny's account of ancient art and from contemporary literary theory. In his 1436 discussion of *storie*, the noblest task presented to an artist, Alberti does not mention battles. But it was to the depiction of battles, with their mixture of the haphazard and the planned, of noble sights and squalid ones, and their mass of details deployed over acres of ground, that his advice was especially relevant. Selection and ennoblement had always been a problem, coped with on an *ad hoc* basis in terms of subject, patron and mere convenience. As Alberti's notions gained an audience they became a creed. We shall see their impact when we fill in the account of battle depictions produced during the Wars of Italy with that second group of masterpieces by which the Renaissance battle scene is remembered, the works by Leonardo and Michelangelo (1503–6) and Giulio Romano and his assistants (1523–4).

Meanwhile, in the absence of major commissions for actual battle paintings, the ground rules for the rendering of them were becoming transformed by para-military exploration of what were, in aesthetic terms, their major components: the *pas de deux* of personal encounter, the *corps de ballet* encounter of masses. The crass energies of war were thus sublimated into the less dread concepts of individual combat and choreographed conflict, and motifs and methods were developed that were to bypass or condition the rendering of the reality of battles for centuries to come.

The *pas de deux*, influenced by the joint cult of antiquity and nudity (in this case not, perhaps, without an added jolt from the homo-erotic element in Renaissance life and culture), took as a central theme the combat between Hercules and the giant Antaeus, who was unbeatable unless he was lifted from the earth from which flowed his strength. An excuse for the theme was provided by one of Florence's most respected humanists, Cristoforo Landino: only by being lifted from earthly concerns can man commune with a higher wisdom. But this hardly explains the gusto with which a follower of Mantegna had Hercules loft Antaeus with a fine display of genitals and buttocks (Fig. 203),[55] or Antonio Pollaiuolo use the encounter as a demonstration of what new patterns would be revealed as the owner of the jaggedly outlined encounter-piece rotated his small bronze on its axis,[56] or the clenching strain of Signorelli's superbly robust drawing of c.1490.[57]

Drawings of battle scenes from the Arch of Constantine were made from at least the mid-quattrocento.[58] In the 1470s, Antonio Pollaiuolo produced two visions of conflict between armed naked men (the usual title, *Battle of Naked Men*, is inappropriate: the theme is not battle but the more generalized notion of struggle). The earlier (?), a drawing,[59] is fairly close in mood, though not in specific reference, to comparable clashes on the fronts of sarcophagi. The second, an engraving, is far more personal as well as having a novel, murderous intensity (Fig. 205).

Both the unprecedented size of the plate, and the equally unprecedented fullness of the artist's signature, in a form hitherto reserved for paintings, make this a work

203. Andrea Mantegna (follower of), *Hercules and Antaeus*. Engraving, London, British Museum.

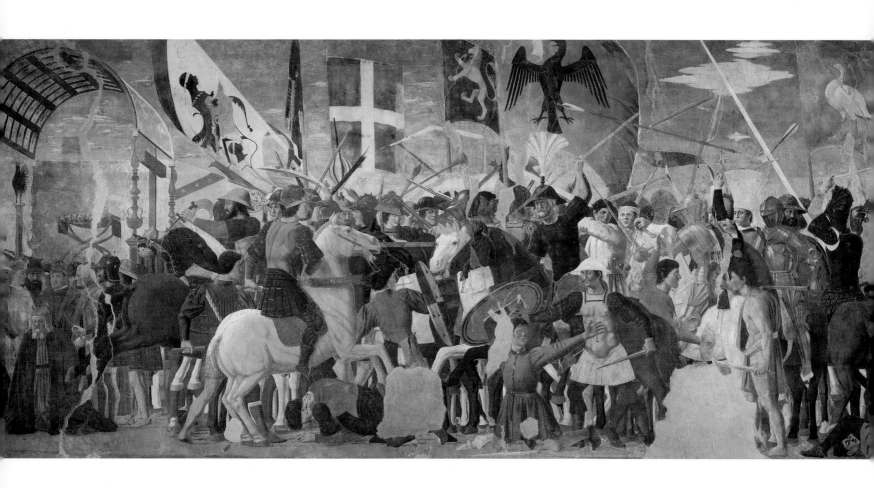

of considered importance. What, apart from its containing a repertory of carefully studied and brilliantly engraved musculatured poses, is it about? The proposals have been many. A tentative winner is the suggestion that it shows Roman gladiators slaughtering one another in a ritual, self-sacrificing bloodbath to commemorate the death of a prominent citizen by identifying his demise with the refertilizing of the earth with the blood they shed. The use of the non-gladiatorial bow counts against this interpretation. Indeed, such interpretations, however ingeniously colourable, are flawed by the inconographical imperative that every picture has to tell a story. There was, after all, a psychological imperative, an acknowledgement of the existence of 'pure' violence, insensate combativeness. There had been a number of works that, in spite of the way in which the contestants had been represented, were about the fighting instinct as such: the early quattrocento *Battle between Orientals* by the Maestro del Bambino Vispo,[60] the chivalrous *c.*1440 Florentine cassone panel *Battle Scene*,[61] the cheerful frieze of putti attacking one another with bows and sticks in an illumination of 1472.[62] Children's games, tavern brawls, civic riots: artists were not insulated from the more savage side of human nature, and the devotion to nudity and the repertoire of classical conflict scenes further released combat from a formal, historically justifying context. If Pollaiuolo's engraving has a 'subject', then it draws on the very loose one of the Ages of Mankind; the change from the earliest Golden Age of peaceableness amidst a bounteous nature (the trees and luxuriant plants in

205. Antonio Pollaiuolo, *Combat between Naked Men.* Engraving, *c.*1471–2.

204. Piero della Francesca, *The Victory of Heraclius over Chosroes.* Fresco, *c.*1460. Arezzo, S. Francesco.

159

206. Andrea Mantegna, *Battle of the Sea Gods*. Engraving, *c.*1485–8.

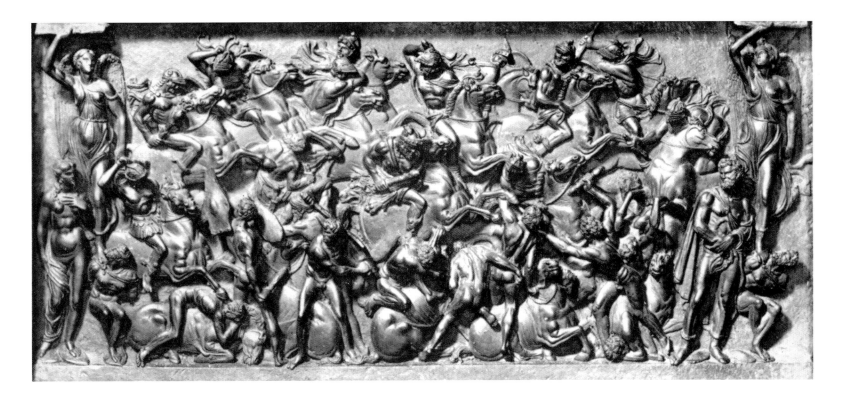

the background) to the contemporary Iron Age (the chain fought over in the central episode) of material values and the violence that accompanied them.

A decade later, Mantegna's 2-plate engraving *The Battle of the Sea Gods* (Fig. 206), takes cover in more explicit references to classical motifs and theme, but is similarly about conflict, an urge shared by gods and men, for all its allusive, tragi-parodic mood. This too is about the birth of conflict in the history of humankind. Neptune, who lives through all ages, ostentatiously turns his back while Envy, the emaciated, long-dugged figure on the left, brandishes her identifying label over a world that has become rancid with the struggle for property: in this case not a chain but women.

It might be noted that in both these works the Albertian canons for decorum – postulated for 'real' historical subjects – that preached that a hand should not be raised above the head, nor an elbow above the shoulder, nor one foot moved further than its own length from the other, are defiantly breached.

Towards 1490 the hero-less conflict piece acquired the dignity of bronze in Bertoldo's supple rephrasing and imaginative infilling of a much battered sarcophagus in the Pisan Campo Santo (Fig. 207).[63] Made for his chief patron, Lorenzo de' Medici, and installed – as we know from the inventory made after Lorenzo's death in 1492 – over a fireplace in the room opposite his palace's chief reception room, this relief, made in a time when Lorenzo's hospitality was at its most cosmopolitan, must have been admired for its own classicizing sake, for neither it nor its model contained any clues as to who was fighting whom. Backed up by the circulation of Pollaiuolo's and Mantegna's multiples, the location of Bertoldo's relief was an endorsement of the art for art's sake conflict piece. And so was the slightly later marble relief by Bertoldo's and Lorenzo's young protégé Michelangelo (Fig. 208).

This was made shortly before Lorenzo's death in 1492 and the artist hung on to it for the rest of his life. Followers of the lead of Michelangelo's earliest biographers, Condivi and Vasari, have called it either the *Battle of the Centaurs* or the *Battle of Centaurs and Lapiths*. But there are no centaurs. So there are no Lapiths. Classically influenced (though no sources have been identified), responsive to the expressiveness of the nude male body in isolated or intertwined action as well as wracked

207. Bertoldo, *Battle*. Bronze, late 1480s.

208. Michelangelo, '*Battle of the Centaurs*'. Marble, *c.*1492.

209. Domenico Campagnola, *Battle of Nude Men*.
Engraving, 1517.

passivity (the crouched figure in the left foreground), this lusciously free composition is simply about bodies coiled in or recoiling from action. If a subject had been suggested to him, and the humanist Angelo Poliziano, a *habitué* of the palace, was well poised to nudge the young artist towards a mythological or historical theme, Michelangelo followed the examples of Pollaiuolo and Bertoldo and produced a plastically visceral and unreferential vision of conflict. In 1517 one of the greatest of Renaissance imaginary conflicts was produced in the form of an engraving, *The Battle of Nude Men* (Fig. 209), by Domenico Campagnola. And at about the same time the Master of the Year 1515 published his engraved *Engagement in a Wood*,[64] a simpler composition but one of great vigour, especially notable for its energetic rendering of a frequently repeated Roman relief motif, a horse rearing over the raised shield of a fallen warrior.[65]

Energy, anticipating even the toppling forms of Giulio Romano's later *Sala dei Giganti*, informs every detail of the piled-up composition of a drawing by Domenico which,[66] though undated, is surely closely related to his engraving. It is an experiment in how far free draughtsmanship can, in style and composition, modernize impressions deriving from the shallow plane and calmer diction of Roman relief sculpture. The engraving is freer still. It achieves depth, it tones down the extravagance of the pose of the drawing's central horse by reversing it, and adds a flickering light that gives an air of verisimilitude to what remains a fantasy. Mars's hound of war, baying towards a contemporary drum which lies amidst the action, now pro-

162

vides a theme: conflict is the core of battle. And both drawing and engraving being produced in a time of actual war, the implication is that for artists this core is more stimulating to emotion and imagination than the recording of the particulars of costume and the extensive deployment of units in real battles. Art was concerned with essence, not *rapportage*.

There is, then, no cause for wonder that when, a decade into the Italian Wars (commissions of 1503 and 1504), Leonardo's *Battle of Anghiari*,[67] which had taken place in 1440, and Michelangelo's *Battle of Cascina* (1364)[68] put the idealized dynamics of conflict above an historically accurate visualization of the chronicle accounts with which the former was certainly,[69] and the latter presumably, supplied.

These large frescoes were to adorn the still undecorated walls of the new council chamber, designed in 1495, which was added to the Palazzo della Signoria to house the members of the Greater Council, Florence's quasi-'democratic' substitution for the restricted form of political representation that had been manipulated by the Medici before their expulsion in the previous year. Known subsequently as the Sala del Cinquecento, it was an emotive political symbol of liberation and change.

The commissions came at a time of crisis. Florence was having little success with its attempt to recapture its rebel port, Pisa. The by-blows from the Franco-Aragonese war being fought out in the peninsula put the republic at constant risk. The death of Alexander VI in August 1503 and the election of Julius II in November made the policies of the Papacy an uncertain factor. In 1502, in order to give an element of continuity to the direction of policy, another unprecedented constitutional change had been made. From a rotating, two-month period of office the head of state, the Gonfalonier of Justice, was appointed for life, as was the Doge of Florence's rival republic, Venice. The frescoes were, in all likelihood, to flank the dais in the centre of the long east wall where the Gonfalonier presided.

These were, then, commissions of singular moment, the first public ones to have been ordered in Italy since the commemoration in 1480 in Siena's town hall of *The Defeat of the Florentines at Poggio Imperiale*. Now, after over twenty years of sometimes radical change in the nature of Italian art, two men of different temperament but equally acknowledged genius, were hired to renew the not very strong tradition of civic battle pieces in a setting of exceptional significance.

Both engagements were, of course, Florentine victories, Cascina over a Pisan force, hence its specific relevance, Anghiari against the 'tyrannous' Duke of Milan, Filippo Maria Visconti, thus a more general call for confidence in the city's retuned republicanism. Both tapped the need to believe that Florence's destiny was in divine hands. Savonarola, who had put the weight of his oratorical fervour behind the creation of the Greater Council, had been executed in 1498. But his declaration that Christ, not a member of the Medici family, was the guardian-leader of Florence, was taken up in a commission to Andrea Sansovino in 1502 for a statue of Christ to be placed behind and above the Gonfalonier's seat. And Filippino Lippi was engaged to paint an altarpiece on the opposite wall which was to include representations of the saints (St Victor for Cascina, St Peter for Anghiari) on whose feast days the victories had been won. Leonardo's brief specifically mentioned the latter's apparition at dawn on the day of the action.

This brief, preserved among Leonardo's papers, filleted chronicle sources to produce an episodic narrative of the sort thoroughly suited to guide the episodic treatment favoured by the now outmoded cassone painters. This cannot have been the only briefing Leonardo received before he began his preliminary drawings. There were, besides, men who could remember tales of a battle that took place only 63 years before. The final, overall sketch, if there was one on paper as well as in talk, must have represented an agreed compromise between what happened and what he wanted to do.

The 'chronicle' summary is at least an indication of an official brief. What was the one he gave himself?

The issue is of some psychological as well as artistic interest. He had noted, in around 1490, that war was a most bestial madness, *pazzia bestialissima*. Subsequently he had done rather well from it. He had hawked his services to Lodovico Sforza as primarily a military expert, had been a military adviser to Venice and to Cesare Borgia. He had produced many drawings of improved fortifications and more lethal weapons. In 1504 he broke off work on the fresco to act as military adviser to the ruler of Piombino, Jacopo Appiani, with Florentine consent. In 1506 he was summoned to Milan, again with Florence's agreement, as the city needed the assistance against Pisa of Milan's then conquerors, the French. Though he returned to Florence in 1507, effectively he had lost interest in *Anghiari*, and his ideas are known only through drawings that do not allow the composition as a whole to be reconstructed, and a frenetically animated grisaille (Fig. 210) by Rubens[70] based on lost copies of what was obviously a central episode, the so-called *Battle for the Standard*, which may be Leonardo's relocation of the brief's emphasis on the struggle for command of the bridge over the Sovara river which intersected the battleground, or his acknowledgement of the captured battle standards which were preserved in the palace.[71] Frustration with the failure of the adhesion to the plaster of a new medium he had invented for this commission must have contributed to a teeming mind's decision to cut its losses.

And the mind? Everything points to Leonardo's seeing battle in terms of conflict rather than as a particular occurrence. A bookish, if unscholarly man, he may have become acquainted by word of mouth with the (as yet untranslated) advice to the painter in the Greek Demetrius Phalereus's treatise *On Style*. Contradicting Alberti's ban (by omission) on battles as suitable historical subjects, Demetrius wrote that a serious artist should choose 'cavalry . . . battles, in which he could show horses in all their movements – some galloping, some rearing, some sinking to the ground'.[72] In any case, Leonardo's previous advice to himself on how a battle should be represented included horses 'galloping with mane streaming in the wind' as well as other features that showed up in the Anghiari sketches: the strained physiognomy of the contestants, details like 'one of the combatants, maimed and fallen on the ground, protecting himself with his shield'.[73] This describes the bottom left figure in the *Battle for the Standard*, and echoes a sketch of his own for the equestrian monument for Francesco Sforza of *c.*1483–4.

For *Anghiari* pressed into service not only Leonardo's a priori notion of how a battle would be rendered in terms of the smoke and dust and atmospherically differentiated space, of agonized action detail and of quiet masses waiting on the turn of events, but on his mental stock of adaptable models: the piled clash of four horses on the 'Phaeton' sarcophagus,[74] now in the Uffizi but then at S. Maria in Aracoeli in Rome, Bertoldo's *Battle* or, more probably, the Pisan relief that influenced it, classical details then being spurs to invention rather than reproduction.

In any case, Leonardo treated his commission far more as an artistic than a documentary challenge. The two episodes that appear from his drawings to have been intended for inclusion in the fresco cannot constitute the whole composition. But from both the pent-up energy in the drawing of the skittish horses of the Florentine reserves, and the snarling clash of horses and riders in the set-piece battle for the Florentine standard, for which there remain close-up physiognomical studies, it is clear that he worked outwards from two conflict-based assumptions: the frenzy of men in the throes of combat, and the call on the design skill of the artist to convey the tension that converted thinking men into blood-addicted, scrapping animals. And it was precisely the conflict core that, from its fragments, stimulated later artists. The influence of the Anghiari material has been traced from Campagnola's *Battle* to Giulio Romano's *Battle of Constantine*[75] and the lost battle piece that Titian at last, in 1537, produced for the Palazzo Ducale.[76] Its concentrated ardour chimed well with the taste of the venturous young Vicentine cavalryman Luigi da Porto for the 'marvellous skirmishes'[77] in which he delighted in preference to literally more

210. Rubens (attrib.), Leonardo da Vinci's *The Battle for the Standard*. Paris. Louvre.

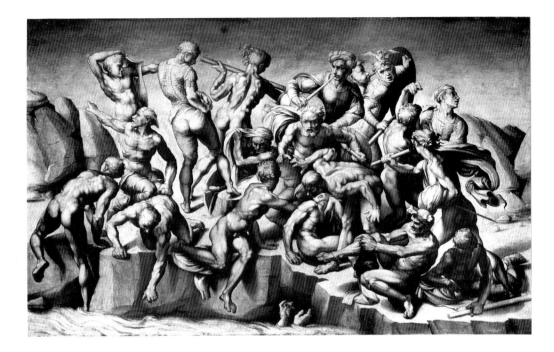

regimented formal battles, and some knowledge – he was in the city until 1511 – of the standard group surely underlies the detail, written some thirty years later, in Francesco Guicciardini's description of the 1495 battle of Fornovo in his *History of Italy*, where he refers to 'the horses fighting with kicks, bites and blows no less than the men'.[78] It was Leonardo's closing in to the core of conflict rather than following the fortunes of a sprawling, eddying, pause-filled battle that led Vasari, yet another generation later, to praise the author of what he knew of *Anghiari* for 'the wonderful ideas he expressed in his interpretation of the battle'.[79]

The point has been laboured enough. Art's inventions, anchored in psychological experience or expectation, and made respectable by association with classical references, were more interesting to artists than the records of particular events. Michelangelo, thinking on the same lines and working in the same circumstances, got no further than a cartoon on paper which was, if we are to believe Vasari, torn up between artists avid to learn from Michelangelo, not from history.

He refers to 'many groups of figures' and to 'innumerable figures on horseback charging into battle'. But the only section known is the group of nude soldiers called to the alert while bathing, which was copied in grisaille by Bastiano da Sangallo (Fig. 211). More varied in pose, clearer in outline, and imaginatively harder than his earlier *Battle* relief, this composition, for all the figurative rhythm that sums up the whole gamut of moods from indolence to urgency, differs from Leonardo's 'standard' group as an anatomy of, rather than an empathy with the concept they both respond to, that of conflict. It has an exemplary, almost didactic air. This is why those who wished to learn tore fragments from it.

The composition responds to an episode recorded in a contemporary chronicle. On the day before the battle, a false alarm was sounded to ginger the resting troops into a state of preparedness. This reference, or an echo of it, must have been brought to Michelangelo's attention. Within elastic limits, civic commissions told an artist what to represent. But what the artist did was determined by his seeing a historical event as a challenge to what was uppermost in his mind as a free interpreter. This is clear from his practice: the ideally posed figure in the Albertina drawing for the central, topmost figure, for example.[80] He is there as a studio drawing from a model. He handles a pole. A pike, a standard? This was not the point. The drawing is simply absorbed into the overall composition.

ANNO·DNI
MDLXXXV

PONT·SVI
PRIMO

IV

166

An opinion from a scholarly Florentine connoisseur later in the century did not even assume that the scene may have been based on something that had actually happened. Writing of what he knew about *Cascina*, Raffaello Borghini expressed the opinion that 'when painters . . . wish to demonstrate the excellence of their art, they take fables or historical scenes that suit their purpose . . . or . . . sometimes invent them for themselves as Michelangelo did when, wanting to show men in various attitudes of muscular tension, he invented [*fince*] soldiers who, while washing themselves in a river, heard trumpets and drums calling them to battle.'[81]

Anghiari has been described as 'the first battle scene of modern times which really looked like a battle'.[82] But a battle is an event, fought by particular groups of men at a particular time and in a particular manner. As with *Cascina*, we do not know what the finished fresco would have looked like, nor how much either artist cared about the events he was referring to, nor how far the historical reality of the battles would have been grasped, or expected, by the audience for whom they were intended. If both artists had been commissioned to paint the *Battle of Anghiari* from the same brief, each would have depicted a different 'battle'.

What is novel about the evidence for the works that has survived is the means adopted to convey the notions of urgency and conflict. These reach not towards real battles in the past but towards the methodology employed in the greatest of all finished Italian battlepieces (Fig. 212), Giulio Romano's *Battle of Constantine* (parts of which follow designs by Raphael) of 1523–4,[83] an event in AD 312 for which no adequate source existed, though pious legend, following the story in Eusebius's *Ecclesiastical History* of the cross that appeared in the sky to Constantine before he defeated Maxentius at the Ponte Milvio, had established the battle as the key to the subsequent recognition of Christianity as a religion to be accepted within the Empire. Hence its commemoration on a grand scale in the Vatican.

To his knowledge of drawings by Leonardo and Michelangelo (or of engravings after the latter), the artist added a wider acquaintance with antique battle motifs than either had possessed. Copied, varied, reversed, these were integrated into a densely packed composition which was at once fastidiously academic and, around the still centre of the enlightened Emperor, emotionally percussive. Widely known outside Rome from its preliminary drawings and subsequent engravings, the fresco became, as Vasari noted, 'a guiding light for all who had to paint similar kinds of battle after him'.[84] And 'similar' does not only mean classical. Vasari himself used elements from it in his Medicean battle scenes in the Palazzo della Signoria. If Rubens turned to it chiefly for ancient subjects like *The Defeat of Sennacherib*, it was drawn on by Antoine-Jean Gros for his 1806 *Battle of Aboukir*, which took place in 1798.

Giulio's *Battle* proved a widely influential virus, and there is nothing we have noticed about the attempts of Italian artists to achieve victories in their recurrent personal struggles to subdue awkward facts to interpretative fictions that makes this surprising. But what of the encounters between the real and the renderable among their northern colleagues?

212. Giulio Romano, *The Battle of Constantine*. Fresco, 1523–4. Vatican Museum, Sala di Constantino.

CHAPTER 7
The Representation of Battle: Germany and Switzerland

D ürer's was a far from lone voice when he justified his writing, and illustrating, a treatise on fortification in 1527 by the remark that 'the necessities of war weigh more heavily and in a new manner upon our age'.[1] But this awareness did not lead to any significant solution to the problems inherent in the representation of battles: the reconciliation of record, atmosphere, and art.

The battle picture does not fit with any readiness into the sort of north–south contrast urged by Wölfflin, between the Germanic love of realistic detail and the Italian bias towards an overall simple grandeur.[2] Fresh interest in the everyday soldier coexisted with an acceptance of convention when it came to the battles he fought.

Conventions, though, need not be banal. In skilled and energetic hands they can switch the observer's mind from the particular to the codified via suggestion without failing to tap the instinct to be connected, through art, to reality. Their long life, as well as their convenience to the practitioner, is due in part to the observer's wish not to disbelieve.

The conventions long worked out within the panel paintings and manuscript illuminations of the International Gothic were vigorously caught up in a painting (Fig. 213) in Graz by the Master of the St Lambert votive panel of *c.*1430. It records a victory of the chivalrous hero-king Lewis the Great (reigned 1342–82) over Hungary's arch-enemy, the Serbs, translated into Hungary's later chief adversary, the Ottoman Turks. Everything here is counter-documentary. Lewis on his white horse is a St James figure. The whispering couple in the centre are based on conventional representations of Longinus and his squire. The quarrelling in the foreground over booty reflects the soldiers quarrelling over the lots cast for Christ's robe at the foot of the cross. On the left the Virgin protects the non-combatant laity and accepts the female saint's representations on behalf of the church in the background which she bears, in scaled-down replica, on her arm. The combat takes place on a bright greensward backed by an indigo sky methodically patterned with stars. This is not to say that those who knelt before it were not reminded of the king who had battled his way towards Hungary's greatest extension, or of the current threat from Ottoman incursions north of the Balkans. If Vasari could see verisimilitude and passion within Piero's static and stylized *Battle of Chosroes*, we are not to write off the St Lambert Master's pile of clichés – the fallen horse, the litter of broken weapons, the pierced bodies, the swords, javelins, pole-arms and banner brandished against the sky – as mere unreverberative flourishes. And, as the Ottoman threat intensified, such conventions lived on: in the stained and painted glass representation (*c.*1477) of Charlemagne's victory over the Avars at Regensburg in the Lorenzkirche, Nuremberg,[3] in the 1512 *Battle with the Turks* panel in the Mariazeller Wunderaltar.[4] As long as conventions still worked on the imagination, there was little need to discard them.

These were quasi-legendary, indeed, quasi-sacred subjects. But late medieval illuminators' conventions were still seen as having juice in them by the illustrators

213. Master of the Votive Panel of St Lambert, *Battle of Lewis of Hungary*, *c.*1430. Graz, Alte Galerie.

214. Anon., *The Battle of Grandson, 1476*. Miniature, 1513. Lucerne, Zentralbibliothek, Amtlicher Luzerner Chronik, ff.99v–100.

of German and Swiss civic chronicles when dealing with comparatively recent, remembered events. While the latter, in their details or their 'off-duty' recording may have led better artists in the direction of genre, battles and sieges used tested formulae: bloc confronting bloc or, as in the 1513 depiction (Fig. 214) in the *Amtlicher Luzerner Chronik* of the 1476 battle of Grandson, an almost random scattering of battle facts: marching units, clashes, tents, 'portraits' of huge guns.

That there was no wide demand for narrative verisimilitude in the north, any more than in Italy, is shown by the dry, highly schematic battle illustrations in such printed books as Hans Erhart Tüsch's *Die burgundische Historie* (Strasburg, 1477)[5] or Niclas Schradin's *Chronik dieses Krieges* (Sursee, 1500).[6] Similarly schematic, though more detailed, were the many single-sheet woodcut depictions of battles that were produced from the early sixteenth century. Even artists as fascinated by realistic detail as Hans Sebald Beham (*The Siege of Rhodes*, 1522)[7] or The Master HM (*The*

215. Holbein the Younger, *Infantry Battle*. Drawing, *c.*1530. Basle, Kunstmuseum, Kupferstichkabinett.

Battle of Mühlberg, 1547)[8] were content with expressing the notion of an engagement rather than a description of it. These were, of course, designed as news-sheets, they incorporate identifying lables (Beham) or add descriptive verses (Master HM). Yet in these, and other cases, the quality of draughtsmanship, and the imaginative incorporation of apparently real, but fictitious, genre details, is of a high order. It was an artistic loss when, from the mid-century, the demand for more information made the inscriptions (now more frequently in prose than in verse) longer and the pictures more banal.

Because of the difficulties inherent in the battle piece, other illuminators' conventions were gratefully accepted. The representation of a body of cavalry as a forest of lances, of an infantry attack as characterized by the pictorially attractive 'fall of pike,' were used as patterning devices within a varied composition or to organize the composition of a more selective scene. A supreme example of the latter is the pen and wash *Infantry Battle* (c.1530) by Holbein the Younger (Fig. 215). Conjecturally a study for a wall in the Basle council chamber, this bears no indication of who is fighting whom, or when, or why. The expressionist power of the splayed V of the composition, anchored near our eyes by the massive forms in personal combat and dwindling backwards into anonymous savagery, owes much to the pikestaffs which shoot up left and right in sprays of energy. And it was not just German artists who retreated from *Soldatenleben* genre to convention when undertaking battle subjects. Niklaus Manuel, when faced, in the surviving fragment of his St Ursula altarpiece,[9] by the need to portray a battle, fell headlong backwards into a world of remembered decorative and compositional clichés. The engagement was a legendary one. But it draws nothing from his experience as a soldier or his interest, as draughtsman and writer, in his fellow combatants.

Dürer produced no battle drawing or print. He died just before he might have been commissioned to join Duke Wilhelm IV of Bavaria's cohort of battle artists. A few labels suggest that he might have considered working the Hohenaspern drawing up to a 'news' print. And in his 1527 *Siege of a Fortified Town* woodcut we have some idea of how he might have treated a Wilhelmine commission (Fig. 216).[10]

'Reality' here is restricted to the horizon, where flames gout from villages fired by the invaders, and to the immediate foreground, where a peasant woman, accompanied by two children, gestures her dismay and a peasant, carrying an axe, crouches by a tree stump as he watches the conflict in progress.

This is utterly dehumanized. An inexorable, organized horde of pin men advance towards a void and a curved mass of stone.

216. Albrecht Dürer, *Siege of a Fortified Town.* Woodcut, 1527.

217. Albrecht Dürer, *Fortress on a Sea Shore*. Drawing, *c.*1527. Milan, Ambrosiana.

This is one of those *Bastei*, or fortress-bastions he described in the fortification treatise to which the woodcut is related, erected here to supplement the town's unmodified medieval defences.

The surprise party of the ant-army has scattered before the ditch to dig trenches and set up a battery protected by gabions. They open a distracting fire while the main body moves towards them across the plain: four advance blocks of pikemen, halberdiers and arquebusiers, the main body of pike with protective sleeves of arquebusiers, its standards protected by halberdiers. Alongside, the two supplementary siege trains move forward. The rearguard is too sketchily drawn for its armament to be discerned. Behind comes the commissariat division, wagons and herds of cows and flocks of sheep protected from assault from the rear by cavalry.

On this body's left flank wedges of horse and infantry move to cover the town's main gate. On its right, a cavalry detatchment dashes to control a bridge across the ditch. Meanwhile a disciplined mass of the defenders has issued from the main gate, in square and wedge formations backed up by some artillery, to take the enemy in flank.

This astonishing scene is at once individual and convention-based. Dürer's vision of impersonal confrontation is his own, but his vocabulary derives from earlier blocks-of-troops formulae and may owe something to the abstract formation diagrams in two Italian books published in 1521, Machiavelli's *Arte della Guerra* and Battista delle Valle's *Vallo: Libro continente appertenentie ad capitanii*. Another work of his last years, again probably 1527 (he died in 1528), the *Fortress on a Sea Shore* (Fig. 217),[11] attests to his quickening retreat from the human interest of war. Here, in one of the most beautifully assured of his landscape drawings, a circular fortress squats on the beach, unmanned, unattacked, a machine imposed on nature. It reflects his technical and mensurating preoccupation with drawings of a low circular fortress which echoes, though with no established connection, Leonardo's interest in a doughnut-shaped citadel. Here it has escaped the world of the advisory, the practical, into a very Germanic, Danubian one of a timelessly enduring Nature invaded by human hazards – robbers, satyrs, wild men – now, in this case, a mantrap.

As in Italy, in a number of works the theme of conflict, abstracted from the demands of historical reality, acknowledged the fever of war without locating it. Such scenes came later in the north, and at first hybridly, as in Hans Lützelburger's 1522 *Battle between Peasants and Nudes* in which the aesthetic endeavour collides with the subject matter (Fig. 218).[12] Happier in effect were the aesthetic-conflict prints between nudes or classical warriors produced by the Beham brothers and Aldegrever.

218. Hans Lützelburger, *Battle between Peasants and Nudes*. Engraving, 1522.

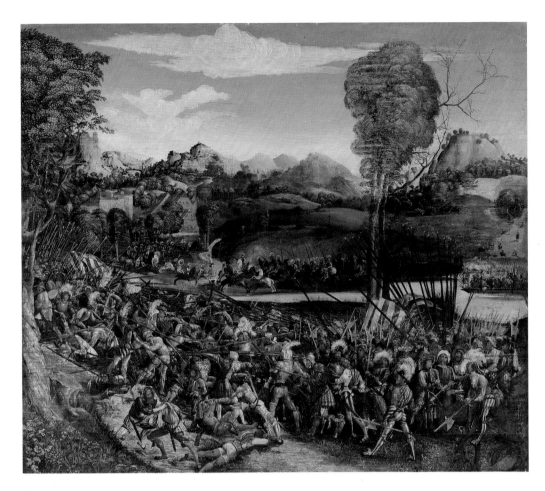

219. Anon., *Landsknecht Battle*. 1514. Würtzburg, Universitatssammlung.

These are fewer than their Italian parallels, and fewer still were personifications of personal combat like the Antaeus theme that was so popular in the south.

On the other hand, specifically Germanic were quite numerous 'battles without heroes', contemporarily rendered engagements without identifiable leader or apparent historical reference. Holbein's drawing appears to fall into this category, though if it were a sketch for a town hall commission a historical situation would presumably have been at least suggested at a later stage. Earlier examples were the 'Gladius' panel of *c.*1510 in Munich,[13] probably cut down from a larger work, so this, too, might have contained a historical reference (though not a hero, for this is clearly the centre of the composition) and the remarkable anonymous *Landsknecht Battle* painting of 1514 (Fig. 219).[14] Its size (110 × 127cm) and medium (oil on wood) ensure that this vigorous and grandly panoramic scene of conflict with its carefully placed fashionplate details was a commission that reflected a taste for imaginary battles in strictly modern dress. Prints picked up the fashion; in 1530, for instance, Niklas Stoer produced two woodcuts, one of a *Battle of the Landsknechts*,[15] which made bold use of the 'fall of pike' pattern (Fig. 220), another (of two sheets) of a *Cavalry Battle*.[16] The latter has devices identifying the opposing forces as French and Burgundian, but it remains essentially a battle for its own sake. And by then such scenes had become a not infrequent part of the iconography of Swiss designs for painted glass, whether in the drawing by Niklaus Manuel of *c.*1507 celebrating the war service of a young infantry captain (a siege detail of such splendid vigour and particularity that attempts have been made to identify the action)[17] or in Hans Funk's *The Old and the New Confederate* with its unspecific scene of Swiss infantry routing Landsknechts.[18] For all its Apocryphal context, the Battle of Betulia, so popular in northern Judith prints, was really another excuse for a

220. Niklas Stoer, *Battle of the Landsknechts.*
Woodcut, 1530.

battle for its own sake, bearing out the popular taste for representations of unspecific battles, as does Wolf Huber's late (?1540s) drawing of a *Battle before a Besieged Town* (Fig. 221).

In spite of its 'ideal' composition, and his hurried indifference to the way in which the opposing blocs are costumed and armed, Huber's drawing, eschewing such decorative conventions as the 'forest' or 'fall' of shaft weapons, has a strong feeling of the artist's participation in the real nature of a large-scale conflict. He had, of course, much to draw on by this period in his life – his early genre interest in soldiers; his fellow artists' battle-and-landscape contributions to the *Triumphzug* miniatures; his own attempt to convey the atmosphere of the Battle of Pavia; the *Siege* woodcut of Dürer which may have suggested the sally in strength from the town; the approach of the most sympathetic of his Danubian colleagues, notably Altdorfer, to the exemplary paintings commissioned by Wilhelm IV.[19] But none of

221. Wolf Huber, *Battle before a Besieged Town.*
Drawing, ?1540s. Karlsruhe, Staatliche
Kunsthalle.

these, nor the mastery of notational penmanship he had acquired, nor the necessity to organize his battle, inhibited his unforced sense of the naturalness of combat between enemy peoples.

As in Italy, a chronology of the northern 'art' battle piece resolves itself into clusters of works responding rather to the whims of patronage than to the winds of war. And the record is similarly maimed by losses. The representations of the battles of Murten and Dornach in, respectively, the town halls of Freiburg and Solothurn, and the battle scenes that were painted in fresco for the town hall of Augsburg:[20] all have gone. The northern record is, however, somewhat more complete because of the greater number of multiples in the form of prints and of those drawings which reflect the more open mind of northern artists towards secular subject matter.

Urs Graf's 1521 *Battlefield* drawing is the most startlingly original Renaissance image of war (Fig. 222), the only one that comments on the conflict it delineates. Other images attempt to glorify, analyse or ornament acts of war. Comment, particularly gloomy, sermonizing comment, was the last thing that occurred to artists working either for pay or on their own initiative. It has been suggested that there was a strain in Swiss attitudes to war that might have accepted so girdingly tragic a

222. Urs Graf, *Battlefield*. Drawing, 1521. Basle, Kunstmuseum, Kupferstichkabinett.

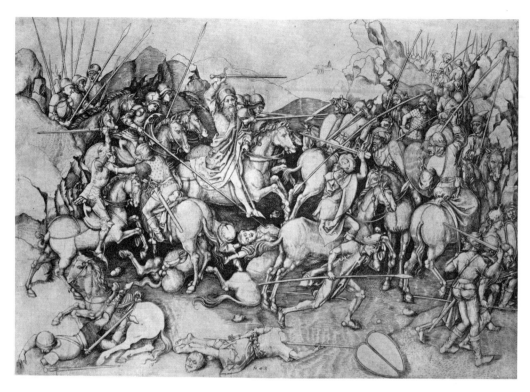

223. Martin Schongauer, *The Battle of Clavijo.*
Engraving, *c.*1470–5.

vision: delayed resentment over the 'betrayal' of the Swiss contingents at Marignano (1515) by their allies, the pacifist views of the ex-army chaplain, the Zurich Reformer Ulrich Zwingli, who was denouncing the squandering of Swiss bodies in foreigners' wars. But not only was Urs Graf an artist to whom the act of drawing was an unusually spontaneous reaction to a burst of feeling, but the *Battlefield* contains equivocations that make this explanation less than convincing.

A battle is in progress. In the middle ground a body of Stradiot (or Hungarian) light cavalry ride against units of pike. Bodies are strewn on the ground between them. In the background, very sketchily presented, an encounter between units of pike is beginning. In the foreground there is a clutter of naked, dead men, lanced, gashed and stripped. Art, as far as pose is concerned, plays little part here. A splayed figure, guts spilling from his side, displays his genitals. In the rictus of death an upside-down horse dies with the bray of an ass. Other dead or dying men lie or tumble in unacademic abandon. An indictment of war? The fired homesteads on the right, the hanged civilians, the glimpse of 'peace', the lake with its bridge and boat, support this interpretation. Yet the dominant figure in the composition is the young warrior on the left whose unnaturally long pike shaft relates him to the conflict behind him. Below is the split tympanum of war's drum, the only symbol in the drawing. But, dressed 'to kill', his body stretched, his buttocks tautened, his sword, defying gravity, sticking horizontally out, he drains his flask. He is ready to begin again. There is no pacifist message here, rather, surely, a grim acceptance that warfare is self-renewing, an ineluctable consequence of the aggressive spryness within human nature.

Be that as it may, a point to be made is that the foreground of the drawing – without precedent in the artist's previously war-accepting, indeed often preening work – would probably have been less gauntly horrid had he not known the first German art-battle image, the engraved *Battle of Clavijo* which has been attributed to Schongauer (Fig. 223), with the awkward convulsions of its fallen horses, its mortuary human victims, its staring dead heads, so near in their effect to that of the cadaver slumped over the upturned flank of the horse on the right of the *Battlefield*.

And in turn, these less than elegant features, which have caused doubt to be cast

176

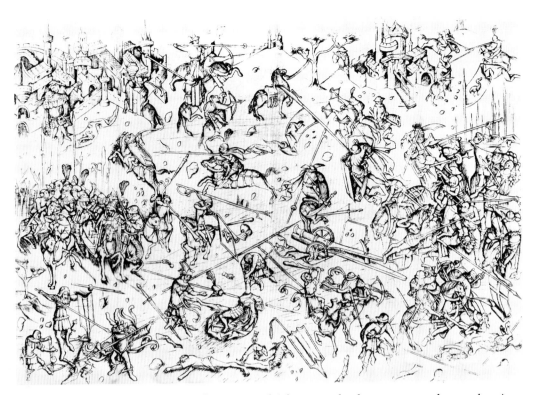

224. Anon., 'The Great Battle'. Engraving, second third of fifteenth century.

on Schongauer's authorship of a print which none the less no one else at the time (c.1470–5) could surely have produced, would be difficult to explain were it not for the influence of a yet earlier engraving, the anonymous, undated, and unprecedented (for instance the random pattern formed by pikes, lances and gun-trails) engraving, the conventionally titled *Great Battle* (Fig. 224).

This has been seen, surprisingly, but with some relevant parallels of details, as deriving from a lost Netherlandish painting of around 1430, and its subject identified as a generalized reference to the wars waged with scant success by the Emperor Sigismund in the 1420s against the Hussites, a subject unlikely to arouse the interest of an artist working within the ambiance of the Burgundian Netherlands. The appeal of the work, however, relies on neither argument. It presented a zanily organized anthology of the motifs used by illuminators to give energy if not cogency to their battles. And, as from a model book, Schongauer took from it what suited his mood and purpose: on the left the horseman pursuing a fleeing adversary who protects his back with his shield, in the right foreground the stricken horse on its back, in the left-centre (reversed by Schongauer) the stretched-out corpse associated with a shield. Conventions, borrowings: we must take both for granted when reviewing the battle pieces produced in the 'realistic' north.

In February 1499 the Swabian war in which the Swiss won their independence from the Empire broke out. After a series of defeats, notably at Hard (near Bregenz on Lake Constance) and at Dorneck (above the present town of Dornach in Canton Solothurn) Maximilian I called off his troops and those of his allies, the south German cities and nobles who formed the Swabian League, and ended the 'Swabian War' in September with the Peace of Basle. Fought with great savagery, much of it directed against civilians, the war raised Swiss national consciousness to a new intensity and confirmed the old antipathy between them and their German neighbours. Both consequences affected the interest artists went on to express in the lives and natures of Reisläufer and Landsknecht.

We have already looked at two works commemorating the war, the Danubian Master PW's animated map of the whole theatre from Bregenz to Dorneck, and the lively woodcut *Dorneck 1499*.[21] The amphibious attack on Hard was also treated on

177

225. Hans Baldung (attrib). *The Great Battle of the Lake of Constance*. Drawing, ?c.1510. Berlin, SMPK.

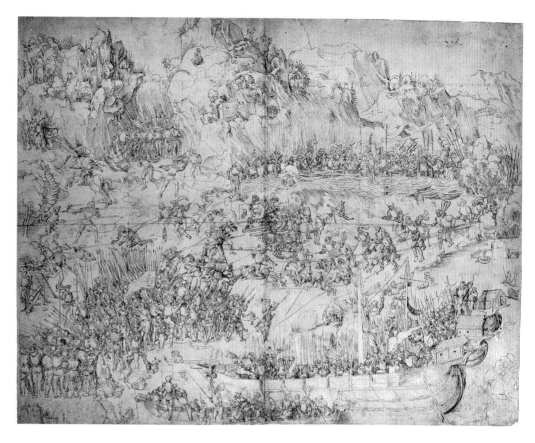

its own in a drawing, *The Great Battle of the Lake of Constance* (Fig. 225), attributed to Baldung and undated (in 1499 he was only 15 years old). It is difficult not to feel that the overall configuration owes something to the upper left-hand sheet in the Master PW's engraving, though there is no copying of motifs or echoing of his manner of rendering landscape or figures. It is unlabelled, the actions are spread out more inconsequentially and it avoids, therefore, traditional 'battle' conventions. For all its sketchiness, and its lack of interest in perspective scale, the drawing does, however, convey a sense of what a stretch of countryside occupied by military engagements is 'like'.

The fourth work in this early-sixteenth-century cluster is the large anonymous *Woodlands Battle (Schlacht im Walde)* (Fig. 226)[22] painting which records the victory on 19 June 1502 of an army recruited in and by Nuremberg over its aggressive neighbour-chieftain the Margrave Kasimir of Brandenbach-Ansbach, one of those Honest Burgher versus Overweening Baron conflicts that were over and done with in Italy but were still very much a part of the German sociopolitical scene and which, we have noticed, helped promote the image of the town-paid soldier above that of the knight.

Though Nuremberg was already a city of artistic repute, and though the art-loving Willibald Pirckheimer led the militia reserve (and is shown on the white horse left of centre speaking to the Commander-in-Chief, Ulman Stromer), the work, apart from its size and its being on canvas, would be happier swinging over a tavern door than hanging on the wall of a private house or town hall; it is less the work of an 'artist' than of a sign-painter.

With its pale (watercolour) tonality punctuated by a scattering of accented details all brought up close to the surface it seems more akin to Mogul than to European work. Unusual in its medium and style, peppered with jauntily postured but expressionless figures and with no clear narrative structure, the work pins down a rush of reminiscences derived from the shifting hours of actual experience and,

later, the proud anecdotal memories, of a nimbly hack painter who had quite possibly taken part in the action and spread it all out for the delectation of himself and his friends. Such a conjecture hardly explains the work's survival. But in any case, for all its charm, and the evidence it amasses of early Germanic interest in soldier figures and military equipment (weapons, wagons and so forth), it has to be left as a fascinating curiosity in the margin of the chronology we are embarked upon.

There is one more 'sport' to consider before reaching the cluster of battle works deriving from the patronage of Maximilian: the packed hordes breaking into a vivid confusion of personal combats in the large panel painting of the *Battle of Orsha*, now in the National Museum in Warsaw (Fig. 227).[23] It is anonymous, but has stylistic features that have linked it to the ambiance of Cranach; the probable self-portrait of the artist, gauging the action, it seems, as he sits in civilian clothes on the river bank on the right as if to show that he had been present, bears this out.

The painting was first recorded in Cracow; its subject and its size, no less than 162 × 232cm, point to a Polish commission. Orsha, on the Dnieper near Smolensk, was the site of the victory of a Polish–Lithuanian army raised by Sigismund I over a far larger Muscovite force. The battle is represented from the point of view of the Polish victors. Study of the costume, armament and weapons (like the cannon being dragged across the bridge on the lower right, which has been compared to Dürer's *Great Cannon* etching of 1518) has led to a date near to that of the 1514 battle itself. Normally, such an argument has only a *post quem* validity in an age careless of anachronism, but it is convincing here because of the quite unusual visual voracity with which the artist seizes on such details, his strong genre interest and, perhaps, his insistence – if the civilian figure is correctly identified – on appearing to be his own eyewitness.

The overall composition can be discerned readily enough. In the centre two compact and bright-toned units confront one another. Around them, behind and to their left troops pullulate in dense swarms. In the foreground and on the right the artist has used the Dnieper to present an upward curving frieze of details (Fig. 228), not just of gruesome hand-to-hand conflicts and terrified drownings but of such homely details as the emptying of water from boots, the pulling on of wet shoes with the aid of straps, arrows falling out of a quiver as a bowman falls backwards, the postures of exhaustion as well as of death. Burgundian and Swiss manuscript illustrations had hinted at the potential of such genre fringes to block engagements, but this artist carried further the fascination with the military predicaments that had prompted them, revealing to an extreme that interest in what experience was like that was so conspicuously lacking among southern artists.

These overall aspects of the composition are readily seizable. But for an analysis of its narrative elements I gratefully turn to the historian, Zdzislaw Zygulski, who has deduced its content from the documents relating to the battle.

> The events are portrayed in simultaneous representation: successive episodes, often involving the same personages, are shown in one pictorial field without any indication of the passage of time The picture was meant to be read from right to left, in strips from top to bottom, and in some cases from bottom to top . . . in some parts a definite number module applies, many separate groups of figures numbering seven or its multiple, while some other quantities are also systematically repeated.[24]

None the less, the implication that the artist knew what the documentation available to a modern scholar reveals is not necessarily to be accepted. Neither is it easy to agree with the idea that an artist who so loved his own brand of unsophisticated immediate *verismo* would also be so intellectual a deployer of the key incidents.

Certainly no such analytical expertise was demanded by Maximilian I, anxious though he was that his *équipe* of artists should do justice to the military campaigns that he saw as his chief claim to the homage due to his dynastic and imperial role.

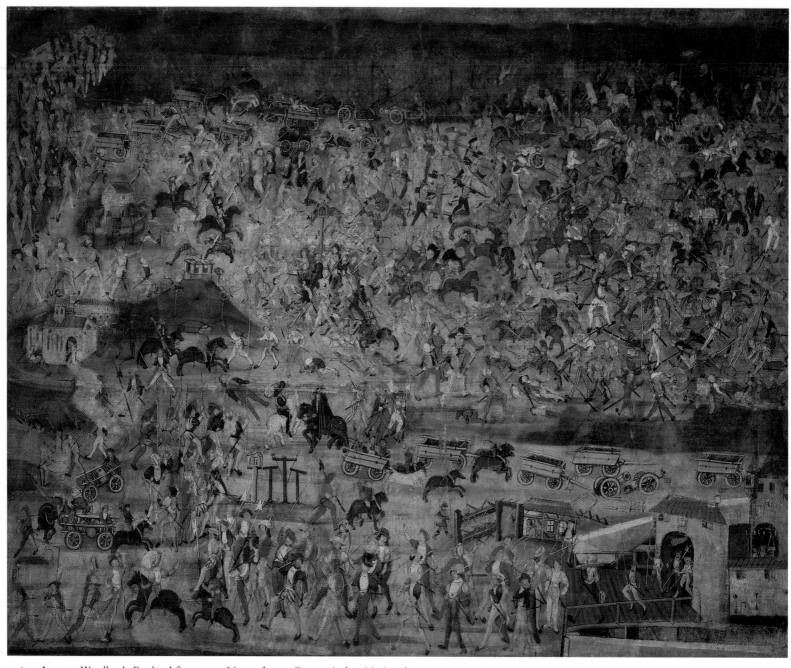

226. Anon., *Woodlands Battle*. After 1502. Nuremberg, Germanisches Nationalmuseum.

227. Anon., *The Battle of Orsha 1514*. *c.*1515–20. Warsaw, National Museum.

228. Detail of Fig. 227.

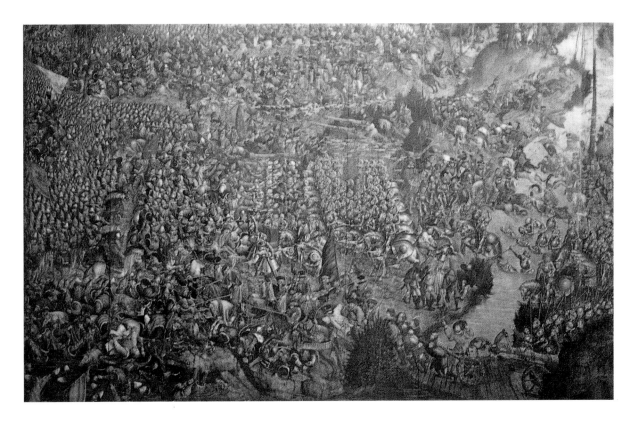

229. Master of the History, *Battle of Guinegate, 1479*. Coloured drawing, ?before 1515. Vienna, Staatsarchiv.

230. Hans Burgkmair, *Battle before a Castle*. Woodcut, 1512–16.

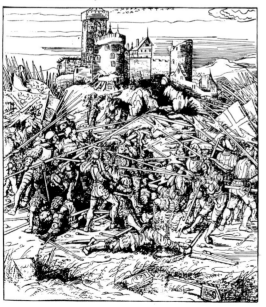

The artist of the *Historia Friderici et Maximiliani* was expected to isolate vignettes illustrating Maximilian's military education and his settlement of problems arising from, not being buried amidst, conflict. When the Emperor did license the depiction of a battle, as in the case of his victory over the French at Guinegate in 1479 (Fig. 229), he was content with a thin, generalized pattern characterized by sprays of lances and pike shafts. And when he commissioned Jörg Breu to design windows reminding him, as he hunted from one of his lodges in the Tyrol, of the victories that he had won in the neighbourhood, like his storming of the castle of Geroldstein (Kufstein),[25] to the north-east of Innsbruck, he was, again, content with landscape views that contained either genre scenes of his troops moving into action or patterned scrimmages that stood for, rather than described, an event.

The Boston proofs for the *Weisskunig* woodcuts[26] that were accumulating between *c.* 1514–17 show his close interest in the project but although the engagements were known intimately to him he does not query their treatment by the artists chiefly concerned, Burgkmair, Leonhard Beck and Schäufelein. Faced by over seventy battles and sieges they could hardly have been expected to research them with the pertinacity attributed to the *Orsha* painter.

So they relied on formulae. If it was a siege then the town or fortress rears in the background behind clashing infantry forces which are sometimes, as in Burgkmair's unidentified *Battle before a Castle*[27] delineated with a surge of real feeling for the conditions in which such engagements were fought (Fig. 230). Battles in open ground were treated more summarily, as when Schäufelein took refuge in an explosion of shafts and flags behind a modicum of particularized foreground incidents that could have stood for any military engagement anywhere, even if it purported, for instance, to represent Maximilian's attack on the Venetians before Cividale in 1508.[28]

The large, vividly coloured miniatures depicting Maximilian's major campaigns in the painted version of the *Triumphzug* were entrusted to The Master of the History, Lemberger and to Altdorfer, sometimes assisted by his workshop. To the first only siege scenes were allocated, perhaps because of his easy knack with those genre details which helped to bring them, or siege conditions in general, back to memory and for which we have looked at them in a previous chapter.[29] Lemberger solved the problems presented by a type of subject new to him, by bridging the gaps between the two modes that he had mastered in earlier commissions, the high-angle view of populated landscapes and close-ups of soldiers and weapons, with conventionalized blocks of troops and sparse skirmishes represented by rays of pole-arms – a see-through technique which, allied to his deploying both conventions in contour-like lines, enabled the terrain over which the battle was fought to be readily discernible (Fig. 231).

Altdorfer, also then a novice battle painter, similarly drew on an experience of landscape and of military genre. Both fed directly into his extensive view of the siege of Kufstein (the incident chosen to represent *Der Bayrisch Krieg*).[30] More remarkable was his easier, racier manipulation of the conventions needed in the depiction of large numbers of troops, while leaving the natural setting to dominate the transitory conflicts of men, and while providing close-ups, in the foreground or on the flanks of action, or within the swirls and columns of massed encounters, that spoke to the knowledge of those who had experienced battle itself. The interest in how he handled these miniature assignments is intensified by the probability that their effectiveness led not just to his being invited, later on, to paint *The Battle of Issus* (the *Alexanderschlacht*), but to the rehearsed technique that put this in the first rank of all the formal battle paintings that have ever been produced.

The extent to which Maximilian did not require documentary verisimilitude from the *Triumphzug* miniatures is well displayed in the double spread of the *Great Venetian War* (Fig. 234). In the right-hand half, his troops, under the Duke of Brunswick, are poured by Altdorfer down from mountain passes north of Friuli and

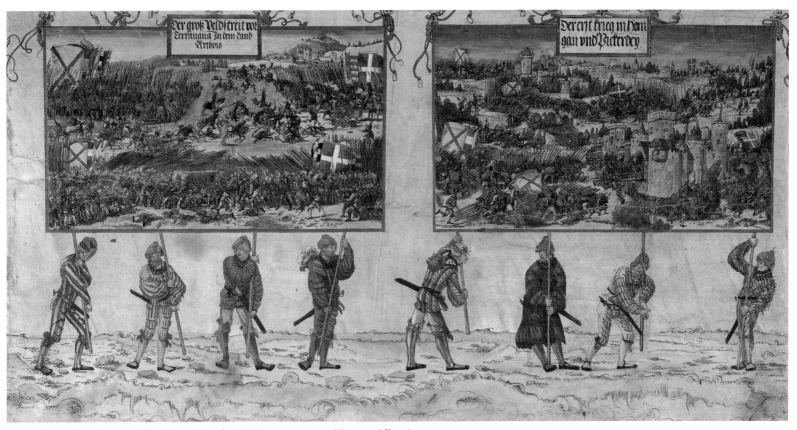

231. Georg Lemberger, *The War in Picardy*. Miniature, c.1512. Vienna, Albertina.

strike towards the Venetian lagoon. At its edge a bristling body of pike forces the lion of St Mark to retreat from the mainland and swim for refuge to the city shown on the left. Neither Venice itself nor the fictionalized landscape reveals any first-hand knowledge and the inclusion of the smaller lion on the right, being brushed aside, and the larger one put to flight across the lagoon, makes this the most purely propagandistic of the *Triumphzug* war scenes. Though the miniatures are thought to have been completed in 1515, it is tempting to connect the latter image, haloed though not winged, with Carpaccio's great *Lion of St Mark* which stands with its hind legs in the lagoon, its forelegs on the mainland.[31] Painted in 1516 to symbolize the reconquest by Venice of its possessions after the collapse of Maximilian's plans, the image was striking enough for word of mouth, if not a drawing, to have brought it, though not necessarily its significance, to Altdorfer's notice.

As in the *Weisskunig*, Maximilian approved of programmes that included defeats as well as victories, seeing his campaigns, win or lose, as a series of legally justified and gloriously undertaken deeds of war. None of Altdorfer's miniatures is more splendidly energized than the unspecific battle between German and Swiss infantry with which he sums up the series of the former's defeats in the Swabian War, the gravest of blows to the authority of the Empire.

Landscape again in *The Terrible Swiss War* (*Der greulich Sweytzer Krieg*) dominates the action it absorbs (Fig. 233). The main battle is deployed in a curving diagonal swathe rising from the lower left. There is no conspicuous leadership, the masses create their own patterns of force, pikestaffs standing up straight as reed beds or slanting down to become a storm of criss-crosses at the points of contact between force and force. Quick squirls of white indicate the feathered head-dresses favoured by either side. The effect is both unreal and convincing, the more closely observed skirmish in the right foreground providing a sort of key to the conventions represented in the main conflict.

We are looking at conventions deployed amidst an overall convention: that of the *Triumphzug* itself, in which the miniatures are feigned to be painted, labelled standards borne aloft by a frieze of Landsknecht standard bearers. The extent to which Altdorfer and his colleagues can create illusions of real conflict panoramas opening beyond the frames as though through windows, within this artificial framework owes something, of course, to working procedures, the labels at the top and the standard bearers at the bottom being 'added' to the separately pondered and executed war scene, but to apply such a framework without its destroying the miniatures' sense either of place or experience is a remarkable achievement.

It is at least not unlikely that their vision was assisted by lost examples of an approach to the delineation of military episodes later represented by the illustrated chronicle (Fig. 232) that recorded the events that took place around the monastery of Weisenau (in Hesse, near Mainz) during the 1525 Peasants' War.[32]

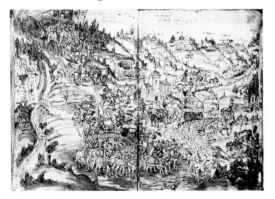

232. Anon., *Action near Weisenau during the Peasants' War*. Drawing (miniature), *c*.1525. Wurtemberg, Schloss Zeil.

They are the work of one of those cartographer-chorographers whose work was more hospitable to human interest than that of the geometrically austerer contemporary surveyor-cartographers of Italy. Though not himself an artist, he was not unaware of artistic devices which could balance and give a sense of occupied foreground to his sketches. Above all one gets the impression of a man who had mastered the shorthand knacks of the topographer and the campaign draughtsman – bristling pike masses, isolated jottings of separate figures, and so forth – and was giving visual form to the experiences poured out to him by those who had lived through them in what amounts to a pictorial equivalent of ghostwriting. These anonymous illustrations suggest that around the formal German battle scene there was a penumbra of pictorial journalism skilled at taking account of the here and now.

In contrast to the localized dramas of the Peasants' War, no other encounter aroused such international interest as did the battle of Pavia in that same year, 1525. Seen even before the event itself as a climactic clash between Valois insistence on

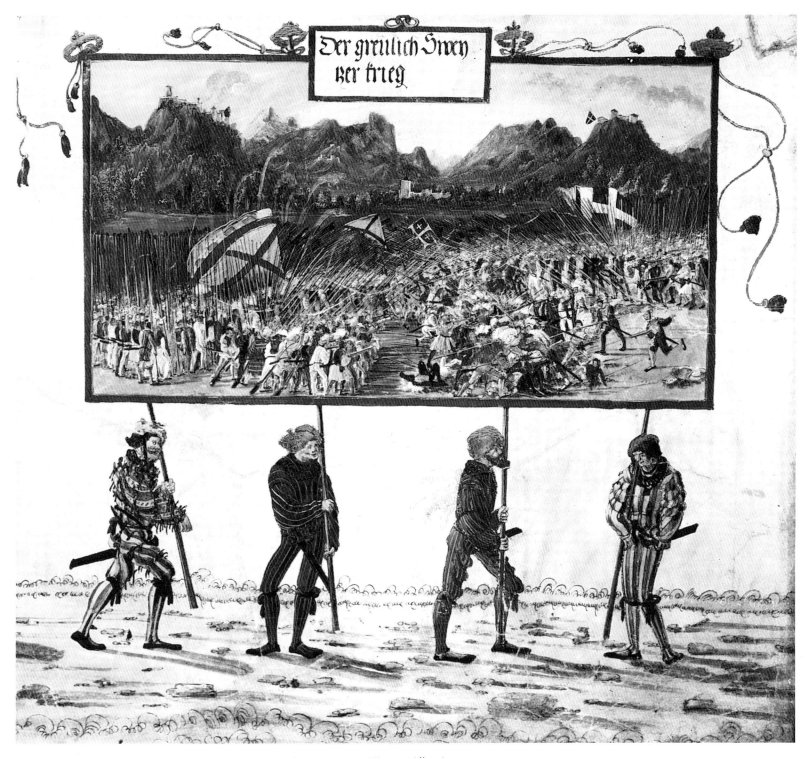

233. Albrecht Altdorfer, *The Terrible Swiss War*. Miniature, *c*.1515. Vienna, Albertina.

234. (*following pages*) Albrecht Altdorfer (the standard bearers by other hands), *The Great Venetian War*. Miniature, *c*.1515. Vienna, Albertina.

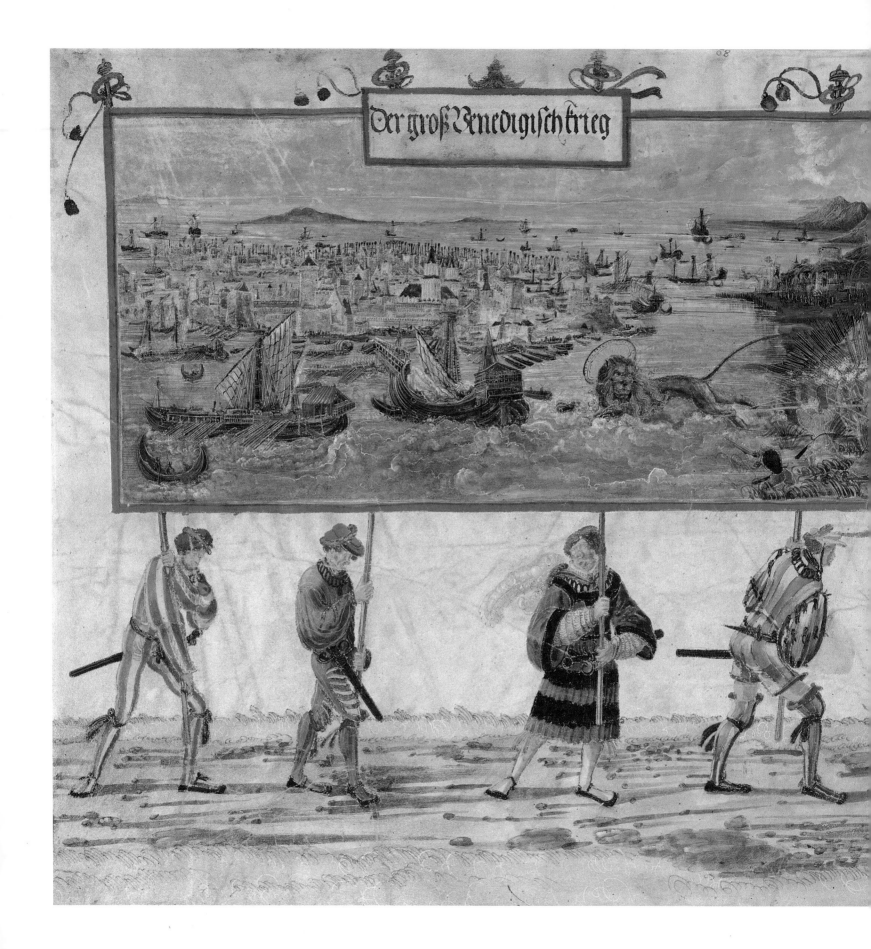

Der groß Venedigisch krieg

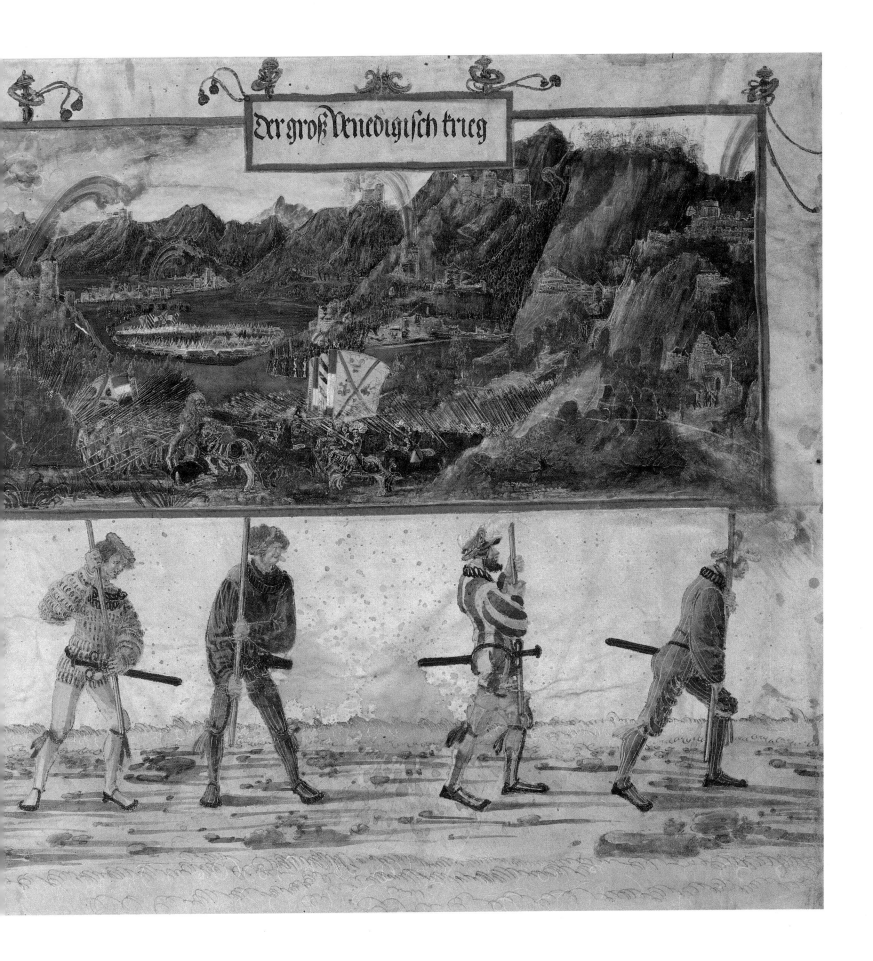

Der groß Venedigisch krieg

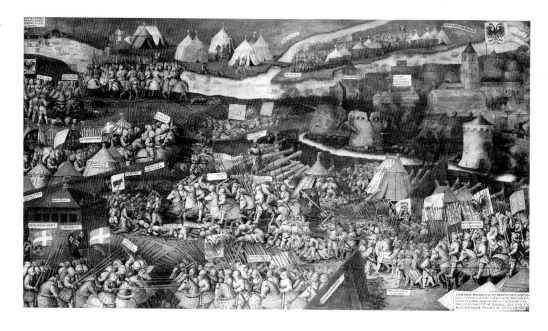

235. Anon., *The Battle of Pavia, 1525.* ?1525–30. London, Tower Armouries.

236. Anon., *The Battle of Pavia, 1525.* ?1525–30. Oxford, Ashmolean.

controlling Milanese Lombardy and Habsburg determination to dominate this strategic nexus which controlled logistic communication between Spain, Germany and up through the 'Spanish Road', to the Netherlands, Europe waited upon the outcome of yet another French challenge to Maximilian's successor, the Emperor Charles V, on Italian soil. The event, the battle of 24 February 1525, more than justified the news hunger of a huge geopolitical area, few of whose components were not directly concerned in the struggle through alliance or personal service. The Imperial forces won. The glamorous Most Christian King of France, Francis

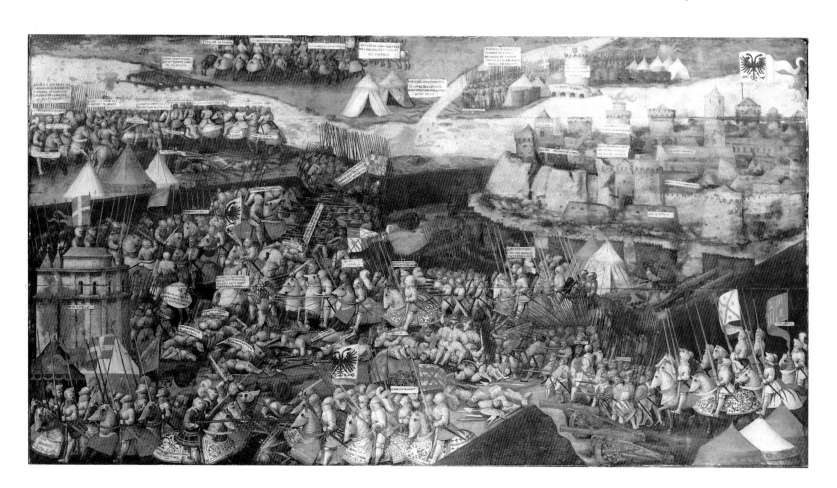

I, hero of so many encounters both in the field and in bed, was taken prisoner and shipped into captivity in Spain. No wonder so many artists were commissioned or volunteered their services to commemorate the event.

For reasons we have come to appreciate, no Italian artist can be connected with any of these representations, though the labels on the decorative pseudo-documentary panel painting in the Tower of London (Fig. 235)[33] points to an Italian pro-Imperial patron of an upper Rhenish artist woodenly abreast of transalpine conventions. In the case of the painting in the Ashmolean, Oxford (Fig. 236),[34] the French labels which identify protagonists and leaders, together with its technique, suggest a similar origin for a different patron: to have taken part in a campaign of such unusually dramatic significance could have been reason enough to want a reminder of it, even if the chances of war had gone against one. On the victor's side, no Spanish commemoration is known. From the Habsburg Netherlands, the response to accounts of the battle was loyal and varied, from the neatly undisturbing painting in Vienna[35] and the larger and more animated reconstruction of the event in Birmingham, Alabama,[36] to the tapestries designed by Barnaert van Orley.[37]

In spite of the parade of information in the long prose text accompanying it, Schäufelein's 6-part woodcut[38] of the same or the following year was carefully

237. Hans Schäufelein, *The Battle of Pavia, 1525.* Woodcut, *c.*1526.

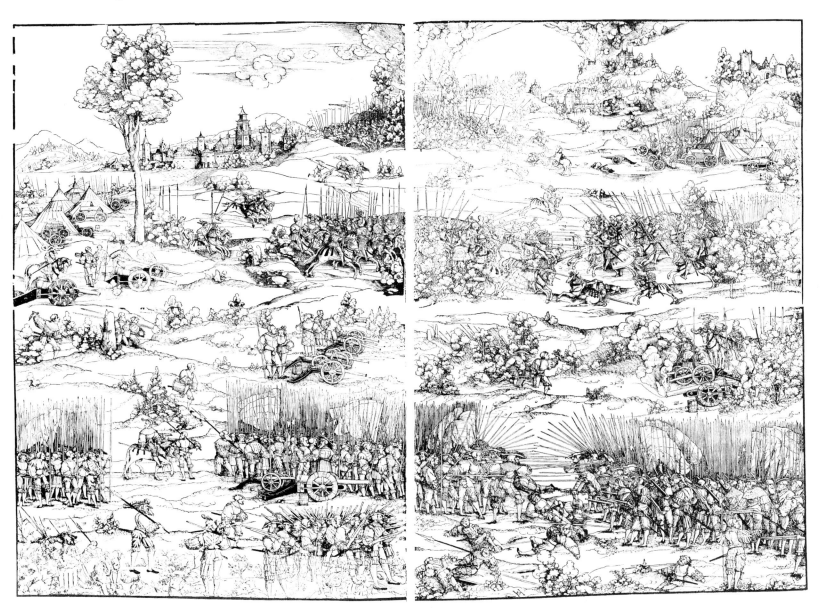

189

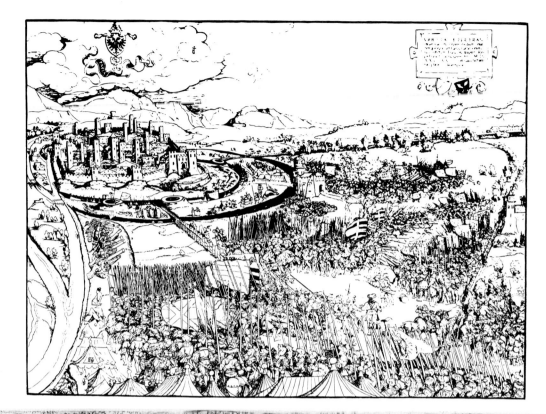

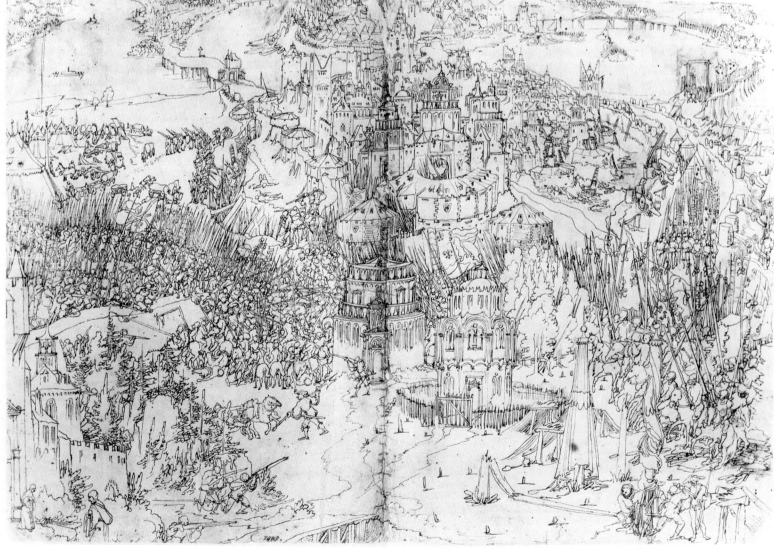

executed but cynically composed, with a somewhat lackadaisical infantry encounter in the foreground, a cavalry one in the middle, and a second cavalry engagement sketchily indicated at the top (Fig. 237). The gaps are filled with the genre plums that the artist could by now pull out the pie of visual clichés almost automatically: sprawling dead, individual running soldiers, carts and cannon parked beside tents, riderless horses and so on. Though topographically closer to the scene of the action, Jörg Breu's rather later, clumsier woodcut (Fig. 238) is equally off-hand though it was shrewdly issued with alternative identifying captions, one in German for a local audience, the other in Latin for a wider one.

In its subordination of episodes to a generalized view of conflict it is nearer than Schäufelein's composition to the *Triumphzug* miniatures, and their influence seems even stronger on Huber's large *Pavia* drawing (Fig. 239), with its free play of genre details (like the tent canvases collapsed against or furled round their king-posts – one of which is snapped off) skirting a central, largely imaginary townscape around which engage or form up armies whose role can only be deduced from the standards, Imperial and French, borne amongst them. It has been seen both as a *modello* for the *Pavia* relief for the tomb of his patron Niklas von Salm (who commanded a company at the battle and was partly responsible for the capture of Francis I)[39] in the Votivkirche, Vienna – and the sculpture does appear to be a free if dogged adaptation of it – and as suggesting the possibility that the cycle of classical battles planned for Wilhelm IV of Bavaria might at an early stage have included contemporary subjects of outstanding fame.

We move still further towards this link between the *Triumphzug* and the Wilhelm cycle when we look at the one German painting of Pavia, Ruprecht Heller's careful but dull, indeed in details unconsciously comical, *Battle of Pavia* of 1529 in Stockholm (Fig. 240). In a mood quite different from that in which Italian artists and their patrons operated, Heller felt no qualms about showing Landsknechts fighting on both sides and against one another, some (Frundsberg's corps on the lower left)

238. Jörg Breu, *The Battle of Pavia, 1525*. Woodcut, *c*.1526–7.

239. Wolf Huber, *The Battle of Pavia, 1525*. Drawing, *c*.1530. Munich, Staatliche Graphische Sammlung.

240. Ruprecht Heller, *The Battle of Pavia, 1525*, 1529. Stockholm, National Museum.

victorious, others (the fleeing infantry on the right) beaten. In the north battles could be seen as events interesting for their own sake rather than as fodder for patriotic encouragement or self-congratulation.

There is one more work to be considered before we turn to the Wilhelmine cycle, the 1518 *Battle with the Huns outside Regensburg* (Fig. 243) which was produced by Altdorfer's workshop for the surface of a piece of furniture, a table: no wonder that one has to bear in mind the number of battle images that may have been lost!

This is an excited version of the threshing mêlée conventions used to animate the *Triumphzug* minatures. Genre details are reduced to a minimum, while the central figures, Alaric and his pursuer, are isolated in the lower middle ground by their brighter tonality and larger scale.

This is a novel feature. Another is the unprecedented rendering of the sky above the horizon, divided, because the battle was recorded as having gone on for three days and two nights, into three light and two dark, star-studded zones. In the central one is shown a sword-wielding angel under a floating cross. The former crudely anticipates the use of the sky as a timepiece in *The Battle of Issus*, the latter perhaps the prominent labels that hang down into the air above that and the other battle scenes in Wilhelm's series and give, as those in the *Triumphzug* did not, a sense of timeless significance to the conflicts below them.

Wilhelm, the ruler (in tandem with his brother Lewis) of Bavaria from the attainment of his majority in 1511, was a nephew through his mother of Maximilian. Like him, he was a determined jouster. It was also in Maximilian's vein that he commissioned in 1524 a somewhat mediocre group of artists to record the costume of all his court functionaries.[40] As a staunch Catholic in a time of early Reformation, and as the beneficiary of a humanistic education, he was abreast of Italian fashions, though he wanted them to be translated into local practice by Germans. His court historiographer, who almost certainly devised the programme followed by Altdorfer and his colleagues, had a Latin name, Aventinus; but this was derived from his home town, Abensberg, and to his friends he was plain Johannes Turmair. The man he consulted to guide his Italianate plans for a park and pleasure buildings on the outskirts of his capital, Munich, was none other than Altdorfer, artist, trusted town councillor of Regensburg (he turned down the invitation to become mayor in 1528 because of his work, notably *Issus*, for Wilhelm), as well as the city's municipal architect. The work was carried into effect by a local architect, Leonhard Halder. It was typical of German feeling that, unlike his contemporaries Henry VIII of England, Francis I of France and Sigismund I of Poland, Wilhelm did not feel that Italian ideas should be carried out by Italians.

His project was for a gallery of paintings in one of the houses of entertainment in his park that would remind its visitors of the great deeds of militant men and courageous women in the past, whose lustre he would, by commemorating, share.[41] This was not alien to German interest in the 'worthies' of classical and biblical times, though this was a much frailer tradition (and one manifested chiefly in prints) in Germany than in Italy. Wilhelm's cycle was unique in Germany, and he called exclusively on artists in his own catchment area: apart from Altdorfer, he employed Jörg Breu and Hans Burgkmair from Augsburg, the Nuremberger Barthel Beham, Melchior Feselen, who was based in Ingolstadt, and the outstanding if only moderately gifted local artists Abraham and Hans Schöpfer and Ludwig Refinger.

The 'war' pictures were distinguished from the 'heroine' pictures by their format: the war scenes were tall, the latter broad. This crucial separation (we know nothing of its significance for the hanging of the paintings) was probably suggested by Altdorfer who had the Duke's ear and, from his *Triumphzug* miniatures via the *Battle against the Huns*, had come to see 'battle' in impersonal, cosmic, sky-including terms, as against the close-up record of female rectitude. Certainly the choice of a tall format (*c.*160 × 120cm) played a considerable role in the works' effectiveness.

Produced over a period of some ten years, the military subjects[42] were:

These fall into two categories, four major military engagements (Issus, Cannae, Zama, Alesia), and four stories of exemplary behaviour in a military context – 'pro patria' as the Horatius label has it;[43] in these the tall format is adhered to and the acts of courage and self-sacrifice are watched by whole armies.

Burgkmair's *Cannae* (Fig. 241) is a decorative and vigorous but routine rough and tumble organized, on the simplest possible lines, in four tiers: at the bottom a cavalry engagement with the familiar tumbled horses, bodies and arms, in the second strip an infantry engagement, in the third another cavalry one, in the fourth mountains and sky, with, instead of a label in feigned relief an inscription *Clades. Rom. Ad. Cannas* (The Defeat of the Romans near Cannae), and – in the manner of the *Battle with the Huns'* angel and cross – mythological and zodiacal figures. Their interpretation has proved elusive. The moon on the left and the sun on the right may suggest, as in *Issus*, the passage of time, which only a viewer with Livy in his hand could work out from the identifying labels indicating episodes identified with particular leaders and groups. The central group of Jupiter, Saturn and Mars (in a

241. Hans Burgkmair, *Hannibal's Defeat of the Romans at Cannae*, 1529. Munich, Alte Pinakothek.

242. Jörg Breu, *The Battle of Zama*, c.1530. Munich, Alte Pinakothek.

243. Albrecht Altdorfer (and workshop), *Battle with the Huns outside Regensburg*, 1518. Nuremberg, Germanisches Nationalmuseum.

244. Albrecht Altdorfer, *The Battle of Issus*. 1529. Munich, Alte Pinakothek.

plunging foreshortening quite uncharacteristic of Burgkmair), relate the temporal affairs of man to the timeless concerns of the planetary gods.

Both sides wear 'classical' armour and equipment. Breu sees Scipio's defeat of Hannibal in 1530 terms as far as Scipio's Romans are concerned (Fig. 242). The Carthaginians are turbanned and wear the exotic hybrid armour of which we shall see much when looking at the representation of soldiers in religious art.

Breu's approach to the source – Livy again – handed to him by Aventinus, was quite different from Burgkmair's and led to a quite different composition.

He chose the great encircling movement planned by Scipio to open the engagement and which conditioned its eventual success. Breu divided his field into two halves. In the lower the Romans press in against the Carthaginians from the top, left and right, while in a brilliant solution to the problem of what to do with the foreground he introduces the main theme of encirclement with a direct, head-on confrontation, which avoids cliché by revealing him not only as an engaging master of picturesque detail but as one of the greatest and most versatile of Renaissance horse painters.

The upper half is divided, not unsubtly, into two bands. In the lower, distant camps are divided by a perspective avenue leading to the upper: a landscape evaporating towards the distant north African coast and an immensity – a quarter of the whole painting field – of sky. Later overpaint in this area of the (?)seventeenth century, which includes the label, makes it difficult to calculate its original effect, though its area alone suggests the timelessness, the absorption of the temporary into the eternal, that does so much to establish the metaphysical aura of these otherwise highly particularized works.

Though Feselen's painting (Fig. 245) has come to be known as *The Siege of Alesia* it is really a battle piece, with the town in the background unassaulted save by silent guns, bright and sanitized from any sense of the reality of conflict. Its engaging artist plumped for the conventions associated with the German representations of Pavia and tried to compensate for his conceptual laziness by a fine attention to detail. The 'good' army, Caesar's, is shown in terms of the infantry and cavalry costumes of 1533 (that they are 'good' is conveyed by the Habsburg eagle on their flag on the lower left). Vercingetorix's Gauls are, in contrast, shown as classically clad Romans.

Feselen, too, has divided his field horizontally into halves. In the lower an infantry battle is topped by a cavalry one and in both the 'forest' convention of pike shafts and lances is offset by genre close-ups of personal encounters and individual figures, one of which, the halberdier in the left foreground, looks directly and vapidly out at us. In the upper half the city and the siege lines round it (whose occupants pay no attention to the battle), are surmounted by a distant landscape of numbing hackwork and – the painting's saving grace, apart from its overall prettiness – an immensity of sky. Fouled though it is by ineptly rendered clouds, this once again justifies the choice of a format which linked the forces of men to those of nature, a linkage never made in Italy. Italians were the formalists of war. Germans were potentially its philosophers.

Such, at least, is the generalization one is tempted to make when turning to the artist who was the most likely to have suggested to Wilhelm both the format of the battle pieces and, thus, the mood that was encouraged by this.

As with many of those masterpieces whose authority has tempted later generations to interfere with them, *Issus* (Fig. 244) is not exactly how Altdorfer left it. It has been cut, though not by much, at the top. At the same time, ?*c.*1600, the label was reduced in height when a longer inscription in German was boiled down to the present Latin one. Its gist, the roll-call of victims and prisoners, was left intact with its 'for whom the bell tolls' resonance as it turns on an axis which points down towards the central moment of this particular conflict, the figure of Alexander pursuing the chariot of Darius.

Such a reflection, alien perhaps to the sensibility of Altdorfer's contemporaries,

245. Melchior Feselen, *The Siege of Alesia*. 1533. Munich, Alte Pinakothek.

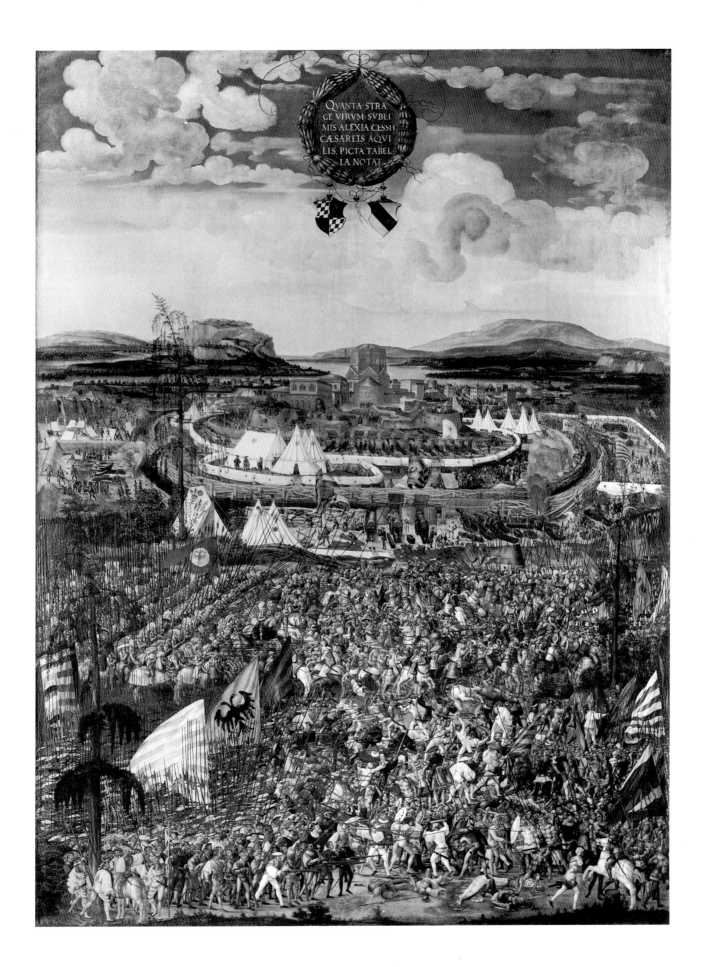

QVANTA STRA
GE VIRVM SVBLI
MIS ALEXIA CESSIT
CÆSAREIS AQVI
LIS, PICTA TABEL
LA NOTAT

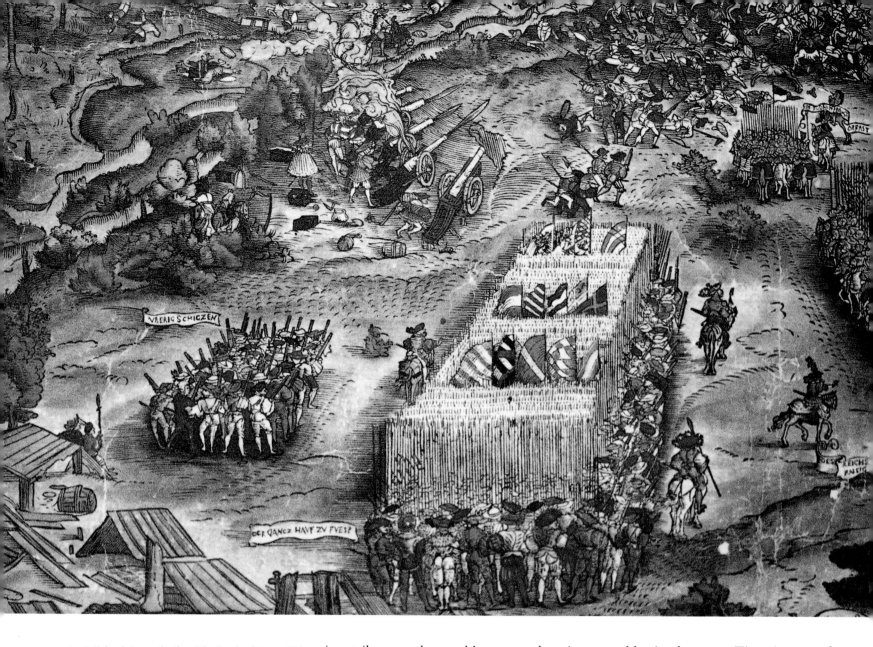

246. Michael Ostendorfer, *The Battle of Enzenfeld*, (detail). Coloured woodcut, 1539. Vienna, Albertina.

is a tribute to the work's constantly reinterpretable timelessness. Time is part of the subject matter of all these Wilhelmine battle pieces, but nowhere is its role more conspicuous than in *Issus*. The battle took place in 333 BC. Altdorfer clads it in the costume of 1529 with some turbans and occasional exoticizations well within the range of contemporary theatrical, pageant or parade armours. He labels his antagonists and some of their units' standards. This is *that* battle. His modern armies are without gunpowder weapons. But the turbans, the environed city on the right, the countryside overrun with the dense conflict of opposing armies: surely he was tapping some reaction to the Turkish siege of the Imperial capital, Vienna, whose outcome was threatening his country as he painted. The turning tablet in the sky, the moon, the sun from whose turbulent setting a dying warmth picks out the brighter accents within the sombrer blues, greens and browns of the last stage of the action as Avertinus had described it in an excursus in his 1526 *Bavarian Chronicle*; Altdorfer's halving of the pictorial field, keeping the unprecedentedly controlled details of the masses within the patterns of combat to the lower zone, while devoting the upper to the loftily envisioned landscape (through which the estuary of the River Pinarus is shown as widening from the east into the Mediterranean) and to the atmospheric conflict which, in spite of its still centre, stormingly dominates the mood of the

198

compositon as a whole: all these features promote his vision of a time scale that is neither specific nor synchronous but unending.

That the less formal battle piece went on to attract talented German artists (partly because of the continuing Turkish pressure that led to the publication in 1539 of Michael Ostendorfer's commanding series of woodcuts (Fig. 246) of which the Albertina holds a contemporarily coloured set)[44] could lead us forward in an area unoccupied by an equivalent interest evinced by artists in Italy in spite of their own consciousness of the Turkish threat which culminated in the war of 1537–40. But with the Wilhelm cycle, and with Altdorfer's greatest work, unrivalled in its combination of detail and idea in his own, or any other work of the European Renaissance, we may turn from warfare to War.

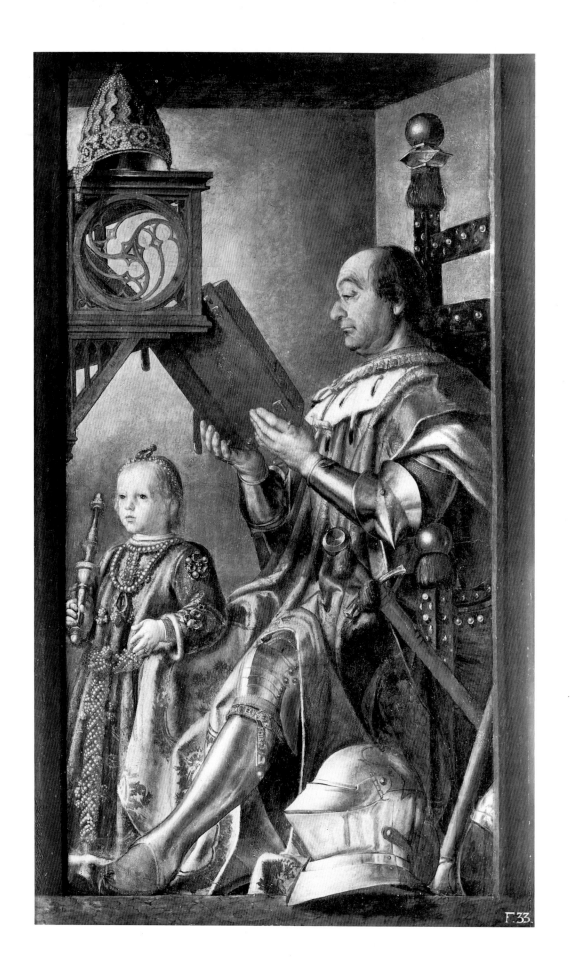

CHAPTER 8
War and Values: the Visual Vocabulary

OVERWHELMINGLY, THE IMAGES we have reviewed have been, in any large sense, unjudgmental. The soldiers have been scolded for their personal vices. That battles involved wounds and deaths has been acknowledged. But only two works have looked askance at the ideological status of military activity as a whole, and both, significantly, were the works of a single artist (Urs Graf's *A Casualty of War* and *Battle* drawings) who was quite unusually indifferent to a public opinion which all over Europe assumed that war was an inescapable aspect of existence which might, on occasion, be a positive good.

There were fissures in this stratum of consensus, dissident voices, monitory or programatically pacifistic, that broke through in the words of sermons or books. But art's expression of values depended on a far more restricted vocabulary of signs and symbols that could communicate meaning, and these were either progressively flawed as straightforward vehicles for comment, or freshly enlisted among the supporters of warfare.

We have seen that neither the arts themselves nor more than a few individual artists suffered hardship as a consequence of warfare. If the Sack of Rome shook the equilibrium of some of those who were caught up in it (Marcantonio Raimondi, according to Vasari, was reduced to beggary by the ransom he had to pay), it was not war but Protestant iconoclasm that checked careers and narrowed the range of artistic production.

It is true that Mantegna's Parnassus[1] of *c.*1497 implied that only when Mars and Venus were in peaceful harmony could the Muses freely dance, but the theme only became naturalized later and outside the Italo-Germanic area, from Lukas de Heere's *The Seven Liberal Arts in Time of War* (they sleep)[2] to the following century's painting by Michael Sweerts, *Mars destroying the Arts*,[3] and Rubens's *The Horrors of War*, of which he wrote 'you will find, under the feet of Mars, a book as well as a drawing on paper, to signify that he treads underfoot all the arts and letters.'[4] It took the brutality of the Wars of the Netherlands and the pervasive horrors of the Thirty Years War that succeeded it, to ram this message home. More typical of our place and period was Cellini's vast sculptured project to laud Francis I, in the guise of Mars, as the protector of learning and the arts.[5]

For earlier, and especially in Italy, the identification between arms and letters, war and culture, had become habitual. Alberti dedicated his *De Pictura* to Gian Francesco Gonzaga hoping that he would enjoy the treatise 'with your usual kindness, in which no less than in the glory of arms and the skill of letters you exceed all other princes'.[6] Justus of Ghent's portrait of Duke Federico of Urbino (Fig. 247) showed him reading in his famous library of manuscripts while clad in armour.[7] In the debate between the rival merits of arms and letters, already hackneyed before Castiglione embarked on it in *The Courtier*, Caesar was constantly cited as being both warrior and writer; no wonder that his portrait, whether by Desiderio da Settignano[8] or by a later, anonymous Florentine sculptor (*c.*1525),[9] showed him as the type of the keen-witted intellectual.

247. Joos van Gent, *Federico da Montefeltro and his Son*. *c.*1476. Urbino, Galleria Nazionale delle Marche.

248. Petrarch Master (Hans Weiditz), *The Happy and the Unhappy Mothers*. Woodcut, 1532.

249. Petrarch Master (Hans Weiditz), *War the Father of all Things*. Woodcut, 1532.

Erasmian pacifistic ideas, though widely circulated through the press, found no echo in the arts except, possibly, through a sharpening of Hans Weiditz's reaction to the themes he illustrated in the 1532 German translation of Petrarch's *De Remediis utriusque Fortunae*: the cultivated bourgeois whose sleep is disturbed by dreams of the clashes between armed men, and the happy mother (Fig. 248) who welcomes the son returning modestly from the university with his degree beside the mother who faints with misery at the sight of the son who comes swaggering home from the wars.[10]

His largest, double-page woodcut (Fig. 249) illustrates Petrarch's reflections on Heraclitus's pessimistic conclusion that 'War is the father of all things'.[11] There is conflict in the sky: wind, rain, hail and a frizzling sun; birds fight other birds and eat small animals; animals fight among one another and are hunted by men, while men fight among themselves; time, in the form of a giant spider's web, fights the apparent stability of a house; soldiers attack women and death carries off a soldier from his lover's side; a cock struggles to retain his rule of the dung heap; the farmer fights to control the advance of a nature which is already in conflict with itself. This crowded composition, which anticipates the Netherlandish assemblages of images derived from folk sayings or proverbs, sums up the conviction that since conflict is embodied in every aspect of the universe, war is inevitable.

To generations familiar with chronicles describing the past as a battling towards the present, there was little reason to doubt that the process would continue. War

remained one of the chief matters within the historical record. Daniel Hopfer made the point in a lively way in his etching *History and Victory seated under a Trophy of Arms* (Fig. 250),[12] where Victory dictates what the historian should inscribe on his tablets. The sense of war's inevitability had long been built into that old concept, the unstoppable Wheel of Fortune, and the continued vitality of the notion that war necessarily recurred was still shown by Karel van Mander in the advice he gives in his 1604 *Handbook of Allegory* to an artist wishing to illustrate 'the common saying about the circular course of the world or the world's way: peace brings livelihood; livelihood wealth; wealth pride; pride strife; strife war; war poverty; poverty humility; humility brings peace'.[13] And so on. Both this concept, and that of the Heraclitan conflict, had anger at their core, and Burgkmair's striking woodcut (Fig. 251) was only one of many representations of *Anger* as a warrior.[14] The cycles of war and peace were set by human nature and patterned by history.

Literary pacifistic ideas, or idealistic notions that Europe's internecine conflicts could at least be shifted to a common cause against the Turks, found little nourishment. In the north, the feeling of helplessness in the face of recurring violence led to the dark and fearful lore of the Wild Horde, a rush through stormy nights of a gathering of the enraged dead, especially those executed for crimes, who fought amongst themselves and turned against any mortal unfortunate enough to encounter them.

Of around 1515, the carelessly muddy colours and clumsy painting technique of Urs Graf's small treatment of the subject[15] – which was surely not a commissioned one – makes the pressure that led him to treat it in this medium all the more of a tribute to its power (Fig. 252). The group of resurrected criminals in the right foreground are portrayed as madmen: one rides a horse sitting backwards, another crouches indifferently with his arms beneath a stick under his drawn-up knees (not a punishment used on an execution ground). In the opposite corner a battle is in progress while soldiers strain to bring a large, unnaturally mouthed cannon into position before a troop of horse comes up. Above, in the midst of a V of storm clouds, two nude deities stand on a globe. The female figure (?Bellona–Fortuna) holds in one hand a grenade spouting artificial fire, in the other a horn from which gushes the gale that perturbs the sky. The male (?Mars–Wotan) stretches out a streaming fire-bowl and grasps a pole-arm; standing on one leg he steadies himself by hitching his right leg across his companion's buttocks. There is a pungent whiff of the Sabbat about this nightmare of conflict which cuts revealingly into the reasoned discourse of contemporary preachers and treaty-making diplomats who paid tribute to the possibility of lasting peace.

Princes were responsible for the just settlement of conflicts. But the symbol of justice was, after all, a sword, and the court of appeal for cases between nations was the battlefield. Prelates were responsible for interpreting the views of God, but however 'blessed are the peacemakers', they were also responsible for preserving the Church within which his will could be proclaimed. The wars that preserved the integrity of his chosen people (Cranach portrayed Joshua as a contemporary soldier in his woodcut title page for *Das ander Teil des alten Testament* of 1524)[16] had not ceased with the coming of Christ. Popes were rulers of territory as well as being lines of communication with God's continuing concern for his people. Julius II himself donned armour for the field. So did his principal warrior-recruiter among the Swiss, Cardinal Matteus Schinner, Bishop of Sion in the Valais.

The Christian life itself had long been seen as a fight against the devil and temptation and active Christian virtues expressed in military terms. Andrea Sansovino was repeating an old iconographic tradition when he portrayed courage as a military commander on his sculpted tomb (1507) for Cardinal Basso della Rovere in Sta Maria del Popolo.[17] Soldier saints who had literally fought the good fight rallied the determination of the faithful from a thousand altars and windows.

The refinement of the effectiveness of gunpowder weapons did nothing to shock

250. Daniel Hopfer, *History and Victory Seated Under a Trophy of Arms*. Etching, ?c.1530.

251. Hans Burgkmair, *Anger*. Woodcut, c.1510.

Europe into reconsidering the war–peace–war cycle. Men of letters – Ariosto conspicuous amongst them – might condemn guns as destroying the values of chivalrous warriors, but warriors of that class folded them into their armouries as part of the necessary process of being up to date. Well before Maximilian learned to cast them, they had entered the emblematic imagery of aristocratic warriors both south and north of the Alps as exemplifying the power and blaze of military resolution. There was some equivocation in religious imagery. On the title page of the Basle 1489 edition of Augustine's *City of God*[18] a devil shoots at an unarmed angel with a handgun aimed from the battlements of the neighbouring Hell-Town, while on the title page of the Leipzig 1510 edition of Celifodina's *Scripturae Thesaurus* (Fig. 253), angels defend their castle of righteousness with cannon against devils armed only with pike, halberd and clubs. But the Church did not attempt to outlaw the new weapons as it had, so unsuccessfully, their technological predecessor, the crossbow. Similarly, another issue that consumed much paper, the inferiority of modern armies and their leaders to those of antiquity, involved no rethinking of the political usefulness of war, but simply a recommendation to learn from those ancient commanders, Hannibal, Caesar and others, whom the miniaturist Giovanni Pietro Birago showed the condottiere Francesco Sforza engaging in animated discussion (Fig. 254).[19]

Against such a background, and from the use made of the arts by princes to glorify their military deeds and commands, peace was an insubstantial concept, and representations of it, whether in personified or allegorical form, tended to lack conviction. It was a case of the devil having all the best tunes.

In 29 BC Augustus, after uniting the territories of the Roman Empire, ordered the temple of Janus to be closed for the first time in 200 years. Later, to emphasize the benefits his victories over his rivals and enemies had brought to Roman subjects, he instituted the cult of the goddess Pax, whose images rapidly became identified with Minerva's olive, the caduceus of Mercury, symbol of peaceful traffic, and the cornucopia of plenty.

His proclamation of 'eternal peace' was well known in the Renaissance. The slogan is worn by one of the harpies in Nicoletto da Modena's engraved trophy panel, *Victoria Augusti*, of towards 1512.[20] It is identified here, with engaging whimsicality, with the 'hope' of the people to enjoy the benefits suggested by the olives and cornucopias. But the idea of peace is subordinated to the more glamorous notion of victory. And it was also well known that Augustus remained involved in wars on the frontiers of the Empire for much of the rest of his life. 'Peace' was 'ours'

252. Urs Graf, *The Wild Horde*, c.1515. Basle, Kunstmuseum, inv.258.

253. Anon., *Angels Defending the Citadel of Heaven*. Woodcut, 1510.

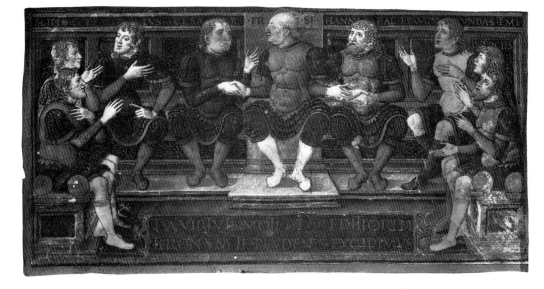

254. Giovanni Pietro Birago, *Francesco Sforza among Classical Commanders*. Miniature, c.1460. Florence, Uffizi.

255. Jacopo de' Barbari, *Victory*. Engraving,
c.1500–3.

not 'theirs'; it was a more localized idea than war, and therefore conceptually weaker.

In image after image buoyant victory erodes the less glamorous connotations of peace. In a late-fifteenth-century miniature in an account of the life of Francesco Sforza,[21] over an inscription lauding him as 'master in war and peace and ever the victor', he rides on in armour, baton of command in hand. As early as *c*.1500–3 Jacopo de' Barbari had, in his idiosyncratic way, admitted defeat when facing the Peace-Victory equivocation.[22] Slumped empty-handed amidst a litter of Roman battle implements, a nude, winged female figure gazes apathetically upwards. Winged, she is Victory (Fig. 255). But in her lack of conviction about victory's consequences she is also a very contemporary Peace.

256. Francesco Cariani, '*Allegory of a Venetian Victory*'. ?*c*.1520. Rome, Private collection.

Neither for what she personified, nor for her involvement in any gripping mythological story, did Peace have anything more than an appeal to the sense of duty of the artists who were called on to represent her. The very idea was at odds with what was known about human nature and about past and present history, and it was flawed by the constant repetition of that old tag 'in peace prepare for war'. Treaties designed to settle wars, with their persiflage about enduring peace, produced images either covertly sceptical, as in Neroccio di Landi's wan paw-shake exchanged between the Florentine lion and the wolf of Siena in 1480,[23] or generalizingly allegorized as in Cariani's so-called *Allegory of a Venetian Victory* (Fig. 256). This, though probably painted some years later, may refer to the Treaty of Noyen which in 1516 confirmed the recovery by Venice of its mainland territories. In that case, the battle and siege on the right could refer to the May 1516 campaign to force Maximilian to surrender Verona. But there is nothing specific about this all-purpose contrast between war and peace (represented on the other side by the tranquil traffic on the lagoon and the harmony personified by the two instrumentalists). Nor is the message optimistic. Peace has occurred because Fortuna has stepped from her globe and holds it steady. Her gaze and her streaming hair turn in the direction of 'war', and beside her, again on the 'war' side, is the infant natural man, already tearing at the flowers. There is no sense of *Pax aeterna* in this beguiling work.

In Germany, where a more colloquial expression of what peace could offer might be expressed, a title page spelled out the consequences that should flow from Charles V's proclamation in 1521 of a Public Peace (*Landtfried*) (Fig. 257) to be observed within his domains; in the upper register, the constant threat of armed ambush in Germany's forest, in the middle, the proclamation that feuding had been outlawed, in the lower peasant men and women who go unafraid about their everyday tasks. But this was a comment on a specific act of state, not a reference to Peace itself.

Artists, in any case, worked at their best when representing abstractions within the context of a secure traditional form. For the north German sculptor Bernt Notke, it was the image of a saint. His *St George* (Fig. 258)[24] in Stockholm Cathedral was commissioned by the Lord Protector Sven Sture as a thank-offering for Sweden's victory over Denmark at Brunkeberg in 1471. Jagged, vibrant with compositional brio and with colour (polychrome over wood), this is one of the greatest statements of northern late Gothic art. The dragon rears up after surviving the lance thrust. The saint rises in the saddle – looking trustingly ahead to God rather than down at his target – before swinging down his sword for the death blow. The princess watches the outcome from a distance (not, surely, from the castle on which she is now placed) just as the Swedes had waited for the outcome of Brunkeberg. A traditional image spoke to a current mood of triumph and thankfulness, and of all the works commissioned to mark a military event in this period, Bernt Notke's is probably the only one still found relevant and moving to national consciousness.

The 1559 peace treaty of Cateau-Cambrésis stilled for a while the strife between France and Spain and their allies and satellites. Allegorizing it for Philip II of Spain,[25] Stradanus tactfully put him in Roman armour. Peace guides the hand which puts a torch to a bundle of weapons topped by a bound male figure representing, in a grotesque echo of the grilled St Lawrence, war. The Augustan reference is made clear by the detail on the left: Janus closing his temple.

In spite of the significance of his temple doors, open in war, closed in peace, Janus was very rarely called into the pictorial vocabulary of military comment. Literally two-faced, looking in both directions at once, he was, as the guardian spirit of doorways and gateways and frontiers, more watchdog than war god. He was also the god who 'opened' the new Roman year (not the medieval calendar year which commonly began in March) with his month January. He was, therefore, seen in terms of the pragmatic, rather than the moralizing, scythe and hourglass representation of time. Thus while at first glance the section of the portico frieze at

257. Anon., Title page, *Public Peace Proclamation of Charles V.* Woodcut, 1521.

258. Bernt Notke, *St George*. 1470s. Stockholm, Cathedral.

Lorenzo de' Medici's villa at Poggio a Caiano (Fig. 259), which shows Janus standing outside his temple while his priest opens it to release an armed Mars and his soldiers, may be read as 'war', the frieze's overall theme, the cycle of the year, presents him as January releasing the energy which in March (the month of Mars) would renew the earth's fertility.

Exceptionally, he was shown in a German woodcut of 1499 (Fig. 261) illustrating a poem on the Swabian War by Sebastian Brant. In this *Allegory of Peace and War* an armoured Mars stands in the flames of war which are echoed on his standard and in the burning homesteads in the background. In the middle, striding between soldiers slaughtering peasants and a group of cannon, a pikeman carries a firebrand of his own. This scene is contrasted with one in which peasants plough, harrow and watch their sheep. Beside a table stands Mercury, holding a rustic caduceus while dressed

as a merchant with a full purse. Musicians reflect the harmony between man and productive nature. Sitting at the table, temple key in hand, and looking at both scenes with equal interest, is the double-headed Janus, comfortably ensconced for the moment on the side of peace but, like Pax, a weather gauge figure powerless to initiate the conditions that bring him into the open.

Cariani's painting was unusual in drawing on the image of Fortune to make a generalized point about her role in positively mediating between war and peace. It is true that her role was, as the historian, Francesco Guicciardini wrote, 'greater in military affiars than in any others'.[26] But she was commonly thought to play a part in the incidents of a battle, not in the outcome of a campaign, and, above all, to influence the chances of survival of an individual – as we have seen in connection with northern *Soldatenleben*.[27] It is, conjecturally, in this role that, as goddess-mistress, she holds her globe, besought by a female who has brought Cupid to aid her cause, to favour her armoured suitor who touches her with a gesture surely borrowed from the northern motif of The Soldier's Farewell. Of surpassing tenderness, this painting by Titian (Fig. 260), which has been entitled, on the grounds of the resemblance of the features of the soldier to identified portraits, *An Allegory of Alfonso d'Avalos, Marchese del Vasto*, puts Fortune where she firmly belonged in the public imagination: as a seductive, whimsical, amoral spirit who affected the lives of individuals but had little power over the larger issues within which their destinies were subsumed.

Pax, Janus, Fortuna: these were figures who drew little sustenance from mythological narrative, astrology or – save for Fortune's Wheel – from medieval iconography. The war figure who qualified most highly on all these counts was Mars. Yet there came to be equivocation here too. His straightforward medieval, demonic aspect was diluted as Renaissance scholarship rediscovered both the ennoblement of him by the Romans and their splitting his significance into sections: patron of the race (as the father of Romulus and Remus), avenger of wrongs, totem of triumphs, imposer of peace, guardian spirit of the military campaigns that brought armies out of winter quarters. In the late mid-fifteenth-century Lombard manuscript *De Sphaera*[34] his feral aspect was preserved and his children burn houses, drive off cattle, fight one another (Fig. 267). In a German block book of *c*.1450[28] they kill peasants, fire their houses, drive off their cattle. These instances were propelled into the sixteenth century by the flywheel of tradition, but, with the exception of Georg Pencz's zodiacal *Mars* of 1531,[29] their sense that the god stood for war *tout court* faltered. With warfare, on both sides of the Alps, so habitual, so commonplace, the urge to personify it in ogrish terms grew weary. Filippino Lippi's Mars of *c*.1500 in the Strozzi chapel of Sta Maria Novella in Florence is deliberately frightening

259. Anon., *Janus Opens the Temple for Mars.* Glazed terracotta panel. Poggio a Caiano, Medici Villa, portico (now removed to storage.)

260. Titian, *An Allegory of Alfonso d'Avalos, Marchese del Vasto. c.*1530–2. Paris, Louvre.

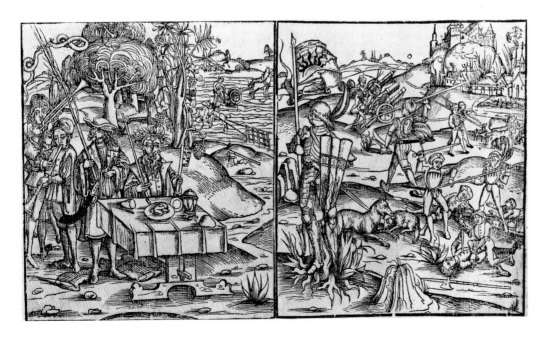

261. Anon., *Allegory of Peace and War.* Woodcut, 1499.

262. Filippino Lippi, *St Philip Conjures the Monster from the Temple of Mars*, c.1497–1502. Florence, Sta Maria Novella, Strozzi chapel.

263. Follower(?) of Mantegna, *Mars between Diana and Venus*. Coloured drawing, c.1500. London, British Museum.

264. Anon. (Florentine), *Mirror with Mars and Venus*. Late fifteenth century. London, Victoria and Albert Museum.

(Fig. 262). He is shown as an idol on his own towering altar engorged with references – trophies, loot, prisoners – to his pride and brutality, as a demonic pagan deity to whom the Apostle St Philip defiantly refuses to sacrifice. But this is the last time in Renaissance art that Mars assumes the mien of an uncompromisingly evil force.

More commonly this potency was lost within the figure style of individual artists, or by their focus as they picked and chose among the aspects of his cult and story thrown up by humanist scholars. Above all he was linked, following Homer, Ovid and Lucian, to Venus. It was as personage rather than as personification, as an actor in a narrative rather than as a deity, that Mars gathered in the interest of southern artists and their patrons, and slipped, definitively, from his altar.

In a drawing close to Mantegna (Fig. 263) he is shown like a Hercules at the

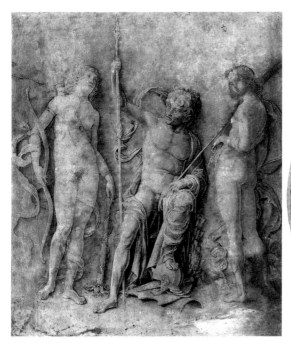

265. Anon., *Venus and Mars*. Woodcut, ?late fifteenth century.

266. Jacopo de' Barbari, *Mars and Venus*. Engraving, ?c.1495.

crossroads, choosing the way between virtue and vice, represented respectively by a nude upward-looking Diana and a nude Venus seen from behind and provocatively turning her head towards the spectator. Such fancies as these were anchored in the popularity from the mid-fifteenth century of the story of the affair – some commentators on the myth saw it as a marriage – between Mars and Venus. In a late-fifteenth-century German woodcut their relationship was seen in abstract terms (Fig. 265).[30] Mars shoots with a handgun into a town and its surrounding countryside (generalized by being surrounded by the circle of the zodiac) while Venus empties a bucket of water to extinguish the flames he has caused. But as the theme takes hold in Italy, Venus appears less as Peace subduing War than as the post-coital calmer-down of male aggressiveness. Peace becomes satisfied love. And in scenes so calmly, thoughtfully beautiful as the *Mars and Venus* paintings by Piero di Cosimo[31] and Botticelli[32] the mood is perfectly congruent with the marriage chests they decorated.

The mood appropriate to newlyweds did not last. From the late fifteenth century (a Florentine mirror frame in the Victoria and Albert Museum: Fig. 264) the 'affair' version of their story had become colloquialized among the decorative arts. When Jacopo de' Barbari in his (?)c.1495 engraving (Fig. 266) envelops the armoured Mars and naked Venus in a shared, encircling cloak, and she listens thoughtfully to a whispered invitation enhanced by the pleading gesture of his right hand, the obviousness of the proposition hardly needs the mute comment by the tiny cupid as he sucks his finger. And when Antonio Lombardo sculpted his naked *Mars*[33] (a pendant, it may be conjectured with some confidence, to a lost *Venus*) with the inscription 'I, Mars, do not conduct war well unless I have taken off my clothes', what sort of war did he mean? While contemporary reactions, or an artist's intentions, in works of this sort cannot be gauged with any certainty, surely there was no clear-cut analogy here with David's rejection of Saul's armour before going to fight Goliath.

For the decline in seriousness of treatments of the Mars and Venus story continued. There was little allegorical significance in the fresco designed by Giulio Romano of *The Bath of Mars and Venus*[34] in the Palazzo del Te in Mantua in the early 1530s, and the seriousness once inherent in the theme ran rapidly downhill thereafter towards the frank pornography of Giulio Bonasone's etching of ?c.1555 (Fig. 268).[35]

267. (*this and facing page*) Anon. (Lombard), *Mars and his Children*. Miniature, mid-15c. Modena, Biblioteca Estenso, Ms. *De Sphaera* (Lat. 209).

212

268. Giulio Bonasone, *Mars embracing Venus*. Etching, ?c. 1555.

269. Andrea Schiavone, *Bellona*. Drawing, c. 1546–52. Rotterdam, Boymans-van Beuningen Museum.

Naked, and caressed by her equally naked lover on mouth, breast and between the legs, she exclaims, in the legend below, 'Let us have done now with kissing, Mars my fine friend, come between my thighs if you want to taste in me the sweets of heaven'.

This slippage from seriousness took place over a period throughout which war remained either actual or perturbingly latent. Still, Mars had a sister, Bellona, also taken seriously in antiquity as a war deity, and known about in the Renaissance at least after Boccaccio's *Geneologia Deorum*. Lacking any interesting let alone scandalous personal narrative, it might have happened that while Mars philandered, she took over from him as the representative of wars that were becoming less personal and more horrific in a time that saw such advances in the effectiveness of gunpowder weapons. But the future of Bellona's image came later, when women rulers (Elizabeth I, Catherine de Medici) needed to be flattered and when the writers of iconographical guides, from Vincenzo Cartari's *Le Imagini* of 1556, expanded the vocabulary of mythological references. At the verge of our period Schiavone produced a drawing for an etched figure of Bellona (Fig. 269). For all the stern associations it calls up in details of costume, overall how chic it is!

Minerva had, in an early stratum of her myth, been a war goddess. She continued to be represented as armed, sometimes armoured. As a personification of war she was not subject to a slippage in seriousness due to the narrative interest of her story, rich as this was (she had been courted by Vulcan for instance), but to a diversification of her role. She was associated as closely with wisdom as with war. Indeed in the Ferrarese game cards she appeared, similarly armed, as 'Philosofia'.[36] She was seen as an intelligence that steered war away from unnecessary savagery and towards peace. In Botticelli's *Pallas and the Centaur*,[37] armed with an unexpectedly up-to-date halberd, she strengthens the archer man-beast's sense of rational control.

When coupled with Mars her role was not so much to pacify (that was Venus' role) as to inform and moderate. In his *Allegory of Bologna* Bonasone, in a stiff woodcut of shortly before 1555 (Fig. 270)[38] for Achille Bocchi's *Symbolicarum quaestionum . . . libri quinque* published in that year, neatly summed up much of what she had meant in the context of Renaissance warfare. Thanks to the early establishment and continuing fame of its university, Bologna liked to think of itself as the most learned of Italian cities (*Bononia docet*). On the left is a trophy of books linking Bologna, through the S.P.Q.B. label, to the learning of ancient Rome. On the right is a trophy of arms. Both float, rather than being planted in the ground, because we are approaching the age of emblems. Between them stands the helmeted Minerva, bearing the city's *Libertas* standard. Political liberty, it is claimed, is the result of a wise use of force, based on the familiar relationship between arms and letters.

Just how far the meaning of these mythological personifications had been sophisticated away from any real reminder of war and peace as factors of experience can be summed up in the work of an expatriate Italian, Niccolò dell' Abbate of Modena (Fig. 271). Working as an employee of Francis I at Fontainebleau, he reviewed the salient aspects of his character in an eulogistic but perhaps not altogether seriously intended illuminated portrait.[39] He was a warrior. So he receives the helm and sword of Mars. He was prepared to settle wisely (though in fact only when he had been defeated or run out of cash) for peace. So he wore Minerva's Gorgon head and was clad in her unaggressive maiden dress. He was a fosterer of the arts: the caduceus and the winged sandals of Mercury. He was a successful lover: Cupid's quiver over his shoulder. He was a passionate huntsman: Diana's bow. Standing for so much, Francis was left standing for nothing in particular.

In Germany and Switzerland, though an interest in classical mythology was never as general as in Italy, scholars and cultivated patrons added an awareness of its protagonists and their stories to their previous acquaintance with ancient, especially Roman, history. But artists showed only the slightest interest in exploiting the meaning of the major deities in a military context, apart from Mars with his plane-

tary children. It is another aspect of the Germanic interest in the particular rather than the generalized that conditioned the rendering of military subjects north of the Alps. But, in any case, subject as their identities were to moral slippage and diversification of identity, mythical characters did not supply a pictorial language which had anything new or telling to be 'said' in the arts about warfare. And this was accepted by those later Italian iconologists who, like Cesare Ripa in his 1593 *Iconologia*, told artists how to portray not Mars or Bellona but War, not Minerva but Intelligence, images not quite free from mythological associations but representing crisper elements within pictorial discourse.

In the course of the period changes in artistic technique and patronal attitudes meant an overall increase in the number of portraits and monuments (as opposed to tombs) that were produced. A due proportion of these were concerned with men who had followed military careers. In patrician and aristocratic palaces, in churches and, more occasionally, in public squares, the public was exposed to the values expressed in these commemorative works. Obviously, they were not designed to denigrate militancy. And though armours and captured standards might be given to churches as personal ex-votos, and a votive chapel might very rarely be erected on a battlefield by a grateful victor, we are far away from the nineteenth-century war memorial with its ability to chill as well as to encourage militant patriotism through the listed names of the fallen.

The partial classicization of Italian élite culture gave an intellectual endorsement to militancy by linking contemporary leaders to the successes in wars of the Romans. As early as ?*c.*1440 the monument to the Marchese Spinetta Malaspina admitted his contemporary man-at-arms effigy into the ancient world by having two Roman soldiers draw back the flaps of the tent in which he is revealed (a device frequently to be repeated on Italian woodcut title pages).[40] Federico Gonzaga wished Costa to show him as a Roman commander,[41] and Giulio Romano's *modello* for his tomb placed him in the age of Livy rather than his own.[42] In 1559 Vasari showed Cosimo I (Fig. 272), in an allegory of the most important engagement of his reign, the 1539 battle of Montemurlo[43] that established his position in Florence, not as a god but as a

270. Giulio Bonnasone, *Allegory of Bologna*. Woodcut, *c.*1555.

271. Niccolò dell' Abbate (attrib.), *Allegorical Portrait of Francis I*, *c.*1545. Paris, Bibliothèque Nationale.

272. Giorgio Vasari, *Allegory of Montemurlo*, (detail). 1559.

273. Luca Maurus of Kempten, *Tomb of Roberto da' Sanseverino*. 1493. Trento, Cathedral.

274. Titian, *Equestrian Portrait of Charles V*. 1548. Madrid, Prado.

Roman emperor rising from his throne while Roman soldiers forced his prisoners (Filippo Strozzi and his allies) to crouch before him in the attitude of conquered barbarians.

The armed donor convention of the International Gothic fell out of favour in Italy. And so did the chivalrous tomb slab. There were few successors to the impressive deep-relief figure of the armed and armoured Guglielmo de Birra, who died in 1494, in Sta Anastasia, Verona.[44] In the north, however, the seal of chivalrous approval for the militant career continued to be displayed in this form well into the 1540s when the superb bronze relief effigy of Georg von Liechtenstein (d. 1548) was installed in a wall frame in S. Michael's church in Vienna. Commonly the slab tomb was of stone. From the 1490s workshops produced memorial slabs of such high quality and bold design that when seen in isolation or in rescue assemblages of originals or copies such as those in Regensburg, Munich, Graz and Budapest, they reveal the formidable self-justification of the military caste.

This sense of the rightness of personal service because of birth made Maximilian order the statues of the ancestors who were to surround his tomb to be shown, regardless of their actual careers, as armoured warriors. And this northern allegiance to the traditional role of the Second Estate was displayed in one of his few vengeful acts. The Neapolitan condottiere Roberto da Sanseverino was killed while fighting for Venice against an Austrian army which in 1487 sought to push the Venetians back from the frontier they had established in the Habsburg territory north of Verona. Maximilian refused the family's request to be sent his body, but commissioned from Maurus of Kempten a tomb slab for Trent cathedral (Fig. 273) – which showed him holding a broken lance with the standard of St Mark dangling upside down! None the less plate-clad and sternly watchful, the figure of Sanseverino is one of the noblest of its kind, though artistically perhaps the high point in Germany of the Christian endorsement of war through the values of chivalry was the free-standing bronze tomb figure of Otto IV of Henneberg by Pieter Vischer[45] in the Stadtkirsche, Römhild of *c.*1488, with its expression of ardent, selfless heroism.

In Italy it was Tullio Lombardo who in 1529 cast a nostalgic glow of refinement over the tomb for Guidarello Guidarelli,[46] who had died in 1505 (not in battle, as the armoured figure suggests, but from a wound received in a private brawl). And this glow could recur, as it did in the equestrian portrait (Fig. 274) with which Titian commemorated Charles V's victory over the Protestant Schmalkaldic League at Mühlberg in 1547. Here, because of the circumstances, the artist's unique command of enhanced naturalism was infused with the idea of the Christian warrior as the divinely inspired huntsman of the enemies of God.

The woodcut portrait, a northern speciality, showed the subject (as Augustin Hirschvogel did Charles V in the year before Mühlberg) simply as a warrior of commanding presence.[47] In Italy, however, a number of paintings focused on the subject's role as a part-time soldier proud to have been of service to his state (as in Titian's *Pesaro Altarpiece*,[48] with its references to Jacopo Pesaro's service against the Turks) or as a distinguished professional equally proud of his role in serving others. Simply to stay with Titian, his Alfonso d'Este (?*c.*1527–8 known only from a seventeenth-century copy),[49] hand on the muzzle of one of the pieces of artillery for which he was famous, is as much a political-military icon as a portrait. So was his portrait of Francesco Maria della Rovere.[50]

Military professionalism had become for its own sake a subject for art. And as if in reaction against this rigidity of characterization, a new genre emerged, that of the 'romantic' military portrait. This caught the mood of the concurrent introspective, 'state of mind' civilian portrait, and applied it to men who did not see themselves as circumscribed by soldiering. Sebastiano del Piombo's *Man in Armour* (who holds, unusually, an arquebus)[51] is clearly seen by himself and the painter as more interesting than the occupation suggested by his equipment. In Parmigianino's *Galeazzo da San Vitale*[52] we confront a sensitive man of taste as well as a warrior. In Savoldo's

Portrait of a Soldier with a Mirror (Fig. 275), the dreamy subject has allowed the painter not only to imply that his armour is irrelevant to life's more thoughtful concerns, but to make the purely artistic point that by using a mirror painting could match the ability of sculpture to show a subject from more than one point of view.

Both the professional and the romantic portrait arose from circumstances that did not occur in Germany. There princes did not commonly fight for pay for others and men of gentle birth were less pulled between the tradition of military service and the appeal of peaceful self-cultivation. It is also because of the dependence of the Italian merchant republics on mercenary leaders and their forces that the peninsula produced some of the most striking of all Renaissance images of military figures. The frescoed equestrian monuments to Sir John Hawkwood by Uccello (1436)[53] and to Niccolò da Tolentino (Fig. 276)[54] by Castagno (1456) in the Florentine cathedral were both in the nature of posthumous awards for services rendered: they were also a proclamation, in a competitive world, of the extent to which Florence honoured as well as paid its condottieri, and advertised Florence as a caring employer. Physiognomically neither can be checked for accuracy. But in any case in the heroic portrait lifelike traits were less important than the dominating expressions: confident watchfulness in Hawkwood's case, stern determination in Niccolò's.

Venice's riposte was in 1447 to permit (and possibly subsidize) the heirs of Gattamelata (Erasmo da Narni), their captain general who had died four years before, to engage Donatello to make an equestrian monument in his memory (Fig. 277), and, moreover, to erect it in his birthplace, the chief subject city of the Republic, Padua, in a focal point outside the city's great pilgrimage church of S. Antonio. This was the most conspicuously placed and impressively heroic image to have been created in Italy since the equestrian statue of Marcus Aurelius: and that was made to honour an emperor. Gattamelata was the son of a baker. Though he is not armed as a Roman, certain details of his costume, his short curling hair and the mausoleum doors carved on the statue's base all give the monument a strongly humanistic, if not strictly a classical air; within a few years of its completion in 1453 an observer

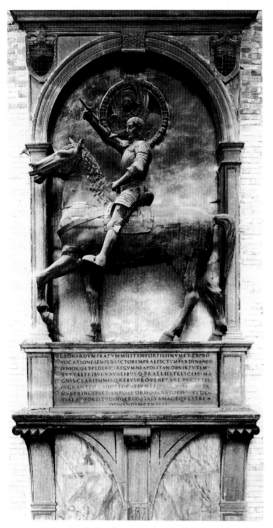

278. Antonio Minello, *Tomb of Leonardo da Prato.* 1513–14. Venice, SS. Giovanni e Paolo.

referred to it as a 'triumphant Caesar'. It is probable that Venice came to regret allowing such prominence to a symbol of freelance military power, even though Donatello emphasized the delegated baton as much as the sword. When the Republic's next outstanding condottiere, Bartolomeo Colleoni, left part of his considerable fortune to the Republic on condition that it erected a bronze equestrian statue in his memory in Piazza San Marco, the bequest was honoured, but the site fudged: Verrocchio's statue,[55] completed in 1496 after his death by its caster, Alessandro Leoni, was placed well away from the Piazza in the Campo SS. Giovanni e Paolo, one of whose sides is closed by the Scuola di San Marco. Again the classical inspiration was noted at the time. A visiting Dominican friar who saw the model in 1483 noted that in commemorating a captain in this way the Venetians were 'imitating the custom of the heathen nations'.

Hitherto, equestrian monuments had been reserved, as symbols of authority, to rulers or, if dedicated to military men, made of wood and placed in the churches where they were buried. In the early fifteenth century Paolo Savelli's tomb in the Frari, Venice, was topped by his effigy riding a wooden horse. Colleoni himself rides a gilded one in his funerary chapel in his home town, Bergamo. The tombs erected later by the Republic for condottieri who served in Venice's wars to win back the mainland after Agnadello in 1509 were paid for by the government, but they, like those for Niccolò Orsini, Leonardo da Prato (Fig. 278) and Dionigi Naldo (the first two on horseback and carefully identified with the lion of St Mark) in SS. Giovanni e Paolo, were modest affairs.[56] If the da Narni had not paid much, if not all of the cost, and Colleoni's bequest the whole, the grandest evidences of the role in Italy of men who fought not for reasons of faith, fealty or patriotism, but as entrepreneurs for pay, would not have been created. And though the number of such fighter–businessmen was to increase there were no more commemorations of their type of service on so culturally ardent, and so politically permissive a scale.

Apart from linking human actions to those of gods, enhancing the repute of commanders by putting them in Roman dress and invoking the war steed as an emblem of militancy (at a time when cavalry was playing a dwindling role in actual combat), Italian humanist interest brought again to the surface other sources of imagery which endorsed war as an ennobling aspect of human endeavour: those of triumph and trophy.

In his essay *Of the True Greatness of Kingdoms* Francis Bacon remarked that since Roman times 'the wars of latter ages seem to be made in the dark, in respect of the glory and honour which reflected on men from the wars in ancient times'. Chivalric honours and heraldic devices could not compare 'for martial encouragement', with 'the trophies erected on the battlefield' and 'the triumph . . . , one of the wisest and noblest institutions that ever was'.[57]

The nature and purpose of the Roman triumph (to celebrate the victor, display the spoils of war, reward meritorious soldiers and to provide a focus for patriotic rejoicing) had been explored from a variety of sources by Flavio Biondo in his *Roma Triumphans* of 1456–60 and by Roberto Valturio in his *De Re Militari* (c.1450, published 1472). A number of mid-fifteenth-century works attested to the timeliness of this aspect of the revival of interest in the practices of the ancient world, like Felice Feliciano's drawing of *A Roman Triumph* (Fig. 279), cassoni panels (whose dimensions suited processions) depicting with a wealth of ahistorical details the triumphs of Scipio, Caesar and Emilius Paulus, and, more impressively, the sculptures of the Triumphal Arch gateway of the Castelnuovo in Naples.[58] This, the work of many hands over the years 1452–66, was designed to commemorate the triumphal entry of Alfonso of Aragon into Naples in 1443 after the fluctuating fortunes of his campaigns against René of Anjou. The procession, with Alfonso borne aloft in the middle, occupies the frieze over the main archway. Inside are panels to left and right showing the departure for and return from the wars. The Triumph motif reached an extraordinary height of knowledge and panache with

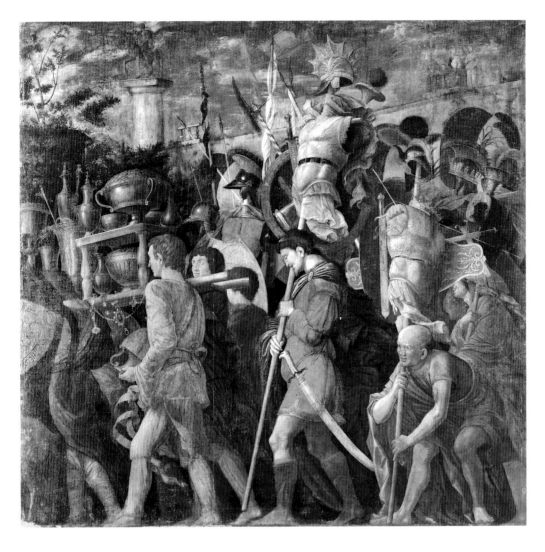

280. Andrea Mantegna, *Triumphs of Caesar* (detail), *c.*1480–*c.*1492. Hampton Court.

Mantegna's *Triumphs of Caesar* (*c.*1480–*c.*1492) (Fig. 280),[59] the first and greatest of attempts on a grand scale to recapture the historical appearances and mood of one of the 'noblest institutions that ever was'.

This particular rush of antiquarian zeal had been prepared for by another motif which had already assumed a pictorial tradition: that of The Triumph of Fame. In the most popular of his poetic works, the *Trionfi*, Petrarch had conceived the potent idea that popular medieval abstractions such as chastity, time, death and fame could be imagined in terms of the classical triumph while tapping at the same time the contemporary familiarity with the retinues and floats of religious processions. Fame's chariot was accompanied (Petrarch was, after all, a laureate poet) by men of letters, but hers was the only triumph to include soldiers:

> 'Full of ecstatic wonder at the sight,
> I watched Bellona's minions, famed in fight'.

And this vision of famous warriors of all periods was sharpened by Petrarch's admirer and friend Boccaccio who, in his *Amorosa Visione*, imagined Fame as the loadstone and tutelary deity of chivalrous knights. It is thus that she appears on a Florentine birth tray of *c.*1449 (Fig. 281),[60] standing not on a Petrarcan chariot but on a globe (from which trumpets poke through to broadcast great deeds to the four corners of the world) resting on a complex static plinth. Before her, and the token prisoners representing the bound barbarians who were an essential part of Roman

279. Felice Feliciano, *A Roman Triumph*. Drawing, 1465. Modena, Bibl. Estense. Cod & L.5.15, f.35.

281. Domenico Veneziano and the Master of the Adimari Cassone (attrib.), *The Triumph of Fame. c.*1449. New York, Metropolitan.

282. Agostino di Duccio, *Triumph of Sigismondo Malatesta.* 1454–7. Rimini, Tempio Malatestiano.

283. Hans Schäufelein, *Triumphal Procession of the Emperor Charles V*. Woodcut, 1537.

triumphs, a group of men-at-arms salute her as she holds out the two chief emblems of their credo: a sword and an image of Cupid.

The beauty of this painting, given that it probably was designed by one artist, Domenico Veneziano, and executed by another, the Master of the Adimari Cassone, points to the happy acceptance of a mutually sympathetic theme. It led, nevertheless, into a cul-de-sac. The main stream of *Trionfi* illustrations followed both the charioted traffic of Petrarch's imagination and his emphasis on classical protagonists. The float-and-retinue convention, as it increasingly conditioned civic as well as religious festival parades, blended more and more naturally into the mood of the formal Roman triumph. Agostino di Duccio's 1454–7 relief in the Tempio Malatestiano in Rimini shows a chariot led by Roman soldiers through a classical arch (Fig. 282). On its first tier a bust of Sigismondo Malatesta, framed with victorious laurel, is supported by putti bearing a coat of arms. The vehicle is topped by Victory. Fame, trumpeting away, is displaced to one side. The relief neatly blends the two rapidly conjoining triumph motifs: the Petrarcan and the one that was to take the lead away from medieval allegorizing: the classicizing commemoration of a historical event.

Fuelled from its twin sources, the Triumph theme proved a remarkably fecund one, seconded all the time by pageant-masters anxious to have their cumbrous floats remarked upon. There were 'triumphs' of the seasons, of virtues, of the Cross: a last artistic glow of commitment to the theme in Italy was caught in Titian's magnificent woodcut *The Triumph of the Faith*.[61] But by then the specifically military triumph too had lost its appeal. The Italian Wars brought no resounding victories, or conquests to celebrate. Italian pageant-masters were reduced to organizing triumphs on classical lines for their own conquerors: for Charles VIII's entry into Siena in 1494, for Louis XII's various entries – in 1499, 1507 and 1509 – into Milan. But the lack of cause for patriotic gloating, coupled with the fear of admitting larger numbers of mercenary troops into city centres, meant that domestic triumphs, like that described in Florence by Luca Landucci in 1514,[62] were devoted to fancy-dress reconstructions of ancient ones, in this case that of Camillus.

In the north, where engravings either immediately after Mantegna's *Triumphs of Caesar* or reflecting it were known, the motif circulated without takers until it was invoked by Maximilian I's advisers. He had, after all, won victories and made conquests. And he was an Imperial ruler, the natural heir to those 'Roman emperors, who did impropriate the actual triumphs to themselves and their sons' as Bacon, somewhat restrictively, put it. However, neither in the version of the *Triumphzug* at which we have looked, nor in the fantastically playful but over-seriously allegorized version, *The Great Triumphal Car*, which Dürer produced independently in 1522,[63] nor in later treatments was there more than a weak pulse

224

emanating from antiquity itself, either directly, or mediated by Mantegna. A northern preference for the record of an occasion rather than for couching it in antiquarian terms brought the glamour of the triumph down to the level of the parade, or review, gallant and dignified in Schäufelein's 1537 9-part woodcut *Triumphal Procession of the Emperor Charles V* (Fig. 283)[64] (though this was hardly more than a muted and cut-down version of *The Triumph of Maximilian* woodcut frieze), positively casual in Antoni of Wroclaw's painted frieze of 1535 running round the top of a room in the Wawel Castle, Cracow. Here King Sigismund sits as small detachments of infantry and cavalry march or, rather, stroll past him to the sound of fife and drum. The effect is that of a relaxed routine rather than a celebration of the monarch's strength.

Bacon's trophies had been real monuments, set up by Hellenistic or Roman generals on the scene of battles they had won, sometimes in the form of a pile of actual arms taken from the dead, sometimes in more permanent sculpted form. In the latter medium they were also erected in Rome itself as permanent memorials of the transitory triumphs.

In Renaissance imagery they were borne aloft in portable form as part of the imaging of the spoils of conquest, as they were in the tailor's-dummy assemblages hoisted above the processing troops in Mantegna's *Triumphs of Caesar*. They had already appeared as framing motifs in illuminated manuscripts[65] and pilaster adornments, as in doorway surrounds in the Ducal Palace at Urbino. They embellished Bambaia's monument to Gaston de Foix (Fig. 284). Their decorative possibilities led in the early sixteenth century to the production of engraved models[66] which could help both painters and sculptors to fill in awkward voids and margins when dealing with military subjects conceived in a classical vein. They provided challenges to compositional ingenuity, but, no longer based on actual ceremonies, they added little more than a tang of learned spice to military subject matter. And, like the classicized triumph, they met with little welcome in the Germanic north.

All the images we have looked at in this chapter have accepted, if not actually lauded, the place of warfare in the self-definition of individuals and peoples. However oblique[67] or uncontemporary their references, the designs of artists heeded the summons of the drum and followed the flag.

284. Il Bambaia, *Trophy*. Relief panel, after 1515. Turin, Museo Civico.

CHAPTER 9
Soldiers in Religious Art

ITHERTO, PREOCCUPIED WITH secular works, we have only glanced into that great alternative gallery of military images, the frescoes, altarpieces and private devotional works of religious art. In turning to them after considering the means open to artists to express opinions about warfare, we shall discount battle scenes; these engagements were divinely ordered or permitted and not open to comment, and for compositional reasons it was possible to distinguish the 'good' army from the 'bad' one only in the most conventional terms: helmets versus turbans, 'honest' heraldry on shields and banners versus scorpions or crescents. But individual soldiers had been enlisted into the Passion story and the chequered history of the propagation of the faith, and the devil was also a recruiter. It was required, therefore, to particularize bad soldiers as well as virtuous ones. And to insert recognizably contemporary soldiers within the secure context and traditional iconography of religious art was to create a tension greater than that generated in the more novel or vaguer contexts derived from humanistic or chivalrous values. Religious works were, however, at least in urgent moods of doubt, fear and hope, and especially in wartime, with kin and homeland in danger, subject to a more urgent scrutiny and response than were secular works. In any case, no survey of soldier imagery that locked itself outside the period's churches could be complete.

The hill of Calvary, in Mantegna's painting of 1457–9 (Fig. 285), has been under military occupation. The wound in Christ's side, the breaking of the malefactors' legs, are alluded to with the utmost reticence. Two soldiers, one behind the group of Marys, the other in the right foreground, look up at the work they have supervised. Others continue to gamble for Christ's robe, watched quietly by two of their officers, one of whom holds it by one end, while a Jew holds the other, a summation of the connivance that has brought God to Golgotha. But the soldiery's chief task is done. One man descends the steps leading down from the platform on which Mantegna has presented the scene. The rest file off at the rear to begin the long climb back to Jerusalem.

In 1511 Wolf Huber – or an artist very close to him – drew an earlier stage in the drama (Fig. 286).[1] The cross on the left has been installed. The final wedges are being driven into the socket of Christ's Cross, and one of the soldiers stands back to signal that it is steady in the vertical. Another arduously waits for the fixing in position of the third. In this scene the military are not simply supervising a punishment carried out in an area subject to civilian jurisdiction, but have planted the crosses of the Passion in their own provost marshal's execution ground. It is on his gibbet that the hanged man behind the Marys rots; his is the raised wheel on which men are exposed when their bones have been broken after an infringement of military discipline; one of his men guards the ground, hand on sword, while another, behind Christ's cross, prepares to plunge his dagger into another malefactor.

This is not the moment to point the contrast between the two works, between Mantegna's Roman soldiers, painted by a man of antiquarian interests south of the

285. Andrea Mantegna, *Calvary*. 1457–9. Paris, Louvre.

286. Wolf Huber (?), *Calvary*. Drawing, 1511. Berlin SMPK. Kupferstichkabinett.

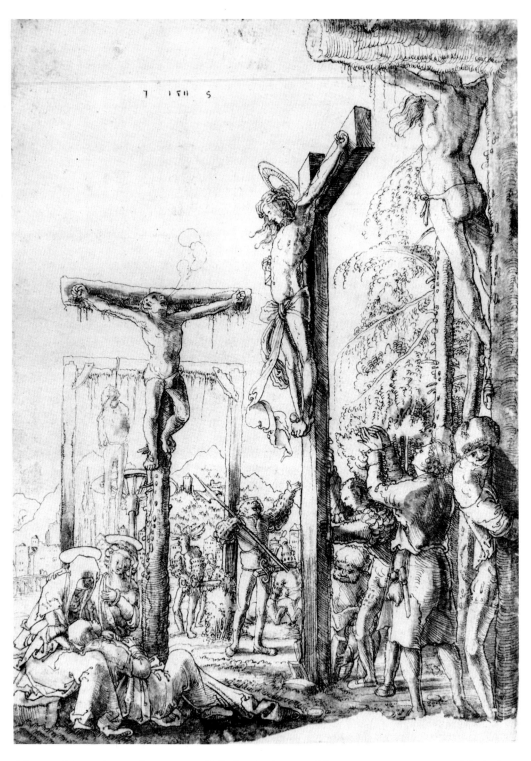

Alps and in a time of peace, and Huber's thoroughly contemporary Landsknechts, drawn north of the Alps in a time of war; rather, to suggest the vision, shared by two utterly different imaginations, of the central Christian mystery as being stage-managed by soldiers. It is a vision made all the clearer by the decision of both not to focus attention on the two soldiers who stepped out of the ranks and became indissolubly part of that mystery, Longinus and the Good Centurion.

Fully typical of militarized Calvary compositions was the *Crucifixion* by the Master of the Tabula Magna (Fig. 287), painted in *c*.1446 for the *Stiftskirche* in

287. Master of the Tabula Magna. *Crucifixion.*
*c.*1446. Munich, Alte Pinakothek.

Tegernsee in Bavaria. The three crosses punctuate four groups of soldiers; from the left: a 'guard' group, Longinus's escort, the entourage of the Good Centurion, a second flanking guard group. A simpler formula for large, crowded compositions was summed up in the *Crucifixion* fresco of 1470–1 at Clusone[2] where between two populous guard groups to left and right, Longinus and the Centurion are left more alone between the crosses.

The reading of such compositions and the many variations played on these formulae relied on common knowledge of who the irreducible cast of characters on Calvary were. From time to time, artists had detached them from the crowded narrative of that scene and brought them forward in, as it were, a curtain call for divine principals. In Italy, such a work was Crivelli's predella panel in the parish church of Massa Fermana (Ascoli Piceno) of 1468.[3] From the spectator's left they are: Longinus, clasping his hands in prayerful gratitude, his lance resting on the ground and balanced against his shoulder, the Virgin, Christ on his cross (the only one shown in such scenes), John, the Good Centurion. In the north woodcuts acted as didactic intermediaries between worshipper and 'high' art, and one, roughly contemporary with Crivelli's panel, restates long-familiar knowledge (Fig. 288).

The soldier on the right, who points to Christ while turning to the two Jews with the words of his label, '*vere filius dei est*', is the Good Centurion who, according to Matthew and Mark, was moved by Christ's cry as he gave up the ghost and by the earthquake that occurred then, to say 'Truly this was the son of God.' On the left, behind the thief who recognized the divinity of Christ and whose soul, therefore, is being picked up by an angel, is the soldier who, in St John's words, 'with a spear pierced his side, and forthwith there came out blood and water'. Well before the Renaissance, devotional literature and pious legend had given him a name (Longinus), a miracle (his impaired sight was restored when drops of blood from the wound he made fell on his eyes), and a biography (he became a convert, a monk, a missionary and finally a martyr and saint).

The soldiers of Calvary were, then, not simply the instruments of Pilate's political authority. They also, through the two soldier-converts, symbolized the propagation

of the faith among the Gentiles which led from Christ to Christianity. In addition, they stood for the spiritual perceptiveness of the west as opposed to the obscurantism of the near east. Longinus's blind eyes were opened. The Pharisees argue back at the Good Centurion even while the devil takes the soul of the stubborn malefactor above their heads. This latter theme, that of the Good Centurion as the first missionary, faded in Italy from the trecento but remained animated in the north. Between the two, the Jew Stephaton, permanently transformed by medieval prejudice from the soldier (therefore Roman) of the Gospel, futilely dabs the negating vinegar on his sponge towards the Saviour's lips.

Given the biblical and legendary contexts and his potential linking to the nature of the soldiery of an artist's own day, how was Longinus to be portrayed? What was most important was to show the miracle associated with the first human contact, after the Circumcision and Flagellation, with Christ's blood. In German and Bohemian painting, almost habitually up to the mid-fifteenth century and in regional centres up to the early sixteenth, this was commonly achieved by Longinus's pointing to his eyes; on occasion, one was shown closed, the other open, as though to prise apart the split second of the miracle. Almost always he was shown with his soldier-servant whose function it was to guide the lance home into Christ's side or, thereafter, to gaze in wonder at his newly sighted master. Sometimes – a motif continued at least until Hans Raphon's 1508 *Crucifixion*[4] – the significance of the wound is stressed by an angel catching part of the blood in an eucharistic chalice as the lance pierces Christ's side.

In quattrocento Italy the prominence earlier accorded to the significance of Longinus became muted. Salimbeni's fresco in the Oratory of the Baptist in Urbino[5] sums up a waning didactic tradition, with its symmetrical emphasis on the lance of Longinus and the letters spelling out the Good Centurion's acknowledgement of Christ's divinity, and its association of chalice with lance point. The revival in Boccati's *Crucifixion* predella in Perugia[6] of trecento emotional realism was unusual: the mounted Longinus charges past the kneeling Marys as though ramming his lance at a quintain.

It was unusual, too, that much later, in 1531, Lotto should give the traditional Longinus-servant group the status of an almost audible shout of exalted recognition.[7] Normally representations were sobered by the depersonalizing typological tradition codified in the illustrated versions of the *Biblia Pauperum* (Fig. 289) which circulated in block-book and printed form in growing numbers from the mid-fifteenth century. Here the blood drawn from Christ's side is likened to the emergence of Eve from Adam's and to the flow of proto-eucharistic water from the rock that Moses struck.[8] The sobering of narrative that following from the quattrocento feeling for decorum is well exemplified in a drawing by Jacopo Bellini (Fig. 290);[9] the Marys mourn; the Good Centurion on the right vouches for Christ's divinity; Longinus, converted, worships. And by a perhaps involuntary association of ideas, the entirely un-Calvary figure charging in from the left, and seemingly about to topple back out of the saddle, suggests the conversion of another ex-brute and persecutor, Paul, to whom we shall turn later on.

So whereas in religious drama Longinus could be represented as a villainous warrior – in a Perugian *sacra rappresentazione* he was even made to declare that he came to Calvary determined to get his lance into Mary as well – before being transformed into a regenerate one, in art the significance of his action tended to denature his visual impact as a soldier. Commonly, north and south, shown as old and bearded, he was a ritual figure; however garbed, as Roman, 'oriental' or plated man-at-arms, he was never colloquialized into a reminder of the potentially villainous soldiers of the artist's own day.

Neither was the Centurion. Sometimes, to strengthen the energy of his converting zeal, he was shown as a combination figure: as he explains the significance of his revelation he holds Longinus's lance. More frequently he balances the grief of

231

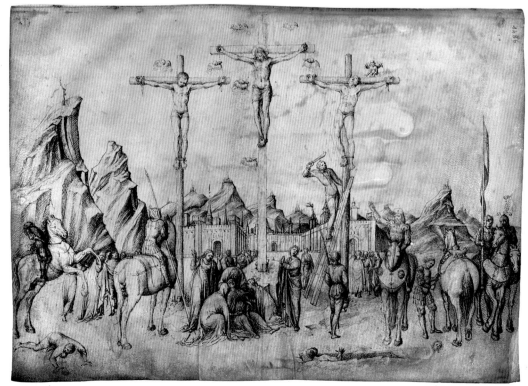

the Marys on one side of the cross with his own affirmation of Christ's divinity to those around him on the other. His role as haranguer of the Jews was less common in Italy, but it recurs in the declamatory *Crucifixion* of c.1521 which Pordenone painted for the Cathedral of Cremona (Fig. 291). And in the north the pagan character of the Centurion was, in order to make his conversion all the more exciting, at times associated with a human face in relief on his shield which, though always male, tapped the atropaic force of the use of the Gorgon face in ancient art. And because he was a man of eloquence, he was often shown – though usually wearing a sword – in civilian garb. As with Longinus, his militancy was absorbed by what he symbolized.

Indeed the New Testament as a whole did not invoke the image of the soldier as a warrior. When the soldier came to John the Baptist and asked 'And what shall we do?' he answered in terms that envisaged them as behaving only in a police role; 'Do violence to no man, neither accuse any falsely; and be content with your wages.' If soldiers figured largely in the story of the Passion and in the Acts of the Apostles it was because political authorities used them – as they did in the Renaissance – to discipline potentially dangerous minorities.

We should also bear in mind that when the Testament narrative singles out an individual soldier it is because he had a 'good' part to play in God's providential plan. Thus Cornelius, the centurion of Capernaum, is named because his faith in Jesus's power to cure his servant *in absentia* prompted Christ's reproachful comment to his followers: 'I have not found so great faith, no, not in Israel.' And the other Cornelius, the centurion of Caesarea, is named because his Gentile household's baptism by Peter gave momentum to the earlier spontaneous conversions of Longinus and the Good Centurion.

Neither Cornelius offered much purchase for the imagination of artists. Nor did *Acts* minister to any Renaissance distrust of the period's soldiery. Its narrative pre-

289. Anon., *Typology of the Issue of Blood from Christ's Side.* Woodblock from the Esztergom *Biblia Pauperum*, ?c.1450.

290. Jacopo Bellini, *Crucifixion.* Drawing, c.1440s. Paris, Louvre.

233

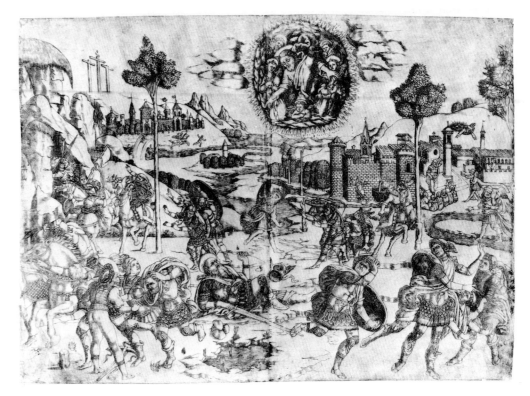

292. Baccio Baldini. *Conversion of St Paul.* Engraving, *c.*1465.

294. (*facing page, top*) Giovanni Antonio Pordenone, *Conversion of St Paul. c.*1528. Spilimberg, Cathedral.

295. (*facing page, below*) Master H.L., *St George. c.*1510–15. Munich, Bayerisches Nationalmuseum.

293. Lucas Cranach the Elder, *Title page of Epistles of St Paul.* Woodcut, 1528.

served a neutral attitude to the troops whose sleep permitted Peter's escape from prison and to the centurion – another soldier-Gentile! – whose kindness to Paul enabled him to carry the Gospel to Rome.

Paul himself was born and bred a Jew, though a Roman citizen, and it was his zeal for the old law that made him a persecutor of the followers of Jesus. Nowhere is any reference made to his being a soldier. When in the *Golden Legend* he tells Nero that he is a soldier of God, the sense is purely figurative; his habitual attribute, a sword, refers to his martyrdom, not his career. Yet with one accord artists showed him as having been one when divine revelation felled him on his way to Damascus, whether armoured as a Roman, as in Baccio Baldini's engraving (Fig. 292) of *c.*1465, or as a late Gothic knight as in Martin Enzelsberger's altarpiece of the later 1490s.[10] It was as a soldier that he could repeat the conversion experience of Longinus, and his first words on recovering from it, 'What shall I do, Lord?', echoed the question the soldiers had put to John: 'And what shall we do?'. From the first Cornelius, acceptance of the Gospel had been associated with converted Roman military officers, and it must have seemed appropriate to climax the military line in the story that led to, and then radiated away from Calvary, with one who could be shown at the head of his troops. Again, there is no scriptural licence for showing 'the men which journeyed with him' as a troop of horse, but Cranach the Elder showed Paul as a cavalry commander on the title page of a commentary on the Epistles in 1528 (Fig. 293), as, at about the same time, did Pordenone on his startling organ door in the cathedral of Spilimberg (Fig. 294).

Because of their roles in fostering or bearing witness to the divine plan, we have been dealing with soldiers who had to be shown as 'good'. And their line would be prolonged if we were to add the military saints. George, Maurice, Victor, Florian – all were Roman soldiers; Sebastian had even been captain of the Pretorian Guard. They and many others whose cults were more local – William of Aquitaine, Quirenus, Hypolitus, Liberale, Felix, Theodore, Valerian, Venentius and the rest – looked down from glass and from altarpieces. And, with manners smoothed to the court life of heaven, they were necessarily gentlemen all.

For whether portrayed in plate-armour or (more frequently in Italy than in the north but far from exclusively) in the classical cuirass, the military saints belonged necessarily to the knightly class. Their legends gave them officer status. They frequently attended on the Virgin in altarpieces. They could not be inferior in status to the wealthy or noble donors who invoked and shared the picture space with them. They were practically immune from any infection of their images from changing military practices or values. The few exceptions, like the Master H.L.'s sculpted *St George* (Fig. 295) of *c.*1510–15, with its allusion to the feathers and broken outline of the Landsknecht figure, come as something of a shock.

It is when we turn from the named 'good' soldier tradition within Renaissance Christian art (just before the mid-quattrocento Giovanni di Paolo had provided Longinus and the Centurion with haloes)[11] to the anonymous ones who massacred the Innocents, herded Jesus through the sufferings and humiliations of the Passion, and assisted in the slaughter of his saints, that we come to scenes in which the artist was freer to express his own attitude to the military, or one he knew would be shared by his patron or audience. We are far from the gentle St Florian or the meekly enduring Sebastian when we see Anton Woensam's soldiers after the slaughter of the Christian Theban Legion ribaldly sitting on the bodies of their victims, drink in hand.[12]

In comparing north with south, there are material factors to the borne in mind: the greater number of scenes that were produced in the north because of the popularity of Passion-series woodcuts and, to a lesser extent, the influence of the custom of hanging a canvas *Fastentuch*[13] decorated with Passion scenes in front of the high altar during Lent; the particular intensity of pre-Reformation religiosity and the popularity of printed digests of the Bible; the taste in the north from *c.*1500 for representations of contemporary soldiers and incidents in their lives; possibly the greater reliance of northern artists on the costumes, gestures and grimaces of street theatre than on posed assistants in the workshop who provided a more neutral basis for representation. And there are less material factors: iconographic tradition, historicism (should early Christian scenes be rendered in real or subjective temporal terms?), aesthetic and devotional values (should decorum and meditation or emotion and identification take precedence?).

Nourished by a homilectic literature which insisted that the devout reader should imagine the episodes of the Passion and of martyrdoms as though he had been present himself, fifteenth-century northern altarpieces had, in many hands, become richly anecdotal. A south German painting of *c.*1490 (Fig. 296), as arresting for the clear beauty of its landscape as for the radial organization of its surface through the spokes of the three crosses on which Christ respectively sits in meditation, is nailed, and raised, contains amidst this 'old' narrative organization 'new' anecdotal material of an everyday sort: a workman indicates to another how much lower down he must drill the nail holes for Christ's feet, a bespectacled scribe writes out the INRI inscription while an assistant lies beside him holding up an ink pot. None the less, even with the northern urge towards empathy, it is remarkable how many artists flinched from the genre opportunities offered not only by the soldiers gambling for Christ's robe, but by the discussion groups which shared or dissented from the Good Centurion's awareness of Christ's divinity, or by the doomed guard who failed to prevent his rising from the tomb.

However meticulously aspects of their costume or armament might be rendered in contemporary terms, a repertory of inhibiting devices was employed to prevent them walking out, as it were, to join the ranks of actual contemporary soldiers: a turban, a fantasized shield, a deliberately outmoded weapon like a flail (all used by Schongauer), an exaggerated grimace that stopped the 'soldier' connotation in its tracks and switched it to those of 'humour' or 'vice'. As a result, whether jammed into crowds hustling Christ to Cavalry or baying outside Pilate's palace, or dwelled on as individuals, soldiers were marked in some way as being reserved within the

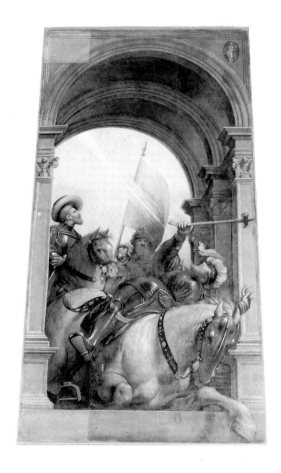

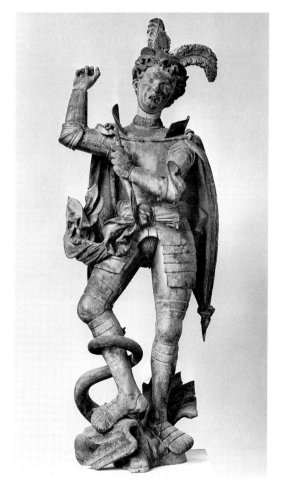

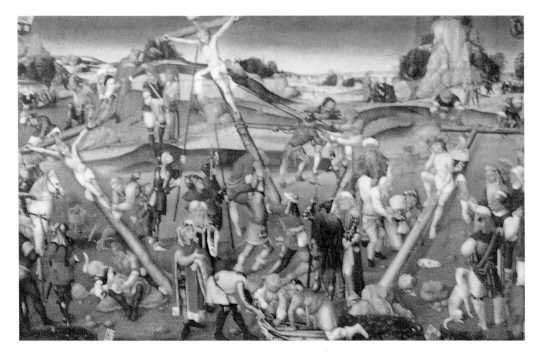

296. Anon, South German, *Crucifixion. c.*1490. Frankfurt, Städelisches Kunstinstitut.

significance of sacred story. The exceptions before 1500 were few. One, particularly interesting for suggesting a popular source for the artistic refinement of Landsknecht costume, was the rough and ready *Arrest of Christ* in a 1469 Book of Hours (Fig. 297).[14] illuminated in Neustift, Upper Bavaria.

Dürer, in *c.*1498, marked the Good Centurion, as he talks to an oriental Longinus, with an indication of that characteristic Landsknecht insignia, the St Andrew's cross, and in his *Arrest* of 1502 shows another preparing to rape a woman in the background, but generally it is notable how he kept a rein on his observational appetite in religious subjects, very seldom allowing up-to-date soldiers to confuse the timelessness of the overall setting. These were rare infections from secular imagery.

While alive to these issues, let us take up the 'bad soldier' episodes in the New Testament and in Christianity's struggle to establish itself.

The brutality of soldiers toward civilians was a common theme in chronicles north and south of the Alps. The Massacre of the Innocents was, then, a scene inviting a transcription from life. But we have seen that artists generally avoided comparison with contemporary events[15] – in this case it would be the atrocities following the sack of a town. German artists concentrated on the expression of personal anguish and savagery, as summed up in the distraught mother tugging the

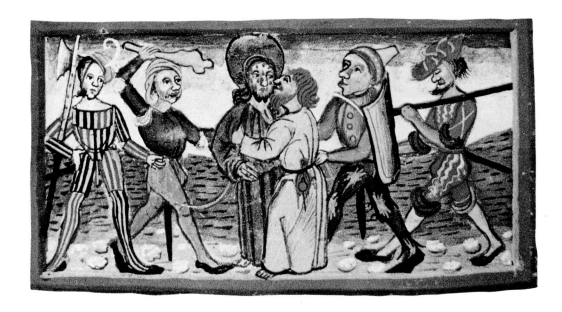

297. *Arrest of Christ.* Miniature, 1469.

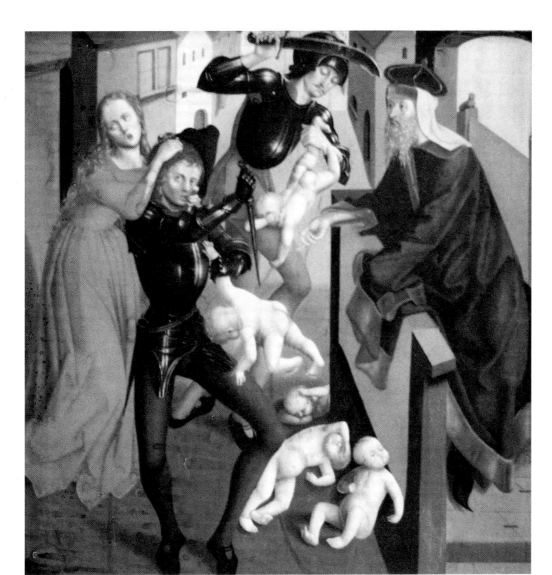

hair and wrenching at the sides of the mouth of the soldier stabbing her baby in the 1480s panel by the Master of the Augsburg Visitation (Fig. 298). In Italy, though prompting an unwonted excitability in works by Fra Angelico and Matteo di Giovanni,[16] the tendency was to play down the jumbled horror of the Massacre itself and to achieve a lucid overall composition based – as evidenced by Raphael's none the less intensely felt drawing for an engraving by Marcantonio Raimondi (Fig. 299)[17] – on a variety of studio poses, and this makes Altobello Melone's contemporary setting for his wild *Massacre of the Innocents* (Fig. 300) in the Cathedral of Cremona all the more surprising, especially as his commission called for printings which were more 'beautiful' than those of Boccacio Boccaccino which they replaced.

Later New Testament scenes involve soldiers operating within a judicial framework, and the treatment becomes still more equivocal.

In Italian and German cities soldiers, unless called out in times of riot, normally had nothing to do with the processes of arrest and punishment. Arrest was the function of the civilian law officer and his *birri*, a force which might contain ex-soldiers but was, like the executioner and torturer and their assistants, on the municipal payroll. And when their numbers were inadequate to arrest or escort a criminal, recourse was had to civic guards, not to soldiers in the sense of those paid to fight an enemy rather than carry out police functions.

The Gospel narratives make it clear that the first three stages in the Passion, the

237

299. Raphael, *Massacre of the Innocents*. Drawing, *c*.1511. London, British Museum.

300. Altobello Melone, *Massacre of the Innocents*. 1517. Cremona, Cathedral.

301. Jörg Breu, *Christ before Caiaphas*. Panel, *c*.1505. Melk, Kloster.

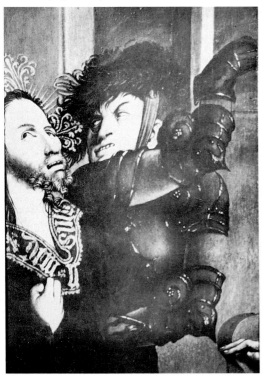

arrest of Christ and his being taken before the high priests Annas and then Caiaphas, were in the hands of the Jewish administration's police force: 'Are ye come out as against a thief with swords and staves for to take me?' asked Jesus. Giotto, in the Scrovegni Chapel, had been careful to observe this distinction. In the later Renaissance, however, in the south as well as the north, as in paintings by Altobello of 1517[18] and by Hans Leu at about the same time (Peter's victim sprawls back to reveal his Landsknecht codpiece and trews),[19] the arrest is shown being carried out by soldiers. And it is in full battle armour that a soldier prepares to strike Christ as he stands before Caiaphas in a panel of *c*.1505 by Jörg Breu (Fig. 301).

Once Jesus had been passed into Pilate's jurisdiction, however, punishment, from the Flagellation to the Crucifixion, was carried out by the military. *The Golden Legend* quotes St Jerome: 'Jesus is delivered up to the soldiers to be scourged, and the scourges lacerate that most sacred body and that breast wherein God dwelt.' And in St John: 'The soldiers platted a crown of thorns, and put it on his head And they smote him with their hands.'

How these scenes were rendered, and those of earlier stages in the Passion sequence, depended, of course, on factors far more complex than drawing a conscious parallel between contemporary and ancient judicial procedures. Breu was tapping a northern emotive response to the cruelties to which Jesus was exposed in an attempt to make the spectator feel personally responsible for behaviour whereby Christ each day was tortured afresh; for every sinner had it in him to be a 'bad' soldier or a torturer. One of the verses accompanying the frontispiece of Dürer's *Large Passion*, where Christ is mocked by a soldier who offers him a reed and points to a scourge, reads 'I still take floggings for thy guilty acts.'[20] In Italy decorum muted the violence. Moreover, in Italy Passion prints like Israhel von Meckenem's 'cruel' *Crowning*[21] did not play anything like the mediating role between devotional literature, which was equally fervent on both sides of the Alps, and art. Nor, in the Germanic world, was there that humanistically induced respect for the institutions of the ancient world that could, in a Florentine engraving of about 1460, make Christ's flogging seem so unimportant an episode within Pilate's orderly judgement hall (Fig. 302). Indeed, for Italian artists with a historical sense, it was difficult to think of Roman soldiers, who had come to be celebrated as ideal citizen-warriors and a reproach to the mercenary and self-seeking soldiery of the present, as being shown in a 'bad' role.

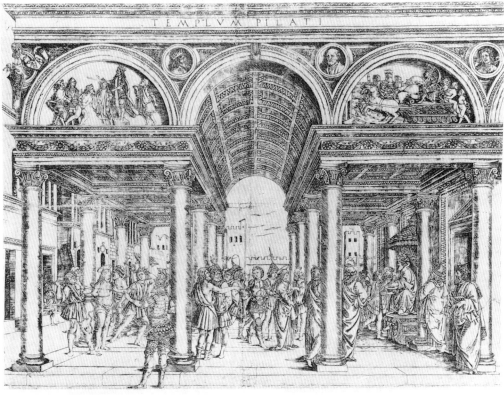

302. Anon. (Florentine), *The Flagellation in Pilate's Judgement Hall*. Engraving, *c*.1460.

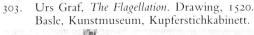
303. Urs Graf, *The Flagellation*. Drawing, 1520. Basle, Kunstmuseum, Kupferstichkabinett.

To bring contemporary soldiers into a religious theme was, we have suggested, potentially to trouble it with an infusion of experience or prejudice. Soldiers, seen, suffered from or merely talked about, provided a reality test quite different from that of studying a girl suckling her child as the model for a Madonna, or a dissectable body salvaged from the gallows to help with the venous system of a decapitated saint. How one reads the artist–reality relationship is another matter. It is tempting to think that the difference between Urs Graf's somewhat routine treatment of the Flagellation in the background of his early woodcut (which dates from 1503–6)[22] with its soldier–torturer distinction, and the savage dervish whirl of soldier–tormentors around the pitifully slumped figure of Christ in a drawing of 1502 (Fig. 303), reflects his own experience as a soldier in the meantime; or that the Swiss infantrymen who are so prominent in Niklaus Manuel's *Mocking of Christ* drawing of about 1518[23] reflected *his* service with such blasphemous fellow soldiers. But one cannot be sure. Grünewald's *Christ carrying the Cross* of 1523–5 (Fig. 304) shows him similarly environed with figures from the coarsest ranks of the soldiery; and Grünewald did not serve in any war.

A bias within Italian works had been to encourage a contemplative 'think on these things' reaction, in contract to the northern bias towards calling for active empathy. A number of Italian artists, under the influence of the notion of historical distance which was part of humanism's exploration of the ancient world, set their Passion scenes in the classical past, whereas most northern artists kept to a convention which, however 'timeless' or exotic, prompted an imaginative link with the present. These different approaches to chronology had encouraged the contemplation–empathy divergence. And, to move from the Gospels to the early centuries of Christianity, they affected the depiction of scenes of martyrdom.

Here, again, there was a stronger tendency to preserve the difference between soldier and torturer or executioner in Italy, though this was seldom so fastidious as in Mantegna's *Martyrdom of St James* where, as in his *Flagellation* engraving,

304. Mathias Grünewald, *Christ Carrying the Cross*. 1523–5. Karlsruhe, Staatliche Kunsthalle.

239

305. Andrea Mantegna, *Martyrdom of St James.*
Fresco. 1453–7. Padua, Eremitani (now
destroyed).

306. Sodoma, *Deposition.* ?c.1510. Siena, Ac-
cademia.

307. Jan Joest, *Arrest of Christ. c.*1500. Dresden,
Gemäldegalerie, Alte Meister, inv.841.

soldiers merely hold the ring while the executioner prepares to bring his mallet
down on the *mannaia*, or short guillotine (Fig. 305). And there was, until the 1520s, a
stronger instinct than in the north to protect events in the past from contamination
by references to the present.

This historicism was not consistent. Uccello was content to write S.P.Q.R. on
the shield of a contemporary soldier in a martyrdom scene.[24] Working at the same
time in Ferrara, Cosimo Tura made Roman soldiers haul St Maurelius off to execu-
tion[25] while Ercole de' Roberti, as we saw, had Jesus arrested with a noose slipped
over his head by a member of the Ferrarese court guard.[26] Contracts with artists
did not specify the period within which scenes were to be located. This was up to
them, within the overall historicist bias of the culture in which they were working.
The direction to Michael Pacher in the commission for an altarpiece to include Sts
Florian and George went no further than to specify 'fine armoured men, silvered
and gilded when needed'.[27] And for details of armour and other aspects of military
costume, artists looked to the works of their predecessors and kept alive conven-
tions – like the mocking of 'paynims' by equipping them with risibly fantasticated
or mismatched components, or maintaining, because of their pictorial effective-
ness, features that had long been superseded, like the 'pig-faced' basinet of 1360–1410
which haunted the imagination as late as the generations of Dürer and Grünewald.[28]
They also looked around: at actual soldiers but also at Roman sculpture, or draw-
ings made from it; at soldiers in manuscript illumination; at foreign merchants and
ambassadors' trains and at gypsies and wandering troupes of entertainers from the
near east; at street or church theatre which caught hints from such visits and pre-
served them in their wardrobes; at processions like the one Dürer watched in Ant-
werp in 1520 which included 'St George with his squires', 'a very goodly knight
in armour' and 'boys and maidens most finely and splendidly dressed in the cos-
tumes of many lands, representing various saints'.[29]

As with productions of Shakespeare today, the story came first, and it was up
to the artist, as with the director, to choose its setting. Humanist historicism,
in any case, coexisted in most artists' minds with a blithe disregard of anachronism.
In the right-hand foreground of Carpaccio's *Martyrdom of the 10,000* of 1515,[30] a
Romanized soldier confronts a contemporary one; a similar juxtaposition occurs
in the right foreground of Sodoma's *Deposition* (Fig. 306), where two soldiers –
possibly Longinus and the Good Centurion – happily chat across a costume divide
of a millenium and a half.

In the north the historicist element was less fluid. Basically it consisted of a dressing-
up-box approach, a mixture of no-longer-fashionable civilian finery, contemporary
parade armour, turbans and headbands suggestive of the east, helmets fantasticized
away from any a direct reference to period. In Jan Joest of Kalkar's torchlit pro-
cession leading towards the arrest of Christ of *c.*1500 (Fig. 307),[31] though holding
contemporary weapons, pike and halberd, the soldiers – like the swordsman grasp-
ing Christ, who wears German particoloured hose, an eastern European quilted
jacket and a Levantine turban – the emphasis is not so much on a particular place or
time but on the contrast between sacred (the robes of Christ and Peter) and profane.
So it was in 1504 when Hans Burgkmair[32] placed between an undatably oriental
Longinus and a Jewish officer of the high priests' watch a Good Centurion wearing
an eastern turban, a western breastplate of a type that was by then fifty years out
of date, and frilly mail garters of a sort that had never been worn.

This eclecticism, with its hints of actual Levantines, Jews or Turks, and of quasi-
oriental Hungarians and Slavs, of armour in stained-glass windows, on tombs or
preserved in castles, of patrician fashions of an earlier year like the Magdalen's
gown, may all the same have drawn the spectator's imagination towards the pres-
ent, away from the less attention-demanding detail of the stereotyped costume
of Christ in his loincloth, the Marys in their robes. And even when marked with
some element of fancy dress, soldiers, because of their continuing function across

240

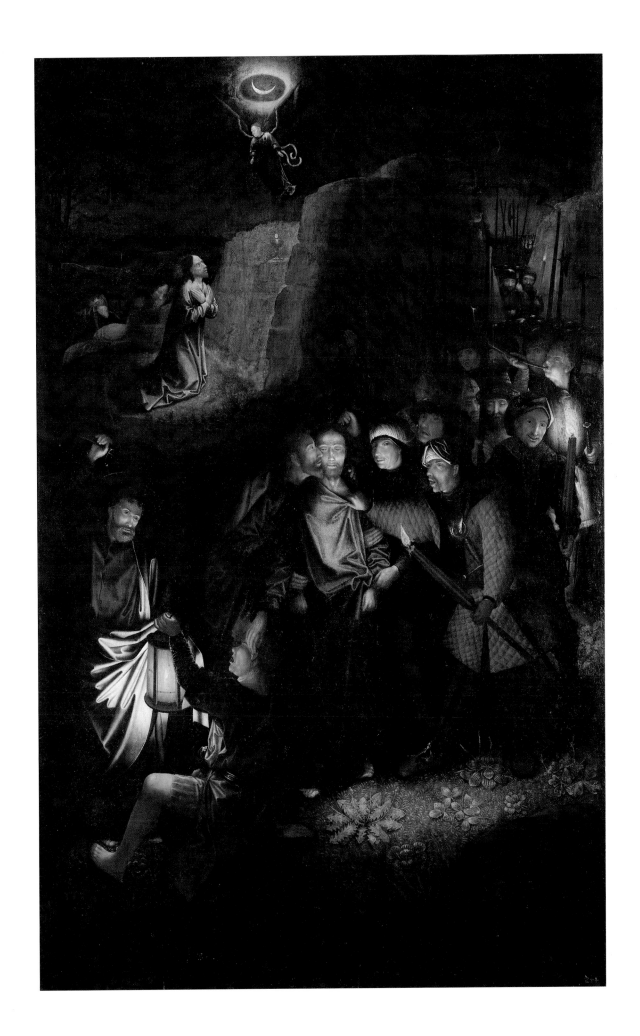

the ages, and their alarming and changing weaponry, were best calculated of all the characters in religious art to bring the imagination forward in time. Joerg Ratgeb was, with Grünewald, the outstanding visionary of German Renaissance art. The soldiers in his 1517 or 1518 *Resurrection* (Fig. 311), toppled back by the blast of Christ's take-off from his tomb, are dressed as no contemporary soldier could be. But the one in the left foreground props himself on his gun, and between him and his recumbent colleagues are the up-to-the-moment jug and playing cards with which they had been beguiling their watch. In another work of 1517, the Augsburg *Crucifixion* by one of the sons of Ulrich Apt, in spite of the flights of angels over-head, the artist put the entire cast of its central panel in almost undiluted modern dress, with particular emphasis on the harshly realist hair-pulling wrangle between the soldiers dicing in the foreground.[33] And in Daniel Hopfer's supremely 'northern' etching of *c.*1520(?) (Fig. 308),[34] a jeering soldier reaches his long-pole partisan clear across the composition to guide Longinus's lance to its target. On the whole, however, the genre figure of the Landsknecht was played down in Passion scenes. Perhaps this had something to do with the fact that German artists were working for an audience many of whom, while prepared to think ill of soldiers in the abstract, or be interested in accurate representations of them in a secular context, had been, or could be, soldiers themselves.

It was in scenes of martyrdoms, which lay outside the bonding emphasis of homiletic tracts and were chronologically 'later' (however vaguely), that the Landsknecht figure found its main point of entry. Thus two Landsknechts attack the saint's ship in Kulmbach's 1508 drawing *The Martyrdom of St Ursula*,[35] and a Landsknecht captain harangues the group of soldiers and civilians who have gathered to watch a bishop being roasted alive, bolted into a suit of armour, in Cranach's preparatory drawing (Fig. 309) for a wall painting[36].

In martyrdom scenes, as in the Flagellation, a distinction was often made between the soldiers who directed an execution or torture and the men who carried it out. In his *Beheading of the Baptist* altarpiece,[37] Cranach went so far as to give his own features to the halberdier who is present at, but not carrying out, the execution. But in his earlier painting of *c.*1505 *The Martyrdom of St Catherine*,[38] he used a more recent way of exploiting the growing fascination with Landsknecht costume and making it a pictorial focus without directly contaminating the patriotic side of the identity of the serving soldier. This was to portray executioners, as he did to eye-catching effect, as dandies, borrowing and refining what were in colour, cut and material and well-filled codpiece, *haute couture* versions of the Landsknecht mode. Rapidly taken up by others, such as Holbein the Elder in his *Martyrdom of St Sebastian*[39] and Leonhard Beck in the *Flogging of St Margere*,[40] by 1513 or 1514 the convention was followed to dazzling effect by Niklaus Manuel in his *Beheading of the Baptist* (Fig. 310).[41]

If very few paintings or sculptures insistently identified the 'bad' soldier in religious art with the contemporary Reisläufer or Landsknecht, however equivocal their reputation, in northern drawings, semi-private works, they harried and tortured what was holy, though this note was sounded chiefly by a few Danubian artists living in the central Landsknecht recruitment area. Erhard Altdorfer (or the Master of the History?) drew a Landsknecht troop closing in on Christ as he prayed at the foot of the Mount of Olives.[42] Albrecht Altdorfer made no bones about St Catherine having her head cut off by a Landsknecht[43] and had a group of them cat-calling at the pierced St Sebastian.[44] Wolf Huber's *Beheading of the Baptist* of *c.*1512–15, known from a mid-sixteenth-century copy,[45] naturalized the event among the citizens and soldiery of a contemporary German town (Fig. 312). But no other work took so committed a view – well beyond the ordinary scope of devotional identification – that the soldiery of the present equalled the 'bad' soldiers of the Testament past as did the 'Huber' drawing with which this chapter opened.

In Switzerland and Germany the cautious advance of naturalistically portrayed

308. Daniel Hopfer, *Crucifixion*. Etching, *?c.*1520.

309. Lucas Cranach the Elder, *Martyrdom of a Saint-Bishop*. Drawing. Weimar, Kupferstichkabinett, inv. K.K.98.

310. Niklaus Manuel, *Beheading of the Baptist*. *c.*1517. Basle, Kunstmuseum, Kupferstichkabinett inv.424.

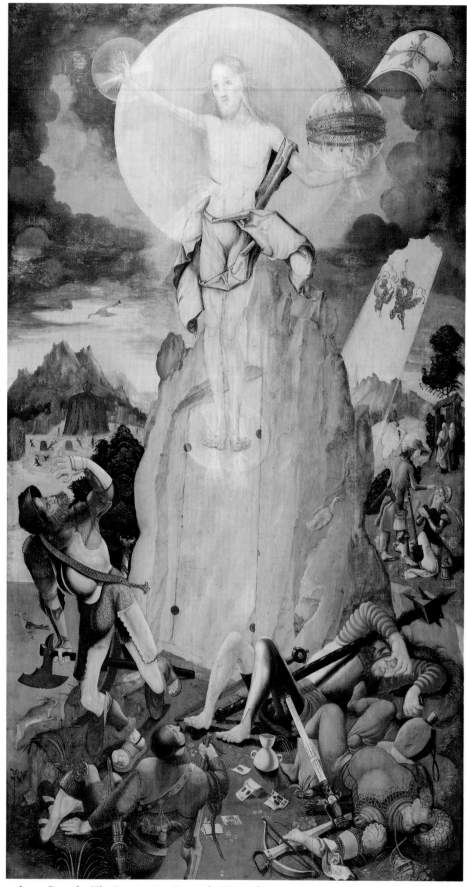

311. Joerg Ratgeb, *The Resurrection*. From the Herrenberger Altar, 1517–18. Staatsgalerie, Stuttgart.

312. Wolf Huber, *Beheading of the Baptist*. Mid 16th century copy of drawing of 1512–15. Stockholm, Nationalmuseum.

313. Girolamo Romanino, *Pietà*. 1510. Venice, Accademia.

Way to Calvary[53] is clearly taken from art rather than life; we have noted that the painting was once attributed to Dürer.[54]

Yet it was around then that the Germanic example of associating real soldiers with religious subjects was sufficiently absorbed through prints (and perhaps drawings) to allow for independent observation. The bias against the element of here-and-now that had come to characterize religious art since the triumphant *gravitas* of a work like Altichiero's *Crucifixion* fresco of the 1370s,[55] was, at least in northern Italy, mitigated. Dosso now, without any sense of pose or borrowing, had contemporary soldiers hurl stones in *The Martyrdom of St Stephen* (Fig. 315).[56] The soldiers forcing Christ before Caiaphas could have been beckoned in from the streets around the cathedral at Cremona where Romanino was working;[57] his whiplashed *Christ shown to the People* (Fig. 316) by a soldier and a worried young official is not only one of the most tenderly thoughtful versions of the subject but has the horrid immediacy of a news broadsheet. And Pordenone's *Beheading of St Paul* (Fig. 317) reads, like Huber's *Execution of the Baptist*, as a quasi-journalistic report on a violent incident in a provincial town. On the other hand, it would be difficult to account for the spectral, pox-marked presence of the soldier louring over and contaminating the reflective mood of Rosso's *Lamentation over the Dead Christ* (Fig. 318), without accepting the influence of the jesting, grimacing 'bad' soldier of Germanic prints.

The partial liberalization of the Italian imagination from its aesthetic and temporal norms was localized and fairly brief. Perhaps, blending later into the energetic spirit of the Counter-Reformation, it helped to check the humanistic take-over of early Christian history. At least it throws some light on the relationship between the stances of northern and southern artists and the extent to which, as far as the delineation of the soldier was concerned, there came to be some closing of the gap between them.

317. Giovanni Antonio Pordenone, *Beheading of St Paul*. Fresco, after 1517. Travesio, Parrochiale.

318. Rosso Fiorentino, *Lamentation over the Dead Christ*. c.1528. Sansepolcro, S. Lorenzo.

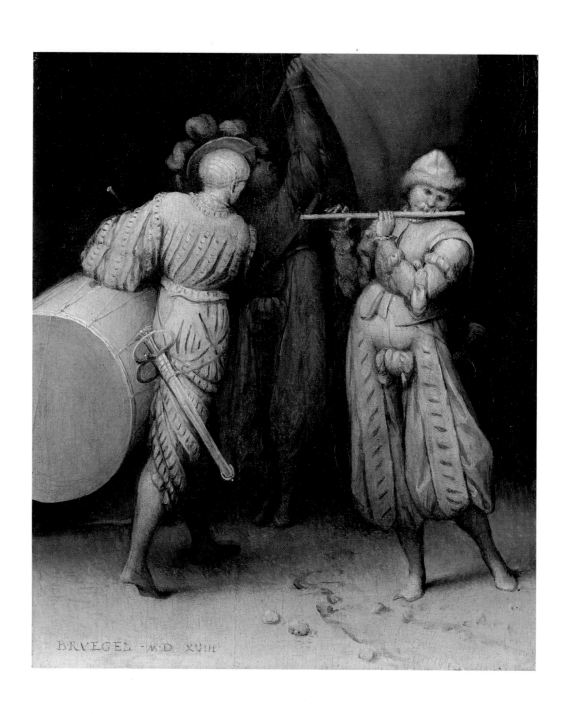

EPILOGUE
Beyond the Italian and Germanic Worlds

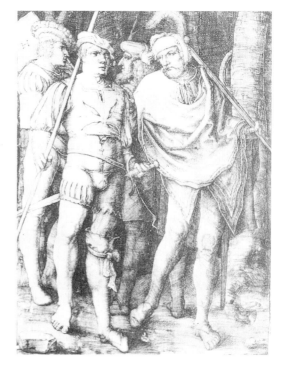

320. Lucas van Leyden, *Four Soldiers in a Wood.* Engraving, *c*.1507.

W ARFARE WAS COMMON to Europe as whole. And, westwards of the central plains of Poland and Hungary, it was waged by armies whose recruitment, armament and organization had much in common. Yet to move now further afield is to realize the extent to which the exploration of military themes was concentrated in central and northern Italy, Switzerland and, above all, Germany.

This is true even of that area, Flanders and the Netherlands, that had most in common with the military practices and the artistic vitality of the towns and courts of Germany and northern Italy.

Only Lucas van Leyden (like his artist father, a member of one of the city's militia companies) took a recurrent interest in the figure of the individual soldier. His engravings of *Four Soldiers in a Wood* (*c*.1507) (Fig. 320), *A Standard Bearer* (*c*.1510)[1] and his drawing of a *Drummer, Fifer and Standard Bearer* of 1518–19 (Fig. 321) are, however, not so much reflections of the everyday life of his own world (such as he showed in his *Milkmaid* or *Beggar Musicians* engravings and, most remarkably, in his *The Card Players* painting)[2] as the reaction of a draughtsman of exceptional skill and alertness to those German prints which were in circulation well before his personal encounter with Dürer and his wares in Antwerp in 1521. And it is difficult to believe that the subject and the swagger of his soldier and girl arms bearers (Fig. 322), who so jauntily step from their niches on the shutter reverses of the *Healing of the Blind Man* (*c*.1531), were not urged into being by the example of Swiss designs for heraldic glass. But the soldier figure was not to capture the imagination of artists until after the mid-century, as it did in such works as the little painting by Breughel, *The Three Soldiers* (drummer, fifer, standard bearer) in the Frick (Fig. 319)[3] and, later still, in Golzius's flamboyant standard bearer prints, which took up the earlier Germanic models with superb address. By then warfare had come to the Netherlands in new forms of terror and patriotism. The print market was busily occupied with propaganda sheets, siege scenes and illustrated instruction manuals. The soldier figure, no longer an exotic arouser of curiosity, became as it had been in Germany and Switzerland, an exhalation from a public concern with war and its agents.

While a moralizing literature concerned with social types and manners persisted, and led to the inclusion of soldiers in the 1520s woodcuts attributed to Jan Wellens de Cock, such as the *Baggage Train of the Ship of St Renyt* (a version of the Ship of Fools theme),[4] the interest in social life that had done much to awaken Swiss and German interest in soldier figures and military genre faded from the 1470s. There was no successor to illuminators like Jean le Tavernier or the Master of Anthony of Burgundy who seized opportunities to open their pages on to scenes of street or domestic life. Genre became restricted to representations of the labours of the months, a still vital tradition because of its association with the calendar. Rarely, this led to the isolation of the peasant as a social type, as in the late-fifteenth-century painted glass *Peasant holding a Spade* in Glasgow.[5] Glass, too, in windows sponsored

321. Lucas van Leyden, *Drummer, Fifer and Standard Bearer.* Drawing, 1518–19. Berlin, SMPK.

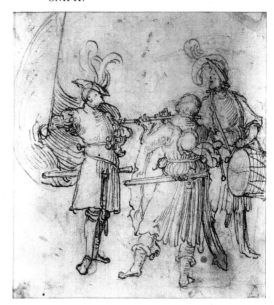

319. Pieter Breughel the Elder (attrib.), *The Three Soldiers*, 1568. New York, Frick Collection.

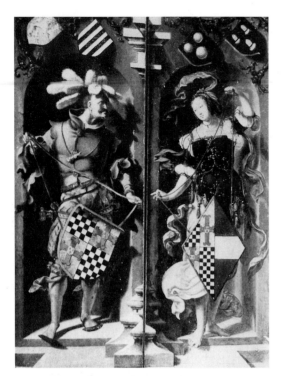

322. Lucas van Leyden, *Arms Bearers. c.*1531. Leningrad, Hermitage.

by guilds, showed tradesmen and craftsmen – bakers, in the case of a 1503 window in St Sulpice, Diest.[6] But here too soldiers had no such traditional guild support system to keep them in the artist's eye, numerous and prominent as they were in the mobilizations and small wars of the period. The growing strain of eroticism, particularly marked in Jan Gossaert (Mabuse)'s treatment of the Fall[7] and in mythological scenes from the second decade of the sixteenth century, led to no such transferral of sexual interest to the soldiery as occurred in Switzerland and Germany. Not the soldier but, at least from Quenten Metsys's 1514 *The Money Changer and his Wife,*[8] the banker and his ilk became the favoured non-aristocratic occupation group for pictorial scrutiny. And when, after the mid-century, this interest widened again into a whole school of Mannerist–Social Realist artists (Peter Aertsen, Joachim Beukelauer, Herri met de Bles, Marten van Cleef and others) it was with the sales and service elements in society that they concerned themselves.[9]

Amidst the symbolic world of animal and social grotesqueries populated by the allusive imagination of Hieronymus Bosch and his imitators, the few fighting men who flickered marginally into sight were there because of the surreal potential of their metallic garb. Apart from one staffage vignette of soldiers robbing a traveller,[10] Bosch showed no interest in soldiers as such and saw the conflicts that corrupted the world not in terms of men-made war but of apolaptic judgement. Only one of his followers shifted his imagistic vocabulary on to a battlefield, Alart Duhameel, in his *c.*1500 engraving *The War Elephant* (Fig. 323), and this, while showing an awareness of previous battle illuminations, imposed a scattering of fantasies over a field of combat rather than absorbing battle itself into the world of fantasy.

While the depiction of battles (accepting that much may have been lost or destroyed in later convulsions) does not appear to have interested artists or patrons, there were two major and splendid exceptions to that indifference. Both were commissioned in the imperial interest from artists with connections in the Brussels tapestry workshops, who transmuted the large-scale decorative skills they had brought to celebrating the feats of classical and chivalrous encounters into heroic records of contemporary campaigns.

In 1531 the Marquis of Pescara, who had played a prominent part in the defeat of the French at Pavia, commissioned seven tapestry designs from Barnaert van Orley

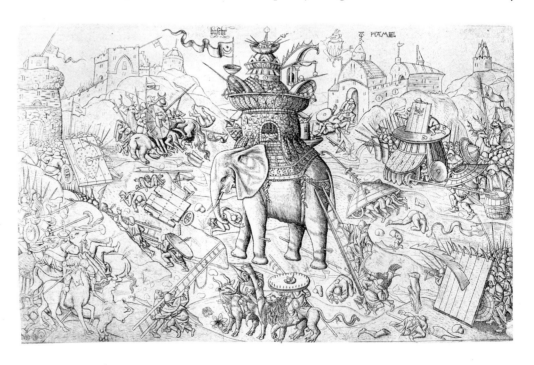

323. Alart Duhameel, *The War Elephant.* Engraving, *c.*1500.

250

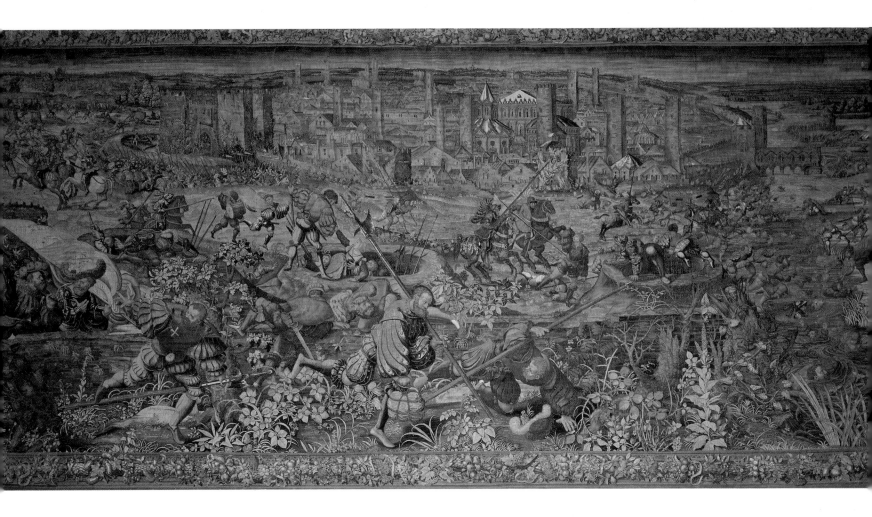

as a present to the Emperor and victor, Charles V. Working from what must have been a detailed brief analysing the event, van Orley broke the engagement into seven compositionally self-contained episodes,[11] from the advance of Charles's army to the break-up of the French after the routing of their cavalry. Understandably each scene focused on some French discomfiture – their womenfolk are forced to flee under escort; Francis is taken prisoner; a prominent place is allotted to the eve-of-battle desertion of the unpaid Swiss (Fig. 324), complete with the Germanic cliché of a Landsknecht sloping off with his boy servant and a purloined cock. Battle is portrayed in terms of skill, the brilliantly coloured splendour of costumes, and pictorially effective individual poses and groupings. No one is out-at-elbows or unlaundered. There are a few reminders of agony, none of dust or smoke. The foliage frames which surround each episode creep engagingly into the action depicted; an owl sleeps serenely within yards of the French artillery at full blast. The series magnificently exemplifies the ability of the arts, fine and decorative, to combine information with charm, and to minister, in this case not too blatantly, to personal and national pride.

The second exception occurred when Charles took Jan Cornelisz. Vermeyen with him on the expedition that led to the conquest of Tunis.[12] Vermeyen had been court painter to Charles's sister Mary, titular governor of the Netherlands on his behalf from 1531, before the Emperor set off on what he saw as a Christian adventure that would link his fame with that of his grandfather Maximilian I, who had been so intent on getting artists to record his deeds.

Maximilian, however, did not take them with him on campaign. There is un-

324. Barnaert van Orley, designer, *Attack on the French Camp at Pavia*. Tapestry, *c.*1531. Naples, Capodimonte.

325. Jan Conelisz. Vermeyen, *The Conquest of Tunis 1535*. Cartoon, detail. Vienna, Kunsthistorisches Museum.

specific evidence that Charles VIII had taken artists on his 1494 invasion of Italy. Still, there is some reason for describing Vermeyen as the first war artist. There were two others, Pieter Coeck and, a much vaguer figure, Jaime Aleman, identified in Charles V's entourage, but only the results of Vermeyen's observations can be identified.

These, based on sketches on the spot (or so it was made to seem by his use of the familiar topographer's trick of showing himself drawing what was before him), were worked up into full-scale coloured cartoons, now in Vienna, and then, after long travail in the workshop of Guillaume Pannemaker of Brussels, these became in 1554 the set of twelve tapestries that constitute the most elaborate and costly of all the celebrations of the Emperor's military career.

Lustrous with gold thread, the tapestries were designed to be magnificent and serve the purpose of propagandistic eulogy. Vermeyen was not concerned to revive familiar compositional formulae and stood well back from infusing the work with any personal comment. The Emperor's entourage was splendid, the troops, Spanish, German and Italian, clean and orderly. The ships, standards flying, sails billowing or furled, make a picturesque and impressive show. The successive attacks on Turkish sallies from the strong point of La Goletta, which had to be taken before it was safe to advance on Tunis itself, were vigorous without being particularly bloodthirsty. Most of the scenes are panoramic, seen from a high viewpoint and are thus psychologically as well as spatially distancing. But from time to time Vermeyen moved in to reveal telling details of a genre nature, a kneeling arquebusier firing from the left shoulder, a soldier wounded in the rump by a lance thrust (Fig. 325) pitching headlong into the water, a burdened woman and a small boy walking with the standard bearer, fifes and drums of a unit returning from Tunis to the camp at La Goletta (Fig. 326). Only in one scene, the last, *The Embarkation for the Return* (Fig. 327) is a sombre note sounded: while stripped Turkish corpses lie shrunken and unregarded in the sun, Christians are given formal burial by the clergy. But one of the themes Vermeyen was surely advised to make clear (in such matters as the pillage after the fall of Tunis, for instance, in another scene) was that the rules of war did not apply equally to Christians and infidels.

In around 1461 an anonymous Flemish illuminator of one of the many manu-

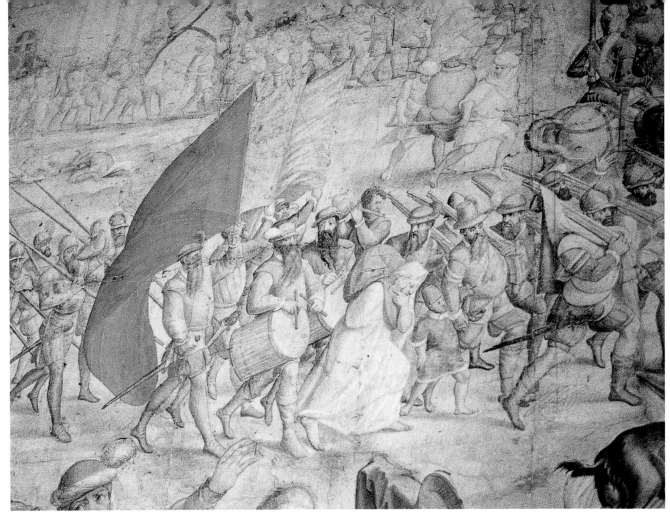

326. Detail of Fig. 325.

327. Detail of Fig. 325.

328. Anon. (Flemish), *The Tree of Battles*. Miniature, *c*.1461. Brussels, Royal Library MS.9079, f.10v.

329. Pieter Breughel the Elder. *Anger*. Drawing, 1557. Florence, Uffizi.

scripts of Honoré Bonet's 1387 treatise on military law and morality, *The Tree of Battles*, illustrated the title (Fig. 328) with a leafless tree amidst whose branches king fights king, bishop bishop, merchant merchant, doctor (medical) doctor, woman woman and, of course, soldier fights soldier, soldier abuses peasant. Over all, God sits between the warring angels.[13] Bonet's text suggests that there are rational solutions to the problem of an age in which 'I see all Holy Christendom so burdened with wars and hatreds, robberies and dissentions, that it is hard to name one little region, be it duchy or county, that enjoys a good peace.'[14] But since 1387 neither reason, expressed through law and diplomacy, nor charity and humility, urged by the clergy, had broken the peace–war–peace–war cycle of inevitability or quenched the envy and anger in human nature that kept it going. These despondent themes were universal. They rang true to what happened, to what people were like. In the Netherlands, with its occasional pockets of artistic attentiveness to popular fears, they occasionally surfaced. A late example is the series of female personifications of 1546 by Cornelis Antonicz. The images are weak. The strength lies in the accompanying texts.

330. Lucas van Leyden, *Mars and Venus*. Engraving, 1530.

Envy.	I, envy, cruel in my intent
	Bring many in such great torment . . .
	I am the door of death, the gate of hell.
War.	I, angry war, fearful of deed,
	Full of betrayal . . .
	Envy is my foundation . . .
	I burn, I steal, I kill, I plunder . . .
Poverty.	When war is dragging on
	I, Want, come to everyone's door.[15]

These were the folk rationalizations that were later to cause Pieter Breughel in his 1557 drawing to show *Anger* (Fig. 329) as a Bellona figure braying forward her

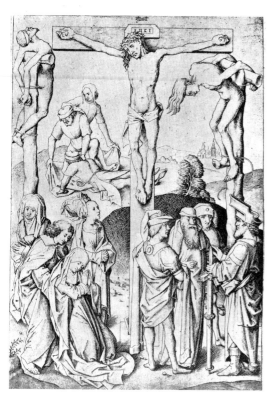

331. Master of Zwolle, *Calvary*. Engraving, 1480.

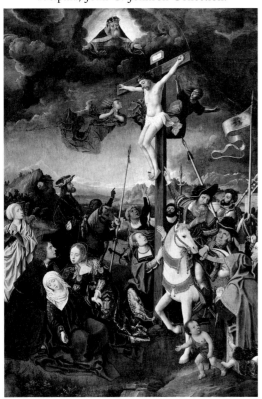

332. Jan Mostaert, *Crucifixion*. ?Late 1540s. Philadelphia, John C. Johnson Collection.

weird crew of betrayers (the severed head on the shield-charger is a reference to Salome) and infidels (the crescent on the other shield) unleashing the cruelty instinctive alike to beasts and men. Breughel was unique in the sixteenth century for his ability, in spite of an intense artistic sophistication, to respond to crude popular fears and their moralized stances. His *Dulle Griet* deployed the theme of covetousness – envy, anger, again – across a flaming, war-stricken landscape in which not only soldiers but their accoutrements had a baleful life of their own[16].

Within our period, however, and in less independent minds, thinking about war's causes and role was top-dressed by the play upon it of Italianate deity personification. Lucas van Leyden, for instance, produced in the 1520s an engraved Minerva[17] in Amazonian guise holding a Gorgon shield with one hand and, in the other, a cavalry lance she could not possibly have wielded had she risen to her feet: adding symbol to personification reveals the weakness of his conviction. His *Mars and Venus* engraving, of 1530 (Fig. 330) is far more considered, with its brooding but watchful swordsman, watched in turn by Venus; this striking composition anticipates later treatment of 'the pacific Mars', a Mars who uses his strength to protect rather than destroy. But the growing taste, influenced by Italy and France, for classical imagery (as in the tomb of the warrior prince Engelbert of Nassau, erected between 1526 and 1538 with its Roman soldier slab-bearers)[18] and mythological subjects brought only repetition of Italian themes, like the restrained sexual explicitness of Willem Key's masterpiece of the mid-century, *Mars and Venus discovered by Vulcan*.[19]

In religious art there was a notable persistence of the import of the good soldiers to the Passion story. In the Master of Zwolle's 1480 *Calvary* engraving Longinus is giving an earnest lecture to the Jews on the significance of his miracle (Fig. 331).[20] Within Maerten van Heemskerck's Italianizing, Mannerist *Crucifixion* of 1538–42[21] he is still a prominent central figure, though the gesture of indicating his blindness, as though to indicate Maerten's irritation at having to do anything in a conventional way, is left to his squire. And the debate whose raging determines the whole atmosphere of Jan Mostaert's stormy *Crucifixion*[22] arises chiefly from the miracle that happened to Longinus and the revelation that visited the Good Centurion (Fig. 332). This persistence of the good soldier element in crucifixion iconology, even in the work of Italianized artists like Heemskerck and Mostaert, owed something to the emphasis on 'being there' when imagining the Passion that was one of the insistent motifs within the Netherlandish *Devotio Moderna*. 'So when we go to Mass', as a popular devotional work had it, 'we in fact go with the friends of our Lord and with the Lord Jesus himself to the hill of Calvary'.[23] This not only encouraged representations of the Carrying of the Cross as street theatre observed by modern spectators (the anonymous late-fifteenth-century drawing in the Albertina is an example)[24] but in conjunction with the eucharistic view of Christ's body as a mystical comestible, led to paintings as disconcerting as Dieric Bouts's 1458 *Last Supper*[25] set in a strictly contemporary Gothic hall with up-to-date attendants waiting on the biblically clad disciples, or Mostaert's *Deposition*[26] in which Christ's naked body is handled, not simply adored by, sterling members of the contemporary bourgeoisie.

The *Devotio*'s injunction to be with Christ did not, however, lead to Gospel scenes being rendered either in accurately historical or consistently up-to-date terms. The hybrid, dressing-up-box costume convention remained the norm. It was to take Breughel, in his 1564 *Procession to Calvary* to see it as a contemporary execution scene, prodded on by soldiers, past equally contemporary spectators (Fig. 333). It is true that Patenier introduced an occasional up-to-date soldier: a halberdier and an arquebusier join the biblical group listening to John the Baptist, a soldier, smartly turned out in hose of yellow and black stripes and with green, slashed sleeves trots away with the orientals who flee from the explosion of St Catherine's wheel.[27] And the Germanic dandy makes an occasional appearance, as he does in a *c.*1522 anonymous Brussels altarpiece of *The Martyrdom of St Ursula*.[28] It is possible that the

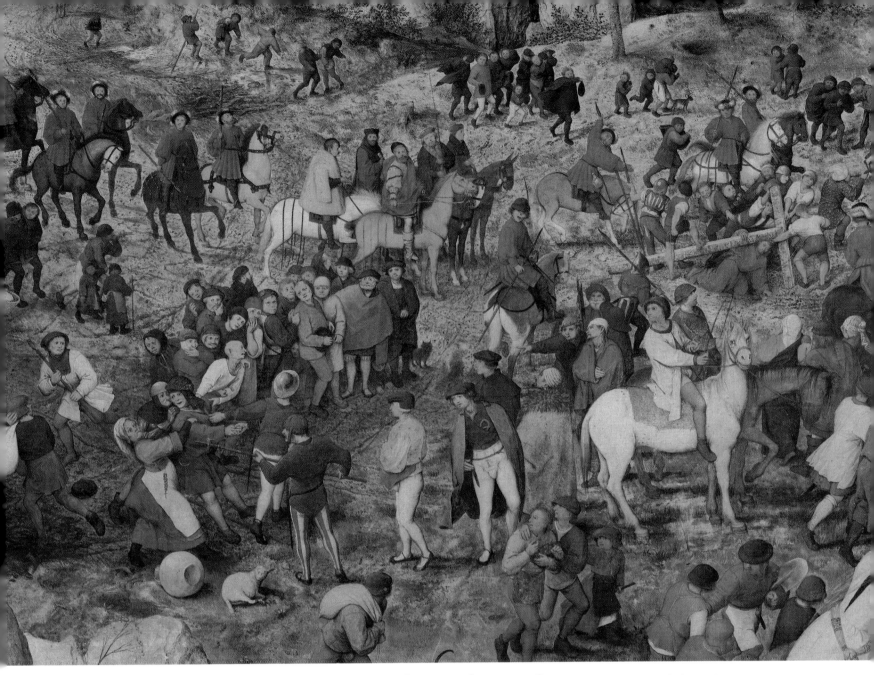

sloppily dressed but still dandified executioner in the early-sixteenth-century *Be-heading of St John the Baptist* by the Pseudo-Bles anticipated them.[29] There was, however, little attempt in this period to project literary reactions to soldiers into their parallels in religious art. Bosch's jeering, sadistic soldiers in his *Crowning with Thorns*[30] and *Carrying of The Cross*[31] keep alive an old northern tradition of emotively cruel Passion scenes, but he does not discriminate between them and the civilian haters of Christ. In one of the few works in which all the soldiers, as opposed to the protagonists, are shown in contemporary costume, Jacob Cornelisz. van Oostsanen's *David and Abigail* (?1520s) (Fig. 334) they are a pleasant enough lot as they troop along to the sound of fife and drum: pikemen, halberdiers and arque-busiers, one of whom breaks off to have a pot-shot at a bird in a tree. But this is one of the Old Testament's calmer stories.

In France the notion that a soldier, other than a well-born one in a portrait or on a tomb, might be imagined as an individual had no appeal. It was rare, in those illuminations which were the chief medium for secular subjects in the second half of the fifteenth century, to separate even a group from the mass of an army or a royal

333. Pieter Breughel the Elder, *Procession to Cal-vary* (detail): *Simon of Cyrene and his Wife Prevented from Assisting Christ.* 1564. Vienna, Kunsthistorisches Museum.

257

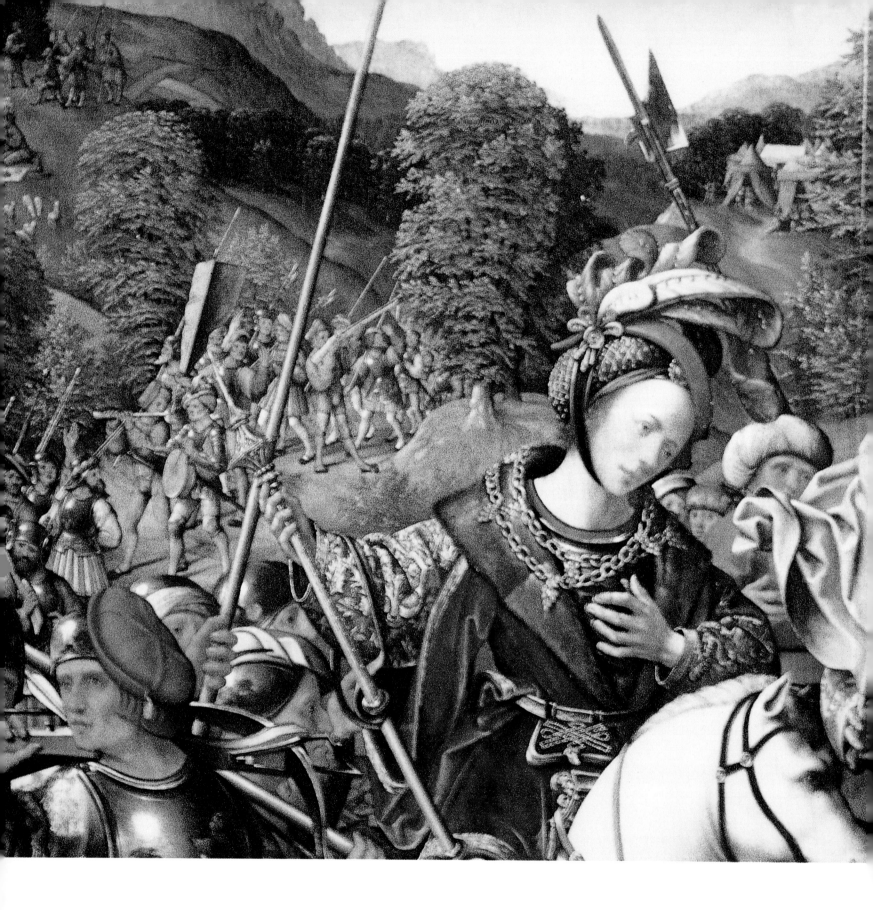

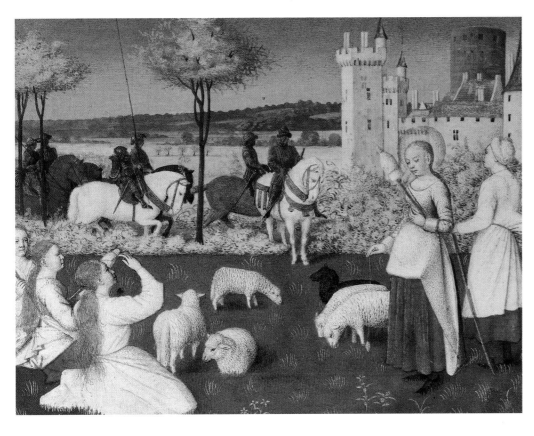

guard. Quite exceptional is the magical sheet from Jean Fouquet's *Hours of Etienne Chevalier* (between 1452 and 1456) which shows a cavalry 'lance' – the man-at-arms and his immediate support group – turning in from a country lane across a meadow towards a group of young women spinning and watching sheep (Fig. 335). It illustrates the story of *The Meeting of St Margaret and the Prefect Olybrius*,[32] but it might well have reminded its readers of the perambulations of the units of the *compagnies d'ordonnance* set up in 1445. But this vein of potential resonance was not pursued by others.

Soldiers occasionally turned up in the occupations represented on misericords,[33] but French treatments of such round-ups of various occupations as chess manuals and the Dance of Death remained severely traditional. Though illustrations of the Three Estates theme broadened to include craftsmen and merchants, they stopped short of the soldier. And before any groundswell of popular interest in infantrymen, generated by decades of military expeditions to Italy and by the establishment of a permanent infantry militia, the *legions*, in 1534, had awakened the interest of artists (who worked, in any case, for a more restricted social market than their colleagues in Germanic or Netherlandish territories), classicism had checked any impulse towards military genre. There was no transition from the convention whereby soldier = knight, as in the 1488 title illumination of the widely read compilation *La Mer des Histoires*,[34] to the design for the triumphal arch (Fig. 336) erected to welcome Henry II into Paris in 1549 where Hercules, symbol of French strength, was linked to a merchant, a cleric, a peasant, and a soldier – a Roman one.[35]

Visual interest in war remained concerned, as it had been in the past, with battles. Later fifteenth-century and early sixteenth-century France was no more chivalrous, in its determination to keep abreast of the growing importance of infantry and gunpowder weapons, than was any other western European country, but in cultural tone it was more chivalric. Deeds of war, whether of the Greeks at Troy, or of heroes of Romance or of monarchs and nobles in the Hundred Years War, main-

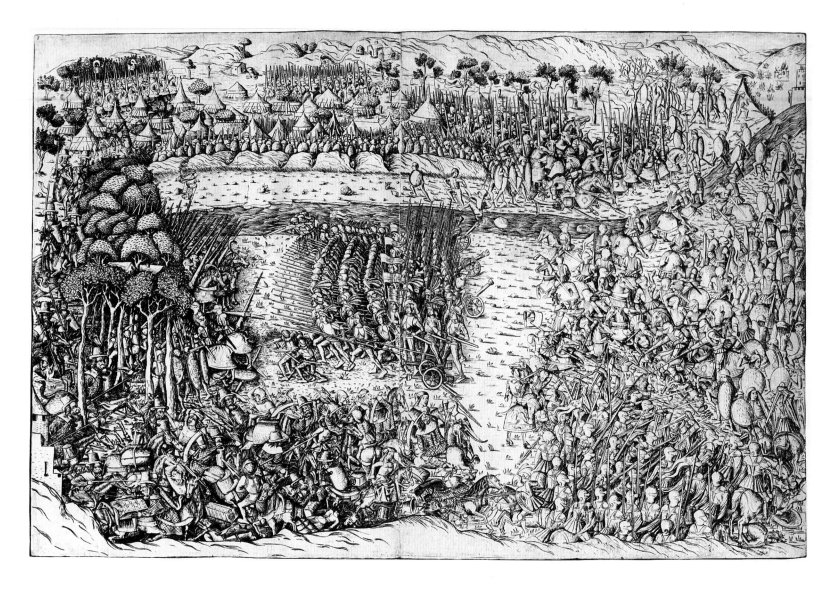

337. Anon., *The Battle of Fornovo, 1495*. Engraving, ?1495.

tained the profitability of tapestry workshops and manuscript ateliers. It was in the latter, so much freer to experiment and reveal the individual talent of illuminators, that painting won free from the humdrum ritual violence of Gothic battle scenes towards a new concentration on the sense of mass, on extensive and believable landscapes quietly suffering armed incursion or close-up skirmishes which – even if dealing with the Trojan War – had the smack of imagined real experience. But the advances made here ran out with the dwindling of aristocratic patronage for secular illuminated manuscripts. They were not carried over into illustrations in the rival medium of the printed history, romance or chronicle, which relapsed into repeating, often charmingly enough, conventions by now archaic.

Because of the public interest aroused by the regular bulletins Charles VIII sent back to France during his 1494–5 campaign in Italy and the glamour attached to a French monarch's ability, after so long an immersion in domestic problems since the end of the Hundred Years War, to go adventuring abroad, the battle of Fornovo, in which he broke free for his return to France from the Italian forces arrayed to trap him, led to the issuing, possibly even before the end of 1495, of a remarkable engraving, *The Battle of Fornovo* (Fig. 337). This was the first and (if we include its immediate offspring) last French attempt in this period to provide an authentic pictorial document of a military engagement. The print does enable the battle to

be imagined, and, to some extent, felt, as a real occasion. It draws, clumsily, on manuscript idioms for landscape, for the delineation of ranks and personal combats. Its sense of reality falters: the feeble cannons, the troops' ability in a couple of strides to cross the river Taro whose width and current played a major part in the Italian battle plan; the bland smiling faces. None the less, there are numerous details that are freshly thought out, like the raised hands of the man-at-arms whose lance has been shattered from his grasp, revealing bare palms within his gauntlets. And the breaking into the French baggage train and the slaughter by the Italian stradiots of its guard and camp-followers (including women) gives an energetic veracity to this key, and much written about at this time episode, that was unparalleled either in France or elsewhere.

In spite of the succession of campaigns that followed, which included such famous victories as Agnadello (1509) and Marignano (1515), which determined the status of France as an aggressive power in international affairs after 1495, no significant, let alone innovative representation of battle followed the first Fornovo engraving. Apart from the unimpressive *all'antica* battle reliefs on the tomb of Louis XII (commissioned by Francis I from Giovanni di Giusto, one of the Italian artists he preferred to those of native stock), the next battle scenes that attempted to convey what battle was like were the reliefs on Francis's own tomb (also in St Denis), carved in c.1552 by Pierre Bontemps[36] though not installed in the completed monument until 1558. The reliefs illustrating stages in the campaigns that led to the victories of Ceresole d'Alba (near Cuneo, in Piedmont) in 1544 and Marignano (1515) are all now in modern dress. Obviously carefully coached in what had happened at the time, and assisted, it seems likely, by being abreast of German military woodcuts (Fig. 338), Bontemps, in spite of an occasional lapse (a gunner sighting his artillery piece into the backs of his own troops) (Fig. 339), produced – especially in the Marignano series – works of the greatest beauty of execution which glorify and adorn war without paraphrasing it too far from its actuality.

In a country where the dominant ethos of the patrons who commissioned secular works was militant there was little interest in images that presented war in abstract or explanatory form. In any case, French artists, their market jostled by Italian immigrants, were caught between two stylistic and ideological strains, one classicizing, the other flowing on from the forms and values of international Gothic. Literate royal military administrators and warrior nobles in the later fifteenth century were well versed, thanks to manuscript and printed translations, in the methods and accomplishments of the 'pristine wars'. When Italian artists came to France, and Italian prints circulated there in the following decades, their reception in certain quarters was easy. Louis's tomb made the classicization of military scenes 'official'. Francis paralleled his down-to-earth military career with the *Triumph of Scipio* episodes in a tapestry series designed c.1533–4 by Giulio Romano.[37] When the

338. Pierre Bontemps (and assistants), *Captain, Fifer and Drummer*. Relief panel, Tomb of Francis I, c.1552. Paris, S. Denis.

339. Pierre Bontemps (and assistants), *Battle Scene*. Panel on Tomb of Francis I, c.1552. Paris, S. Denis.

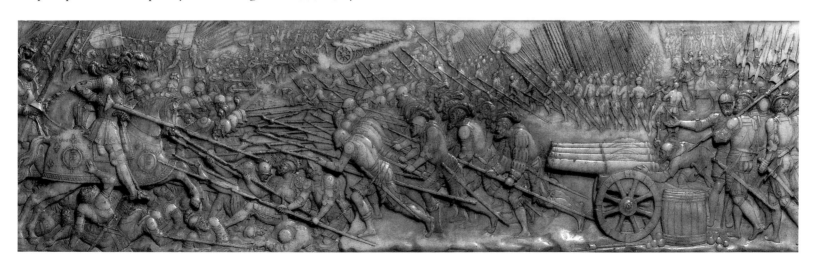

prince of Carpi, Alberto III, died in exile in France in 1531, his bronze tomb,[38] one of the finest of all Renaissance monuments in its elegance and thoughtful simplicity (Fig. 341), showed him reclining awake, in Roman costume, propped on his elbow as he reads a book. It is difficult to imagine that this, rather than being a copy of Livy, or Vegetius, or Valerius Maximus, is a work of devotion, an impression strengthened by the presence of two other volumes beside him. On the other hand, the traditional 'in his armour as he was' tomb formula, so hauntingly represented on the mourner monument to Philippe Pot (d. 1453),[39] continued to be updated. Galiot de Genouillac, who died in 1546 after a career as Francis I's Master of Artillery, was commemorated in his local church of Assier (near Cahors) not only by an up-to-date siege scene but by his portrait in relief standing proudly beside one of his cannon.[40] Between the two strains there was little room, let alone demand, for inventions of a quasi-philosophical kind. And French religious art, increasingly isolationist and at the same time loyal to indigenous precedents, contributed little to the soldier's advance from battlefield to altarpiece.

We are not to expect much that is relevant to this book, with its stress on range, quality and originality, from countries such as England and Spain, which apart from architecture and tomb adornment, were artistic backwaters relying for nourishment on imported Netherlandish and Italian talent, even though they were immersed over long periods in wars at home or abroad.

In England, despite those famous bowmen of Crécy and Agincourt, the common soldier as an individual was ignored in the arts save for the memorial window of c. 1524 in the parish church of Middleton, in Lancashire (Fig. 340), which included the sixteen archers who had accompanied Sir Richard Assheton to Flodden (1513) and had fallen there. Pious figures, scarcely distinguishable one from another, they are none the less named in inscriptions running alongside the bows they carry. So totally unusual is this anticipation of the village war memorial that at first glance they may be taken as a tribute to Sir Richard's loins rather than his tenantry. Otherwise, soldier images marched in from across the sea, as did the prettily Germanic drummer, fifer, standard bearer and arquebusier in a c. 1539 calligraphic initial from a survey of the lands belonging to Glastonbury Abbey – lands that owed military service, but not in this alien guise (Fig. 342).

Among the complaints offered in justification of the 'Evil May-day' anti-foreigner riots in London in 1517 was the falling into the hands of immigrant craftsmen,

341. Anon. (Franco-Italian), *Tomb of Alberto III of Carpi*. After 1531. Paris, Louvre.

342. Anon., *Decorative Initial with Soldiers*. Miniature, c. 1539. Oxford, Bodley Rolls 19 (27814).

340. Anon., *Memorial Window to Sir Richard Assheton*. c. 1524. Middleton parish church.

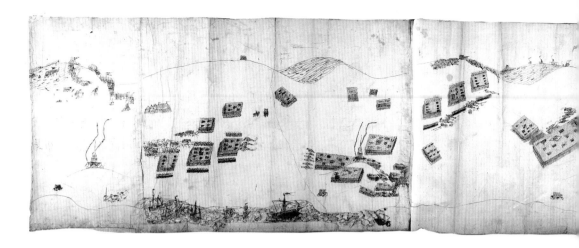

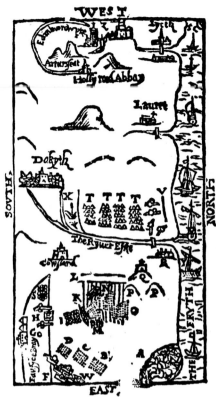

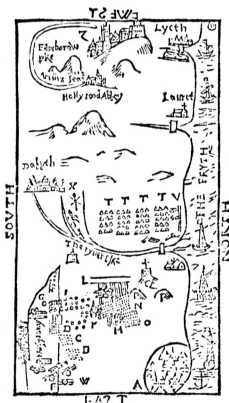

chiefly Netherlanders, of those 'painted cloths' which, as a cheap substitute for tapestries, were the dominant carriers of secular and decorative subjects into private houses. And the same preference for the artistic wares of the Low Countries appears in the inventories of paintings bought for the households of royal or courtier patrons.[41] Among them were mutedly erotic (Lucretia for instance) and genre subjects (kitchen and banquet scenes). Henry VIII was a lavish patron and an extremely self-conscious war leader, not just a connoisseur of personal arms and armours, but deliberately abreast of developments in weaponry and fortification, yet the only surviving representation of a battle was *The Battle of the Spurs* (1513)[42] produced later than the event and by a foreign artist. The most original works, unparalleled at the time elsewhere, were the woodcut diagrammatic plans of stages in the 1547 Battle of Pinkie (Fig. 343) in Sir William Patten's *The Expedicion into Scotland* (London, 1548), and the independent drawings of the same action attributed to John Ramsay (Fig. 344). These are pioneer attempts to describe the units involved in a battle, and successive snapshots of its development and conclusion, but while such an approach

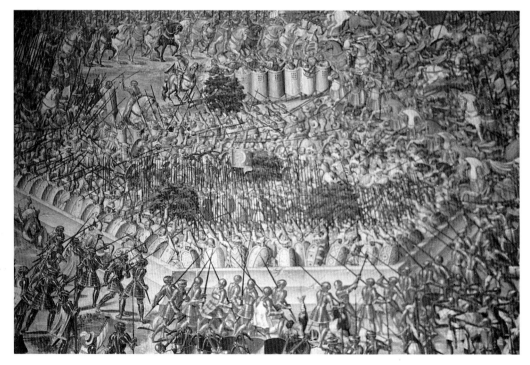

343. *Diagrams of the Battle of Pinkie, 1547.* Woodcuts, 1548.

344. John Ramsay (attrib.), *The English Cavalry Attack the Scots at the Battle of Pinkie, 1547.* Drawing, ?1548–50. Oxford, Bodleian, MS. Eng. Misc. C. 13R.

345. *Battle in 1431 against the Moors.* Fresco, late sixteenth century. Escorial, Hall of Battles.

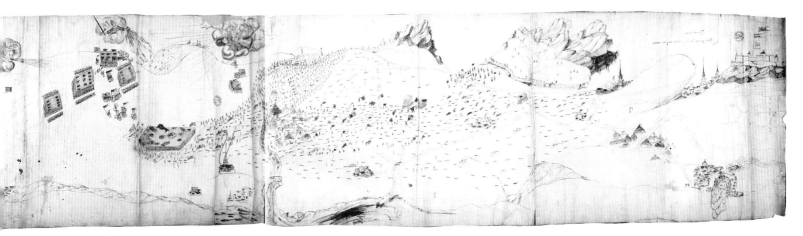

came to determine the composition of many battle paintings from the seventeenth century onwards, Patten's and Ramsay's plans belong rather to the history of the explanatory military diagram.[43]

In the Iberian peninsula a comparably thin output of prints, whether singly or as printed book illustrations, an even weaker demand for secular subject matter, and the growing dependence on immigrant artists that followed the linking of Spain with the Netherlands on the accession of Charles of Habsburg to the crowns of Castile and Aragon in 1516: all were factors that repressed the emergence of a specifically Spanish pictorial reaction to warfare. Service with armies alongside, or in opposition to, Landsknecht regiments and the availability of German prints through trade contacts and in north Italian war theatres meant, however, that their costume from *c*.1510 not only came to affect the description of soldiers in a number of altarpieces and a few of the woodcuts used by the German Coci press in Saragossa in the 1520s,[44] but influenced fashionable costume itself.[45]

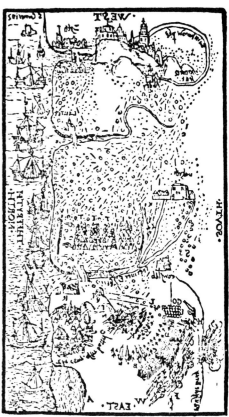

It is characteristic that the late sixteenth century frescoed *Battle in 1431 against the Moors* (Fig. 345) in the Escorial Hall of Battles – at some 175 feet long perhaps the largest of all battle scenes – was painted by a team of Italian artist-decorators as a re-phrasing of a fifteenth-century Flemish tapestry commemorating the event.[46]

In sum what this glance at other countries makes clear, within its limits, is suggestive enough. An analysis of their military organization, wars and patronage centres would not add much to an understanding of the imbalance between the images of military interest produced in them and in Switzerland, Germany and Italy. These, especially the last two, were the countries which supported the greatest number of artists of open-minded talent or original genius and it is one aspect of their astonishing outpouring of visual images that became the subject of this book.

NOTES

CHAPTER 1: Germanic Military Genre

1. Hollstein, 1954–80, vol.3, p.112.
2. Ibid., p.113.
3. Ibid., p.114. And see Martin Luther, Andersson and Talbot, 1983, pp.257–8.
4. Hollstein, 1954–80, vol.4, p.75.
5. Strauss, 1972, no.6.
6. *Illustrated Bartsch*, 1978–, vol.11, p.163.
7. Manuel, 1979, pls.122 and 124.
8. *Illustrated Bartsch*, 1978–, vol.13, p.206; van Marle, 1971, vol.1, fig.296.
9. Winzinger, 1952, p.60.
10. Mielke, 1988, pl.41. He sees the figure as Pyramus.
11. See p.67.
12. Mielke sees his work as an aspect of Altdorfer's (e.g. Ibid., p.43).
13. Benesch and Auer, 1957, pl.44.
14. Ibid., pl.43. In colour in Mielke; he gives it to Altdorfer.
15. *Gothic and Renaissance Art*, 1986, p.283.
16. Koegler, 1926, pl.XIII.
17. Zemp, 1967, fig.4.
18. Cockshaw, 1979, p.47.
19. Winzinger, 1975, figs. (Anhang) 11 and 12. The authorship is uncertain. For Kölderer I follow Baldass, 1923, fig.35. Winzinger, 1972–3 is surer than in 1963 of an attribution to Altdorfer.
20. Winzinger, 1963, figs.76–80, followed by unnumbered details.
21. Geisberg, 1974, vol.1, pp.246–50.
22. Ibid., vol.4, pp.1185–9.
23. Kok, 1985, p.228.
24. Winzinger, 1972–3, vol.2, pl.10, right.
25. Geisberg, 1974, vol.4, pp.1208–9.
26. Ibid., pp.1210–13.
27. Strauss, 1974, vol.3, p.1775.
28. Geisberg, 1974, vol.1, pp.261–7.
29. Winzinger, 1979, vol.2, no.86.
30. Geisberg, 1974, vol.4, pp.1196–7.
31. Paul Coles, *The Ottoman Impact on Europe* (London, 1968) fig.55.
32. Geisberg, 1974, vol.1, pp.261–7.
33. Kurth, 1963, nos.344–5. See below, pp.171–2.
34. Geisberg, 1974, vol.2, pp.640–9.
35. Warburg Institute, Photographic Collection.
36. Geisberg, 1974, vol.3, pp.880–6.
37. Ibid., pp.892–909.
38. Trans. H.H. Hudson (Princeton University Press, 1951) pp.30–1.
39. Andersson, 1978, pl.29. Symbols analysed Andersson, 1977.
40. Manuel, 1979, pl.170. Verses transcribed pp.475–6.
41. Scheidig, 1955, p.161.
42. Geisberg, 1974, vol.3, pp.1172–81. Standard bearer on p.1177.
43. Translation from Moxey, in Smith, 1985, pp.68–9.
44. Werner, 1980, p.105.
45. Kohlschmidt, 1935, pp.1–15.
46. Hollstein, 1954–80, vol.11, p.26.
47. Liebe, 1972, fig.53.
48. Strauss, 1975, vol.3, p.1148.
49. Hollstein, 1954–80, vol.7, p.108.
50. Bernhard, 1978, p.394.
51. Scheidig, 1955, p.72.
52. E.g. Pächt and Jenni, 1983, Tafelband, pl.101.
53. E.g. Coo, ?1939, fig.39.
54. Kok, 1985, p.223, left.
55. Mielke, 1988, pl.17.
56. Graz, Alte Museum, Joanneum.
57. Scheidig, 1985, p.256.
58. Andersson, 1978, pl.30; Parker, 1926, pl.51.
59. Rowlands, 1987, p.160.
60. As illustrated, e.g. by Schoen *c*.1530; Geisberg, 1974, vol.4, p.1194.
61. Koepplin and Falk, 1974, vol.2, fig.289.
62. Dobrzeniecki, 1977, no.48.
63. Nuremberg, Germanisches Nationalmuseum, inv. Gm.1153.
64. Vienna, Kunsthistorisches Museum, inv. 950.
65. Stuttgart, Alte Galerie.
66. Hollstein, 1954–80, vol.1, p.74.
67. Mende, 1978, fig.453.
68. Geisberg, 1974, vol.3, p.1089.
69. Strauss, 1974, vol.3, pp.1519, 1547, 1525, 1531.
70. Geisberg, 1974, vol.2, p.674.
71. Hammerstein, 1980, fig.111.
72. Kunze, 1975, vol.2, fig.186.
73. Levin, cat., 1976, fig.14L.
74. Hammerstein, 1980, figs.153 and 156.
75. Ibid., fig.276 (*pace* the description of the soldier as a 'Räuber').
76. Geisberg, 1974, vol.4, p.1528.
77. See top of this page.
78. Manuel, 1979, pp.252 ff. and pl.70.
79. Cortesi and Mandel, 1972, col. pl.50.
80. Brückner, 1975, pl.19.
81. Marina Warner, *Joan of Arc. The Image of Female Heroism* (London, 1981) fig.28.
82. Quoted in Andersson, 1978, p.30.
83. Schilling, 1943–5, vol.4, p.766.
84. Bory, 1978, fig.242.
85. See Stechow, 1966, p.40, for 'looting'.
86. E.g. Schilling, 1943–5, vol.3, p.31.
87. Winzinger, 1952, pl.39.
88. Mandach et al., ?1942, p.105.
89. Strauss, 1975, vol.3, p.1074.
90. Best repro. in Mielke, 1988, pl.26. None of the previous literature, cited on p.60, identifies the subject, it seems to me, correctly.
91. Hollstein, 1954–80, vol.6, p.201.
92. Major and Gradmann, n.d., no.22.
93. Mielke, 1988, pl.10.
94. Buchner, 1927, fig.4.
95. Beerli, 1953, pl.Xa.
96. Manuel, 1979, pl.123, lower right.
97. Panofsky, 1955, p.108.
98. Wirth, 1979, fig.71, top.
99. This was modified into an image of the transmission of Aids in frontispiece to the *Spectator* of 15 November 1986 by Nicholas Garland.
100. Manuel, 1979, pl.114 and p.339 for verses.
101. *Images of love and death*, Levin, 1975, pl.xl. (This was paraphrased in Ligozzi's 1597 *Allegory of Death* drawing in the Pierpont Morgan Library.)
102. E.g. *Deutsche Kunst*, 1971, fig.564.
103. Mielke, 1988, pl.35 as a copy after Altdorfer.
104. In Manuel, 1979, pl.95, she is dubbed a *Hexe*.
105. Andersson, 1978, pl.34.
106. Marrow and Shestack, fig.30.

CHAPTER 2: The Germanic Image of the Soldier

1. Fig.13.
2. Winkler, 1925, fig.68.
3. Deuchler, 1963.
4. Lehmann-Haupt, 1929, pp.36–7, pls.70–1.
5. *Tschachtlan Berner Chronik*, 1933, pls.73, 145, 189.
6. Schilling, 1943–5.
7. Duthaler, 1977, p.1.
8. Möller, 1976, and his bibl.
9. Musper, 1971; Schreiber, 1926–30.
10. Lehrs, 1969, fig.405, for another 'grounded horseman' image by the Master B.M.
11. Strauss, 1974, vol.1, p.37.
12. Munich, Nationalmuseum.
13. Bange, 1949, fig.3.
14. Finest whole example in Kupferstichkabinett, Kunstmuseum, Basle. Repro. of whole in P.D.A. Harvey, *The History of Topographical Maps* (London, 1980) fig.56.
15. Best collections are in the Historisches Museum, Berne, and the Landesmuseum, Zürich (see Schneider, 1970). For Funk, see Manuel, 1979, pl.154. In general, Boesch, 1955.
16. Schleuter, 1935, pl.ii, figs 5 and 6.
17. See *Gothic and Renaissance Art*, 1982, no.209.
18. See pp.171–2.
19. *Illustrated Bartsch*, vol.10, p.195.
20. Strauss, 1974, vol.2, p.627.
21. Buchner and Feuchtmayr, 1924, fig.97.
22. Geisberg, 1974, vol.2, p.596.
23. Winkler, 1942, pl.1.

24. Koch, 1941, pl.8.
25. Geisberg, 1974, vol.3, p.1054.
26. Winkler, 1942, pls.6. 20, 52, 53.
27. Winzinger, 1963, figs.109, 110.
28. Oettinger, 1959b, fig.7.
29. A drawing of a Landsknecht with his head turned to look behind him; Rowlands, 1988, fig.174.
30. Geisberg, 1974, vol.3, p.1052.
31. Winzinger, 1979, vol.2, fig.16.
32. Geisberg, 1974, vol.3, p.832.
33. A conjectural interpretation. Winzinger, 1979, vol.2, pl.220. He gives the drawing to that last resource, The Master of the Landsknechts.
34. Given to Altdorfer in Mielke, 1988, cat. no.173.
35. Both Nuremberg, Germanisches Nationalmuseum.
36. Hollstein, 1954–80, vol.11, p.180.
37. Winzinger, 1963, fig.126.
38. Mielke, 1988, fig.92.
39. Hollstein, 1954–80, vol.11, p.64.
40. Manuel, 1979; Mandach et al., c.1942; both *passim*.
41. Zschelletzschky, 1975, p.315.
42. Lieb and Stange, c.1960, pls.224 and 112.
43. Geisberg, 1974, vol.4, p.1471.
44. Dodgson, 1903.
45. It is a pity that the constant rubbing of the prominent codpiece of the right-hand figure of *Two Landsknechts* (?c.1550) in the Metropolitan Museum, New York, inv. 1982. 60. 118, 119, which has worn it to a coppery colour that contrasts with the greenish-black of the rest of the figure, cannot be dated.
46. For comment, Moxey in Smith, 1985, pp.18–19.
47. Geisberg, 1974, vol.4, pp.1332–41.
48. Geisberg, 1974, vol.4, pp.1316–28 and 1354–5.
49. Ibid., vol.3, pp.1144–64 and 1166–71.
50. Ibid., vol.1, pp.251–60.
51. See p.110.
52. Hinckeldey, 1981, p.292.
53. Bruno, 1937, p.144.
54. Miller, 1976, p.11.
55. Moxey in Smith, 1985, pp.70–1.
56. See discussion in Bleckwenn, 1974.
57. Osten and Vey, 1969, fig.5.
58. Stuttgart, Alte Galerie, inv. L.23.
59. Strauss, G., 1966, p.82.
60. Sumberg, 1941, fig.10.
61. Post, 1954–9, fig.31.
62. Rowlands, 1985, pl.1.
63. Bruno, 1937, pl.xvi.
64. Andersson, 1978, p.21.
65. Illustrated Bartsch, 1978–, vol.17, p.141.
66. Geisberg, 1974, vol.3, p.797.
67. Beerli, 1953, p.89.
68. Franz Bächtiger in Manuel, 1979, p.13.
69. In general: Husband, 1980; *Wilden Leute*, 1963.
70. Holborn, 1937, pp.44–5.
71. Both Zürich, Landesmuseum.
72. Geisberg, 1974, vol.3, p.889.
73. *Kunst der Reformationszeit*, 1983, p.186.
74. By Cranach the Younger, Geisberg, 1974, vol.2, p.623.
75. Maximilian I, 1969, fig. 51.
76. Geisberg, 1974, vol.2, p.587.
77. Maximilian I, 1969, pl.vi.
78. Oettinger, 1959b, pp.90–3, 95.
79. Kok, 1985, fig.53.1.
80. Schilling and Schwartzweller, 1973, vol.2, fig.73.
81. Ibid., fig.171.
82. Werner, 1980, pp.94–5.
83. Geisberg, 1974, vol.3, p.775. On its meaning, see Andersson and Talbot, 1983, p.294.
84. Geisberg, 1974, vol.2, pp.436–7.
85. Panofsky, 1955, pp.151 ff. and fig.207.

CHAPTER 3: Italy: Soldiers and Soldiering

1. David Landau in Martineau and Hope, 1983, pp.330–1.
2. Ibid., pl.463.
3. Essling, 1907–14, pt.1, vol.2(i), pl.83.
4. Müntz, 1894, facing, p.298.
5. Shoemaker, 1981, fig.3.
6. *Illustrated Bartsch*, 1978–, vol.27, p.132.
7. Liechtenstein, 1985, no.130.
8. Inv. 6881.
9. E.g. Oberhuber, 1973, no.76. and Panazza, 1965, pl.214, for Romanino's *Soldier seen from behind* and *Standard Bearer*.
10. Berenson, 1955, fig.30.
11. Pallucchini and Rossi, 1983, figs.79, 79a.
12. Berti, 1973, pl.lviii.
13. Gibbons, 1968, fig.20.
14. Shapley, 1979, vol.2, pl.330.
15. Omodeo, 1965, figs.41, 42.
16. Partsch, 1981, fig.103.
17. Saggese in Sesti, 1985, vol.1, fig.8 (p.61).
18. Sercambi, 1978, vol.2, figs.432, 54, 332, 300, 500.
19. Filangieri, 1956.
20. Degenhart and Schmitt, 1982, pt.2, vol.4, p.77.
21. Carli, 1950, pl.xxxvi.
22. Ricci, 1928 and Pächt, 1951.
23. Mallett, 1974, fig.10.
24. Woods-Marsden, 1985, 405–9.
25. Schubring, 1923, vol.1, no.140.
26. Essling, 1097–14; Sander, 1969.
27. Essling, 1907–14, pt.2, vol.1, pp.132–3.
28. Respectively in the Pitti and the Metropolitan Museum, New York.
29. Cappi Bentivegna, F., 1962, passim.
30. Hind, 1970, pl.119.
31. British Museum, inv. 1899, 6–15, 1.
32. Garzelli, 1977, e.g. col. pl. xiii, figs. 67, 104.
33. Valcanover, 1981, under Sala 21.
34. Ed. Paolo Fossati, Turin, 1967.
35. Borgia, 1984, pl.79.
36. Ch. 6.
37. Mellini, 1965, p.46, top right.
38. See p.149.
39. D'Ancona, 1954, p.56.
40. Berenson, 1955, fig.146.
41. For a fuller version of what follows see Hale, 1988c.
42. Hendy and Goldscheider, 1945, pl.67.
43. Varese, 1967, pls.43, 44.
44. Pignatti, 1972, pl.32.
45. Zampetti, 1978, pl.ii.
46. Ibid., pl.xxv.
47. Museum of Fine Arts, inv.939.
48. Gombosi, 1937, p.30, bottom.
49. Semenzato, 1984, pls.135, 139, 142, 132, 143.
50. Pallucchini, 1969, vol.2, pl.81.
51. Zampetti, 1978, pl.L.
52. Giorgione, Atti, 1979, fig.109.
53. Gibbons, 1968, fig.26.
54. Giorgione, Atti, 1979, fig.131.
55. Zampetti, 1955, pl.62.
56. Veca, 1981, p.116.
57. Pallucchini and Rossi, 1983, figs.97, 98.
58. De Grummond, 1972, fig.15. Date suggested by Philip Rylands in a letter for which, and his lending me the manuscript of his doctoral thesis on Palma Vecchio, I am most grateful.
59. Zampetti, 1978, pl.xxxviii.
60. Settis, 1978. For references to later, soldier-based interpretations, see J.R. Hale, 'Michiel . . .', 1988.
61. Pignatti, 1972, p.163.
62. Berenson, 1963, *Venetian School*, vol.2, fig.673.

CHAPTER 4. North and South: Contrasts I

1. Coates, W.A., 'German pidgin-Italian', *Papers of the 4th Annual Kansas Linguistics Conference*, 1969. pp. (typescript) 66–74. I owe this reference to Peter Burke.
2. *The Courtier* trans. George Bull (Harmondsworth, 1967) p.90.
3. *Ritratto delle cose della Magna*, in *Arte della Guerra*, ed. S. Bertelli (Milan, 1961), p.211.
4. Andersson, 1977, P.13.
5. See p.45.
6. See Andersson, 1977, pp.30–42.
7. Rowlands, 1988, p.215.
8. *Prints and Drawings of the Danube School*, 1969, p.106.
9. Ibid., p.108.
10. Pianzola, 1962, p.12 suggests actual service as a soldier.
11. Christensen, 1973, p.214.
12. Pope-Hennessy, 1958, p.83.
13. Paccagnini, 1972, p.60.
14. Muraro, 1961, vol.1, p.356.
15. On artists and fortifications, see Hale, 1977.
16. *Autobiography*, trans, George Bull (Harmondsworth, 1956), p.33.
17. Pope-Hennessy, 1985, p.33.
18. Leitner, 1880–2.
19. Rasmo, 1980, pp.126 ff., figs.102, 121, 167.
20. See p.52.
21. Heffels, 1981, fig.58.
22. Appelbaum, n.d., p.18.
23. Ibid., p.19.
24. Baldass, 1923, pl.118.
25. See also Unterkircher, 1983, pls,16, 18.
26. E.g. Baldass, 1923, pl.75
27. Tyrol *Zeugbuch*, on deposit, Vienna Waffensammlung, ff.lllv–ll2r
28. Böheim, 1892–4, pt.1, p.95.
29. Musper, 1976.
30. Liechtenstein Codex G. Inv. 57.40. For 1775 examples see *Illustrated Bartsch*, 1978– vol.11, pp.115, 149, 163.
31. Appelbaum, n.d. gives illustrations on reduced scale.
32. E.g. ibid., pls.100, 102.
33. Dodgson, 1963, pp.33–4.
34. *Theuerdank*, with its 118 woodcuts by Schäufelein, Beck, Burgkmair, Traut(?) and Erhard Schoen (?), does not illustrate campaigns.
35. Hind, 1970, pl.8.
36. See pp.157–81.
37. *Opere*, 1878–85, vol.5, pp.407–8.
38. Hind, 1970, pl.46.
39. Levin, 1975, figs.53A, 53B.
40. Winzinger, 1963, fiG.155.
41. *Illustrated Bartsch*, 1978– vol.27, p.334.
42. Borea, 1979, p.343.
43. Martineau and Hope, 1983, fig.1.
44. Ibid. (referred to as *The Triumph of Christ*) pp.318–19.
45. Barocchi, 1964a, fig.63.
46. *Opere*, 1880, vol.5, p.429.

CHAPTER 5. North and South: Contrasts II

1. Hinckeldey, 1981, p.69.
2. Goldschmidt, 1944–6, pls.1–3, 6–7, 12–15. I owe this reference to Sir Ernst Gombrich. See also Müller, 1981.
3. *Illustrated Bartsch*, 1978– vol.86, pp.123–41.

4. Raupp, 1986, p.61.
5. Pierpoint Morgan Library, New York.
6. Prevenier and Blockmans, 1985, fig.29.
7. Winkler, 1941.
8. Ameisenowa, 1958, col. pl.vii.
9. Treue et al., 1965.
10. Ritkin, 1973. For illustrations in Latin ed., see Hirth, 1972, figs.1271–82.
11. Pianzola, 1962, pp.16–17.
12. Raupp, 1986, p.172.
13. Ibid., p.176.
14. Ibid., pp.41–9; Moxey, 1982; Coo, ?1939, figs.44–52.
15. Pianzola, 1962, p.7.
16. Moxey, 1982, p.111.
17. Strauss, G., 1959.
18. Moxey, 1982. *The Ship of Fools*, trans. Edwin H. Zeydel (Columbia University Press, 1944).
19. Winkler, 1942, pl.9.
20. Alpers, 1983, pp.116, 118, pl.60.
21. Jakrzewska-Śniezko, 1972, figs.57–9. I am grateful to Dr Gabriela Majewska for obtaining new detailed photographs for me from the negative.
22. Barth, 1987, p.37.
23. Kunzle, 1973, 201.
24. Guerry, 1950, pp.58–66.
25. Referred to by Corvisier, 1969, p.512.
26. Ibid., pp.509–13, 518–19; Rasmo, 1980, pp.107, 199.
27. Above, p. 31.
28. Guerry, 1950, fig.16.
29. Hind, 1970, pls.321–3.
30. Hind, 1963, vol.2, fig.239.
31. Kristeller, 1897, fig.114.
32. Ibid., fig.68.
33. Berenson, 1957, *Venetian School*, vol.1, fig.83.
34. Berenson, 1968, *Central and North Italian Schools*, vol.3, fig.1227.
35. Berenson, 1957, *Venetian School*, vol.1, fig.375.
36. Whalley, 1982.
37. Bergamini in Furlan, 1985, p.202, figs.27.8, 27.6.
38. Garbrielli, 1959. The authorship is discussed in Ch.2.
39. Ibid., p.210
40. Griseri, c.1974, pl.v.
41. Griseri, c.1974, pl.xii.
42. Berenson, 1968, *Central and North Italian Schools*, vol.3, fig.1135.
43. Hind, 1970, pl.746b.
44. Levenson et al., 1973, no.87, pp.232–3.
45. Victoria and Albert Museum, London.
46. Pope-Hennessy, 1968, pls.115–16.
47. Sander, 1942, vol.6, no.588.
48. Husa, 1967, figs.141–2, 147–8, 152–3, 154–6.
49. See Starn, 1987, esp. pp.17–18 and 23–5.
50. Brandi, 1983, pl.xxxvi, and fig.84.
51. Partsch, 1981, figs.175–86, pls.v. and viii.
52. Boccaccio, 1966, vol.3, p.739.
53. Toesca, 1966; *Hausbuch der Cerruti*, 1979.
54. Kindly explained to me by Prof. Vittore Branca in anticipation of his work on the subject.
55. Berenson, 1968, *Central and North Italian Schools*, vol.2, fig.509.
56. Ibid., vol.3, fig.1136.
57. Von Holst, 1974, fig.24.
58. See pp.246–7.
59. Carli, 1981, pp.102–3.
60. Berenson, 1955, pl.176.
61. Sander, 1942, vol.5, no.227.
62. Essling, 1907–4, pt.2, vol.1, p.178.
63. Sander, 1942, vol.5, no.139.
64. See p. 92.
65. Chastel, 1983, pp.112–13.

66. Panofsky, 1955, p.11.
67. Quoted in Gombrich, 1976, p.112.
68. Osten and Vey, 1969, fig. 32.
69. Hetzer, 1929, fig.34.
70. Kassel, Gemälde Galerie.
71. Dolce, 1970, p.77.
72. Vasari, 1875–85, vol.5, pp.402–3.
73. Klein and Zerner, 1966, pp.34–5.
74. Baxandall, 1971, p.11; my translation.
75. *De pictura*, trans. Grayson, 1972, p.85.
76. Klein and Zerner, 1966, p.34.
77. *De pictura*, trans. Grayson, 1972, p.77.
78. I owe this quotation to John Onians.
79. *De pictura*, tr. Grayson, 1972, p.75.
80. Knab et al., 1983, fig.504.
81. E.g. *Giorgio Vasari*, 1981, figs. 156–7; Barocchi, 1964, fig.65.
82. Cox-Rearick, 1984, fig.189.
83. Gaudioso, 1981, vol.1, fig.118, pl.12.
84. Marle, 1923–36, vol.7, figs.268–9.
85. Hind, 1970, pl.465.
86. Hartt, 1958, pp.151–2, figs.322–6.
87. Venice, Cà d'Oro.
88. Chastel, 1965, figs.133.
89. Hind, 1970, pl.467.
90. Giorgione, 1979, figs.166, 164–5.
91. Dumont, 1973, figs.65, 34.
92. Schmidt, n.d., pl.59.
93. Kadatz, 1983, pp.296, 142.
94. Pallucchini and Rossi, 1983, p.128.
95. See pp.246–50.
96. Mâle, 1917, esp. pp.5, 47, 205.
97. Winkler, 1921, pp.9–10.
98. Wölfflin, 1958, pp.16, 18, 56, 118, 144, 181, 183–4, 225
99. Longhi, 1941, p.3.
100. Ivins, 1969, p.61.
101. Washburn, 1959–68 vol.6, column 87.
102. Brand, 1965, p.57.
103. Alpers, 1983, p.44.
104. Leigh Fermor, 1979, p.98. See also pp.144–51.
105. Cologne, Wallraf-Richartz Museum, inv. WRM 179.
106. Graz, Alte Galerie.
107. Frankfurt, Historisches Museum.
108. Smith, 1983, pp. 24–5.
109. Munich, Bayerisches Nationalmuseum, inv. 79/335.
110. Museum für Kunst and Gewerbe. Master I.P.
111. Lehner, 1971, fig.24.
112. Levenson, et al., 1973, pl.711 top.
113. Hollstein, 1954–80, vol.3, p.93 top.
114. Battisti, 1981, pp.14–15.
115. Panofsky, 1955, figs. 194–5.
116. Bernhard, 1978, p.283.
117. Phillips, 1984, p.65.
118. Steinberg, 1975–6.

CHAPTER 6. The Representation of Battle: Italy
1. Machiavelli, 1961, pp.409–10.
2. See pp.196–9.
3. *The Whole Familiar Colloquies*, trans. N. Bailey (Glasgow, 1877) p.39.
4. Snow-Smith, 1979, pp.210 ff.
5. *The Letters of Charles Dickens*, ed. K. Tillotson (Oxford, 1977) vol. 4, p.221.
6. Saxl, 1939–40,
7. See note 69.
8. Barocchi, 1964, p.52.
9. See pp.175–6.
10. Wittkower, 1978, pp.189–90.
11. Chastel, 1983, *passim*.

12. Vasari notes, however, that some of Piero della Francesca's 'panel pictures with little figures' for Federico da Montefeltro, 'have . . . come to grief on one another of the many occasions when that state [Urbino] has been ravaged by war'. (Vasari, 1965, p.192).
13. *Illustrated Bartsch*, 1978–, vol.27, p.103.
14. Ibid., vol.25, p.241.
15. Rosand and Muraro, 1976, p.34.
16. Vasari, 1875–85 vol.8, pp.123–9.
17. Carli [1950], pl.XLVI.
18. Prague, National Gallery of European Art.
19. Hope, 1980, fig.35.
20. Semenzato, 1984, pl.139.
21. John Shearman, 'The Vatican Stanze: functions and decoration', *Proceedings of the British Academy* 57, 1971.
22. Berenson, 1963, *Florentine School*, vol.2, fig.1723.
23. Epilogue.
24. See pp.250–1.
25. Chambers, 1970, p.82.
26. Nicodemi, 1945, figs.2, 16, 46, 48.
27. Brandenburg et al., 1975, pp.35–7.
28. Quoted in Chastel, 1983, p.126.
29. *Galateo*, trans. R.S. Pine-Coffin (Harmondsworth, 1958), p.48.
30. Barocchi, 1971, vol.1, pp.138–40.
31. Morassi, 1931; Fumagalli, 1894.
32. Pinelli, and Rossi, 1971.
33. Above, p.144.
34. Papini, 1915, p.115.
35. Shaw, 1983, pl.226.
36. Castelnuovo, 1985, fig. on p.174.
37. Quoted in Mellini, 1965, p.26. Camposanto, 1960, figs.75–6,
38. Brandi, 1983, fig.104.
39. Ibid., figs.91–5.
40. Ibid., fig.313.
41. Borgia et al., 1984, pl.80.
42. Schulz, J., 1978, fig.25.
43. Schubring, 1923, *Tafelband* no.103.
44. Pope-Hennessy and Christiansen, 1980, pp.20–23.
45. Ibid., pp.18–19.
46. Schubring, 1923, *Tafelband*, no.105.
47. Ibid., no.109.
48. Frankfurt, Städelsches Kunstinstitut. *Kleine Werk-monographie* 27, 1982.
49. Schubring, 1923, no.126.
50. See generally, and for refs., Starn and Partridge, 1984.
51. 1950, p.22.
52. Generally, and for refs., see Woods-Marsden, 1988.
53. Paccagnini, 1972, p.51.
54. 1965, p.195, pl.77.
55. *Loan Exhibition*, 1915, no.60.
56. Ettlinger, 1978, figs.79–82.
57. Popham and Wilde, 1949, fig.12.
58. E.g. Baxandall, 1971, fig.2.
59. Popham and Wilde, 1949, fig.6.
60. Antal, 1947, fig.156.
61. Schubring, 1923, *Tafelband*, no.130.
62. Armstrong, 1981, fig.28.
63. Pope-Hennessy, 1958, fig.139 and pls.92–3.
64. Hind, 1970, pl.870.
65. See Otto J. Brendel, 'A kneeling Persian: migrations of a motif', in *Essays in the History of Art Presented to Rudolph Wittkower*, ed. D. Fraser et al. (London, 1967) pp.62–70.
66. *Antiquity*, 1979, no.46.
67. Generally, and for refs., see Kemp, 1981, p.213ff.
68. For refs, see van Einem, 1976, pp.30–4; Gould, 1966.
69. The 'brief' is in Richter, 1939, vol.1, pp.349ff. The

'Battle for the Standard' group may have been influenced by the account of Anghiari in Neri di Gino Capponi, *I Commentari, Rerum Italicarum Scriptores*, ed. L. Muratori, vol.18, Milan, 1731.

70. I am very grateful to Dr P.E.A. Joannides for letting me read his 'Leonardo da Vinci, Peter-Paul Rubens, Pierre-Nolasque Bergeret and the "Fight for the Standard"' in advance of its publication in *Accademia Leonardo da Vinci*.
71. Information from Professor Nicolai Rubinstein.
72. Everyman edn. (London, 1934) p.219.
73. MacCurdy, 1938, vol.2, p.251.
74. Bober and Rubinstein, 1986, fig.27,
75. See p.166.
76. Gould, 1975, p.140 and fig.73.
77. *Lettere storiche*, ed. B. Bressan (Florence, 1857) p.191.
78. Quoted in Peter Burke, *The Renaissance Sense of the Past* (London, 1969) p.113.
79. Vasari, 1965, p.267.
80. Berenson, 1963, *Florentine School*, vol.2, fig.1211.
81. Barocchi, 1971, vol.1, p.345.
82. Hartt, 1958, p.48.
83. Ibid., figs. 58–67. And see Gombrich, 1963, pp.33–7.
84. Quoted in Gombrich, 1963, p.34.

CHAPTER 7 The Representation of Battle: Germany and Switzerland

1. *Etliche Unterricht, zu Befestigung der Stett, Schloss und Flecken*, Nuremberg, 1527, f. A ii r.
2. 1958, pp.176–9.
3. *Gothic and Renaissance Art*, 1986, no.44.
4. *Maximilian I*, 1969, fig.41.
5. *Illustrated Bartsch*, 1978–, vol.81, pp.272–8.
6. Kunze, 1975, vol.2, figs.157, 173.
7. Geisberg, 1974, vol.1, p.268.
8. Ibid., vol.3, p.865.
9. Manuel, 1979, pl.28.
10. Knappe, 1964, pp.383–4.
11. Strauss, 1974, vol.4, p.2361.
12. Raupp, 1986, p.39.
13. Bayerische Staatsgemäldesammlungen.
14. Buchner, 1924, fig.148. Where the group in the left foreground to be elucidated, however, a historical reference point might emerge.
15. Geisberg, 1974, vol.4, p.1343.
16. Ibid., p.1342.
17. Manuel, 1979, pl.75.
18. See pp.23–4.
19. See pp.192–9.
20. Escher, 1917, pp.31, 38–9.
21. See pp.50–2 and 49.
22. Nuremberg, Germanisches Nationalmuseum, inv. Gm. 579.
23. Zygulski, 1979, figs. *passim*.
24. Ibid., p.111.
25. Baldass, 1923, pl.40.
26. See p.103.
27. *Deutsche Kunst*, 1971, fig.99.
28. *Illustrated Bartsch*, vol. xi, p.150, fig.80(224)–189.
29. See pp.12–13.
30. Winzinger, 1972–3, fig.64.
31. Martineau and Hope, 1983, pp.50–1.
32. Pianzola, 1962, pp.94–9.
33. *Royal Armouries Official Guide*, ed. Peter Hammond, pp.26–7.
34. Macgregor, 1983, p.cxxxiv. Cat. entry pp.318–27 by Gerald Taylor.
35. Kunsthistorischesmuseum, inv. 5660.
36. Inv. K.2126.

37. See pp.250–1.
38. Geisberg, 1974, vol.3, pp.1042–3.
39. Winzinger, 1979, fig.327.
40. John Hay Library, Providence, Rhode Island, Anne S.K. Brown Collection.
41. See Hartig, 1933.
42. Winzinger, 1975, p.40.
43. All illus. in Goldberg, 1983. See also *Altdorfer et le réalisme*, 1984, pp.245 ff.
44. Kupferstichkabinett, typed inv. 276, 1–7.

CHAPTER 8. War and Values: the Visual Vocabulary

1. Martindale, 1979, fig.141.
2. *Triomphe du Maniérisme*, 1955, pl.23.
3. Warburg Institute, Photographic Collection.
4. Florence, Pitti. Jacob Burckhardt, *Recollections of Rubens* (London, n.d.). p.113.
5. Cellini, *Autobiography*, trans. G. Bull (Harmondsworth, 1956) p.271.
6. Trans. Grayson, 1972, p.35.
7. Friedländer, 1968–74, vol.3, pl.116.
8. Chastel, 1965, fig.28.
9. New York, Metropolitan Museum, inv. 14.40.676.
10. Scheidig, 1955, pp.66, 141.
11. Ibid., pp.192–3.
12. *Illustrated Bartsch*, 1978–, vol.17, p.199.
13. Stechow, 1966, p.72.
14. Geisberg, 1974, vol.2, p.457.
15. Wirth, 1979, fig.78.
16. Koepplin and Falk, 1974, vol.2, fig.304.
17. Marle, 1971, vol.2, fig.33.
18. Lehner, 1971, fig.31.
19. Plumb, 1961, pp.202–3.
20. Levenson et al., 1973, p.484.
21. *Arte Lombarda*, 1958, pl.clxxx.
22. Levenson et al., 1973, pl.711 bottom.
23. Warburg Institute, Photographic Collection.
24. See Per-Olof Westlund, *Stockholm Cathedral Guide* (Stockholm, 1970).
25. Oxford, Ashmolean Museum.
26. Quoted in Burke, 1969, p.115.
27. See pp.39–41.
28. Warburg Institute, Photographic Collection.
29. Geisberg, 1974, vol.3, p.948.
30. Providence, Rhode Island, John Hay Library, Anne S.K. Brown Collection, vol. 'Soldiers and Landsknechte 15th and 16th centuries'.
31. Bacci, 1976, pls.xxviii–xix.
32. National Gallery Catalogues, *Earlier Italian Schools*, vol.1 (London, 1953), pl.69.
33. Martineau and Hope, 1983, p.364.
34. Hartt, 1958, vol.2, fig.259.
35. *Illustrated Bartsch*, 1978–, vol.29, p.28.
36. Hind, 1970, pl.347.
37. Gombrich, 1972, fig.52.
38. *Illustrated Bartsch*, 1978–, vol.29, p.99, right.
39. *The Age of Renaissance*, ed. Denys Hay, London (1967). p.178, fig.37.
40. London, Victoria and Albert Museum.
41. See p.144.
42. Hartt, 1958, fig.514.
43. Monbeig-Goguel, 1972, fig.210.
44. Cappella Pellegrini.
45. *Deutsche Kunst*, 1971, fig.19.
46. Ravenna, Galleria dell' Accademia.
47. Davis, 1970, fig.19.
48. Martineau and Hope, 1983, p.55.
49. Hope, 1980, pl.29.
50. See p.144.
51. Freedberg, 1972, vol.2, fig.455.
52. Berenson, 1968, *Central and North Italian Schools*,

vol.3, pl.1801.
53. Pope-Hennessy, 1950, pl.10.
54. Horster, 1980, pls.113, 117.
55. Pope-Hennessy, 1958, fig.89, pls.84–5.
56. Schulz, A.M., 1987.
57. *Essays* (London, 1902) pp.82–3.
58. Pope-Hennessy, 1958, fig.113, pl.107.
59. Martindale, 1979, *passim*.
60. Pope-Hennessy and Christiansen, 1980, p.11.
61. Rosand and Muraro, 1976.
62. Landucci, 1927, p.274.
63. Geisberg, 1974, vol.2, pp.702–11.
64. Ibid., vol.3, pp.1031–9.
65. E.g. Alexander, 1985, pl.13.
66. E.g. Hind, 1970, pl.555.
67. On the uncertain meaning of Dürer's *The Landscape with the Cannon* etching, see Bechtold 1928 and Bialostocki, 1976.

CHAPTER 9. Soldiers in Religious Art

1. Winzinger, 1979, vol.2 no.167. On authorship, vol.1, pp.137–8.
2. Cortesi and Mandel, 1972, pl.32.
3. Salvini and Traverso, 1980, pp. 236–7.
4. Gmelin, 1974, p.563.
5. Berenson, 1968, *Central and Northern Schools*, vol.2, fig.503.
6. Ibid., fig.774.
7. Berenson, 1955, fig. 248.
8. E.g. Soltész, 1967, pl.26. In two woodcuts of 1547, Augustin Hirschvogel paired Longinus piercing Christ's side with the extraction of Eve from Adam's; *Illustrated Bartsch*, 1978–, vol.18, pp.176–7.
9. Degenhart and Schmitt, 1984, fol.18.
10. Egg, 1972, pl.67.
11. Berlin, Dahlem, inv. 1112C.
12. Munich, Alte Pinakothek.
13. E.g. Innsbruck, Ferdinandaeum, inv. T44.
14. Peintner, 1984, p.73.
15. See p.27.
16. Museo di S. Marco, Florence, and Capodimonte, Naples.
17. Jones and Penny, 1983, p.85
18. Berenson, 1968, *Central and Northern Schools*, vol.3, fig.1674.
19. Basle, Kunstmuseum, inv. 1412.
20. Aston, 1968, pp.200–1.
21. Shestack, 1967, no.187.
22. Worringer, 1923, p.16.
23. Manuel 1979, p.109.
24. Berenson, 1963, *Florentine School*, vol.2, fig.668.
25. Ibid., 1968, *Central and Northern Schools*, vol.2, fig.728.
26. See p.75.
27. Stechow, 1966, p.77.
28. See Mann, 1932, pp.262–6.
29. Stechow, 1966, p.100.
30. Lauts, 1962, figs.179–80.
31. *Kunst der Reformationszeit*, 1983, p.123.
32. Falk, 1968, pl.14.
33. Goldberg et al., 1967, fig.19.
34. *Illustrated Bartsch*, 1978–, vol.17, p.91.
35. Winkler, 1942, fig.22.
36. Barth, 1987, p.22.
37. Friedländer and Rosenberg, 1978, fig.73.
38. Ibid., pl.11.
39. Munich, Alte Pinakothek.
40. Benesch and Auer, 1957, fig.72.
41. Manuel, 1969, pl.39.
42. Benesch and Auer, 1957, fig.60.
43. Halm, 1958, fig.29.

44. Winzinger, 1952, fig.26.
45. Winzinger, 1979, vol.2, fig.199. A somewhat mechanical mid-sixteenth-century copy, possibly via an intermediary one; ibid., vol.1., p.148.
46. Valcanover, 1981, p.42.
47. Venice, Accademia. See pp.82–3.
48. *Zenale*, 1982, p.143.
49. Berenson, 1968, *Central and Northern Schools*, vol.3, fig.1437.
50. Ibid., 1963, *Florentine School*, vol.2, fig.1282.
51. Gibbons, 1968, fig.16.
52. Giorgione, 1981, p.90, fig.3.
53. Pallucchini and Rossi, 1983, pl.xlii.
54. See p.84.
55. Mellini, 1965, esp. figs.73–4, 76.
56. Ekserdjian, 1988, p.55.
57. Ferrari, 1961, pl.34.

EPILOGUE. Beyond the Italian and Germanic Worlds

1. *Lucas*, 1978, fig.140.
2. Ekserdjian, 1988, p.83.
3. Campbell, 1985, p. xxxv.
4. Jacobowitz and Stepanek, 1983, pp.264–5.
5. Burrell Collection, inv. 45/446.

6. Prevenier and Blockmans, 1985, figs.45–6.
7. E.g. Friedländer, 1968–74, vol.8, pl.64.
8. Prevenier and Blockmans, 1985, fig.92.
9. Moxey, 1977.
10. Tolnay, 1966, p.117.
11. Naples, Capodimonte, inv. 390–6.
12. Houday, 1873.
13. Prevenier and Blockmans, 1985, fig.110.
14. Ed. G.W. Coopland (Liverpool University Press, 1949) p.79.
15. I owe this reference, and the translation, to Christine Armstrong.
16. Grossmann, 1973, pls.36–7.
17. Delen, 1969, pt.2, pl.1, no.3.
18. Kloek et al., 1986, pp.49–51.
19. Braunschweig, Anton Ulrich Museum.
20. Hollstein, 1949–84, vol.12, p.259.
21. Friedländer, 1968–74, vol.9, pt.2, pl.217, top.
22. Grosshans, 1980, fig.35. Friedländer, 1968–74, vol.10, pl.13.
23. Quoted in Jacobowitz and Stepanek, 1983, p.161.
24. *Old Master . . . Albertina*, 1985, no.22.
25. Friedländer, 1956, fig.81.
26. Ibid., fig.237.
27. Both Vienna, Kunsthistorischemuseum. For St

Catherine, see Friedländer, 1968–74, vol.9, pt.2, fig.250.
28. Esztergom, Christian Museum.
29. Friedländer, 1968–74, vol.11, fig.4.
30. Tolnay, 1966, p.308.
31. Ibid., p.310.
32. Sterling and Schaefer, 1972, pl.43.
33. Bridaham, 1969, e.g. figs.510, 524, 568.
34. Martin, 1931, pl.xviii.
35. See Niccoli, fig. 2.
36. Brandenburg et al., 1975, fig.25; Bory, 1978, figs. 227, 229.
37. Hartt, 1958, vol.2, fig. 474–83.
38. Paris, Louvre.
39. Paris, Louvre.
40. Vaux de Foletier, 1925, pls.iv and xii.
41. See Campbell, 1985, pp.xv ff.
42. Millar, 1963, vol.2, pl.9 and vol.1 (text) p.54, where an Italian authorship is also entertained, and a date of post-1553 implied.
43. Hale, 1988b.
44. E.g. Lyell, 1926, fig.101.
45. Bernis, 1962, fig.7–10, 44, 49.
46. Based on information and photographs kindly supplied to me by Dr. Alan Borg.

BIBLIOGRAPHY

Age of Breughel, The, cat., Washington, National Gallery, 1986.

Alberti, Leon Battista, *On Painting and on Sculpture*, trans. Cecil Grayson, London, 1972.

Albertina, *Old Master Drawings from the Albertina*, New York, Morgan Library, 1985.

Aldegrever, Heinrich: Die Kleinmeister und das Kunsthandwerk der Renaissance, cat., Stadtkirche, Unna, 1986.

Alexander, Jonathan, *Italian Renaissance Illuminations*, New York, 1977.

—— 'Italian illuminated manuscripts', in Sesti (1985).

Alpers, Svetlana, *The Art of Describing. Dutch Art in the Seventeenth Century*, University of Chicago Press, 1983.

Altdeutsche Gemälde, cat., Augsburg, Stadtsgalerie, 1967.

Altdorfer et le réalisme fantastique dans l'art allemand, cat., Centre Culturel du Marais, 1984.

Ameisenowa, Zofia, *Rekopisyi pierwodruki illuminowane Biblioteki Jagiellońskiej*, Wroclaw-Krakow, 1958.

Amman, Jost, *293 Renaissance Woodcuts for Artists and Illustrators: Jost Amman's Kunstbüchlein*, Intro. Alfred Werner, New York, 1968.

Andersen, Flemming et al. (eds), *Medieval Iconography and Narrative. A Symposium*, Odense, 1980.

Andersson, Christiane, *Popuar Lore and Imagery in the Drawings of Urs Graf*, D.Phil. thesis, Stanford University, 1977.

—— *Dirnen, Krieger, Narren. Ausgewählte Zeichnungen von Urs Graf*, Basle, 1978.

—— and Talbot, Charles, *From a Mighty Fortress. Prints, Drawings and Books in the Age of Luther 1483–1564*, cat., Detroit Institute of Arts, 1983.

Antal, Frederich, *Florentine Painting and its Social Background*, London, 1947.

Antiquity in the Renaissance, cat., Smith College Museum of Art, 1979.

Appelbaum, Stanley (ed.), *The Triumph of Maximilian I. 137 Woodcuts by Hans Burgkmair and Others*, New York, n.d.

Armstrong, Lilian, *Renaissance Miniature Painters and Classical Imagery. The Master of the Putti and his Venetian Workshop*, London, 1981.

Arrigoni, P. and Bertarelli, A., *Le stampe storiche conservate nella raccolta del Castello Sforzesco*, cat., Milan, 1932.

Arte Lombarda dai Visconti agli Sforza, cat., Milan, 1958.

Aston, Margaret, *The Fifteenth Century: The Prospect of Europe*, London, 1968.

Bacci, Mina, *L'opera completa di Piero di Cosimo*, Milan, 1976.

Bächtiger, Franz, 'Bern zur Zeit von Niklaus Manuel', in Manuel, cat., 1969.

—— 'Andreaskreuz und Schweitzerkreuz: zur Feindschaft zwischen Landsknechten und Eidgenossen', *Jahrbuch der Bernischen Historischen Museums* (1971–2), pp.205–70.

—— 'Marignano. Zum "Schlachtfeld" von Urs Graf', *Zeitschrift für schweitzerliche Archäologie und Kunstgeschichte* (1974), pp.31–54.

Baldass, L., *Der Künstlerkreis Kaiser Maximilians*, Vienna, 1923.

Baldung, *Hans Baldung Grien in Kunstmuseum Basel*, cat., Basle, 1978.

Bange, E.F., *Die Kleinplastik der deutschen Renaissance in Holz und Stein*, Leipzig, 1928.

Die deutschen Bronzestatuetten des 16. Jahrhunderts, Berlin, 1949.

Barocchi, Paola, *Il Rosso Fiorentino*, Rome [c.1950].

—— *Vasari Pittore*, Milan, 1964a.

—— *Mostra di disegni del Vasari e della sua cerchia*, cat., Florence, 1964b.

—— (ed.), *Scritti d'arte del Cinquecento*, 3 vols., Milan, 1971.

Barth, Renate, *Da Dürer a Böcklin . . .*, cat., Milan (for Museo Correr), 1987.

Baxandall, Michael, *Giotto and the Orators*, Oxford, 1971.

—— *The Limewood Sculptors of Renaissance Germany*, Yale University Press, 1980.

Bean, Jacob and Stampfle, Felice, *Drawings from New York Collections. 1. The Italian Renaissance*, Metropolitan Museum, New York, 1965.

Bechtold, A., 'Zu Dürer's Radierung Die grosse Kanone', in *Festschrift für Georg Habich*, Munich, 1928, pp.112–20.

Beerli, C.A., *La peintre poète Nicolas Manuel et l'évolution sociale de son temps*, Geneva, 1953.

Beets, N., *Lucas de Leyde*, Brussels, 1913.

Benesch, Otto, *The Art of the Renaissance in Northern Europe*, London, 1945.

—— *Collected Writings*, 3 vols, London, 1971–2.

—— and Auer, E.M., *Die Historia Friderici et Maximiliani*, Berlin, 1957.

Berenson, B., *The Drawings of the Florentine Painters*, 3 vols, Chicago, 1928.

—— *Lotto*, Milan, 1955.

—— *Italian Pictures of the Renaissance, Venetian School*, 2 vols, 1957; *Florentine School*, 2 vols, 1963.

—— *Central Italian and North Italian Schools*, 3 vols, 1968, London.

Bergamini, Giuseppe et al., *Affreschi del Friuli*, Udine, 1973.

—— 'Pitture "popolari" in Friuli nel XV e XVI secolo', in Furlan, 1985.

—— *Miniatura in Friuli*, cat., Udine, 1985.

Bergamo per Lorenzo Lotto . . ., cat., Bergamo, 1980.

Bernhard, Marianne (ed.), *Hans Baldung Grien. Handzeichnungen, Druckgraphik*, Munich, 1978.

Bernheimer, R., *Wild Men in the Middle Ages*, Harvard University Press, 1952.

Bernis, Carmen, *Indumentaria española en tiempos de Carlos V*, Madrid, 1962.

Berti, Luciano, *L'opera completa di Pontormo*, Milan, 1973.

Bialostocki, Jan, 'Myth and allegory in Dürer's etchings and engravings', *Print Review*, 5 (1976), pp. 24–34.

Bleckwenn, Ruth, 'Beziehungen zwischen Soldatentracht und ziviler modischer Kleidung zwischen 1500 und 1650', *Waffen und Kostümkunde* (1974), pp. 107–18.

Bloesch, H. *See* Schilling and Tschachtlan.

Blumenkranz, B., *Le juif médiéval au miroir de l'art chrétien*, Paris, 1966.

Bober, P.P. and Rubinstein, R.O., *Renaissance Artists and Antique Sculpture*, London, 1986.

Boccaccio, Giovanni, *Decameron*, intro. Vittore Branca, 3 vols, Florence, 1966.

Boesch, Paul, *Die schweizer Glasmalerei*, Basle, 1955.

Böheim, W., 'Die Zeugbücher des Kaisers Maximilian I', *Jahrbuch der Kunsthistorischen Sammlungen des Allerhöchsten Kaiserhauses* (1892), pp. 94–203 (1894), pp. 295–391.

Borea, Evelina, 'Stampe figurativa e pubblico' in *Storia dell' arte italiana*, Turin, 1979, vol. 2, pp. 319–413.

Borgia, L. et al., *Le biccherne. Tavole dipinte delle magistrature senesi*, Rome, 1984.

Bory, J.R., *La Suisse à la rencontre de l'Europe. Le sang et l'or de la Renaissance: l'épopée du service étranger*, Lausanne, 1978.

Brand, C.P., *Tasso*, Cambridge University Press, 1965.

Brandenburg, A.E. et al., *Gisants et tombeaux de la basilique di Saint-Denis*, Paris, 1975.

Brandi, Cesare, (ed.), *Il palazzo pubblico di Siena*, Milan, 1983.

Bridaham, Lester Burbank, *Gargoyles, Chimeras, and the Grotesque in French Gothic Sculpture*, New York, 2nd ed., 1969.

Bronstein, Léo, *Altichiero*, Paris, 1932.

Brückner, W., *Stampe popolari tedesche*, Milan, 1975.

Bruno, Thomas, 'Stilgeschichte der deutschen Harnischen von 1500–1530', *Jahrbuch der Kunsthistorischen Sammlungen . . . in Wien*, N.F., xi, 1937, pp. 139 seq.

Buchner, Ernst, 'Der ältere Breu als Maler', in E. Buchner and K. Feuchtmayr, *Augsburger Kunst der Spätgotik und Renaissance*, Augsburg, 1928, pp. 272–337.

—— 'Bemerkungen zum Historien-und Schlachtenbild der deutschen Renaissance' in Ernst Buchner and K. Feuchtmayr, *Oberdeutsche Kunst der Spätgotik und Reformationzeit* Augsburg, 1924, pp. 240–59.

—— *Albrecht Altdorfer und sein Kreis*, cat., Munich, 1938.

Burgkmair, Hans, Holzschnitte, Zeichnungen, Holzstiche, cat., Staatliche Museen (E. Berlin), 1974.

Burke, Peter, *The Renaissance Sense of the Past*, London,

1969.

Campbell, Lorne, *The Early Flemish Pictures in the Collection of Her Majesty the Queen*, Cambridge University Press, 1985.

Camposanto Monumentale di Pisa. Affreschi e Sinopie, Pisa, 1960.

Cappi Benivegna, F., *Abigliamento e Costume nella Pittura Italiana*, vol. 1, *Rinascimento*, Rome, 1962.

Carandente, G., *I trionfi nel primo Rinascimento*, n.p., 1963.

Cardini, Franco, *Quel antica festa crudele*, Florence, 1982.

Carli, Enzo, *Le tavolette di biccherne e di altri uffici dello Stato di Siena*, Florence [1950].

—— *Il Paesaggio. L'Ambiente Naturale nella Rappresentazione Artistica*, Milan, 1981.

Castelnuovo, Enrico (ed.), *La pittura in Italia. Le origini*, Milan, 1985.

Cederlöf, Olle, 'The battle painting as a historical source: an inquiry into the principles', *Revue Internationale d'Histoire Militaire* (1967), pp. 119–44.

Chambers, D.S., *Patrons and Artists in the Italian Renaissance*, London, 1970.

Charles Quint et son temps, cat., Musée des Beaux-Arts, Ghent, 1955.

Chastel, André, *Renaissance méridionale. Italie 1460–1500*, Paris, 1965.

—— *The Sack of Rome*, trans. Beth Archer, Princeton University Press, 1983.

Chodyński, Antoni Romuald, *Malbork*, Warsaw, 1986.

Christensen, Carl C., 'The Reformation and the decline of German art', *Central European History* (1973), pp. 207–32.

Clark, Kenneth, *Piero della Francesca*, London, 1951.

—— *Leonardo da Vinci*, Cambridge University Press, 1952.

Cockle, Maurice, J.D., *A Bibliography of Military Books up to 1642*, London, 1900.

Coo, Joz. de, *De Boer in de Kunst*, Rotterdam [c.1939].

Cortesi, Luigi and Mandel, Gabriela, *Affreschi ai disciplini di Clusone*, Bergamo, 1972.

Corvisier, A., 'Les représentations de la société dans les dances des morts du XVᵉ siècle', *Revue d'histoire moderne et contemporaine* (1969), pp. 489–539.

Coupland, G.W., *The Tree of Battles of Honoré Bonet*, Liverpool University Press, 1949.

Cox-Rearick, Janet, *Dynasty and Destiny in Medici Art. Pontormo, Leo X and the Two Cosimos*, Princeton University Press, 1984.

D'Ancona, Mirella Levi, *Miniatura e miniatore a Firenze dal XIV al XVI secolo*, Florence, 1962.

D'Ancona, Paolo, *The Schifonia Months at Ferrara*, Milan, 1954.

Davidson, Bernice F., *Mostra di disegni di Perino del Vaga e la sua cerchia*, cat., Florence, 1966.

Davis, J.C., *The Pursuit of Power. Venetian Ambassadors' Reports . . . 1560–1600*, New York, 1970.

Degenhart, B. and Schmitt, A., *Corpus der italienischen Zeichnungen*, Pt. 2, vol. 4, Berlin, 1982.

—— *Jacopo Bellini. The Louvre Album of Drawings*, New York, 1984.

Delaissé, L.M.J., *A Century of Dutch Manuscript Illumination*, University of California Press, 1968.

Delbrück, Hans, *Geschichte der Kriegskunst im Rahmen der politischen Geschichte*, pt. 4, *Neuzeit*, Berlin, (repr.) 1962.

Delen, A.J.J., *Histoire de la gravure dans les anciens pays-bas . . .*, Paris, (repr.) 1969.

Deuchler, Florens, *Die Burgunderbeute . . .*, Berne, 1963.

Deutsche Kunst der Dürer-zeit, cat., Dresden, 1971.

Dickens, A.G. (ed.), *The Courts of Europe*, London, 1977.

Dillon, Viscount and Hope, W.H. St John, *Pageant of the Birth, Life and Death of Richard Beauchamp Earl of Warwick 1389–1439*, London, 1914.

Dobrzeniecki, Tadeusz, *Catalogue of the Medieval Paintings, Muzeum Narodowe*, Warsaw, 1977.

Dodgson, Campbell, 'Zu den Landsknechten David de Neckers', *Repertorium für Kunstwissenschaft* (1903a), pp. 117–19.

—— *Catalogue of Early German and Flemish Woodcuts . . . British Museum*, 2 vols, London, 1903b.

—— *The Complete Woodcuts of Albrecht Dürer*, ed. W. Kurth, New York (repr.) 1963.

Dolce, Lodovico, *Aretino: a Dialogue on Painting*, trans. W. Brown, London, 1970.

Dumont, Catherine, *Francesco Salviati au Palais Sachetti de Rome . . .*, Geneva, 1973.

Dürer, Albrecht, 1471–1971, cat., Nuremberg, Germanische Nationalmuseum, 1971.

Durrer, R. and Hilber, P. (eds), *Diebold Schilling: Luzerner Bild-Chronik 1513*, Geneva, 1932.

Duthaler, Georg, 'Fahnenbegleiterinnen', *Schweizerisches Archiv für Volkskunde* (1977), pp. 1–19.

Egg, Erich, *Kunst in Tirol. Malerei und Kunsthandwerk*, Innsbruck, 1972.

Ekserdjian, David, *Old Master Paintings from the Thyssen-Bornemisza Collection*, cat., Royal Academy of Arts, London, 1988.

Erasmus en zijn Tijd, cat., Museum Boymans-van Beuningen Rotterdam, 2 vols, 1969.

Escher, Konrad, *Kunst, Krieg und Krieger*, Zurich and Leipzig, 1917.

Essenwein, N. (ed.), *Mittelalterliches Hausbuch*, Hildesheim-Zürich-New York (repr.), 1986.

Essling, Prince d', *Les livres à figures vénitiens de XVᵉ siècle et du commencement du XVIᵉ*, Florence, 1907–14.

Ettlinger, Leopold D., *Antonio and Piero Pollaiuolo*, Oxford, 1978.

Euw, A. von and Plotzek, J.M., *Die Handschriften der Sammlung Ludwig*, vols 3 and 4, Cologne, 1982, 1985.

Evans, Mark L., 'Northern artists in Italy during the Renaissance', *Bulletin of the Society of Renaissance Studies* 2 (1985), pp. 7–23.

Falk, Tilman, *Hans Burgkmair. Studien zu Leben und Werk des Augsburger Malers*, Munich, 1968.

—— *Katalog der Zeichnungen des 15. und 16 Jahrhunderts im Kupferstichkabinett Basel*, pt. 1, Basle, 1979.

Fanti, Mario, *La basilica di San Petronio in Bologna*, Bologna, 1986.

Ferrari, Maria Luisa, *Il Romanino*, Milan, 1961.

Field, Richard S., *Fifteenth-century Woodcuts and Metalcuts from the National Galley Washington*, Washington, 1965.

Filangieri, R., *Una cronica napoletana figurata del quattrocento*, Naples, 1956.

Fiocco, G., *L'arte di Andrea Mantegna*, Venice, 1959.

—— *Giovanni Antonio Pordenone*, 3rd edn, 2 vols, Pordenone, 1969.

Fischel, Lilli, 'Die "Grosse Schlacht". Analyse eines Kupferstich', *Wallraf-Richartz Jahrbuch* (1959), pp. 159–72.

Fischel, Oskar, *Raphael*, trans. B. Rackham, 2 vols, London, 1948.

Flanders in the Fifteenth Century: Art and Civilization, cat., Detroit, 1960.

Formiciova, Tamara, 'I dipinti di Tiziano nelle raccolte dell' Ermitage', *Arte Veneta* (1967), pp. 57–70.

Fraenger, Wilhelm, *Matthias Grünewald*, Dresden, 1983.

Freedberg, S.J., *Painting in Italy 1500 to 1600*, Harmondsworth, 1971.

—— *Painting of the High Renaissance in Rome and Florence*, 2 vols, New York (new edn) 1972.

Friedländer, Max J., *Handzeichnungen deutscher Meister des 15. und 16. Jahrhunderts*, Berlin [1921].

—— *From Van Eyck to Breughel*, London, 1956.

—— *Lucas van Leyden*, ed. F. Winkler, Berlin, 1963.

—— *Early Netherlandish Painting*, 11 vols, New York, 1968–74.

—— and Rosenberg, Jakob, *The Paintings of Lucas Cranach*, Cornell University Press, 1978.

Fumagalli, Carlo, *Il castello di Malpaga e le sue pitture*, Milan, 1894.

Furlan, Caterina (ed.), *Il Pordenone. Atti del convegno internazionale di studio*, Pordenone, 1985.

Gabrielli, Noemi, *Rappresentazioni sacre e profane nel Castello di Issogne e la pittura nella valle d'Aosta alla fine del '400*, Turin, 1959.

Ganz, Paul, *Handzeichnungen Schweitzerischer Meister des XV–XIII Jahrhunderts*, Basle, 1904–8.

Garzelli, A., *La bibbia di Federico da Montefeltro. Un' officina fiorentina 1476–1478*, Rome, 1977.

—— *Miniatura fiorentina del Rinascimento 1440–1525*, 2 vols, Florence, 1985.

Gaudioso, Filippa and Eraldo, *Gli affreschi di Paolo III a Castel Sant'Angelo*, cat., 2 vols, Rome, 1981.

Geisberg, Max, *Die deutsche Buchillustration in der ersten Hälfte des 16. Jahrhunderts*, 8 vols, Munich, 1930–2.

—— *The German Single-leaf Woodcut 1500–1550*, ed. W.L. Strauss, 4 vols, New York, 1974.

—— *Der Meister E.S.*, 2nd edn, Leipzig, n.d.

Gibbons, Felton, *Dosso and Battista Dossi, Court Painters at Ferrara*, Princeton University Press, 1968.

Giorgione. Atti del Convegno Internazionale di Studio per il 5° Centenario delle Nascita, Banca Popolare di Asolo e Montebelluna, 1979.

Giorgione e la Cultura Veneta fra '400 e '500, Rome, 1981.

Gmelin, H.G. *Spätgotische Tafelmalerei in Niedersachsen und Bremen*, W. Berlin, 1974.

Göbel, H. *Wandteppiche*, 3 vols, Leipzig, 1923–34.

Goldberg, Gisela, *Die Alexanderschlacht und die Historienbilder des bayerischen Herzogs Wilhelm IV . . .*, Munich, 1983.

—— et al., *Staatsgalerie Augsburg*. cat., vol. 1, Augsburg, 1967.

Goldfarb, Hilliard T., 'An early masterpiece by Titian rediscovered, and its stylistic importance', *Burlington Magazine* (1986), pp. 419–23.

Goldscheider, Ludwig, *Michelangelo. Paintings, Sculpture, Architecture*, London, 1953.

Goldschmidt, Adolph, 'Die Luzerner illustrierten Handschriften des Schachzabelbuches des Schweizer Dichters Konrad von Ammenhausen', *Innerschweizerisches Jahrbuch für Heimatkunde* (1944–6), pp. 9–23.

Gombosi, G., *Palma Vecchio*, Berlin, 1937.

Gombrich, E.H., 'The style all'antica: imitation and assimilation', in *The Renaissance and Mannerism. Studies in Western Art*, Princeton University Press, 1963, vol. 2, 31–41.

—— *Symbolic Images*, London, 1972.

—— 'The leaven of criticism in Renaissance art: texts and episodes', *The Heritage of Apelles* (London, 1976), pp. 111–31.

Gothic and Renaissance Art in Nuremberg, cat., Metropolitan Museum, New York, 1986.

Gould, Cecil, *Michelangelo: The Battle of Cascina*, Newcastle, 1966.

—— *Leonardo: The Artist and the Non-Artist*, London, 1975.

Griseri, Andreino (ed.), *Affreschi nel Castello di Issogne* [Rome, c.1974].

Grosshans, R., *Marten van Heemskerck. Die Gemälde*, W. Berlin, 1980.

Grossmann, F., *Pieter Breughel. Complete Edition of the Paintings*, London, 3rd edn., 1973.

Grummond, N.T. de, 'Giorgione's "Tempest". The Legend of St. Theodore', *L'Arte*, n.s. XVIII/XIX, 1972, pp. 5–53.

Guerry, Liliane, *'Le Thème du "Triomphe de la Mort" dans la Peinture Italienne'*, Paris, 1950.

Haberditzl, F.M. and Stix, A., *Die Einblattdrucke des XV. Jahrhunderts in der Kupferstichsammlung der Hofbibliothek zu Wien*, 2 vols, Vienna, 1920.

Haendke, Berthold, 'Die Bauer in der deutschen Malerei von ca. 1470 bis ca. 1550' *Repertorium für Kunstwissenschaft* (1912), pp.385–401.

Hale, J.R., 'Italian Renaissance images of war', *Journal of the Royal Society of Arts* (December 1963), pp. 61–79.

—— *Renaissance Fortification: Art or Engineering?* London, 1977.

—— 'Soldiers in the religious art of the Renaissance', Bulletin of the John Rylands University Library of Manchester (1986), pp. 166–94.

—— 'The soldier in Germanic graphic art of the Renaissance', in *Art and History*, ed. R.T. Rotberg and T.K. Rabb, Cambridge University Press, 1988a, pp. 85–114.

—— 'A humanistic visual aid; the military diagram in the Renaissance', *Renaissance Studies* (1988b), pp.280–98.

—— 'Michiel and the *Tempesta*: the soldier in a landscape as a motif in Venetian painting' in *Florence and Italy: Renaissance Studies in Honour of Nicolai Rubinstein*, ed. Peter Denley and Caroline Elam, London, 1988c, pp. 405–18.

—— 'Women and war in the visual arts of the Renaissance' in *War, Literature and the Arts in Sixteenth Century Europe* ed. R. Mulryne and M. Shewring, London, 1981d, pp. 43–62.

Halm, Peter, *Hundert Meisterzeichnungen aus der staatlichen graphischen Sammlung in München*, cat., Munich, 1958.

Hammerstein, Reinhold, *Tanz und Musik des Todes. Die mittelalterlichen Totentänze und ihr Nachleben*, Berne and Munich, 1980.

Harnack, Adolf, *Militia Christi. Die christliche Religion und der Soldatenstand in den ersten drei Jahrhunderten*, Tübingen, 1905.

Hartig, Otto, 'Die Kunststätigkeit in München unter Wilhelm IV und Albrecht V, 1520–1579', *Müncher Jahrbuch der bildenden Kunst* (1933), pp. 147–225.

Hartt, Frederick, *Giulio Romano*, 2 vols, New Haven, 1958.

Das Hausbuch der Cerruti, trans. Franz Unterkircher. Dortmund, 1979.

Heffels, Monika, *Meister um Dürer. Nürnberger Holzschnitte aus der Zeit um 1500–1540*, Ramerding, 1981.

Hendy, P. and Goldscheider, L., *Giovanni Bellini*, London, 1945.

Henze, Helene, *Die Allegorie bei Hans Sachs, mit besonderer Berücksichtigung ihrer Beziehungen zur graphischen Kunst*, Tübingen, 1972.

Hetzer, Theodor, *Das deutsche Element in der italienischen Malerei des Sechzehnten Jahrhunderts*, Berlin, 1929.

Hill, G.E., *Corpus of Italian Renaissance Medals before Cellini*, 2 vols, London, 1930.

Hinckeldey, Christoph (ed.), *Criminal Justice through the Ages. From Divine Judgement to Modern German Legislation*, Rotheburg, 1981.

Hind, A.M., *Engravings in England in the 16th and 17th Centuries*, 2 vols, Cambridge, 1952–5.

—— *An Introduction to a History of Woodcut*, 2 vols, New York, (repr.) 1963.

—— *Early Italian Engravings*, 7 vols, in 4, New York (repr.) 1970.

Holborn, Hajo, *Ulrich von Hutten and the German Reformation*, New York, 1966 (repr. of the Yale University Press edition of 1937).

Hollstein, F.W.H., *Dutch and Flemish Engravings and Woodcuts c.1450–1700*, 28 vols, Amsterdam, 1949–84.

—— *German Engravings and Woodcuts c.1400–1700*, 28 vols, Amsterdam [1954]–80.

Hope, Charles, *Titian*, London, 1980.

Horster, Marita, *Andrea del Castagno. Complete Edition with a Critical Catalogue*, Cornell University Press, 1980.

Houday, J., *Les tapisseries de Charles-Quint représentant la conquête du royaulme de Thunes*, Lille, 1873.

Husa, Václav, *Traditional Crafts and Skills. Life and Work in Medieval and Renaissance Times*, London, 1967.

Husband, Timothy, *The Wild Man. Medieval Myth and Symbolism*, cat., Metropolitan Museum, New York, 1980.

Hutchinson, Jane C., *The Master of the Housebook*, New York, 1972.

Illustrated Bartsch, The, various editors, New York, 1978–.

Ivins, M., *Prints and Visual Communication*, New York, 1969.

Jacobowitz, Ellen S., and Stepanek, Stephanie, *The Prints of Lucas van Leyden and his Contemporaries*, cat., National Galley, Washington, 1983.

Jahn, Johannes, *Deutsche Renaissance. Baukunst, Plastik, Malerei, Graphik, Kunsthandwerk*, Leipzig, 1969.

Jakrzewska-Śniezko, Zofia, *Dwor Artusa w Gdańzku*, Poznan-Gdansk, 1972.

Jones, Roger and Penny, Nicholas, *Raphael*, Yale University Press, 1983.

Kadatz, Hans-Joachim, *Deutsche Renaissancebaukunst von frübürgerlichen Revolution bis zum Ausgang des Dreissigjährigen Krieges*, E. Berlin 1983.

Kemp, Martin, *Leonardo da Vinci. The Marvellous Works of Nature and Man*, London, 1981.

Klein, Robert and Zerner, Henri, *Italian Art 1500–1600. Sources and Documents*, Englewood Cliffs, 1966.

Kloek, W.Th. et al., *Art before Iconoclasm*, cat., Amsterdam, Rijksmuseum, 1986.

Knab, Echkhart et al., *Raphael. Die Zeichnungen*, Stuttgart, 1983.

Knappe, K.-A., *Dürer. Gravures. Oeuvre complet*, n.p. 1964.

Koch, Carl, *Die Zeichnungen Hans Baldung Griens*, Berlin 1941.

Koegler, Hans, *Beschreibendes Verzeichnis der Basler Handzeichnungen des Urs Graf*, Basle, 1926.

—— *Niklaus Manuel Deutsch*, Basle, [c.1942].

Koenneker, Barbara, *Wesen und Wandlung der Narrenidee im Zeitalter des Humanismus*, Wiesbaden, 1966.

Koepplin, Dieter and Falk, Tilman, *Lukas Cranach. Gemälde, Zeichnungen, Druckgraphik*, cat., 2 vols, Kunstmuseum, Basel, 1974.

Kohlschmidt, Werner (ed.), *Das deutsche Soldatenlied*, Berlin, 1935.

Kok, J.P. Filedt (ed.), *Livelier than Life. The Master of the Amsterdam Cabinet or the Housebook Master ca.1470–1500*, cat., Maarssen, 1985.

König, Eberhard, *Französische Buchmalerei um 1450*, W. Berlin, 1982.

Kristeller, Paul, *Early Florentine Woodcuts. With an Annotated List of Florentine Illustrated Books*, London, 1897.

Kunst der Donauschule 1490–1540, Der, cat., Linz, 1965.

Kunst der Reformationzeit, cat., Staatliche Museum, DDR, Berlin, 1983.

Kunsthandwerk der Dürerzeit und der Deutschen Renaissance, cat., E. Berlin, 1971.

Kunze, Horst, *Geschichte der Buchillustration in Deutschland. Das. 15. Jahrhundert*, 2 vols, Leipzig, 1975.

Kunzle, David, *The Early Comic Strip. Narrative Strips and Picture Stories in the European Broadsheet from c.1450 to 1825*, University of California Press, 1973.

Kurth, Willi, *see* Dodgson.

Landucci, Luca, *A Florentine Diary*, trans. A. de R. Jervis, London, 1927.

Lauts, Jan, *Carpaccio. Gemälde und Zeichnungen. Gesamtausgabe*, Cologne, 1962.

Lehmann-Haupt, Hellmut, *Schwäbische Federzeichnungen. Studien zur Buchillustration Augsburgs im XV. Jahrhundert*, Berlin and Leipzig, 1929.

Lehner, Ernst and Johanna, *Devils, Demons, Death and Damnation*, New York, 1971.

Lehrs, Max, *Late Gothic Engravings of Germany and the Netherlands*, New York (repr.) 1969.

Leigh Fermor, Patrick, *A Time of Gifts*, Harmondsworth, 1979.

Leitner, Q. von, *Freydal. Des Kaisers Maximilian I. Turniere und Mummereien*, Vienna, 1880–2.

Levenson, J.A., Oberhuber, Konrad, and Sheehan, J.L., *Early Italian Engravings from the National Gallery of Art*, Washington, 1973.

Levin, William R., *Images of Love and Death in Late Renaissance Art*, cat., University of Michigan Museum of Art, 1975.

Lieb, N. and Stange, A., *Hans Holbein der Ältere*, n.p., [c.1960].

Liebe, Georg, *Soldat und Waffenhandwerk*, (repr.) Cologne, 1972 (previously published as *Der Soldat in der deutschen Vergangenheit*, Leipzig, 1899).

Liechtenstein, The Princely Collection, cat., Metropolitan Museum of Art, New York, 1985.

Lightbown, Ronald, *Mantegna*, Oxford, 1986.

Limentani Virdis, Caterina, *Codici miniati fiamminghi e olandesi nelle biblioteche dell'Italia nord-orientale*, Vicenza, 1981.

Lippmann, Friedrich, *Der italienische Holzschnitt im XV. Jahrhundert*, Berlin, 1885.

—— *The Seven Planets*, London, 1895.

Loan Exhibition of Early Italian Engravings, cat., Fogg Art Museum, Harvard University Press, 1915.

Longhi, Roberto, 'Arte italiana e arte tedesca' [1941] in *Opere complete*, vol. 9, Florence, 1979, pp. 3–21.

Lucas van Leydens Grafiek, cat., Rijksmuseum, Amsterdam, 1978.

Lüthi, Walter, *Urs Graf und die Kunst der alter Schweizer*, Zurich and Leipzig, 1928.

Lyell, James P.R., *Early Book Illustration in Spain*, London, 1926 (repr., New York, 1976).

MacGurdy, Edward, *The Notebooks of Leonardo da Vinci*, 2 vols., London, 1938.

Macgregor, Arthur (ed.), *Tradescant's Rarities . . .*, Oxford, 1983; the entry on the Ashmolean *Battle of Pavia* is by Gerald Taylor.

Machiavelli, Niccolò, *Arte della Guerra e scritti politici minori*, ed. Sergio Bertelli, Milan, 1961.

Magnani, Luigi, *La cronica figurata di Giovanni Villani. Richerche sulla miniature fiorentina del Trecento*. Città del Vaticano, 1936.

Major, A. Hyatt, *Prints and People. A Social History of Printed Pictures*, New York, 1971.

Major, Emil and Gradmann, Erwin, *Urs Graf*, Basel, n.d.

Mâle, Emile, *L'art allemand et l'art français du Moyen Age*, Paris, 1917.

Mallett, Michael, *Mercenaries and their Masters. Warfare in Renaissance Italy*, London, 1974.

—— and Hale, J.R., *The Military Organization of a Renaissance State: Venice c. 1400 to 1617*. Cambridge University Press, 1984.

Mandach, C. von et al., *Niklaus Manuel Deutsch*, Basle [?1942].

Mann, J.G., 'Instances of antiquarian feeling in medieval and Renaissance art', *Archaeological Journal* (1932).

Manuel, *Niklaus Manuel Deutsch. Maler, Dichter, Staatsman*, cat., Kunstmuseum. Berne, 1979.

Marle, R. van, *The Development of the Italian Schools of Painting*, 18 vols, The Hague, 1923–36.

—— *Iconographie de l'art profane au Moyen Age et à la Renaissance*, 2 vols (repr.) New York, 1971.

Marrow, James and Shestack, Alan, *Hans Baldung*

Grien: prints and drawings, cat., National Gallery, Washington, 1981.

Martin, André, Le livre illustré en France au XVe siècle, Paris, 1931.

Martindale, Andrew, The Triumphs of Caesar by Andrea Mantegna in the Collection of Her Majesty the Queen at Hampton Court, London, 1979.

Martineau, Jane, and Hope, Charles, The Genius of Venice, cat., Royal Academy of Arts, 1983.

Maximilian I, Freydal. Des Kaisers Maximilian I Turniere und Mummereien, ed. Q. von Leitner, Vienna, 1880–2.

—— Weisskunig, ed. H.Th. Musper, 2 vols, Stuttgart, 1956.

The Triumph of Maximilian I. 137 Woodcuts by Hans Burgkmair and Others. Intro. and trans. Stanley Appelbaum, New York, n.d.

Maximilian I. 1459–1519, cat., Innsbruck, 1969.

Meister E.S.: ein oberrheinischer Kupfersticher der Spätgotik, cat., Munich, 1986.

Mellini, Gian Lorenzo, Altichiero e Jacopo Avanzi, Milan, 1965.

Mende, M., Hans Baldung Grien. Das graphische Werk, Unterscheidheim, 1978.

Mielke, Hans, Albrecht Altdorfer. Zeichnungen, Deckfarbenmalerei, Druckgraphik, cat., W. Berlin, 1988.

Millar, Oliver, The Tudor, Stuart and Early Georgian Pictures in the Collection of Her Majesty the Queen, 2 vols, London, 1963.

Miller, Douglas, The Landsknechts, London, 1976.

Miniature Flamande, La. Le mécènat de Philippe le Bon, cat., Palais des Beaux-Arts, Brussels, 1959.

Minott, C.I., Martin Schongauer, New York, 1971.

Möller, Hans-Michael, Das Regiment der Landsknechte Wiesbaden, 1976.

Monbeig-Goguel, Catherine, ed., Inventaire Général des Dessins Italiens, vol. 1, Vasari et son Temps, Louvre, Paris, 1972.

Mongan, Elizabeth, 'The Battle of Fornovo', in Prints, Prints Council of America, New York, 1962, pp. 253–68.

Morassi, Antonio, 'The Other Painters of Malpaga', Burlington Magazine, vol. 58, 1931, pp.118–29.

Mortimer, Ruth, Harvard College Library Department of Printing and Graphic Arts. Catalogue of Books and Manuscripts. Pt. 1, French 16th-century Books, 2 vols, Harvard University Press, 1964.

Moxey, Keith P.F., Pieter Aertsen, Joachim Beukelaer and The Rise of Secular Painting within the Context of the Renaissance, New York, 1977.

—— 'Sebald Beham's church anniversary holidays: festive peasants as instruments of repressive humour', Simiolus (1982), pp. 107–30.

—— 'The social function of secular woodcuts in sixteenth century Nuremberg', in Smith, 1985, pp. 63–81.

Müller, Rainer, A., Der Arzt im Schachspiel bei Jakob von Cessolis, Munich, 1981.

Munich, Alte Pinakothek München. Erläuterung zu den ausgestellten Gemälden, Munich, 1983.

Muñoz, José Luis Portillo, La ilustración gráfica de los incunables sevillanos (1470–1500), Seville, 1980.

Müntz, Eugenio, L'Arte Italiana nel Quattrocento, Milan, 1894.

Münz, Ludwig, Breughel. The Drawings. Complete Edition, London, 1961.

Muraro, Michelangelo, 'La scala senza giganti', De artis opuscula. Essays in honour of Erwin Panofsky, ed. Millard Meiss, New York, 2 vols, 1961, 1, p.356 seq.

Muschg, Walter, Die Schweizer Bilderchroniken des 15 und 16 Jahrhunderts, Zurich, 1941.

Musper, H.Th, Die Einblattholzschitt und die Blockbücher des XV. Jahrhunderts, Stuttgart, 1976. (Tafelband to W.L. Schreiber, Handbuch der Holz und Metallschnitte des XV. Jahrhunderts, 9 vols., Leipzig, 1926–30)

Newton, Stella Mary, Renaissance Theatre Costume and the Sense of the Historic Past, New York, 1975.

Niccoli, Ottavia, I Sacerdoti, i Guerrieri, i Contadini. Storia di un Immagine della Società, Turin, 1979.

Nicodemi, Giorgio, Agostino Busti detto il Bambaia, Milan, 1945.

Nijhoff-Selldort, H., 'Der Triumphzug Karl der Vten zu Bologna von Robert Peril, Antwerpen, 1530', Oude Holland (1931), pp.265–9.

Oberhuber, Konrad, Sixteenth Century Italian Drawings from the Collection of Janos Scholz, cat., Washington National Gallery, [1973].

Oettinger, F., 'Ein Altdorfer Schüler: der Zeichner der Pariser Landsknechte', in Festschrift Friederich Winkler, Berlin (1959a), pp. 201–13.

—— Altdorfer-Studien, Nuremberg, 1959b.

Old Master Drawings from the Albertina, cat., New York, Morgan Library, 1985.

Oman, C.C., 'The Battle of Pinkie, September 10, 1547', Archaeological Journal (1933), pp. 1–25.

Omodeo, Anna, Mostra di stampe popolari venete del '500, cat., Florence, Uffizi, 1965.

Orlandini, U., Il manoscritto estenso 'De Sphaera', Modena, 1914.

Osten, Gert von der, and Vey, Horst, Paintings and Sculpture in Germany and the Netherlands 1500–1600, Baltimore, 1969.

Paccagnini, G., Pisanello alla corte dei Gonzaga, cat., Mantua, Palazzo Ducale, 1972.

Pächt, Otto, Italian Illuminated Manuscripts, cat., Oxford, Bodleian Library, 1948.

—— 'Giovanni da Fano's illustrations for Basinio's epos Hesperis', Studi Romagnoli (1951), pp. 91–111.

—— and Alexander, J.J.G., Illuminated Manuscripts in the Bodleian Library Oxford, vol. 3, Oxford, 1973.

—— (with Jenni, Ulrike), Flämische Schule 1, 2 vols, Vienna, 1983.

—— and Thoss, Dagmar, Die illuminierte Handschriften und Inkunabeln der Österreichen Nationalbibliothek. Französische Schule I, 2 vols, Vienna, 1974.

Pallucchini, Rodolfo, Tiziano, 2 vols, Florence, 1969.

—— and Rossi, Francesca, Giovanni Cariani, Bergamo, 1983.

Panazza, Gaetano (ed.), Mostra di Girolamo Romanino, cat., Brescia, 1965.

Panofsky, Erwin, The Life and Art of Albrecht Dürer, Princeton University Press, 1955.

Papini, Roberto, 'I pittori di battaglie in Italia', Emporium (1915), pp. 108 ff., 163ff., 323 ff.

Parker, K.T., Drawings of the Early German School, London, 1926.

—— North Italian Drawings of the Quattrocento, New York, 1927.

Partsch, Susanna, Profane Buchmalerei der bürgerlichen Gesellschaft im spätmittelalterlichen Florenz. Der Specchio Umano des Getreidehandlers Domenico Lenzi, Worms, 1981.

Peintner, Martin, Neustifter Buchmalerei, Bozen, 1964.

Peroni, Adriano, Ottolenghi, M.A.A., Vicini, Donata, Giordano, Luisa, Pavia. Architettura dell' Età sforzesca, Turin, 1978.

Phillips, John A., Eve. The History of an Idea, New York, 1984.

Pianzola, Maurice, Peintres et vilains. Les artistes de la Renaissance et la grande guerre des paysans de 1525, Paris, 1962.

Pignatti, Terisio, Giorgione, Milan, 1972.

—— 'The relationship between German and Venetian painting in the late Quattrocento and early Cinquecento' in J.R. Hale (ed.), Renaissance Venice, London, 1973, pp. 244–73.

Pinelli, Antonio and Rossi, Orietta, Genga Architetto: Aspetti della Cultura Urbinate del Primo '500, Rome, 1971.

Pittura bresciano del Rinascimento, La, cat., Bergamo,

1939.

Plumb, J.H. (ed.), The Horizon Book of the Renaissance, London, 1961.

Pope-Hennessy, John, The Complete Work of Paolo Uccello, London, 1950.

Fra Angelico, London, 1952.

—— Italian Renaissance Sculpture, London, 1958.

—— Renaissance Bronzes from the Samuel H. Kress Foundation, London, 1965.

—— 'Two chimney-pieces from Padua', in Essays in Italian Sculpture, London, 1968, pp. 92–4.

—— and Christiansen, Keith, Secular Painting in 15th-century Tuscany: Birth-trays, Cassone Panels and Portraits, New York (repr. from The Metropolitan Museum of Art Bulletin, Summer 1980).

—— Cellini, London, 1985.

Popham A.E. and Wilde, J., The Italian Drawings of the XV and XVI Centuries in the Collection of His Majesty the King at Windsor Castle, London, 1949.

Popham, A.E. and Pouncey, Philip, Italian Drawings in the Department of Prints and Drawings in the British Museum. The Fourteenth and Fifteenth Centuries, 2 vols., London, 1950.

Post, Paul, 'Das Kostum der deutschen Renaissance, 1480–1550', Anzeiger der Germanisches Nationalmuseums (1954–9), pp. 21–42.

Pouncey, Philip and Gere, John, Italian Drawings in the Department of Prints and Drawings in the British Museum: Raphael and his Circle, 2 vols, London, 1962.

Prevenier, Walter and Blockmans, Wim, The Burgundian Netherlands, Cambridge University Press, 1985.

Prints and Drawings of the Danube School, cat., Yale University Art Gallery, 1969.

Puppi, Lionello, Bartolomeo Montagna, Venice, 1962.

Rackham, Bernard, Victoria and Albert Museum. Catalogue of Italian Majolica, London, 1940.

Rácz, István, Turun Linna, Helsinki, 1971.

Ragusa, Isa and Green, R.B. (eds), Meditations on the Life of Christ, Princeton University Press, 1961.

Randall, Lilian M., Images in the Margins of Gothic Manuscripts, University of California Press, 1966.

Rasmo, Niccolò, Wanamalereien in Südtirol, Bozen, 1973.

—— L'età cavalleresca in Val d'Adige, Milan, 1980.

—— Il Castello del Buonconsiglio a Trento, Milan, n.d.

Raupp, Hans-Joachim, Bauernsatiren. Enstehung und Entwicklung des bäuerlichen Genres in der deutschen und niederländischen Kunst ca.1470–1570, Niederdein, 1986.

Ricci, Corrado, 'Di un codice Malatestiano della "Esperide" di Basinio', Accademie e Biblioteche d'Italia (1928), pp. 20–47.

Richardson, Francis L., Andrea Schiavone, Oxford, 1980.

Richter, J.P. (ed.), Leonardo da Vinci, Literary Works, Oxford University Press, 2 vols, 1939.

Rifkin, Benjamin A., The Book of Trades: Jost Amman and Hans Sachs, New York, 1973.

Rosand, David and Muraro, Michelangelo, Titian and the Venetian Woodcut, cat., Washington, National Gallery, 1976.

Rowlands, John, Holbein, Oxford University Press, 1985.

—— 'The procession of Gluttony', Print Quarterly (1987), pp. 158–62.

—— The Age of Dürer and Holbein, cat., British Museum, 1988.

Salmi, Mario, Luca Signorelli, Munich, 1955.

Salvini, R., L'opera pittorica completa di Holbein il Giovane, Milan, 1971.

—— and Traverso, L., The predella from the XIIIth to the XVIth Centuries, London, 1980.

Sander, Max, Le livre à figures italien depuis 1467 jusqu'a 1530, 6 vols, Milan, 1942. Supplement, ed. Carlo Enrico Rava, Milan, 1969.

274

Saxl, F. 'A battle scene without a hero', *Journal of the Warburg and Courtauld Institutes*, 1939–40, pp.70–87.

Scheidig, W., *Holzschnitte des Petrarcha-Meisters*, Berlin, 1955.

Schilling, Diebold, *Berner Chronik*, ed. Hans Bloesch and Paul Hilber, 4 vols, Berne, 1943–5.

Schilling, E. and Schwartzweller, K., *Katalog der deutschen Zeichnungen. Alte Meister*, 3 vols, Munich, 1973 (for Städelisches Kunstinstitut).

Schleuter, Ernst, *Der Meister PW*, Leipzig, 1935.

Schmid, Heinrich Alfred, *Hans Holbein der Jüngen. Sein Aufstieg zur Meisterschaft und sein Englishe Stil*, Basle, 1945.

Schmidt, Georges and Cetto, Anne Marie, *Peinture et Dessin en Suisse au Quinzième et au Seizième Siècles*, Basle, n.d.

Schneider, Jenny, *Glasgemälde. Katalog der Sammlung des Schweizerischen Landesmuseums Zürich*, 2 vols, Zurich [1970].

Schramm, P.E. and Fillitz, H., *Denkmale der deutschen Könige und Kaiser*, vol. 2, 1273–1519, Munich, 1978.

Schreiber, W.L. *Handbuch der Holz- und Metallschnitte des XV. Jahrhunderts*, Leipzig, 9 vols, 1926–30.

Schubring, Paul, *Cassoni. Truhen und Truhenbilder der italienischen Frührenaissance*, 2 vols, Leipzig, 1923.

Schulz, Anne Markham, 'Four new works by Antonio Minello', *Mitteilungen des Kunsthistorisches Institutes in Florenz*, 1987, pp. 291–326.

Schulz, Juergen, 'Jacopo de' Barbari's View of Venice', *The Art Bulletin*, 60, 1978.

Semenzato, Camillo (ed.), *Le pitture del Santo di Padova*, Vicenza, 1984.

Sercambi, Giovanni, *Le illustrazioni delle chroniche nel codice Lucchese*, ed. O. Banti and M.L. Testi Cristiani, 2 vols, Genoa, 1978.

Sesti, Emanuela (ed.), *La miniatura italiana tra Gotico e Rinascimento*, 2 vols, Florence, 1985.

Settis, Salvatore, *La 'Tempesta' interpretata. Giorgione, i committenti, il soggetto*, Turin, 1978.

Seznec, Jean, *The Survival of the Pagan Gods*, New York, 1953.

Shapley, Fern Rusk, *Catalogue of the Italian Paintings*. vol. I. Text. vol. II. Plates, National Gallery of Art, Washington, 1979.

Shaw, James Byam, *The Italian Drawings of the Fritz Lugt Collection*, Paris, 1983.

Shestack, Alan, *Fifteenth-century Engravings of Northern Europe from the National Galley of Art, Washington D.C.* Washington, 1967.

Shoemaker, Inncs H., *The Engravings of Mercantonio Raimondi*, cat., Spencer Museum of Art, Lawrence, Kansas, 1981.

Singleton, Charles S. (ed.), *Interpretation. Theory and Practice*, Baltimore, 1969.

Sjöblom, Axel, 'Ein Gemälde von Ruprecht Heller im Stockholmer Nationalmuseum', in Buchner and Feuchtmayr (1924) pp. 225–30.

Smith, Jeffrey Chipps, *Nuremberg, a Renaissance City, 1500–1618*, Austin, 1983.

—— (ed.), *New Perspectives on the Art of Renaissance Nuremberg. Five Essays*, Austin, 1985.

Snow-Smith, J., 'Pasquier le Moyne's 1515 account of art and war in northern Italy', *Studies in Iconography* (1979), pp. 173–234.

Soltész, Elizabeth (ed.), *Biblia Pauperum. Die vierzigblättrige Armenbibel in der Bibliothek der Erzdiözese Esztergom*, Hanau, 1967.

Spätgotik am Oberrhein. Meisterwerke der Plastik und des Kunsthandwerk 1450–1530, cat., Karlsruhe, 1970.

Stadt im Wandel. Kunst und Kultur des Bürgertums in Norddeutschland 1150–1650, cat., 4 vols, Brunswick, 1986.

Stange, Alfred, *Deutsche Malerei der Gotik*, 11 vols, Berlin, 1934–61.

Starn, Randolph, 'The Republican Regime of the 'Room of Peace' in Siena 1338–40', *Representations*, 18, 1987, pp. 1–32.

—— and Partridge, Loren, 'Representing war in the Renaissance: the shield of Paolo Uccello', *Representations*, 5, 1984, pp. 33–65.

Stechow, Wolfgang (ed.), *Northern Renaissance Art 1400–1600: Sources and Documents*, Englewood Cliffs, NJ, 1966.

Sterling, Charles and Schaefer, Claude, *The Hours of Etienne Chevalier: Jean Fouquet*, London, 1972.

Stöcklein, Hans, 'Die Schlacht bei Pavia: zum Gemälde des Ruprecht Heller', in Buchner and Feuchtmayr (1924).

Strauss, Gerald, *Sixteenth-century Germany: its Topography and Topographers*, Madison, 1959.

—— *Nuremberg in the Sixteenth Century*, New York, 1966.

Strauss, Walter, L., *The Complete Engravings, Etchings and Drypoints of Albrecht Dürer*, New York, 1972.

—— *Chiaroscuro. The Clair-oscur Woodcuts by the German and Netherlandish Masters of the XVIth and XVIIth Centuries. A Complete Catalogue*, Greenwich, CT, 1973.

—— *The Complete Drawings of Albrecht Dürer*, 6 vols, New York, 1974.

—— *The German Single-leaf Woodcut 1550–1600*, 3 vols. New York, 1975.

Sumberg, S.L., *The Nuremberg Schembart Carnival*, New York, 1941.

Tietze, Hans, *Titian*, 2 vols, Vienna, 1936.

Tietze-Conrat, E., *Andrea Mantegna. Le pitture, i disegni, le incisioni*, London and Florence, 1955.

Toesca, Pietro, *La pittura e la miniatura nella Lombardia dal più antichi monumenti alla metà del Quattrocento*, Turin, 1966.

—— 'Francesco Pesellino, miniaturista', *Dedalo* (1932), pp. 85–91.

Tolnay, Charles de, *Hieronymus Bosch*, New York, 1966.

Treue, Wilhelm, et al. (eds), *Das Hausbuch der Mendelschen Zwölfbrüderstiftung zu Nürnberg. Deutsche Handwerkbilder des 15 und 16. Jahrhunderts*, 2 vols, Munich, 1965.

Triomphe du Maniérisme Européen, Le, cat., Amsterdam, 1955.

Tschachtlan Berner Chronik 1470, ed. H. Bloesch et al., Zurich, 1933.

Uhlitzsch, Joachim, *Der Soldat in der bildenden Kunst 15. bis. 20. Jahrhundert*, E. Berlin, 1987.

Unterkircher, Franz, *Maximilian I. Ein Kaiserlicher Auftraggeber illustrierter Handschriften*, Hamburg, 1983.

Valcanover, Francesco, *Le gallerie della Accademia*, Venice, 1981.

Valente, P.C. (ed.), *La battaglia nella pittura del XVII e XVIII secolo*, Parma, 1986.

Van Einem, Herbert, *Michelangelo*, trans. Ronald Taylor, London, 1976.

Varese, Ranieri, *Lorenzo Costa*, Milan, 1967.

Vasari, Giorgio, *Le opere di Giorgio Vasari*, ed. Gaetano Milanesi, 9 vols, Florence, 1875–85.

Giorgio Vasari, cat., Arezzo, 1981.

—— *Lives of the Artists*, trans. George Bull, 2 vols, Harmondsworth, 1965; London, 1987.

Vaux de Foletier, F. de, *Galiot de Genouillac, maître de l'artillerie de France (1465–1546)*, Paris, 1925.

Veca, Alberto, *Vanitas. Il Simbolismo del Tempo*, Bergamo, 1981.

Venezia e la difesa del Levante da Lepanto a Candia 1570–1670, cat., Palazzo Ducale, Venice, 1986.

Venturi, Adolfo, *North Italian Painting of the Quattrocento*, New York, 1974 (2 vols in 1).

Verheyen, Egon, *The Paintings in the Studiolo of Isabella d'Este at Mantua*, New York, 1971.

Vitry, P., *L'église abbatiale de Saint-Denis et ses tombaux*, Paris, 1908.

Von Holst, Christian, *Francesco Granacci*, Munich, 1974.

Voss, Hermann, *Die Malerei der Spätrenaissance in Rom und Florenz*, Berlin, 1920.

Waldburg-Wolfegg, Graf Johannes, *Das mittelalterliche Hausbuch*, Munich, 1957.

Washburn, G.B., 'Genre and secular subjects', *Encyclopaedia of World Art*, New York, 1959–68, vol. 5, cols 81–99.

Werner, Johannes, *Die Passion des armen Mannes*, Freiburg, 1980.

Whalley, Joyce Irene, *Pliny the Elder, Historia Naturalis*, Victoria and Albert Museum, London, 1982.

Wilden Leute des Mittelalters, Die., cat., Museum für Kunst und Gewerbe, Hamburg, 1963.

Winkler, Friedrich, *Der Leipziger Valerius Maximus. Mit ein Einleitung über die Anfänge des Sittenbildes in den Niederlanden*, Leipzig, 1921.

—— *Die flämische Buchmalerei des XV. und XVI. Jahrhunderts*, Leipzig, 1925.

—— *Der Krakauer Behaim-Codex*, Berlin, 1941.

—— *Die Zeichnungen Hans Süss von Kulmbachs und Leonhard Schäufeleins*, Berlin, 1942.

—— *Hans von Kulmbach. Leben und Werk eines fränkischen Künstlers der Dürerzeit*, Stadtarchiv Kulmbach, 1959.

Winzinger, Franz, *Albrecht Altdorfer. Zeichnungen*, Munich, 1952.

—— *Die Zeichnungen Martin Schongauers*, Berlin, 1962.

—— *Albrecht Altdorfer. Graphik*, Munich, 1963.

—— *Die Miniaturen zum Triumphzug Kaiser Maximilians I*, 2 vols, Vienna-Graz, 1972–3.

—— *Albrecht Altdorfer. Die Gemälde*, Munich-Zurich, 1975.

—— *Wolf Huber, Das Gesamtwerk*, 2 vols, Munich, 1979.

Wirth, Jean, *La jeune fille et la mort. Recherches sur les thèmes macabres dans l'art germanique de la Renaissance*, Geneva, 1979.

Wittkower, Rudolf, 'Transformations of Minerva in Renaissance imagery', *Journal of the Warburg and Courtauld Institutes* (1939), pp. 199–202.

—— *Idea and Image. Studies in the Italian Renaissance*, London, 1978.

Wohlfeil, R. and T., 'Landsknechte im Bild. Überlegungen zur "Historischen Bildkunde"', in P. Bickle (ed.), *Bauer, Reich und Reformation. Festschrift Günther Franc*, Stuttgart, 1982.

Wölfflin, H., *The Sense of Form in Art. A Comparative Psychological Study*, New York, 1958 (first edn, Munich, 1931).

Woods-Marsden, Joanna, 'French chivalric myth and Mantuan political reality in the Sala del Pisanello', *Art History*, vol. 8, no. 4. December 1985, pp. 397–412.

—— 'The sinopia as preparatory drawing: the evolution of Pisanello's tournament scene', in *Master Drawings* (1985–6), pp. 175–92.

—— *The Gonzaga of Mantua and Pisanello's Arthurian Frescoes*, Princeton University Press, 1988.

Worringer, W. (ed.), *Urs Graf. Die Holzschnitte zur Passion*, Munich, 1923.

Zamboni, Silla, *Pittori di Ercole I d'Este*, Ferrara, 1975.

Zampetti, Pietro (ed.), *Giorgione e i Giorgioneschi*, cat., Venice, Palazzo Ducale, 1955.

—— *L'opera completa di Giorgione* (new edn) Milan, 1978.

Zemp, Josef, *Die Schweizerischen Bildchroniken und ihre Architektur-Darstellungen*, Zurich, 1967.

Zenale e Leonardo: tradizione e rinnovamento della pittura lombarda, cat., Milan, 1982.

Zschelletzschky, Herbert, *Die 'drei gottlosen Maler' von Nürnberg. Sebald Beham, Barthel Beham und Georg Pencz*, Leipzig, 1975.

Zygulski, Zdzislaw, 'The Battle of Orsha . . .' in Robert Held (ed.), *Art, Arms and Armour: an International Anthology*, vol. 1, Chiasso, 1979, pp. 108–43.

INDEX

INDEX OF ILLUSTRATIONS

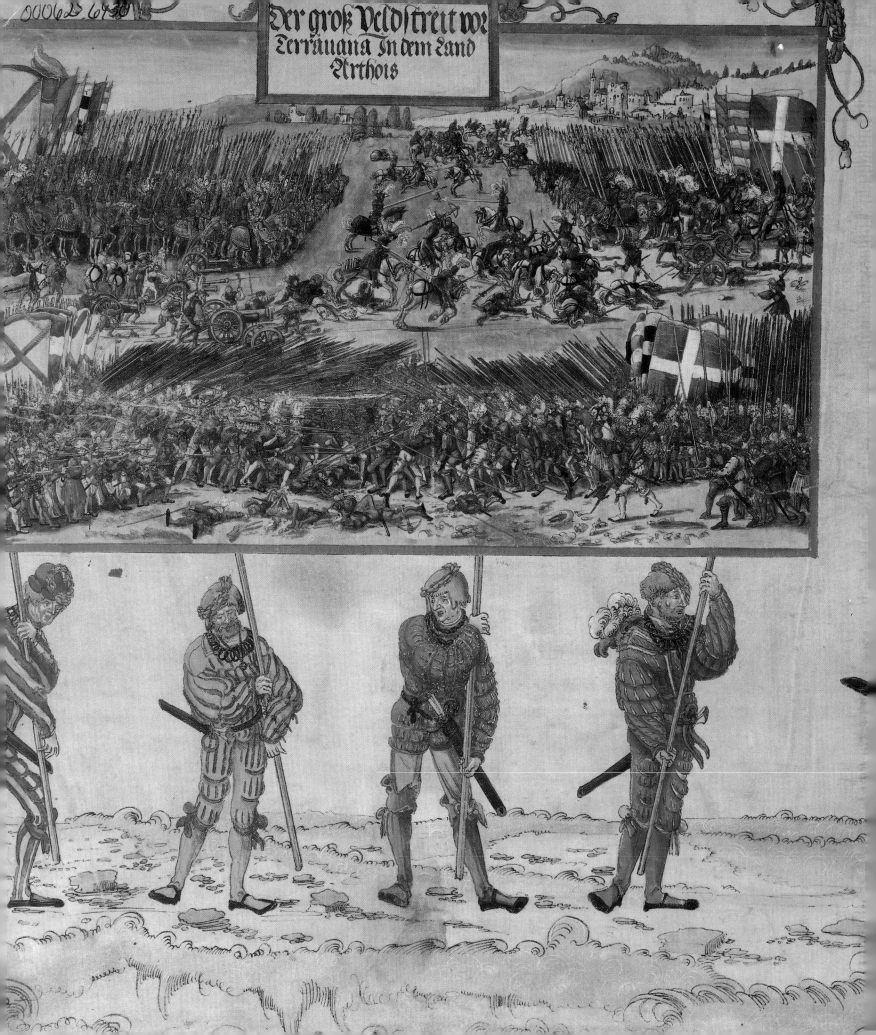

Der groß Veldstreit vor
Terrauana In dem Land
Arthois